FROM DARKNESS TO LIGHT

From Darkness to Light

Writers in Museums 1798–1898

*Edited by Rosella Mamoli Zorzi and
Katherine Manthorne*

https://www.openbookpublishers.com

ISBN Paperback: 978-1-78374-549-4
ISBN Hardback: 978-1-78374-550-0
ISBN Digital (PDF): 978-1-78374-551-7
ISBN Digital ebook (epub): 978-1-78374-552-4
ISBN Digital ebook (mobi): 978-1-78374-553-1
ISBN Digital (XML): 978-1-78374-723-8
DOI: 10.11647/OBP.0151

Cover image: Jacopo Tintoretto, *The Adoration of the Magi*, Scuola Grande di San Rocco, Venice (graphic elaboration by Pier Giovanni Possamai, The University of Venice, Ca' Foscari). Cover design: Anna Gatti

Contents

Acknowledgments

This book originated in a conference held in Venice at the Scuola Grande di San Rocco and at the Salone da Ballo of the Correr Museum, 27–29 April 2016. It was organized by the Venice Committee of the Società Dante Alighieri together with The Graduate Center, City University of New York. Our thanks go first and foremost to the *Guardian Grando* of the Scuola Grande di San Rocco, Franco Posocco, for hosting the conference among the marvellous Tintoretto paintings in the Scuola Grande di San Rocco, to the *Vicario* of the Scuola, Demetrio Sonaglioni, and to the *Procuratrice* of the Scuola, Maria Agnese Chiari Moretto Wiel; to the President of the Musei Civici di Venezia (MuVe), Mariacristina Gribaudi, and to its Director, Gabriella Belli, for receiving us in the Sala da Ballo of the Correr Museum. We would also like to thank Thomas Callegaro of the Scuola Grande di San Rocco for his help collating the images. The conference would not have been possible without a grant from the Gladys Krieble Delmas Foundation through Save Venice Inc., whose Venice Director, Melissa Conn, also received us at the Rosand Library. We are also grateful to Arch. Ettore Vio, former *proto* of the Basilica, for an unforgettable visit to the Basilica di San Marco, which we entered in total darkness and then saw in all its golden light. We would also like to thank the Secretary General of the Società Dante Alighieri, Alessandro Masi, for participating to the welcome addresses together with the Guardian Grando, the President and the Director of MuVe, and with the President of the Amici dei Musei, Paolo Trentinaglia de Daverio. Several scholars chaired the different sessions, making them lively with their comments: we would like to thank Gabriella Belli, for her lively introduction to the works; Paola Marini, Director of the Gallerie

dell'Accademia; Philip Rylands, Director of the Peggy Guggenheim Collection; Renata Codello, General Secretary for MiBact for the Veneto region; Ileana Chiappini di Sorio, art historian; and Daniela Ciani, Pia Masiero, and Simone Francescato, Americanists of the University of Venice, Ca' Foscari. We thank for their papers Giovanni Carlo Federico Villa, professor of art history at the University of Bergamo; Andrea Bellieni, Director of the Correr Museum; Gianfranco Pocobene, of the Isabella Stewart Gardner Museum; and Jean Pavans, the most important translator of Henry James in France: for various reasons their papers could not be included in this volume. Finally, we would like to thank Pier Giovanni Possamai, of the University of Venice Ca' Foscari, for understanding immediately what the conference was about and therefore suggesting the telling image on the cover of this book.

Rosella Mamoli Zorzi and Katherine Manthorne

Notes on Contributors

Cristina Acidini was born in Florence and is an art historian. She has served most of her life under the Ministero per i Beni e le Attività Culturali. She was Superintendent of the Opificio delle Pietre Dure; then, until 2014, of the Florence Polo Museale, including twenty-seven state art museums (Galleria dell'Accademia, Palazzo Pitti, the Uffizi etc.). She has organized and directed restorations, museum re-orderings, exhibitions in Italy and abroad, studies and research. She has written on Renaissance artists such as Botticelli, Michelangelo, Vasari, on the Medicis, and on villas and gardens in Florence. She has been awarded several international prizes. She is now President of the Accademia delle Arti del Disegno of Florence.

Adrienne Baxter Bell is Associate Professor of Art History at Marymount Manhattan College. Her publications include *George Inness and the Visionary Landscape* (2003), which accompanied an exhibition she curated for the National Academy of Design and San Diego Museum of Art, and *George Inness*: *Writings and Reflections on Art and Philosophy* (2007). Recent work includes chapters in *The Cultured Canvas*: *New Perspectives on American Landscape Painting* (2011) and *Locating American Art*: *Finding Art's Meaning in Museums, Colonial Period to the Present* (2016). At the time of writing, her current book and exhibition project is *Transnational Expatriates*: *Coleman, Vedder, and the Aesthetic Movement in Gilded Age Italy*.

Cristina Beltrami is an art historian specialising in the sculpture, painting and applied arts of the nineteenth and the first half of the twentieth century, with special reference to the exchanges between Italy and France. She obtained her Art History Ph.D. at the University of Venice

Ca' Foscari with a dissertation on the sculptural patrimony preserved in Uruguay (1998) and a second Ph.D. in Scienze dei Beni Culturali at Università degli Studi di Verona (2013), with a dissertation entitled: *Una presenza in ombra. La scultura alla Biennale di Venezia (1895–1914)*.

Maria Agnese Chiari Moretto Wiel has a Ph.D. in Art History (1989). Her research interests focus mainly on Venetian paintings and etchings of the sixteenth century and on the Venice *Scuole*; she has written about a hundred publications. From 1981 she has been teaching Venetian art history at the Venice branch of Wake Forest University (Winston Salem, N.C.) and History of Modern Art at the Venice I.S.S.R. 'San Lorenzo Giustiniani'. She has taught History of Drawing, Etching, and Graphics at the Università Ca' Foscari di Venezia (1999–2008) and has taught at Duke University and at the School of Humanities and Social Sciences of the Venice International University. She has been a member of the scientific board of the Marcianum Press. She is a member of the Ateneo Veneto and of the Cancelleria (Secondo procuratore di chiesa) of the Scuola Grande di San Rocco.

Margherita Ciacci has taught at the Universities of Urbino and Florence. She now teaches Sociology at the Florence campus of New York University. Her recent studies and research are focused on Anglo-American culture and personalities, which has resulted in exhibitions and publications including *I giardini delle regine: il mito di Firenze nell'arte pre-raffaellita e nella cultura americana fra '800 e '900* (2004) and *Americani a Firenze* (2012).

Marina Coslovi received her Ph.D. in English and American Studies from Ca' Foscari University Venice and is currently teaching at Nottingham University. She is interested in the relationship between writers and the visual arts, and has published articles on the making of the Whitney Museum in New York and on Henry James and Vittore Carpaccio.

Paula Deitz is editor of *The Hudson Review*, a magazine of literature and the arts published in New York City. As a cultural critic, she writes about art, architecture and landscape design for newspapers and magazines in the U.S. and abroad. Her book, *Of Gardens: Selected Essays* (2016), was published by the University of Pennsylvania Press.

Helen Dorey is Deputy Director of Sir John Soane's Museum. For thirty years she has worked on the authentic restoration of the Museum, culminating with Soane's private apartments (opened in 2015). Her publications include *John Soane and J.M.W. Turner* (2007) and catalogues of Soane's furniture and stained glass. She has curated exhibitions at the Soane, Tate Britain and the Royal Academy. Since September 2015 she has been Acting Director of the Soane and she is also Chairman of the Scholarship Committee of the Attingham Trust, a Trustee of the Moggerhanger House Preservation Trust and a Fellow of the Society of Antiquaries.

Antonio Foscari, professor of History of Architecture at the School of Architecture IUAV, Venice, is the author of many publications on Renaissance architecture. He has directed important projects and restorations, such as the project of the theatre for Leonardo Sciascia at Racalmuto (Sicily) and the restoration of Palazzo Grassi in Venice for FIAT. He is a member of the Accademia Olimpica and has been a member of the Louvre Board for six years.

Pere Gifra-Adroher is a Lecturer of English at the Department of Humanities in Universitat Pompeu Fabra (Barcelona). He is the author of *Between History and Romance*: *Travel Writing on Spain in the Early Nineteenth-Century United States* (2000) and co-editor of a volume on the representation of otherness entitled *Interrogating Gazes* (2013). Most of his research has focused on travel writing and cultural exchanges between Spain and the US during the nineteenth century. He is currently working on an anthology of nineteenth-century American women travellers in Spain.

Lee Glazer is curator of American art at the Smithsonian's Freer Gallery of Art and Arthur M. Sackler Gallery. She has curated numerous exhibitions, including, most recently, *Peacock Room REMIX*: *Darren Waterston's Filthy Lucre*. Glazer is the author of *A Perfect Harmony*: *The American Collection in the Smithsonian's Freer Gallery of Art* (2003) and co-editor of *East West Interchanges in American Art*: *A Long and Tumultuous Relationship* (2012) and *Palaces of Art*: *Whistler and the Art Worlds of Aestheticism* (2013). Her current research focuses on James McNeill Whistler's watercolors, to be featured in an exhibition at the Freer in 2018.

Dorsey Kleitz is a Professor of English at Tokyo Woman's Christian University. His research and publications focus on links between nineteenth- and twentieth-century American literature and Asia — especially Japan. He recently co-edited with David Ewick *'Lacking the gasometer penny': Michio Itō's Reminiscences of Ezra Pound, W. B. Yeats, and Other Matters* (2016).

Page Knox Ph.D. is an adjunct professor in the Art History Department of Columbia University, where she received her doctorate in 2012. Her dissertation explores the significant expansion of illustration in print media during the 1870s, using *Scribner's Monthly* as a lens to examine how the medium changed the general aesthetic of American art in the late nineteenth century. She is also a Contractual Lecturer for the Education Department at the Metropolitan Museum of Art, where she gives public gallery talks, teaches courses for membership, and lectures on special exhibitions as well as the permanent collection.

Burt Kummerow began his history career studying Rome and Greece, especially Pompeii, before going on to examine early America. He helped to found the Living History Movement in the USA and has been a writer, popular speaker, public television producer, museum director and rock musician. As the President of Historyworks Inc. (Maryland), he is a multi-faceted public historian who uses a wide range of skills and experience to bring history to the general public. He is the author of *War for Empire, Heartland, Pennsylvania's Forbes Trail*, and *In Full Glory Reflected, Discovering the War of 1812 in the Chesapeake*. Presently, he is preparing a book for the 200th anniversary of the Baltimore Gas and Electric Company, born in the Peale Museum in 1816. Kummerow has retired as President and CEO and is now the Historian-in-Residence at the Maryland Historical Society.

Kathleen Lawrence is Associate Professor at Georgetown University, having been a visiting scholar at Yale University. She was a professor of English at Brandeis University and formerly of George Washington University. Her scholarly work has appeared in the *Henry James Review, Ateneo Veneto, Emerson Society Quarterly*, and *Harvard Library Bulletin*, among other journals, and focuses on nineteenth-century American authors and artists Henry James, Margaret Fuller, Ralph Waldo Emerson,

and William Wetmore Story. She is completing an edited volume for the *Cambridge Complete Fiction of Henry James* as well as a biography of William Wetmore Story.

Sandra K. Lucore (Ph.D. Bryn Mawr College) is an independent scholar in classical archaeology, currently directing projects at ancient Morgantina (Sicily). Trained also in art history, she has taught western art in Japan, developing an interest in comparative aesthetics. Japan's wealth of museums and galleries provides rich terrain for understanding Japanese art and the aesthetics of display, and for understanding Japanese responses to western art as influenced by this aesthetic (including lighting).

Rosella Mamoli Zorzi is Professor of American Literature, Emeritus, at the University of Venice Ca' Foscari and President of the Venice Committee of the Società Dante Alighieri. She has published widely on American writers and Venice, American writers and Titian, Tintoretto, Tiepolo, in such essays as 'Jacopo Tintoretto, John Ruskin e Henry James' (1996),'Tiepolo, Henry James, and Edith Wharton', in *Metropolitan Museum Journal*, 1998. She has edited several volumes of Henry James's letters, among them *Letters from the Palazzo Barbaro* (1998), *Beloved Boy. Letters to Hendrik C. Andersen, 1899–1915* (2004), *Letters to Isabella Stewart Gardner* (2009). She has co-curated several exhibitions and written in their catalogues, see *Gondola Days. Isabella Stewart Gardner and the Palazzo Barbaro Circle* (2004), *Sargent's Venice* (2006), *Two Lovers of Venice. Byron and Constance Fenimore Woolson* (2014). Her more recent work is the book *'Almost a Prophet'. Henry James on Tintoretto* (2018).

Katherine E. Manthorne is Professor of Art History, Graduate Center, City University of New York. She focuses on hemispheric dimensions of American art, from *Tropical Renaissance. North American Artists Exploring Latin America, 1839–1879* (1989) to *Traveler Artists: Landscapes of Latin America from the Patricia Phelps de Cisneros Collection* (2015). Her research on American landscape art has resulted in *The Landscapes of Louis Remy Mignot: A Southern Painter Abroad* (1996); *Luminist Horizons. The Art and Collection of James A. Suydam* (2006); and *Eliza Greatorex & the Art Women in the Age of Promise* (forthcoming). She is currently organizing exhibitions

for the Newark Art Museum and Laguna Art Museum. Manthorne was formerly Director of the Research Center, Smithsonian American Art Museum. She received her Ph.D. from Columbia University.

Melania G. Mazzucco (1966) is the author of many novels that have been translated into twenty-seven languages, among them *Vita* (2003, Strega Prize), *Limbo* (2012), and *Sei come sei* (2013). In addition to reportage, tales for young people, radio dramas and plays, she has published *Il museo del mondo* (2014), a journey into art in fifty-two paintings. She is a regular contributor to *La Repubblica*. Her novel *La lunga attesa dell'angelo* (2009, winner of the Bagutta Prize) is focused on Tintoretto as is her biography *Jacomo Tintoretto & i suoi figli. Storia di una famiglia veneziana* (2010, Comisso and Croce Prizes); she has also contributed to the catalogue and the exhibition *Tintoretto* (Scuderie del Quirinale di Roma, 2012).

David E. Nye, professor, founded the first Danish Center for American Studies in 1992 at the University of Southern Denmark. He received the Leonardo da Vinci Medal in 2005, the highest honor of the Society for the History of Technology. His more than 200 publications include eight books with MIT Press, including *Electrifying America* (1990), *American Technological Sublime* (1996), and *Technology Matters* (2007). He is currently writing a book on the cultural history of nineteenth-century American illumination. He was knighted by the Queen of Denmark in 2014.

Joshua Parker is an assistant professor of American studies at the University of Salzburg with research interests in place and space in American literature, transatlantic relations and narrative theory. His most recent work is *Tales of Berlin in American Literature up to the 21st Century* (2016), on American authors writing on Berlin. He has edited a volume on Austrian-American relations from 1865–1933, and he is working on a second volume covering 1933 to the present.

Alberto Pasetti Bombardella graduated with honours at the Venice Istituto Universitario di Architettura in 1990, and in the following years he has worked on aspects of museography and exhibition lighting at the Los Angeles School of Architecture (SCIARC) and at the Getty Conservation Institute, with a CNR grant. From 1995 his professional activity has focused on lighting design with Studio Pasetti Lighting.

He is consultant in technological innovation and the valorization of cultural heritage both in the private and public sectors. He has planned innovative projects for regional Superintendencies, Museums and Foundations, uniting research and experimentation, aiming at new forms of visual communication through light. He has published several specialized articles and works on the lighting of exhibitions.

Sergio Perosa is Professor of English and American Literature, Emeritus, at Ca' Foscari University, where he taught from 1958, and a regular contributor to *Il Corriere della Sera*. He co-edited a bilingual 'Tutto Shakespeare' and has published studies, editions and/or translations of Shakespeare, Henry James, F. Scott Fitzgerald, Virginia Woolf, Herman Melville, Edgar Allen Poe, Emily Dickinson, William Dean Howells, John Berryman, Robert Penn Warren, and others. The latest are *Art Making Life. Studies in Henry James* (2015), *Giulietta e Romeo*, a new Italian rhymed version (2016), and *Veneto, Stati Uniti e le rotte del mondo. Una memoria* (2016).

Sarah Quill has worked between Venice and London since the early 1970s, creating a photographic archive of Venetian architecture, environment and daily life. In 2004–2007 she worked as consultant on Lancaster University's research project for the Ruskin Library's electronic edition of John Ruskin's *Venetian Notebooks* of 1849–50. A new and extended edition of her book *Ruskin's Venice: The Stones Revisited* was published in 2015. She is a trustee of the Venice in Peril Fund.

Holly Salmon is the head of Objects Conservation and Lighting Project Manager at the Isabella Stewart Gardner Museum. She received her M. S. from the Winterthur/University of Delaware Program in Art Conservation and a certificate of Advanced Training from Harvard's Straus Center for Conservation. Holly was the Lighting Project Manager during the Gardner's eight-year initiative to redesign lighting in the galleries. She has lectured and conducted workshops on Asian lacquer, laser cleaning and the Gardner Lighting Project.

Emma Sdegno is Lecturer in Victorian Literature and Culture at Ca' Foscari University Venice. She has written several essays on Ruskin, with a major focus on rhetoric and style, and in the context of translation and travel studies. Her publications include two volumes of essays on

Ruskin, Venice and Nineteenth-Century Cultural Travel, edited with R. Dickinson and with K. Hanley (2010), and the translation of J. Ruskin, *Guida ai principali dipinti nell'Accademia di Belle Arti di Venezia* edited by P. Tucker (2014).

Demetrio Sonaglioni graduated in Electronic Engineering at the University of Padua. After some experiences in scientific applied research in Milan and Rome, he worked at RAI-Radiotelevisione Italiana (Venice branch) where he directed the technical aspects of shooting and broadcasting. After he moved to the RAI General Direction in Rome, he renewed the national broadcasting organization: a complex task, with collaborators all over Italy. After leaving RAI, he taught Electronics and Telecommunications for ten years. Since 2008 he has been the *Vicario* (vice president) of the Scuola Grande di San Rocco in Venice, where he contributes to the organization of a place that is full of art and history but is at the same time a 'business machine' to be governed with entrepreneurial and innovative skills, ranging from conservation to organization of events, to looking after the people employed in the Scuola.

Camillo Tonini graduated in Philosophy and has worked for many years as conservator of the historical and geographical collections of the Venice Museo Correr. In this capacity he has curated several exhibitions, including *Dai dogi agli imperatori, Venezia Quarantotto, A volo d'uccello. Jacopo de' Barbari e le rappresentazioni di città nell'Europa del Rinascimento, Navigare e descrivere, Venezia che spera,* and he has published essays on Venetian subjects for exhibition catalogues and special editions such as *La laguna di Venezia nella cartografia a stampa del Museo Correr, La chiesetta del doge a Palazzo Ducale di Venezia.* He was also responsible for the Cataloguing Service of the Museums of Venice, including the civic collections and those of the Venice Ducal Palace. He is the editor of the *Bollettino dei Musei Civici Veneziani.*

Introduction: From Darkness to Light: Writers in Museums 1798–1898

Rosella Mamoli Zorzi and Katherine Manthorne

This book originated from the international conference 'From Darkness to Light: Writers in Museums 1798–1898', organized by the Venice Committee of the Dante Alighieri Society, the Fondazione Musei Civici Veneziani, the Scuola Grande di San Rocco, and the Graduate School of the City University of New York, which took place in Venice between 27–29 April 2016.

The aim of the conference, and of this book, is to compare the viewing experiences of writers and journalists in museums, galleries and churches in the United States, in Europe, and in Japan *before* electric light was introduced. Our historical focus ranges from 1798, the time when the Louvre became a museum open to the public, to the end of the following century.

The project was born in the Scuola di San Rocco, when the new LED lighting system was installed in the lower hall of the Scuola: in the brightness of the LED light, the phantasmagorical figures of the horsemen in Tintoretto's *Adoration of the Magi* suddenly emerged from the background of the painting, as if the rest of the painting had been erased and the ghostly figures shown in all their power as if in a close-up. It was as if the subconscious of the painter had risen to the light, suddenly.

 https://doi.org/10.11647/OBP.0151.28

This upsetting experience caused us to consider a problem often discussed: how lighting can completely change the viewer's perception of a painting. Even if Tintoretto knew exactly what type of (natural) light there would be in the Scuola, and kept it in mind as he was painting his great *teleri*, his paintings nonetheless underwent some transformations over time — for example his colours became much darker than they had been when the paintings were initially completed. The lack of plentiful natural light in the Scuola meant that some of the paintings were obscured by darkness; both John Ruskin (in 1846) and Henry James (in 1869) lamented the difficulty of actually *seeing* the paintings, except for the immense *Crucifixion* in the Sala dell'Albergo, which did receive enough light from the side windows.

In spite of this obscurity and the gradual darkening that the paintings had suffered, both Ruskin and James were absolutely conquered by the beauty and power of Tintoretto's *teleri* in the Scuola. We are therefore confronting an infinite admiration for paintings that could not be seen well: one could even say that we are facing an aesthetics of darkness. Ruskin himself, in spite of lamenting the lack of light, saw in the obscurity the possibility of the 'imagination penetrative.'[1]

This aesthetics of darkness had its admirers, including many of the nineteenth-century visitors to the museums of Florence and Rome, as we explore in this volume. It is still respected today in Sir John Soane's London Museum, as Helen Dorey explains in Chapter 15, as well as in ancient civilizations whose influence is still alive today, as we see in the contributions from Antonio Foscari, who discusses Byzantine culture in Chapter 27, and Dorsey Kleitz and Sandra K. Lucore, who focus on Japan in Chapter 24.

The Scuola Grande di San Rocco remained dark until 1937, lit only by the varying natural light of clear or cloudy days. In that year Mariano Fortuny was asked to light the Scuola with the indirect illumination with which he had experimented in theatres. If this seems a late date for the introduction of electricity many other museums were just as tardy, although a few were more avant-garde — as for instance the Rembrandt Peale Museum in Baltimore, which had gaslight as early as 1816, while the Victoria and Albert Museum used gaslight from 1857.

1 John Ruskin, *Modern Painters*, 5 vols. (New York and Chicago: The Library Edition, 2009), II, Chapter 3.

Part I begins with 'On Light' by Melania Mazzucco, a very well-known Italian writer and the author of two magnificent books on Tintoretto, *La lunga attesa dell'angelo* (2008) and *Jacomo Tintoretto & i suoi figli. Storia di una famiglia veneziana* (2009). Mazzucco introduces us to the 'inner' light of Tintoretto's works. Lamps, candles, tapers and other sources of illumination are not often portrayed by the painter: Tintoretto's light comes from other sources; it is a transcendental luminescence.

The essay by David Nye, one of the best-known world experts on the history of lighting, deals instead with the technology of lighting, the delay between the discovery of new forms of lighting and their application, and explains why so many museums were slow to install electric light.

Agnese Chiari Moretto Wiel, of the Scuola, introduces Part II: On Light at the Scuola Grande di San Rocco and in Venice. The essay by Rosella Mamoli Zorzi deals with the reactions of John Ruskin and Henry James to the Scuola, to their denunciation of its darkness, but also to their articulation of an aesthetics of darkness. Demetrio Sonaglioni's contribution leads us through the changes in the lighting of the Scuola up to the moment when Mariano Fortuny was asked to install his indirect lighting in 1937, developing a system of cupolas that have also been used in the new LED installations. Camillo Tonini illustrates the problems of lighting the Palazzo Ducale, which suffered frequent fires; Emma Sdegno takes us to the Gallerie dell'Accademia with John Ruskin; and finally in this section Cristina Beltrami shows us the reactions of several nineteenth-century French writers to the light of Venice, its natural reflections and its new artificial lighting.

In Part III: On Light in American Museums, we move to the United States. Burton Kummerow's essay presents the fascinating Peale Family's extraordinarily early faith in gaslight, introduced as early as 1816 in their museum in Philadelphia. Katherine Manthorne illustrates the ways in which a very famous and very popular painting, *The Heart of the Andes* by Frederic Church, was illuminated and exhibited in various venues. Kathy Lawrence examines the Yale gallery of 'primitivi' collected by James Jackson Jarves, which nobody at the time really wanted, and the efforts to establish a 'European' gallery. Holly Salmon discusses the challenge of lighting the Isabella Stewart Gardner

Museum of Boston, balancing the need to honour the decisions made by Gardner, who wanted to preserve a sense of mystery in the museum, with the choices made by the board after her death in response to the requirements of modernity. Lee Glazer takes us to the Freer Gallery of Washington, analysing Freer's promotion of the 'power to see beauty' through the creation of his museum, even for people who did not have his privileges.

In Part IV: On Light in Museums and Mansions in England, France and Spain, Sarah Quill deals with the strong opposition to gaslight and electric light in the London National Gallery, and links the idea of extending opening hours (which required artificial lighting) to the fear of having drunkards or prostitutes meeting in the museum. Helen Dorey takes us to the London Museum created by Sir John Soane, 'the architect of light', discussing its original lighting and the effort to keep the museum as mysterious as its founder wanted it.

Marina Coslovi examines the passion for collecting demonstrated by some of the dukes of Cavendish, the owners of Chatsworth, and their resistance to gaslight (which was used only in the kitchens and other domestic spaces) but not finally to electricity. Paula Deitz discusses various moments of appreciation in different museums, including the Louvre, the Avignon Museum and the Venice Palazzo Barbaro, in the essays and novels of Henry James. Pere Gifra-Adroher examines the great Prado in Madrid as it was recorded in the diaries and travel narratives of American visitors in the nineteenth century.

In Part V: On Light in Italian Museums, Cristina Acidini takes us inside the Uffizi and deals with the excess of natural light and the remedies developed to counteract it, without neglecting the darker rooms; she then tells us the shocking story of the lighting of the Cappella dei Magi in the Medici Riccardi palace, painted by Benozzo Gozzoli, ending her essay with the history of the special placing of Michelangelo's *David* in the Tribuna. Margherita Ciacci's essay takes us from Florence to Rome, as Ciacci examines the different perceptual habits of American travellers who sought a new cultural status within a 'process of selective cultural appropriation', where light and darkness are part of the construction of one's subjectivity. Joshua Parker discusses Henry James's ambiguous relation to darkness and light as experienced in the museums of Venice and Florence. In presenting Timothy Cole's amazing engravings of Old Italian Masters for *The Century*, Page S. Knox explores the difficult

material conditions in which these reproductions were completed in dark and ice-cold places. Finally Adrienne Baxter Bell introduces us to an extraordinary and hitherto forgotten woman, Anne Hampton Brewster, who wrote for the *Philadelphia Ledger* not only on works of arts and ceremonies in Rome, but also on the excavations of antiquities in Italy's capital and in the surrounding cities.

In our concluding section, Part VI, On Light in Museums in Japan, Dorsey Kleitz and Sandra Lucore lead us to Japan and to its aesthetics of 'shadows', showing us the influence of Fenollosa in forging a new consciousness for Japanese art.

In the *Postscript*, Sergio Perosa takes us from Shakespeare's 'interpenetration of darkness and light(ing)', to Henry James's museums and his Shakespearean 'contradictory phases of appreciation', by way of Nathaniel Hawthorne, Herman Melville and George Eliot, ending with a Latin poem by Fernando Bandini on the newly restored Cappella Sistina frescoes, where again 'fear of impending doom, that light will be lost and darkness prevail' surfaces at the end.

Alberto Pasetti Bombardella's essay underlines the new possibilities offered by LED lighting in the 'staging' of Tintoretto's paintings, going back to Plato's myth of the cavern as a starting point, while Antonio Foscari's essay meditates on the slow and fascinating perception of art in a centuries-old orthodox church, where obscurity prevails initially, and on the changes brought about in Renaissance buildings by modern sources of light.

Although this collection explores many museums and exhibition spaces there are some that we have not been able to cover, most obviously the history of lighting in the Louvre (though this museum is represented by James's interpretation in Deitz), the Victoria and Albert Museum, the New York Metropolitan Museum, and other major museums. We also regret the absence of papers that were delivered at the conference but could not be published here for various reasons, in particular the essay by Jean Pavans on a story by Henry James and the painting in a French museum that inspired it; the contribution by Gianfranco Pocobene on the lighting scheme that John Singer Sargent conceived for his Boston Library murals; that by Andrea Bellieni on the Museo Correr, one of

the most important museums of Venice; and the paper by art historian Giovanni Villa on the Tintorettos of the Scuola Grande di San Rocco.

This book therefore represents a starting point in a field where much work remains to be done. As we were preparing our conference, for example, we learned that some museums are returning to the use of natural light only, such as the Museum Voorlinden that opened in Holland in 2016. As Cristina Acidini underlines, much time-consuming research work in museum archives is still to be done, looking for contracts, circulars, comments on fear of fires, on electricity, etc. We hope future scholars will be as fascinated as we all were by this topic, and will throw light on it in the years to come.

PART I

ON LIGHT

1. Tintoretto: An Unexpected Light. Lightnings, Haloes, Embers and Other Glowing Lights

Melania G. Mazzucco

In hundreds of paintings, Tintoretto presented a world without sun. Clouds swamp the sky, ripples of mist veil the horizon, candles and torches do not shed light, fires and fireplaces glow red in the distance. Still, his paintings are soaked in light. My chapter will be a short journey into the life and works of Jacomo Robusti, in search of that mysterious source that makes the world's darkness visible.

The exciting and tormented existence of Tintoretto can be summarized — just as in the title of this book — as a journey from darkness to light. His painting is characterised by the revelation of light, and it transcends the traditional opposition between drawing and colour. As a result, those who write about Tintoretto are drawn inescapably to luminous metaphors. He has been compared to a beacon, to a thunderbolt, to a fire flower, to lightning, to a torch.

In 1648 Carlo Ridolfi, his earliest biographer, wrote that his brush was a 'lightning which terrified everybody with a thunderbolt'.[1] In 1660 Marco Boschini, one of the most acute interpreters of his painting,

1 Carlo Ridolfi, 'Vita di Iacopo Robusti', in *Le meraviglie dell'arte, overo le vite de gl'illustri pittori veneti* (Venice: Giovan Battista Sgava, 1648), 2 vols, https://digi.ub.uni-heidelberg.de/diglit/ridolfi1837bd2 This and the other quotations are from 'Vita di Iacopo', in *Vite dei Tintoretto* (Venice: Filippi editore, 1994), p. 48. Translations are by the author throughout unless otherwise stated.

 https://doi.org/10.11647/OBP.0151.01

strikingly summarized Tintoretto's nature in his *Carta del Navegar pittoresco*. Tintoretto, he wrote, 'came into the world with a torch in his hand'.[2] It is with this image that I am going to begin my story.

Tintoretto's apprenticeship is undertaken during the night. A young artist looking for a master, he is trying to teach himself the art of painting. At this time his name is Jacomo Robusti aka Tentor (the dyer), and he is not yet Tintoretto — but I will refer to him using his more famous name. He has managed to copy the small clay models of Michelangelo's statues in the Florence Cappelle Medicee — the very famous *Dawn, Twilight, Night* and *Day*, 'which he studied especially, making numberless drawing after them in the light of an oil lamp [*lucerna*]' — as Ridolfi wrote — 'in order to compose, thanks to the strong shadows made by those lights, strong forms in high relief.'[3]

This biographer also informs us that Tintoretto 'practiced making small wax and clay models, dressing them up with rags, carefully showing their limbs under the drapings of the clothes, inside small houses and perspectives made with wood and cardboard, placing small lights for the windows, arranging thus light and shadows.'[4] Therefore in this preliminary stage of his study, lights and tiny flames were used by the painter in order to perfect his drawing and learn to give relief to forms.

Several years have gone by. Now Tintoretto sells small paintings in the Mercerie, as do many young painters, and those who are unknown and do not have patrons. They exhibit their work in the shops of the Venice commercial area. 'And among the things he exhibited there were two portraits, one of himself with a relief in his hand, and one of his brother playing the cythara, as if it were night, in such a terrific way that everybody was astounded'.[5]

His self-portrait made before he was thirty (ca.1546–48, Philadelphia Museum of Art) also portrays the painter 'as if it were night' — it is the only established self-portrait among his many early canvasses. He emerges from the black background of the canvas as if he were coming to meet us. Light — coming from an invisible source outside the

2 Marco Boschini, *La carta del navegar pittoresco* (Venice: 1660), https://digi.ub.uni-heidelberg.de/diglit/boschini1660/0295; critical edition ed. by Anna Pallucchini (Venice and Rome: Istituto per la collaborazione culturale, 1966), pp. 226–27.
3 Ridolfi, 'Vita di Iacopo', p. 7.
4 Ibid., p. 8.
5 Ibid., p. 10.

painting — falls on his face, giving relief to his handsome features and making his penetrating blue-green eyes shine.

Therefore, in this second stage of his development, the illusion of night becomes a technical way to give relief to his own talent. Indeed, the following couplet was composed regarding his early portraits:

Si Tinctorettus noctis sic lucet in umbris,
exorto faciet quid radiante Die?[6]

Tintoretto is besieged by night from the beginning. He works in a mezzanine in San Cassan — and in that dark area of Santa Croce mezzanines have tiny windows, darkened by the shadows of the palaces. However, he also works in a metaphorical darkness, as his name is still unknown. The young painter sees his opportunity to emerge from this metaphorical darkness by means of the night: his ability to create the illusion of darkness elicits wonder and respect. Tintoretto creates this artificial night by arranging a small theatre of the tiny models in his study. His fiery talent needs darkness.

Given such beginnings, one might imagine that Tintoretto will become a painter of the night. On the contrary: he becomes the painter of light. This is how his colleague and art theoretician Giovanni Paolo Lomazzo defined him, having met him and having seen him work: he is the master of 'what is light', the master of 'reflected lights [...] inferior to no one'.[7]

I have not seen every single painting created by Tintoretto, in spite of so many years of research on this favourite painter of mine. But I feel I can say that in the 200 or 350 paintings by Tintoretto (the question of attribution is controversial) the sky is never clear. The sun rarely shines; it is never at its zenith; it is almost always invisible. A radiant sun appears only twice in his work, in two youthful 'fables': the *Phaeton* (1542, Modena Galleria Estense) and the *Zeus and Semele* (1543–44, Padua Museo Civico). But the Sun here is a mythological divinity — and Tintoretto derived it from a literary source, Ovid's *Metamorphoses*. It is a narrative feature, a deadly sun, lacking any metaphoric or artistic connotation. In those early experiments Tintoretto is interested in the

6 Ibid., p. 10. Ridolfi does not specify who the 'kind spirit' was who wrote these lines.
7 Giovanni Paolo Lomazzo, *Rime* (Milan: Paolo Gottardo Pontio stampatore, 1587), p. 101, https://archive.org/details/rimedigiopaololo00loma/page/101

foreshortening, the plastic rendering of figures, in the 'sottinsu' (seen from below), not yet in luminous effects.

Tintoretto instead is the painter of clouds: he will paint them in any form, consistency, and colour. Thick and white as cotton wool; frayed and misty, of a livid blue; white and golden in the sky where the sun has set; black like cannonballs; orange, lit up by the lightning of a storm as by the flash of a camera.

Almost all the scenes painted by Tintoretto are set at the limits of the day: at its beginning, at dawn, or at its ending, at twilight and at sunset (the most extraordinary example of this 'ora magica che volge al desio' is the Two Marys (1582–87) on the ground floor of the Scuola Grande di San Rocco. Thus, among all the works Tintoretto painted between 1537 (the date of his beginning as an independent master) and 1561, only a single one is set in what we could define, in cinema terms, 'esterno notte'. It is *Judith and Holophernes*, dated unanimously around 1550 (Museo del Prado). Tintoretto challenges and subverts iconographic convention from his earliest work (his most striking talent is his capacity for invention) and in this painting he does not set the scene of the beheading in the dark tent of the sleeping commander, but on its threshold. Judith, followed by her handmaid (who is carrying the white bag in which to wrap up Holophernes's head), advances with sword outstretched towards the victim, who is asleep on his back. In the sky, a thin crescent moon shines. But even though the moon is in its first quarter, it is not a dark night. In the dark blueish-grey sky one can make out the (white) clouds, and Judith does not need a torch or a light to aim with her blade at Holophernes's jugular vein. The painter's creativity is expressed in the foreshortening of the sleeping man and the drapings of the curtain. In this painting — maybe intended as a ceiling picture — light still has a purely narrative function. This is the only narrative moon in all of Tintoretto's oeuvre: all the other moons, scythes as thin as eyelashes, are attributes of the Immaculate Conception.[8]

8 Or else they are full moons; globular, orange, luminous halos, as in *The Agony in the Garden* and in the *Adoration of the Shepherds*, both in the Scuola Grande di San Rocco. The latter moon was painted by Tintoretto between 1578 and 1581: there are no lights or lamps in the painting, as it is not yet night. The orange light dripping from the roof comes from the moon: but it cannot be seen, and indeed we only see its halo. The result is flickering, unnatural, metaphysical light without a source, 'gratuita come la grazia': every thing, every presence achieves 'further meaning, even if remaining visibly its own self'; see Adriano Mariuz, *L'adorazione dei pastori di Tintoretto. Una stravagante invenzione* (Verona: Scripta edizioni, 2010), p. 34.

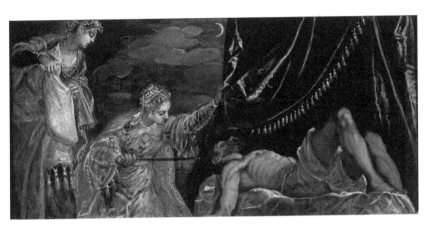

Fig. 1.1 Tintoretto, *Judith and Holofernes*, Museo del Prado, 1550. Wikimedia. Public domain, https://commons.wikimedia.org/wiki/File:Judit_y_Holofernes,_por_Tintoretto.jpg?uselang=en-gb

Instead Tintoretto paints many 'night interiors'. Although he masters a notable sensitivity to landscape, and although gardens, woods, countryside, rivers and lakes appear sporadically in his work and are painted with great virtuosity, his imagination recurs more often to the placing of figures in a closed space. This could be defined as a 'scene', and it will acquire more and more theatrical characteristics as time goes by. Well, how does Tintoretto lights up his dark interiors, which lack windows or doors?

It will surprise the viewer to discover how scanty and rare are diegetic lights in Tintoretto's work — that is, the sources of light inside the representation, visible in the painted scene. One can count them on one hand and classify them in two categories: the taper (or the tapers); and the torch (*fiaccola*).

During the research for my biography of Tintoretto, I explored the role Bramin (Abramino) Milan played in the artist's life.[9] He was a friend of his — in 1567 he became godfather to one of his sons, Giovanni Battista — his patron and commissioner (an authoritative member of the Scuola di San Rocco, whose *guardian grande* he became in 1583). Bramin Milan was a *speziere* (spice merchant) at Melon, with a shop on the Rialto, and he specialized in the sale of wax. In reading the documents that concerned his trade, I learnt that one could obtain candles of any shape,

9 Melania G. Mazzucco, *Jacomo Tintoretto & i suoi figli. Storia di una famiglia veneziana* (Milan: Rizzoli, 2009). As for Bramin Milan, see pp. 475–77.

weight, price and colour, and candles made of white wax were the most expensive, while the yellow ones were the most vulgar. In Venice, candles were used extravagantly, more for religious than functional purposes: one lit a candle to express devotion, to pray, rather than to create light. This was generally the purpose of Tintoretto's 'tapers'. We find them in various works of his, including two with the same subject: the *Presentation of Christ at the Temple*.

In the first painting, created in 1547–48 for the altar of the guild of fishermen (*compravendi pesce*) and displayed in Santa Maria dei Carmini in Venice, a crowd, witnessing the event, emerges from a black background. These extras hold in their bare hands four very long and thin white candles. The presence of candles is not incidental. The liturgical calendar commemorates the Presentation of Christ in the Temple on 2 February, called 'Candelora', that is the day when 'candles were blessed and every lamp was lit up in the churches.' This was done to remind people of the words of Simeon the Just, who, according to Luke, took Jesus in his arms, recognizing in him 'the light that enlightens people.' The *chiaroscuro*, of which Tintoretto will become the master, is still crude in this painting, the shadows are 'roughly carved', according to Pallucchini, who, however, appreciated the constructive density revealed by the young artist.[10]

In the second painting, produced a few years later (between 1550 and 1555) for the altar of the guild of the barrel-makers (*botteri*) and now displayed in the Gallerie dell'Accademia in Venice, there are only two candles, thicker and shorter, surmounted by a red-golden flame and stuck into silver candle holders. In this painting, however, the light flows in from above, from an invisible opening — and, a little less powerfully, from the left, through an equally invisible window or door. For the first time we observe that the source of light is outside the painting. The candles have merely ritual and ornamental functions; they are only a homage to the feast of the Candelora and to the logic of composition, which the painter does not break as yet. But his light is no longer physical.

The torch (*fiaccola*) appears in the best night interior of Tintoretto's early period, his *Saint Roch Cures the Plague-Stricken* in the Church of San Rocco (painted when he was thirty-one, in 1549).

10 Rodolfo Pallucchini and Paola Rossi, *Tintoretto. Le opere sacre e profane*, 2 vols. (Milan: Alfieri — Gruppo editoriale Electa, 1982), vol. 1, p. 136.

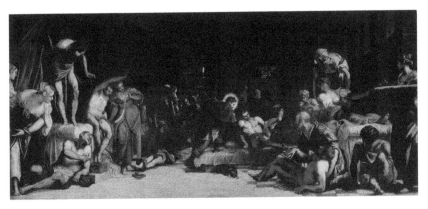

Fig. 1.2 Tintoretto, *Saint Roch Cures the Plague-Stricken*, Venice, Church of San Rocco, 1549. Wikimedia. Public domain, https://commons.wikimedia.org/wiki/File:San_Rocco_Venezia_(Interno)_-_San_Rocco_risana_gli_appestati.jpg

We see a torch (*fiaccola*), but the flame is white and it does not send out any light. In the background there is a window, through which the moonlight streams. The figures, however, are illuminated by a light source from the left, outside the painting: as if someone had opened a door. Otherwise the light of the painting is all internal: it is spread out by the flesh of the diseased, by the halo of the saint.

This spectacular night scene is unusual within Tintoretto's work. Only from the 1560s does his research concentrate on light. But his first night effect experiment is still naif.

His *Last Supper* was painted for the altar of the Most Holy Sacrament in the Church of San Simeone at the beginning of the 1560s, perhaps a little after 1561. We see, quite visible and almost tawdry, a chandelier. It is an unusual object, since, oddly enough, in the many interiors painted by Tintoretto, hardly any chandeliers are present. There are two in another of his paintings of the same period, *The Wedding at Cana* — painted in 1561 for the refectory of the Padri Crociferi, now in the Church of the Salute in Venice. They hang from the coffered ceiling of the nuptial banquet: they are silver, decorated with ribbons. But the white candles fixed in their arms are not burning: the feast takes place in the daytime and they have a purely ornamental function within the painting.[11]

11 A *lamp* had also appeared in a painting of the 40s (ca.1546): *Solomon and the Queen of Sheba*. This work, in a private collection in Bologna, is accepted as autograph in the catalogue by Pallucchini-Rossi (vol. 1, p. 347) but several other scholars deny its attribution to Tintoretto. I will limit myself to underlining that one sees in it a strange portable lamp.

As the Gospels tell, the Last Supper takes place on the evening of Shrove Thursday in the room of a house in Jerusalem (available to Jesus and his disciples thanks to a woman who sympathized with Christ). Tintoretto painted the subject of the Last Supper many times, but never in the same way. In the older version, painted for the Church of San Marcuola (1547), he was content to present a humble and dark room, lacking any illumination (no torch, lamp or lantern). The sources of light, a stronger one on the right and a more feeble one on the left, are both outside the scene.

The maximum luminosity is shed by the white, patched up, tablecloth. The figure of Christ and the haloes of the apostles radiate out light. There is no diegetic light either in the San Felice *Last Supper* (1559, now in the Church of Saint-François-Xavier, Paris). In the San Simeone *Last Supper* on the contrary, Tintoretto concentrates his attention on the search for 'lume' (light) ('di lume'). The chandelier, hanging from the ceiling, looms above the table where Christ and his apostles are sitting. It is a cumbersome metal — perhaps silver — structure, with fourteen candles on two levels. In the painting one can also see a servant, carrying a tall taper, burning with a high flame. Although the shadows of the light on the bodies and the spaces around are interesting, the experiment — perhaps entrusted to his studio by Tintoretto — cannot be said to be successful.

But it has taught the painter a lot. Immediately after, between 1563 and 1564, he paints his most atmospheric 'esterno notte', the *Transportation of Christ to the Tomb* — the altarpiece of the Bassi family's chapel in the Church of San Francesco della Vigna (commissioned by Zuanne, who died around 1561, and by Zuan Alberto). When the altar was taken apart, the canvas was mutilated and reduced, and we can have only have a partial idea of the original composition (represented by a surviving etching). The scene takes place in the evening — as told in the Gospel of Mark. Joseph of Arimathea has asked and obtained from Pilate permission to take down Christ's body from the cross and to bury it in his own tomb. Two women, at the entrance of the place where the body of the Saviour will be placed, are holding in their bare hands two very tall candles. These are very similar to those we saw in the Church of the Carmini: but this time the yellowish light radiating from the small flames illuminates the night. It is Tintoretto's first night scene with a 'natural' light — in the sense that the light irradiates from

its source. Tintoretto's biographer Ridolfi mentions the suggestiveness of this effect: 'the servants with the lights that make lighter the darkness of the night'.[12] However, the golden light that irradiates throughout the painting, and envelops not only the two women but also the body of the dead Christ, does not come really — or only — from those small flames. They are rather the reflection of a supernatural light that reveals the scene — as secret as the transportation of the body that should be done discreetly in order not to be observed — and makes it vibrate with pity and emotion. An even more powerful effect is achieved in the painting created shortly after (ca.1564) for the Scuola Grande di San Marco.

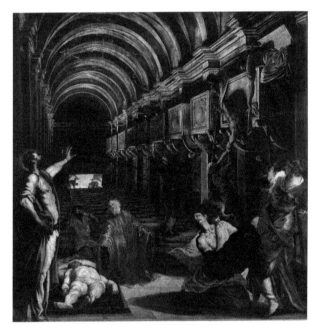

Fig. 1.3 Tintoretto, *The Finding of the Body of St Mark*, Pinacoteca di Brera, Milan, ca.1564. Wikimedia. Public domain, https://commons.wikimedia.org/wiki/File:Jacopo_Tintoretto_-_Finding_of_the_body_of_St_Mark_-_Yorck_Project.jpg

We are inside a dark church in Alexandria. This time there are three sources of light: one from the back of the church where a character holds a torch (*fiaccola*) in order to light up the contents of a tomb that has just been opened. But a blazing light radiates from the bottom

12 Ridolfi, 'Vita di Iacopo', pp. 55–56.

of the tomb, and we cannot see what produces it. The second source of radiance is the tiny flame of a candle, a wax cylinder held by the bare hand of a man busy guiding the movements of those stealing the bodies placed in the wall tombs. This small flame, just like the taper in San Rocco, is white and emits no light. It only sends out a thread of smoke that dissolves towards the ceiling of the vault. The third source of luminescence — and the main one — is invisible. It comes from the right, but the painter does not offer any naturalistic explanation for it. The wall of the church is continuous: there is no door back there. This unreal light envelops the figures in the foreground: the legs of a woman, who is trying to free herself from the grip of a man who is possessed by devils, a kneeling blind man and the foreshortened corpse lying on the floor. The shadow projected by the body of the possessed person is one of the most intriguing in all of Tintoretto's work: a brown stain on the rust-coloured floor. The painting communicates the impression of some esoteric, mysterious, hallucinated ritual. Although the overall effect is extremely realistic — including the chalk-like colour of the corpse — the effect produced by these contradictory lights is absolutely visionary.

In *Saint Roch in Prison, Comforted by an Angel*, dating from 1567, we glimpse a metal (perhaps silver) chandelier, beyond the grate that forms the background wall.

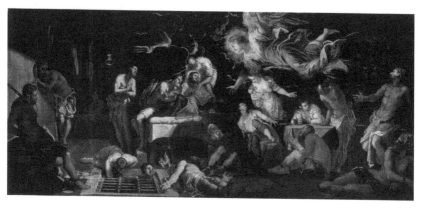

Fig. 1.4 Tintoretto, *Saint Roch in Prison, Comforted by an Angel*, Church of San Rocco, Venice, 1567. CC BY-NC-ND, http://www.scuolagrandesanrocco. org/home-en/tintoretto/church/

Inside the prison there is no artificial light. If, behind the grate, we perceive a fleet of very black clouds floating away in front of the

moon, it is because of a light that enters from the left, from an invisible opening outside the painting. But once more, the main source of light is immanent. It is the angel, and his halo; it is the white clothes of the sick and of their nurses and assistants. It is a paradoxical light — not a naturalistic but a metaphysical light. Since the back wall is a grate the figures should be 'controluce' (backlit), but the light arrives from the opposite side, from where we are standing — and where the painter is. The painting is undoubtedly naturalistic, and even hyper-realistic in some details. But by now we know that the more Tintoretto presents reality in its daily and prosaic details, the more he reveals it as an appearance — the reflection of something else.

The decoration of the Scuola Grande di San Rocco allows him to thematise the clash between darkness and light. In their totality the canvasses represent a sort of epiphany of light. More than once the analogy between Tintoretto's 'sacred poem' and the Gospel of John and his theology of light has been observed.[13] In the numberless night scenes created in the last twenty years of his activity (and not only for this Scuola), Tintoretto experiments with more and more daring luminous effects, or, to use Pallucchini's word, 'integral' effects. At times he includes new sources of light in his paintings, such as the fireplace or the comet. At other times he annihilates these sources totally in order to develop an unreal refraction, a sort of emanation or mysterious phosphorescence, which represents the acme of his research.

The paintings 'with a fireplace' belong to the first series. There are three of them — painted more or less in the same period: between 1575 and 1580. None of these fireplaces is in fact a real source of light. The first appears in the *Christ Washing the Feet of the Disciples* (now at the London National Gallery): it lies in the background, but the fire is hidden by a figure, and only a puff of smoke can be seen (the more pulsing light comes from the golden halo that encompasses Jesus' head). The second fireplace, in the *Last Supper* of the Scuola Grande di San Rocco, sends out only a few weak beams of light, as the fire is dying out. The illumination of the painting comes from Jesus' halo and from a door to the right at the back of the room, which cannot be seen. The third fireplace, seen in *Christ in the House of Martha and Mary*, is a naturalistic detail, an

13 Giandomenico Romanelli, *La luce e le tenebre. Tintoretto alla Scuola Grande di San Rocco* (Venice: Marsilio, 2011).

atemporal fragment of daily life, which offers a contrast with the main scene, whose protagonists are the Saviour, Martha and Mary. The main action is represented in the foreground. In the kitchen at the back, a female servant is stirring something with a wooden spoon in the pot on the fire, but no flame is visible, only smoke.

Even the comet emits only a weak light the first time Tintoretto paints it, in the *Adoration of the Magi* (1581–82).

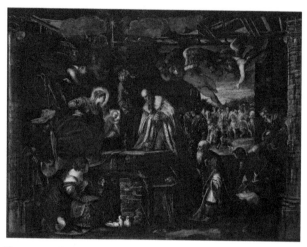

Fig 1.5 Tintoretto, *The Adoration of the Magi*, Scuola Grande di San Rocco, Venice, 1581–82. Wikimedia. Public domain, https://commons.wikimedia. org/wiki/File:Jacopo_Tintoretto_-_The_Adoration_of_the_Magi_-_ WGA22583.jpg

The sun has just gone down behind the snow-capped mountains; outside there is still some light but the illumination of the painting does not come from the star shining in the sky in a gap in the clouds, on the top part of the canvas. Nor does it come from the comet that has guided the Magi on their journey, and now emits only a trace of light. The real illumination comes from the background and from Mary's and Jesus' haloes.

Finally, after experimenting with every possible light trick in his use of 'lumeggiature' and shadows in his haggard *Flagellation of Christ* in Vienna and in Prague, in his last works Tintoretto experimented with the effect of embers and with a lamp with a double flame. *The Martyrdom of Saint Lawrence* is an extraordinarily suggestive night scene, with an indeterminate date, but probably painted around 1580–85. On

the left the flame of an enormous taper (torch) stands out, but in the darkness the rust-coloured embers and the fire burning brightly under the grate stand out even more. The reddish light falls onto the saint's legs — and not only from below, as it should. The reflections of the light and the glimmerings of the burning coals in fact vie with each other to illuminate the bodies and faces of the people present, generating contradictory effects. The reverberation seems to make the embers crackle. The result is an unsteady image, like a photograph out of focus because the subjects moved when it was taken.

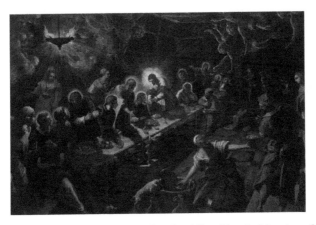

Fig. 1.6 Tintoretto, *The Last Supper*, Church of San Giorgio Maggiore, Venice, 1591–92. Wikimedia. Public domain, https://commons.wikimedia.org/wiki/File:Jacopo_Tintoretto_-_The_Last_Supper_-_WGA22649.jpg

In *The Last Supper* in the Church of San Giorgio Maggiore (1591–92), a metal chandelier with a double flame (perhaps inspired by Roman archaeology) hangs from the ceiling above the table, in the shape of a ship or boat, with globular spheres descending from its lower curve in a decreasing series: one can even see the wicks. Jacomo's chandelier radiates a magic and transcendent luminescence, in which diaphanous disembodied angels dance. This angelic group of immaterial spirits, revealed, animated and at the same time corroded by the light, confers on the scene the sense of a mystery unfolding. But the luminous focus of the painting is Christ, who, at the end of the table, in a position that is seemingly decentered, radiates a magnetic and searing light, which annihilates perspective, upsets the sense of the composition, and disintegrates every rule of vision. Reality, with its still life, the poor,

concrete everyday things, coexists with supernatural evanescence — the matter with the spirit. But the first would have no meaning without the second. In these works, Tintoretto writes with light.

In order to do this he no longer needs to represent material props. His last painting, the *Deposition in the Tomb*, painted in 1594, a few months before he died, for the chapel of the dead in the Church of San Giorgio Maggiore, is a night scene. But nobody lights candles or torches. In this canvas, which is a funeral and a will and testament, Tintoretto takes up and transcends the idea he first explored in the fine painting he created between 1578 and the beginning of the 80s, *Tarquin and Lucretia* (now in the Art Institute of Chicago). Here too he had done away with any source of light. The rape is a claustrophobic and anxiety-laden night interior, generating a surreal, almost metaphysical effect. The room where the attack takes place has no windows (Lucretia has no way out). Neither a torch nor a flame light the scene. It is as if the viewer (and the painter) were present in the room. In the dark, they can perceive objects made incongruous and absurd by the fluid brush stroke that allows them to be only intuited: a statue, the shadow of the bed. The light in the painting is the tender, as if fluorescent, flesh of the helpless woman.

Thirty years earlier, the subject of the *Transportation of Christ to the Tomb* had inspired Tintoretto to paint one of his few real night scenes. This time he chose to light the night not with torches but with faith. The sun is setting behind the Hill of Golgotha, and the shroud that envelops Christ and the body of the Magdalene are sufficient to illuminate the other figures with light.

In the cloudy world of Tintoretto, immersed in a perennial twilight, neither torches, nor fires, nor candles, not chandeliers, nor lanterns, nor fireplaces, nor embers are sufficient to dispel darkness and to illuminate the visible. God and the sacred — the halo, the Holy Spirit — are the lights of the world. There is only one exception, the reflection of God on earth, which retains for the artist the same holy value: the flesh of human beings. Men — wounded, sick, suffering, and women — radiant in their beauty.

The light in Tintoretto's paintings is never a natural light (it is not the sunlight), nor is it an artificial light (it is not produced only by a recognisable source). It is not a direct light, as Lomazzo intuitively understood, but it is 'reflected'. Tintoretto's light is immaterial, spiritual, and at the same time oneiric. It is the light of a vision. We are in the dark

and something appears to us that does not really exist, and which will vanish as soon as we turn around.

This unexpected and precarious light communicates to the viewer a sense of bewilderment. The feeling of unsteadiness produced by Tintoretto's paintings has always been attributed to the movement of his figures, caught up in a vortex that prevents them from having solidity. But in reality the effect of movement is intensified by the effect of the light — indeed it would not exist without it.

Moreover, the sense of uneasiness and bewilderment is intensified by the ambiguity the painter represents to us. Humble and prosaic things — objects familiar from our daily lives: two wicks, some wooden stools, a patched up tablecloth, a cat, a sandal, the copper hanging over the kitchen — are accompanied by things and presences in which we place faith and hope, which we dream of, we pray for, we wish for, we remember, but we don't really own. Nothing is ever what it seems. Tintoretto perhaps sought to represent the inconsistency and vanity of every single thing, even the things he painted with the utmost realism; indeed, those things especially. Therefore Tintoretto is the antithesis of Caravaggio, even if he foreruns and seems to forecast him.

Only God is real. And on this earth God (the reflection of God) is humankind — the frailty of men and their desperate courage, and the beauty of women.

I believe that this uniqueness and at the same time duality of God, who is Man, expresses the most profound meaning of the Christian faith, and that Tintoretto has been able to represent this through light — beyond any rule or ideological imposition.

Whether due to intuition, will, or the reflection of his convictions, Tintoretto has become the painter of light, yet night was necessary to him to his very end. In one of the few narrative passages of his biography, Ridolfi writes that Tintoretto spent most of his time at home. He worked all the time — moved by a creative fire, by love of glory, by the material necessity of feeding a large family. He went out occasionally and unwillingly. 'When he was not painting, he stayed most of the time in his study, set in the furthest end of his house, where in order to see it was necessary to light a lamp at every hour.'[14]

14 Ridolfi, 'Vita di Iacopo', p. 96.

This dark room was womb, cradle, secret space to him: a sort of interior and most private *camera obscura* (only his nearest relatives were allowed in), where he did nothing, or so it seemed, but where in fact he did everything. It was there, where he rested, that ghostly figures emerged, the characters he would draw and then paint on his canvasses. Only in the darkness, lit by a single light, could he invent freely and fire his imagination.

I wish to take leave of Tintoretto imagining him just like this: igniting a light. Remember Boschini: 'he was born with a light in his hand.'

This very simple daily action is also a metaphor for every artistic creation: in order to 'see well' in the darkness surrounding us, one has to 'light a lamp'.

2. The Artificial Lighting Available to European and American Museums, 1800–1915

David E. Nye

As the rest of the contributions to this volume attest, the study of the role of artificial lighting in the display and understanding of art is a fascinating and until now largely unexamined subject. During the nineteenth century, gas and electric lighting became available to museums and art galleries, and it is worth exploring when, why, and where these artificial forms of illumination were installed. In order to lay the groundwork for further investigation, this chapter will briefly explain the different forms of lighting and provide a chronology of their emergence, together with comments on the relative slowness of their diffusion into interior spaces. When first introduced, both gas and electric lighting were primarily used outdoors, to light streets, parks, and squares, or to illuminate large interiors such as railway stations, opera houses, or emporiums. Museums long had little or no artificial light and simply closed at dusk. This was apparently the case with the Smithsonian Institution, for example, until some time after 1880.[1]

1 'Inauguration Ball. The Largest and Most Brilliant Ever Had', *Washington Evening Star*, 57.8, 5 March 1881, https://chroniclingamerica.loc.gov/lccn/sn83045462/1881-03-05/ed-1/seq-1/; C. Melvin Sharpe, 'Brief Outline of the History of Electric Illumination in the District of Columbia', *Records of the Columbia Historical Society, Washington, D.C.* 48/49 (1946–47), 191–207 (pp. 201–02).

 https://doi.org/10.11647/OBP.0151.02

It also appears that gaslight was little used at world expositions from 1851 until 1881. The Paris Exposition of 1855 contained 4979 works by 2176 artists, but it closed at dusk. The London 1862 Exposition had an equally large art display, which closed 30 minutes before sunset. Electricity was more quickly adopted in such venues beginning in 1881. Yet many exposition buildings were still closed in the evening, and the focus at every fair from 1881 until 1915 was the spectacular lighting within the grounds. Visitors to the New Orleans Exposition in 1884 could see its art displays under electric lights at night, but this was unusual. As late as 1900 the Paris Exposition's art exhibition relied on skylights and windows and was not open in the evenings. One lighting engineer considered that Exposition to be 'a distinct step backward,' without a 'uniform scheme of illumination [...] The lighting was a mixture of large and small incandescents, searchlights, projectors, display lighting of the spectacular order, acetylene, Nernst lamps, Welsbach burners, gas, and other illuminants — a conglomeration which was entitled to more credit as an exhibition of all known modern forms of lighting than as a comprehensive scheme of exposition illumination.'[2] Expositions sought to be technologically advanced, yet as this description suggests, a great many different forms of artificial lighting were simultaneously on display, often in a jumble. It was only after 1900 that incandescent bulb lighting became the preferred form. As the example of world's fairs suggests, the adoption of artificial lighting in art museums was a gradual process, and in the case of both gas and electricity occurred only a quarter of a century (or longer) after each these new forms of illumination appeared. This gradual change accords with the history of energy transitions, which typically have required forty to fifty years.[3]

Gas lighting was first developed commercially in Cornwall in 1798, quickly improved in Birmingham and Manchester,[4] and displayed in

2 Luther Stieringer, 'The Evolution of Exposition Lighting', *Western Electrician* 29.12 (21 September 1901), 187–92 (p. 189), https://archive.org/stream/westernelectrici29chic#page/186/mode/2up/search/Stieringer

3 David E. Nye, *Consuming Power: A Social History of American Energies* (Cambridge, MA: MIT Press, 1998). See also David E. Nye, *American Illuminations* (Cambridge, MA: MIT Press, 2018), chapter 2.

4 Leslie Tomoroy, *Progressive Enlightenment: The Origins of the Gaslight Industry, 1780–1820* (Cambridge, MA: MIT Press, 2012), p. 239.

London on Pall Mall in 1807. By 1820 there were 300 miles of gas lines in London. While used primarily for street lighting, many wealthy people also installed gas in their homes. There can be no question that many works of art were being viewed in private London homes under gaslight by the 1820s. In 1814, for example, Robert Ackerman's London home, 'The Repository of Arts,' 101 on the Strand, was fully lighted with gas. Many of the leading artists and collectors saw Ackerman's paintings illuminated there.[5] This does not mean, however, that museums rushed to adopt the new technology of gas lighting. In 1861 the trustees of the British Museum were 'unanimously of opinion, that they would not be justified in allowing the collections [...] to be open at any hour which would require gaslight.'[6] Elsewhere, however, gas lighting was installed in many venues in order to enable the working classes to view the collections during their leisure hours. This was the case at the Edinburgh Museum of Science (1854), the Oxford University Museum (1860), the Birmingham City Art Gallery (1885) and the Victoria and Albert Museum (1857) which installed 196 gas jets in its Sheepshanks Gallery of British paintings. Michael Faraday had assured them that burning gas, provided there was proper ventilation, would not endanger the works of art.[7]

Faraday was optimistic in this assessment. During the nineteenth century, gas for lighting was almost always produced from coal. Natural gas only came into widespread use in the twentieth century, and it has been used mostly for heating and cooking. Victorian lighting gas was not at all the same. It produced less light per cubic meter burned, and it released sulphur, ammonia, and carbonic acid into the air. Burning coal gas tarnished metals, blackened ceilings, increased the humidity, produced unwanted heat in summer, and weakened fabrics. Its soot

5 James Hamilton, *London Lights: The Minds that Moved the City that Shook the World, 1805–51* (London: John Murray, 2007), p. 98.

6 Geoffrey N. Swinney, 'Gas Lighting in British Museums and Galleries', *Museum Management and Curatorship* 18.2 (1999), 113–43.

7 Nicholas Smith, 'Let there be light! Illuminating the V&A in the nineteenth century', V&A Blog, 10 September 2013, https://www.vam.ac.uk/blog/caring-for-our-collections/let-there-be-light-illuminating-va-nineteenth-century; Panos Andrikopoulos, 'Democratising Museums', Heritage Science Research Network, 6 June 2016, https://heritagescienceresearch.com/2016/06/06/democratising-museums/

darkened the surface of paintings, and its acidic vapours damaged canvas and interacted with the chemicals in paint.[8] Gas is also an obvious fire hazard. Electric lights were less damaging, but they also presented problems that will be discussed below. In short, nineteenth-century curators had good grounds to remain cautious about artificial lighting.

This survey examines six basic forms of illumination, depicted below, but it cannot consider the various gas mantles, the many competing arc lights, or differences between incandescent light filaments.

1. Burning coal gas produced perhaps ten-candle power, and it was in general use between 1810 and 1920.

2. The direct current (DC) arc light was the most common form of electric lighting between 1875 and 1900. It produced 2000-candle power by jumping a strong current between two carbon rods, which needed frequent replacement. Its brightness could not be adjusted.

3. The early incandescent light (designed by Edison, Swan, and others) had an enclosed carbon filament, and came in a variety sizes and strengths. Invented in 1879, it was gradually replaced after 1900.

4. The Welsbach mantle was heated to incandescence by gas and produced six times more light than the older gas lights. It was widely adopted after 1885 and was common until the 1920s.

5. The alternating current (AC) arc light spread quickly after 1893 and was greatly improved after 1900. It was rapidly replaced after ca.1910 by incandescent lighting.

6. The tungsten incandescent light became commercially available in ca.1910. It lasted longer than the Edison carbon filament lamp, had an improved light spectrum and more efficient use of electricity. It could be made powerful enough to replace both arc and Welsbach lamps.

8 Harold Passer, *The Electrical Manufacturers, 1875–1900: A Study in Competition, Entrepreneurship, Technical Change, and Economic Growth* (Cambridge, MA: Harvard University Press, 1953), pp. 195–204.

Fig. 2.1 Gas lamp, New Orleans. Photograph taken by daveiam, 12 June 2008. CC
BY 2.0, https://www.flickr.com/photos/daveiam/2584549633/

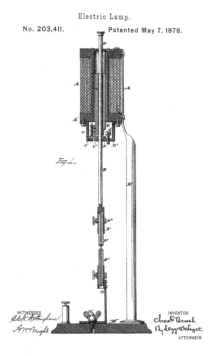

Fig. 2.2 Charles Brush, DC Arc Light, patent granted 1878. Glass shade not
shown in order to reveal the interior mechanism. US Patent Office, Patent
203,411. Public domain.

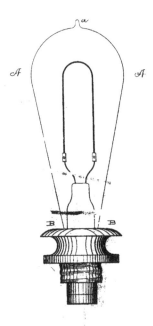

Fig. 2.3 Thomas Edison, incandescent light bulb with carbon filament and improved glass shape, patent granted 1881. US Patent Office, Patent D 12,631. Public domain.

Fig. 2.4 Gas mantle burning at its highest setting. Photograph taken by Fourpointsix, August 2008. CC BY-SA 3.0, https://commons.wikimedia. org/wiki/File:Glowing_gas_mantle.jpg

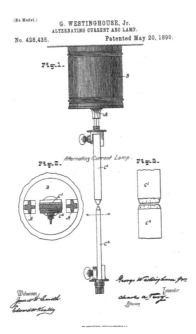

Fig. 2.5 Westinghouse Alternating Current Arc Light, 1890. A frosted glass shade was placed over this mechanism when in use. US Patent Office, Patent 428, 435. Public domain.

Fig. 2.6 Incandescent light with tungsten filament. *Electrical World*, August, 1911.

Each of these three technologies (gas [Figs. 2.1, 2.4], arc [Figs. 2.2, 2.5] and incandescent filament [Figs. 2.3, 2.6]) continually evolved, and consideration of their incremental development is beyond the scope of this survey, as are lighting forms that failed to reach a large market.[9] I will focus on the central characteristics of these three forms of lighting and explain when they became available. Nor does this chapter much concern itself with transatlantic comparisons and contrasts. The same corporations were active on both sides of the Atlantic, and innovations diffused rapidly from one continent to the other. However, there were differences in what forms of light a city or a nation preferred, and these in turn could affect the lighting a museum or art gallery might have access to. For example, in ca.1850 Charles Dickens found that Paris was far more brightly and extensively lighted with gas than London.[10] Or again, in 1900, Boston and New York City had more than four times as much electrical lighting per capita as London, which relied more on gas.[11] One cannot assume that museums everywhere had ready access to gas in 1830 or easy access to electrical services in 1890. Even if they did, they may not have adopted them.

The date of a discovery must not be confused with the date when a technology was widely available. Sir Humphrey Davy demonstrated an arc light at the Royal Institution in 1808, but this did not mean London's streets were illuminated electrically shortly afterwards. Davy used 2000 voltaic cells (batteries) to produce enough current for his demonstration. Batteries were not an economical way to generate and distribute power for a far-flung system, however. It took seven decades of research and development before efficient dynamos lowered the cost of electricity sufficiently so that it became feasible to adopt arc lights instead of gas. One of the first demonstrations of arc lighting was in St. Petersburg 1875, where Alexander Lodyguin, a Russian engineer, showed that a thin

9 The most significant omission is the Nernst lamp, which heated a ceramic rod to incandescence and produced light close to the daylight spectrum. Demonstrated at the 1900 Paris Exposition, it was costly, but it had a niche market and was manufactured by AEG in Germany and Westinghouse in the US. See Paul Keating, *Lamps for a Brighter America: A History of the General Electric Lamp Business* (New York: McGraw Hill, 1954), p. 60.

10 Charles Dickens, *The Uncommercial Traveller* (New York: Charles Scribner's Sons, 1905), p. 202, https://www.gutenberg.org/files/914/914-h/914-h.htm

11 'Electric Lighting in Boston', *Electrical World and Engineer*, September 19, 1903. Reprinted in *General Electric Company Review*, 1 (November 1903), p. 12.

carbon rod sealed inside a glass bulb from which all oxygen had been removed could cast a brilliant light.[12] Paris had arc lights in the Gare du Nord, also in 1875.[13] Several Wallace Farmer arc lights were erected at Philadelphia's Centennial Exposition of 1876.[14] It was in precisely this decade that many American art museums were founded, including New York's Metropolitan Museum of Art (1870), The Boston Museum of Fine Arts (July 4, 1876), and Philadelphia's Museum of Art (1876). However, electric lighting was not used extensively to view the art. Four decades later, the lighting of American museums was 'almost universally from the top, very generally by skylights.'[15] When the Boston Museum of Fine Arts began constructing a new building in 1902, its design ensured ample natural light in every room, with the main galleries on the upper floors, in rooms that had skylights.[16]

What difference did it make whether one saw a painting under natural light, gaslight or electric light? This question was answered in scientific tests made in 1892.[17]

Colour spectrum for sunlight, electric incandescent, and coal gas:

	Red	Green	Blue
Sunlight	1.4	1.8	0.5
Electric incandescent	2.0	1.0	0.8
Coal gas	4.0	0.04	0.2

The test examined British coal gas and the then common Edison incandescent light with a bamboo filament. In the unlikely case that a painting was mostly in shades of red, gas and electric light might not

12 John A. Church, 'Scientific Miscellany: A New Electric Light', *The Galaxy. A Magazine of Entertaining Reading* 30.3 (1875), 415–16 (p. 415), https://babel.hathitrust.org/cgi/pt?id=pst.000066654551;view=1up;seq=425

13 Stephen Inwood, *City of Cities: The Birth of Modern London* (London: Macmillan, 2005), p. 281.

14 Alfred Wallace, *The Progress of the Country* (New York: Harper Brothers, 1901), p. 276.

15 Cecil Brewer, 'American Museum Buildings', *Journal of the Royal Institute of British Architects*, 3rd series, 20 (April 1913), p. 372.

16 Helen Searing, *New American Art Museums* (New York: Whitney Museum of Art, 1982), pp. 40–42.

17 Gustavus Hartridge 'The Electric Light and its Effects Upon the Eyes', *The British Medical Journal* 1.1625 (1892), 382–83.

seem to deviate much from daylight. But if an artwork contained green, then gaslight was a poor choice compared to the incandescent electric light. (Paraffin was slightly better than gas; candles were about the same.) Compared with natural light, coal gaslight had roughly three times as much red, only 2 percent as much green, and 60 percent less blue. The colours seen under burning coal gas were strongly skewed toward reds and ruddy yellows, and lush green landscapes or blue marine views appeared washed out and dull. In 1892 incandescent electric lighting was better but by no means equivalent to daylight: an Edison bulb had 40 percent more red, 40 percent less green, and 60 percent more blue. These test results were only suggestive for a museum director in 1892 who was trying to decide what kind of artificial lighting to install, however, for there were constant innovations in both gas mantles and incandescent filaments, as well as improvements in arc lighting.

Electricity was not adopted everywhere at the same rate, and one cannot assume that a public building or a museum had electric lighting during the last decades of the nineteenth century. In London, the telegraph office was one of the first to install incandescent electric lighting, in 1883. Arc lights were more common, and they were quickly adopted by department stores such as John Wanamaker's in Philadelphia. These worked by passing a strong electric current across a narrow gap between two carbon rods that gradually burned down. The illumination was emitted 'due to the intense heat of the tips of the carbon rods, and also to a smaller degree to the arc itself.'[18] When arc lights were common (1875–1905), they were often powered by direct current (DC), and the upper carbon rod produced most of the light. This rod, which was positively charged, gradually acquired a hollow centre called the 'crater of the arc.' At the same time the lower, negatively charged rod became more and more pointed. These details might seem unimportant, but the crater of the upper arc produced much of the light and directed that light downward to where it was wanted. A DC arc light required considerable maintenance, because the carbon rods burned down rapidly and had to be replaced once a week, a task performed in

18 Franklin D. Jones, *Engineering Encyclopedia: A Condensed Encyclopedia and Mechanical Dictionary for Engineers, Mechanics, Technical Schools, Industrial Plants, and Public Libraries, Giving the Most Essential Facts about 4500 Important Engineering Subjects*, 3rd ed. (New York: The Industrial Press, 1941), pp. 56–57 (1st ed. available at https://catalog.hathitrust.org/Record/005763849).

the daytime. The positive rod burned down about twice as fast as the negatively charged one, and an important innovation was a mechanism to automatically advance the rods at the same rate as they burned down, in order to keep the distance between them constant. Electric arc lights required less maintenance than gas lamps, however, which for decades had to be serviced by a lamp lighter every day. Direct current electric arc lights were particularly common during the 1880s and 1890s in the United States, somewhat less so in France or Britain.[19]

Due to the competition from arc lights, gas lighting was radically improved in the 1880s by the innovation of the Welsbach gas mantle. It was based on the discovery that, while burning gas itself gave off more heat than light, the high temperatures could make other substances incandescent. Invented in Europe in 1885, the mantle contained oxides of thorium and cerium that when heated cast a brilliant white light. So equipped, a gas lamp produced six times more light with the same amount of gas. Its adoption prolonged the gas systems into the twentieth century. In the US, by 1900 more than 10 million Welsbach burners were in use.[20] Some US cities, notably St. Louis and Milwaukee, relied primarily on Welsbach gas lighting in the first decade of the twentieth century. London's streets also had far more gas than electric lighting in 1900. Other cities preferred arc lights, notably Boston and Pittsburg. Yet others had both gas and electric streetlights, including Chicago, Philadelphia, and Paris.

Enclosed incandescent lights were demonstrated in 1879 and became available in a few places in 1881, gradually diffusing into many interior locations. Several inventors developed them at almost the same time, most famously Edison in the United States and Swan in Great Britain. Their corporate interests merged early on. Edison's assistant William Hammer demonstrated the system at the Paris Exposition of 1881 and on the Holborn Viaduct in London. There he installed 230 lamps in January 1882, as well as putting on a successful exhibition at the Crystal Palace.[21] However, just because a new lighting system was displayed does not mean many people understood the technology or installed

19 These comparisons are developed at length in chapters two and three of Nye, *American Illuminations*.

20 Passer, *The Electrical Manufacturers*, pp. 197–98.

21 William Hammer, 'Notes on Building, Starting and Early Operating of the First Central Station in the World, Holborn Viaduct, London, England.' Private

it. The 1881 Exposition Internationale d'Électricité in Paris[22] had 277
arc lamps, 44 arc incandescent lamps and 1500 incandescent lamps. In
subsequent months, the number was increased to 2500 lamps.[23] It was
impressive and even overwhelming to visitors, because the electric light
was so new. Yet Hammer concluded that 'no manager of any future
exhibition is likely to repeat that terrific *mélange* of lights that flooded
the interior of the Palais de l'Industrie with great brilliancy, but with
an impracticable and impossible means of comparing and judging the
relative merits of different systems.'[24]

However, a visitor could certainly see that unlike the arc light, the
incandescent light did not flicker, created far less heat, and came in
different sizes. The arc light shed 2000 candlepower and could not be
turned up or down. The Edison/Swan light, and its many imitators, was
less brilliant and therefore far more suited to illuminating domestic
interiors or individual works of art. The team of inventors working
with Edison created not only the light itself but the still familiar
system of wall switches, sockets, fuses, and wiring systems that would
make it possible to place a light in the most advantageous position to
illuminate a painting rather than an entire room. It therefore would
become the preferred system, eventually, when compared to either
gas or arc lights. In the early 1880s the incandescent electric light
was not widely adopted in public spaces such as railroad stations
or department stores. However, as with gas lighting, it was quickly
adopted by wealthy families, some of whom installed their own
generating plants. Edison's list of early customers reads like the social
register, including J. P. Morgan and the Vanderbilts. In the 1880s a
single light bulb cost one dollar, or half a day's common wages, and
using a single kilowatt hour might cost as much as 20 cents.[25] With this
in mind, consider how stunning was the New Orleans Exposition of

Memorandum book, Hammer Papers, Box 20, folder 1, Smithsonian Institution
Archives.

22 Alain Beltran and Patrice A. Carré, *La fée et la servant: La societé française face a
l'électricité* (Paris: Éditions Belin, 1991), pp. 64–72.

23 Moncel, Comte Th. Du, and William Preece, *Incandescent Lights, with Particular
Reference to the Edison Lamps at the Paris Exhibition* (New York: Van Nostrand, 1882),
https://catalog.hathitrust.org/Record/000847293, p. 49.

24 Ibid., pp. 47–48.

25 David E. Nye, *Electrifying America: Social Meanings of a New Technology, 1880–1940*
(Cambridge, MA: MIT Press, 1990), p. 242.

1884–85. Twenty thousand 16-candlepower incandescent lights lighted its 33 acres of interior space. These were particularly appreciated in the exposition's art galleries.[26]

Beginning in the 1890s a new kind of arc light became available, which used alternating current. This meant that its two carbon rods alternated between being positive and negative. Both of its rods became pointed, and the light was shed equally in all directions. AC arc lights therefore required a good reflector much more than DC arc lights did. Both kinds of arc light were extremely hot, burning at 5500 to 6000 degrees Fahrenheit, and they produced a light too powerful to look at directly. Therefore, arc lights were usually hung higher than gas lighting, and if used indoors they were only suitable for large spaces like opera houses, department stores, and railroad stations.

In Britain, many preferred gas to electric light. Robert Louis Stevenson, for example, disliked the glare of arc lighting, which he declared

> shines out nightly, horrible, unearthly, obnoxious to the human eye; a lamp for a nightmare! Such a light as this should shine only on murders and public crime, or along the corridors of lunatic asylums, a horror to heighten horror. To look at it only once is to fall in love with gas, which gives a warm domestic radiance fit to eat by.[27]

By the 1870s, gas had become traditional, and was associated with the familiar routine of lamp lighting, the ruddy glow of a fire, and domestic comfort.

Americans were generally enthusiastic about the white light cast by electric arc lights, but many Europeans agreed with Stevenson's critique of them in favour of gas. As Chris Otter notes of Victorian Britain, 'The flight from yellowness' of gas 'was not universally lauded. Most people were accustomed to seeing yellow. This is how normal night appeared: ochreous, cosy, peppery. The whiteness of electric illumination was often an unpleasant shock, registered chromatically as bluish.'[28] Preece, who in 1883 had famously complained of the lack

26 Luther Stieringer, 'The Evolution of Exposition Lighting', p. 187.
27 Robert Louis Stevenson, 'A Plea for Gas Lamps', in his *'Virginibus Puerisque' and Other Papers* (Boston: Small, Maynard & Co., 1907), pp. 249–56 (pp. 254–55), https://archive.org/stream/virginibuspueris05stev#page/254/search/a+plea+for
28 Chris Otter, *The Victorian Eye: A Political History of Light and Vision in Britain, 1800–1910* (Chicago: Chicago University Press, 2008), p. 185.

of electrical light in London, noted that compared to gas it indeed appeared blue at first. But 'Americans did not call it blue at all,' after they became accustomed to it, and 'the imaginary blueness rapidly disappeared.'[29] However, as the tests made in 1892 would show, the blueness was not imaginary. The electric light then available was 400 percent bluer than gaslight and 60 percent bluer than daylight. It was not a simple problem of adjustment. Stage actors complained that electric light changed the appearance of their traditional makeup and costumes, which had been developed with gaslight in mind. On the other hand, textiles under electric light appeared more as they did during the day, which is one reason why drapers in London and department stores in New York enthusiastically adopted Edison's system. In short, as late as 1900 one could make a case for either gas or electric lighting, particularly due to the Welsbach mantle, which produced six times as much light with the same amount of gas, which meant that for a given level of illumination the amount of acid, humidity, and smoke were palpably reduced. Gas lighting persisted not only in the streets but also indoors well into the twentieth century, particularly in London.[30]

After 1900, however, a series of improved filaments in incandescent lamps produced more efficient lighting that also more closely matched the spectrum of light found in daylight. Some of these, such as the Nernst light, drew praise at world's fairs, but it proved less successful commercially, due to its high cost. With the development of tungsten filament lamps, however, acceptable quality was united with reasonable consumer prices. Even so, the tungsten filament was weaker in the blue and green wavelengths than natural lighting. It was the best available at an economical price, but it did not fully replicate daylight, a goal only reached in the decades after 1920.

Nevertheless, by 1915 incandescent electric lighting had decisively proved itself the best form of illumination. Compared to gas, it was

29 Cited in ibid.
30 If any museums burned natural gas, it was a far cleaner and more concentrated
 energy form than coal gas. Indeed, natural gas produces double the light with
 the same amount of fuel. It might have been used in museums close to sources of
 natural gas, such as Indiana in the 1880s, but until the twentieth century there was
 no inexpensive means to ship natural gas to large cities such as London, Boston, or
 New York. Therefore, in most cases natural gas can be ruled out as a likely source
 of light in galleries and museums, though not in wealthy households located within
 gas producing regions.

safer, cleaner, brighter, and closer to daylight's palette. However, the distribution of electricity in public places was by no means the same in each country. In general, the French, the Germans, and especially the Americans adopted arc lights more quickly than the British, many of whom preferred gaslight. The incandescent light was adopted more slowly outdoors than arc lighting and made the most rapid progress inside buildings in the United States. Nevertheless, only about 20% of American homes had electrical lighting in 1920, though the figure was considerably higher for public buildings. It seems likely that art galleries and museums adopted electric lighting more readily than gas because of its obvious advantages for both showing and protecting art works, but only a detailed survey can establish to what extent this was the case in each country. Not all areas in Europe had a robust electrical infrastructure between 1880 and 1900, when incandescent service may not have been as available to museums as the less flexible, glaring arc lights. Moreover, the quality of both gas and electric light was not then comparable to daylight, and art works still could best be appreciated under natural light. The high cost of remaining open for longer hours, coupled with the additional cost of electrical lighting also may have retarded adoption in some venues. For all of these reasons, incandescent light bulbs apparently came slowly into use in art museums, though adoption seems to have been earlier in the United States. From 1884 some American expositions displayed art after dark, while the Paris Exposition of 1900 still did not. Future research might focus on the role collectors and patrons played in the adoption of gas and electricity by museums, as they were accustomed to seeing art under artificial illumination in their homes well before it was adopted in museums. Once the chronology of adoption is clearer, it will be possible to chart how painters and curators responded to these innovations, which fundamentally transformed how art could be displayed.

PART II

ON LIGHT AT THE SCUOLA GRANDE DI SAN ROCCO AND IN VENICE

3. Tintoretto in San Rocco Between Light and Darkness

Maria Agnese Chiari Moretto Wiel

The following group of essays are specifically focused on light and its relationship to the production and function of Tintoretto's paintings that remain in *situ*, a theme that may be considered from three main points of view, with particular reference to the monumental cycle the master created for the Scuola Grande di San Rocco. First, the creative approach of Jacopo, who used light as an extraordinary element of communication with the viewer. Second, the often dramatically negative effects of exposure to sunlight on the colour of his canvases. Finally, the problem of the inadequate lighting of the rooms in the Scuola, preventing a proper appreciation of the master's canvases, which were often difficult to read before the recently introduced lighting systems.

The great adventure of the work of Tintoretto, so often defined as the 'painter of the light', begins in San Rocco with a significant night scene: the amazing *Saint Roch Healing the Plague Victims*,[1] created by the young artist in 1549 for the presbytery of the church built by the Scuola to house the relics of its patron saint. In the vast and dark interior of the hospital where the charitable activities of the saint are portrayed, it is the light that is the 'fulcro della composizione, più precisamente la doppia illuminazione, provocata nel fondo dalla luce artificiale delle torce e

1 The painting can be viewed at chapter 1, Fig. 1.2, or online, http://www.scuola grandesanrocco.org/home-en/tintoretto/church/

 https://doi.org/10.11647/OBP.0151.03

in primo piano da un fascio di luce irreale che investe lateralmente la scena, a trasfigurare in senso fantastico il tema'.²

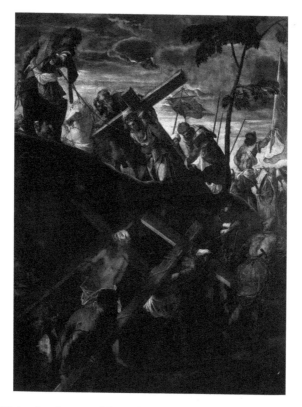

Fig. 3.1 Tintoretto, *Ascent to Calvary*, Scuola Grande di San Rocco, Venice, 1566–67. Wikimedia. Public domain, https://commons.wikimedia.org/wiki/File:Droga_krzy%C5%BCowa.jpg

Already in this early masterpiece the light is the key to reading the event. 'Irradiating the darkened interior with warmth, caressing the morbidly unhealthy flesh of the victims, dramatically spotlighting the central moment of saintly cure and seemingly gathering itself to greatest intensity in the halo outlining Roch's head the light is heavenly rather than natural. As its concentration around Roch suggests, it is created

2 'The cornerstone of the composition. More precisely, it is the double illumination, created in the background by the artificial light of the torches and in the foreground by a beam of imaginary light laterally striking the scene, which imaginatively transforms the subject.' (Author's translation). Stefania Mason Rinaldi, 'La peste e le sue immagini nella cultura figurativa veneziana', in *Venezia e la Peste. 1348–1797* [exhibition catalogue] (Venice: Marsilio Editori, 1979), p. 244, http://opac.regesta-imperii.de/lang_en/anzeige.php?sammelwerk=Venezia+e+la+peste%2C+1348-1797

by the presence of the saint, whose relics in the apse could be seen as the ultimate source, dispelling the darkness of the sickroom with the promise of cure'.[3]

Many years later, in the *Ascent to the Calvary* in the Sala dell'Albergo (1566–67), a pronounced play of light and darkness distinguishes the two sections of the composition, becoming a dramatically expressive element. The deep shadow of the lower half, where the two thieves advance with difficulty, bent under the weight of their crosses, contrasts with the bright tonalities of the upper zone in which Christ walks towards the top of Golgotha immersed in a full light that already seems to foretell his triumph over death.

Fig. 3.2 Tintoretto, *Moses Striking the Rock*, Scuola Grande di San Rocco, Venice, 1577. Wikimedia. Public domain, https://commons.wikimedia.org/wiki/File:File-Tintoretto,_Jacopo_-_Moses_Striking_Water_from_the_Rock_-_1577_-_122kb.jpg

3 Louise Marshall, 'A Plague Saint for Venice: Tintoretto at the Chiesa di San Rocco', in *Artibus et Historiae* 66 (2012), 153–88 (p. 174).

In the late 1570s, the painter offers once again a visionary and fantastic interpretation of the theme of light on the ceiling of the Chapter Hall of the Scuola, in the large canvas representing *Moses Striking the Rock* (1577). Here the light assumes the new, undisputed role of protagonist, being one of the most relevant elements in the structure of the composition, as witnessed also in many of the scenes in the later cycle that he painted on the walls of the same room (1578–81).

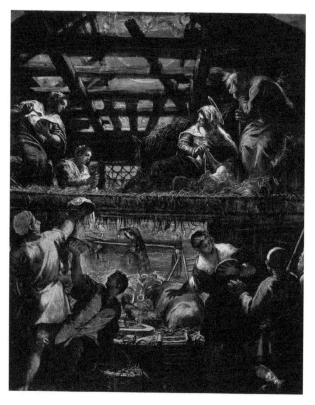

Fig. 3.3 Tintoretto, *The Adoration of the Shepherds,* Scuola Grande di San Rocco, Venice, 1578–81. Wikimedia. Public domain, https://commons.wikimedia. org/wiki/File:Jacopo_Tintoretto_-_The_Adoration_of_the_Shepherds_-_ WGA22550.jpg

In *The Adoration of the Shepherds* (1578–81) the light radiating down through the scattered roof beams of the humble stable suffuses and animates the scene, softly illuminating the calm upper zone. A stronger chiaroscuro accentuates the excited gestures of the shepherds joyfully

offering gifts to the Christ Child who, along with the Virgin, are illuminated by a strong beam of light, indicating the true protagonists of the event. Similarly, in the *Baptism of Christ* (1578–81) the light is a key element, decisive both for the composition and for the expression of spiritual value. Rather than the traditional daylight, Tintoretto shows veils of darkness interrupted by the divine light that pierces the clouds and baths the back of the Saviour who humbly kneels with his bowed head at the feet of John the Baptist. The protagonists are neither in the foreground nor at the centre of the composition. Instead, their importance is demonstrated by the heavenly light that leads the viewer's gaze directly to Jesus, underscoring the dramatic intensity of the moment when God recognizes Christ as his son. The solid,

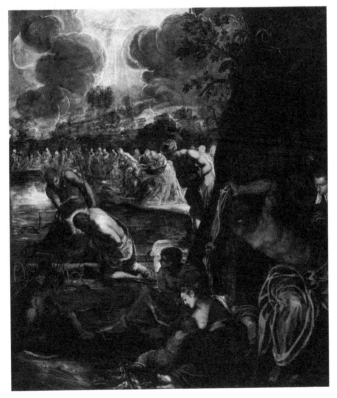

Fig. 3.4 Tintoretto, *The Baptism of Christ*, Scuola Grande di San Rocco, Venice, 1578–81. Wikimedia. Public domain, https://commons.wikimedia.org/ wiki/File:Jacopo_Tintoretto_-_The_Baptism_of_Christ_-_WGA22551.jpg

vital, sculptural figure of the Risen Christ dominates the complex and elaborate scene of the *Resurrection* (1578–81): in the distance to the left, in the first light of dawn, the Holy Women approach the tomb; at the bottom, the soldiers are immersed in darkness; yet the fulcrum of the composition is the dazzling explosion of light that blasts forth from the open tomb.

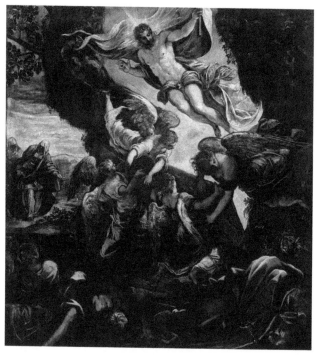

Fig. 3.5 Tintoretto, *The Resurrection of Christ*, Scuola Grande di San Rocco, Venice, 1578–81. Wikimedia. Public domain, https://commons.wikimedia.org/wiki/File:Jacopo_Tintoretto_-_The_Resurrection_of_Christ_-_WGA22555.jpg

However, if the light he creates and controls with such extraordinary skill is a characteristic, brilliant and innovatively expressive medium in Jacopo's art, over the centuries sunlight has proved to be an enemy of many of the colours the painter had originally conceived, inexorably altering many of them.[4]

4 Francesco Valcanover, *Tintoretto and the Scuola Grande of San Rocco* (Venice: Storti, 1983), pp. 8–9, has observed that the general shade of the paintings had 'notably

These effects can be observed in the frieze with *putti* and garlands of flowers and fruits, which connects the wooden frame of the ceiling and the paintings on the walls in the Sala dell'Albergo. A comparison of the frieze today with a fragment of it depicting *Three Apples* (folded under the final part of the frieze itself until it was found during a restoration in 1905 and now framed on the bench in the same room) shows clearly the difference in the original polychromy of the fragment, which preserves the vivid intensity Tintoretto had conceived. Protected from the effects of light and oxidization for centuries, the *Three Apples* reveal the changes that have occurred in the extant frieze, which enjoyed no such protection.[5]

Perhaps even more obvious is the case of the representation of *The Virgin Mary Reading* (commonly known as *St. Mary of Egypt*), located to the right of the altar in the ground-floor Hall. Mary's cloak, originally blue, now appears as a warm golden brown, making the iconographic interpretation of the painting even more difficult.[6] Even after the careful and demanding restoration that took place between 1969 and 1974 and gave them new life,[7] the paintings in the ground-floor hall were still hardly visible, as they had been in the days of Ruskin and James, whose strongly critical impressions are analysed by Rosella Mamoli Zorzi.[8]

darkened due to the alteration with time of some pigments and their relative colour combinations. In particular the blue has become lead-grey, the green brown, the red pale pink, the yellow amaranth. This has created an irreversible change which, if on the one hand has lessened the tone-colour vividness of the chromatic harmony, on the other hand has increased that intensity of luminous effects which originally must have been dramatically set off in the semi-darkness of the room...'.

5 About the chromatic alteration of Tintoretto's palette see: Stefano Volpin, Antonella Casoli, Michela Berzioli and Chiara Equiseto, 'I colori scomparsi: la materia pittorica e le problematiche di degrado', in Grazia Fumo e Dino Chinellato (eds.), *Tintoretto svelato. Il soffitto della Sala dell'Albergo nella Scuola Grande di San Rocco. Storia, ricerche, restauri* (Milan: Skira editore 2010), pp. 138–45; Gianluca Poldi, 'Gli azzurri perduti nei dipinti di Tintoretto. Ri-vedere le cromie grazie alle analisi scientifiche', in Sara Abram (ed.), *La Crocifissione di Tintoretto. L'intervento sul dipinto dei Musei Civici di Padova* (Turin: Editoria 2000, 2013), pp. 101–13.

6 See: Poldi, 'Gli azzurri perduti', figs. 58–61, pp. 105–06.

7 See: Franco Posocco, 'Il restauro di Tintoretto a San Rocco', in *Scuola Grande Arciconfraternita di San Rocco. Notiziario* 37 (May 2017), 104–07.

8 See: the *Notiziario* of the Scuola (Rosella Mamoli Zorzi, 'Dal buio alla luce: la Scuola di San Rocco da Ruskin e James a Fortuny', in *Scuola Grande Arciconfraternita di San Rocco. Notiziario* 32 (December 2014), 49–73).

Step by step the Scuola sought a lighting system that would improve the legibility of Tintoretto's canvases. After successive important interventions, the Scuola has arrived at the current lighting system in the same ground-floor hall and in the Sala dell'Albergo.[9] Thanks to this new illumination, one can now admire all the beauty, power and chromatic strength of Tintoretto's work. A further ambitious and complex project is being carried out in the Chapter Hall at the time of writing and is scheduled to be completed by the end of 2018.[10]

In past centuries and during recent years the problem of darkness, repeatedly emphasized not only by famous visitors but also by the members of the Scuola, influenced the exhibition of several important works.

This is true of Titian's *Annunciation* (ca.1535) and Tintoretto's *Visitation* (1588), which in the 1930s were removed from their sumptuously carved and gilded frames overhanging the arches of the landing of the staircase during the two important monographic exhibitions dedicated to these painters (1935 and 1937). They were not reinstalled there until 2014, since it was believed that in that location they were hardly visible and little appreciated because of the poor illumination.

9 In 2011 the Ground Floor Hall 'è stata oggetto di un progetto di rinnovamento illuminotecnico, cui hanno collaborato Osram e l'architetto Alberto Pasetti Bombardella. Tre gli obiettivi progettuali: conservazione, corretta percezione visiva e interpretazione cromatica, che riassumono la necessità di preservare le opere dal degrado fotochimico ottimizzando le condizioni per la loro visione. Lo studio della nuova illuminazione ha inoltre tenuto in considerazione i vincoli posti dal contesto architettonico e le problematiche legate alle grandi dimensioni dei teleri.' See: *Nuova illuminazione per la Sala Terrena della Scuola di San Rocco*, https://www.theplan. it '[T]he Ground Floor Hall was the focus of a project of lighting renovation, carried out thanks to the collaboration between Osram and architect Alberto Pasetti Bombardella. Among the aims of this project there were: preservation, proper visual perception and chromatic interpretation. Such elements sum up the requirement of preserving artworks from photochemical decay optimizing their visual conditions. The study of the new lighting took also into account the restrictions created by the architectural context and the problems connected with the large size of the canvases.' (Author's translation).
About the works in the Sala dell'Albergo see: Demetrio Sonaglioni, 'La nuova luce dinamica della Sala dell'Albergo' in *Scuola Grande Arciconfraternita di San Rocco*, pp. 74–87; Massimo Maria Villa, 'Venezia. Vedere oltre lo sguardo', *Luce e design*, 9 December 2014, https://www.lucenews.it/venezia-vedere-oltre-lo-sguardo/

10 This very complex work will hopefully be complete by the end of 2018, to coincide with the celebrations for the fifth centenary of Jacopo Tintoretto's birth (*Tintoretto 500*).

Fig. 3.6 Titian, *Annunciation*, Scuola Grande di San Rocco, Venice, ca.1535. Wikimedia. Public domain, https://commons.wikimedia.org/wiki/File: Titian_-_Annunciation_-_WGA22805.jpg

Fig. 3.7 Tintoretto, *Visitation*, Scuola Grande di San Rocco, Venice, 1588. Wikimedia. Public domain, https://commons.wikimedia.org/wiki/File: Jacopo_Tintoretto_-_Visitation_-_WGA22645.jpg

Now, at last, after having had their frames restored[11] and since the creation of a new lighting system that is appropriate and respectful of their preservation, these two extremely precious works can be read much better than in the past when they were shown on easels in the presbytery of the Chapter Hall. In fact, they are now seen from the correct point of view and with the proper enhancement of their ancient wooden frames in a setting for which they had been successfully 'adapted' since the sixteenth century (the *Annunciation*)[12] or conceived *ab origine* (the *Visitation*).

These examples may appear limited and marginal, however it is undeniable that the new possibilities offered by the recent technologies — permanent and dynamic, 'warm' and 'cool' lights — now allow the viewer to better appreciate the quality, the strength and the appeal of Tintoretto's great enterprise in San Rocco, by discovering details that had been hidden by centuries of 'darkness'.

11 The restoration has been carried out by Maristella Volpin, thanks to the generosity of the Friends of the Scuola Grande di San Rocco (Washington, D.C.).

12 For the details of the painting's acquisition by the Scuola and the subsequent events see: Maria Agnese Chiari Moretto Wiel, 'L'*Annunciazione* di Tiziano nella Scuola Grande di San Rocco. Appunti', in *Scuola Grande Arciconfraternita di San Rocco*, pp. 50–57.

4. John Ruskin and Henry James in the Enchanting Darkness of the Scuola Grande di San Rocco

Rosella Mamoli Zorzi

The great Tintoretto paintings of the Scuola Grande di San Rocco[1] continue their dialogue with their contemporary visitors: with a well-known writer, Melania G. Mazzucco, the author of two wonderful books on Tintoretto, *La lunga attesa dell'angelo* (2008) and *Jacomo Tintoretto e i suoi figli. Storia di una famiglia veneziana* (2009); with a Lebanese-Canadian-French playwright, Wajdi Mouawad, who used Tintoretto's *Annunciation* of the Scuola in his play *Ciels* (2009), as a crypto-indication of a terrorist assault by a group of jihadists, whose name is, indeed, 'Tintoretto'; with such unexpected figures as Woody Allen, who set an irresistibly comic seduction scene in the movie *Everybody Says I Love You* (1996) in the upper hall. These are only a few examples of the reactions of contemporary authors to their experience of the magnificent and powerful 'teleri' by Tintoretto in the Scuola Grande di San Rocco, now lit

1 Salvatore Settis and Franco Posocco (eds.), *La Scuola Grande di San Rocco,* 'Memorabilia Italiae', n. 15 (Modena: Panini Editore, 2008), is a fundamental study. See Posocco's essay on the 'vicenda urbanistica' of the Scuola, which was seen by both Ruskin and James with the square closed off by a large wall ('muraglione'), which was torn down in 1910 in order to open a passage to the railway station. On the visitors' 'vasta gamma di possibilità ricettive' ('vast range of reception possibilities', p. 86) and on the 'nessi tra lo spazio reale e quello del quadro' ('on the links between real space and the space in the paintings', p. 133), see Astrid Zenkert's essay in the same volume (pp. 85–159).

 https://doi.org/10.11647/OBP.0151.04

with indirect lighting and new LED lighting, as Demetrio Sonaglioni's and Alberto Pasetti Bombardella's essays document.

But in the nineteenth century the experience of viewing the great canvasses by Tintoretto in the Scuola was very different, as the only light available was natural light:[2] therefore visitors interested in the paintings visited the Scuola at different times of the day, and, if possible, on sunny and unclouded days.[3] This was the experience of the two great writers I am going to consider, John Ruskin and Henry James, who fell in love with the paintings despite not being able to see them properly.

In 1845, the young John Ruskin, the future author of *The Stones of Venice* (1851–53), was absolutely 'overwhelmed' by the power and the beauty of the Tintoretto paintings in the Scuola Grande di San Rocco, as he wrote to his father on 23 September and in other letters that followed: 'I have been quite overwhelmed today by a man whom I never dreamed of — Tintoret. I always thought him a good & clever & forcible painter,

2 There are not many studies on the lighting of *museums* in the nineteenth century, while there are many on the history of the lighting of streets, homes, and theatres. Many are the recent publications on electric and LED lighting in museums. As regards Venice, due to chronological reasons, the subject is not discussed in the important three volumes on Venetian collecting: Michel Hochman, Rosella Lauber and Stefania Mason (eds.), *Collezionismo d'arte a Venezia. Dalle origini al Cinquecento* (Venice: Fondazione di Venezia and Marsilio, 2008); Stefania Mason and Linda Borean (eds.), *Il Seicento* (Venice: Marsilio, 2007); and Stefania Mason and Linda Borean (eds.), *Il Settecento* (Venice: Marsilio, 2009). In the third volume, however, the 'nuova sensibilità per gli allestimenti' ('the new sensibility regarding layout') at the beginning of the nineteenth century is mentioned in the essay by Linda Borean, 'Dalla galleria al "museo"' (p. 40). For a history of lighting, but not in museums, see Wolfgang Schivelbusch, *Luce. Storia dell'illuminazione artificiale nel secolo XIX* (Parma: Pratiche, 1994). The exhibition *Light! The Industrial Age 1750–1900*, at the Van Gogh Museum in Amsterdam (20 October 2000–11 February 2001) was also important as it dealt with the relationship between lighting, pictures and artists. As regards restoration, the critical literature is immense and detailed.

3 Although experiments on the change of colours due to light were carried out by Isaac Newton (*Opticks: or a Treatise of the Reflections, Refractions, Inflections and Colours of Light*, 1704), Pierre Bouguer (1729) and Theodor Grotthuss (1817), it was above all *The Russell and Abbey Report on the Action of Light on Watercolours* (1888) and *The Chemistry of Paint and Painting* (1890) by A. H. Church that had a real influence on museums. The most widely read and significant essay with recommendations on the intensity of light was published only in July 1930 (*The Burlington Magazine*). See James Druzik and Bent Eshoj, 'Museum Lighting: Its Past and Future Development', in T. Padfield and K. Borchersen (eds.), *Museum Microclimates, Contributions to the Conference in Copenhagen, 19–23 November 2007* (National Museum of Denmark, 2007), http://www.conservationphysics.org/mm/musmic/musmic150.pdf, pp. 51–56 (pp. 51–52). The problems light poses for the conservation of paintings appears to have become relevant from the end of the nineteenth century onwards.

but I had not the smallest notion of his enormous power'.[4] The next day he wrote:

> I have had a draught of pictures to-day enough to drown me. I never was so utterly crushed to the earth before any human intellect as I was today, before Tintoret. [...] As for *painting*, I think I didn't know what it meant till today — the fellow outlines you your figure with ten strokes, and colours it with as many more. I don't believe it took him ten minutes to invent & paint a whole length. Away he goes, heaping host on host, multitudes that no man can number — never pausing, never repeating himself — clouds & whirlwinds & fire & infinity of earth & sea...[5]

And, a little later, he wrote:

> ... that rascal Tintoret — he has shown me some totally new fields of art and altered my feelings in many respects — or at least deepened & modified them — and I shall work differently, after seeing him, from my former method. I can't see enough of him, and the more I look the more wonderful he becomes.[6]

What is interesting is the fact that Ruskin was 'overwhelmed' by Tintoretto's paintings even if he complained again and again about the impossibility of seeing the pictures properly, due to the bad lighting. Before giving a detailed descriptions of the paintings in the ground-floor

4 Harold I. Shapiro (ed.), *Ruskin in Italy: Letters to his Parents 1845* (Oxford: Clarendon Press, 1972), p. 210. Ruskin had travelled to Italy to finish the second volume of *Modern Painters*, which was published in April 1846. Ruskin was shocked by the radical restorations that were being carried out in Saint Mark's (they were 'scraping St. Mark's clean', 14 September, p. 201), restorations that Ruskin later helped to stop with his Preface to Alvise Piero Zorzi's *Le Osservazioni intorno ai ristauri interni ed esterni della Basilica di San Marco* (1877). In the vast bibliography on the relationship between Ruskin and Venice, see Jeanne Clegg, *Ruskin and Venice* (London: Junction Books, 1981); Robert Hewison, *Ruskin on Venice* (New Haven: Yale University Press, 2009); R. Mamoli Zorzi, 'Tintoretto e gli americani nell'Ottocento', in *Annali di Ca' Foscari*, 35.1–2 (1996), especially pp. 189–224 on Anglo-American observations. For a discussion of Ruskin's rhetorical strategies in his descriptions of Tintoretto's paintings, see Emma Sdegno, 'Reading the Painting's Suggestiveness', in Jeanne Clegg and Paul Tucker (eds.), *The Dominion of Daedalus* (St. Albans: Brentham Press, 1994), pp. 100–14. See also Emma Sdegno's contribution in the recent Anna Ottavi Cavina (ed.), *John Ruskin. Le pietre di Venezia* (Venice: Marsilio, 2018).

5 Letter of 24 September, in Shapiro, *Ruskin in Italy*, p. 211.

6 Letter to his father, 10 October, in ibid., p. 221. The quotations from *The Stones of Venice* are here used only to illustrate the material conditions of the Scuola. Of course biblical references were very important to Ruskin. On the subject of Tintoretto's theological and biblical ideas in the paintings see Giandomenico Romanelli, *La luce e le tenebre. Tintoretto alla Scuola Grande di San Rocco* (Venice: Marsilio, 2011).

hall,[7] Ruskin offered some general comments on the characteristics of the three halls, which were 'so *badly lighted*, in consequence of the admirable arrangements of the Renaissance architect, that it is *only in the early morning that some of the pictures can be seen at all, nor can they ever be seen but imperfectly'.*[8]

Ruskin attributes the bad lighting to an architect of the 'Renaissance', a period he notoriously hated. The Scuola architect's[9] work is ironically described as 'admirable'. The ground-floor hall is 'a room plunged into *almost total obscurity'*. (*Stones* III, 323); it is presented as 'the *dungeon below...' (Stones* III, 333); '... what little sun gets into the place contrives to fall all day right on one or other of the pictures, they are nothing but wrecks of what they were; ...'(*Stones* III, 323). This observation is clarified by what follows: '...as during the whole morning the sun shines upon the one picture, and during the afternoon upon the other, hues, which were originally thin and imperfect, are now dried in many places into mere dirt upon the canvas'. (*Stones* III, 329)

As for the upper hall, *The Adoration of the Shepherds*, 'painted with far less care than that of the lower' is 'in good light' (the 'far less care' is Ruskin's recurring criticism against Tintoretto's technique of quick brush strokes, a technique that has been appreciated as a sign of modernity by more recent critics):[10] 'It is one of the painter's inconceivable caprices

7 Ruskin began his description of the Scuola from the ground floor hall, while it is well-known that any visit should start from the Sala dell'Albergo, as Tintoretto began his work there. The artist then continued with the upper hall, and finally concluded in the ground floor hall. The chronology is as follows: 1564–67 Sala dell'Albergo; 1575–81 upper hall; 1582–87 ground floor hall. See Paola Rossi, 'Regesto', in Rodolfo Pallucchini and Paola Rossi, *Tintoretto. Le opere sacre e profane* (Milan: Electa, 1982), vol. 1, pp. 126–28, and pp. 188, 200, 225.

8 John Ruskin, *The Stones of Venice*, 3 vols. (London: George Allen & Unwin Ltd., 1925), vol. 3, p. 323, http://www.gutenberg.org/files/30756/30756-h/30756-h.htm, my emphasis. From now onwards *Stones* III.

9 The Scuola architects were more than one, due to the uncertainty of the 'Banca' of the Scuola: Maestro Bon, Zuan Celestro, Sante Lombardo (and his son Tullio, for the decoration of the façade), Antonio Abbondi aka Scarpagnino, aided by the 'pratici' Alvise da Noal and Costantin de Todero. See Manfredo Tafuri, *Venezia e il Rinascimento. Religione, scienza, architettura* (Turin: Einaudi, 1985), Chapter IV, 'Scuole Grandi', pp. 130–44.

10 On Tintoretto's fastness in painting see Romanelli, *La luce e le tenebre*, who reminds the reader of the first evidence of this skill in a 1545 letter by Aretino, and the following comments, n. 5, p. 134. In presenting the great 1937 exhibition Nino Barbantini in his article 'La mostra di Tintoretto: un grande successo' wrote that the 'presunta incompiutezza' ('presumed lack of finish') of Tintoretto's art was the mark 'della sua grandezza e della sua modernità' ('of his greatness and modernity'),

that the only canvases that are *in good light* should be covered in this hasty manner, while those *in the dungeon below*, and on the ceiling above, are all highly laboured'. (*Stones* III, 333)

Sunlight hit both paintings on the right and the left of the main altar, causing damage. *The Last Supper* 'has not only been originally poor, but it is one of those *exposed all day to the sun*, and is dried into mere dirty canvas; where there was once blue, there is now nothing'. (*Stones* III, 338) Similarly *The Miracle of the Loaves* 'is more exposed to the sun than any other picture in the room, and its draperies having been, in great part, painted in blue, are now mere patches of the colour of starch;...' (*Stones* III, 338)

Ruskin proceeds to describe other paintings, including the figure of San Rocco. The figures of the saints 'are *quite in the dark*, so that the execution *cannot be seen* [...] I cannot answer for them).'[11] (*Stones* III, 341). Ruskin presumes these may be the work of Tintoretto but cannot guarantee it. The figures of San Rocco and Saint Sebastian can be seen only 'By a great deal of straining of the eyes, and sheltering them with the hand from the light...' (*Stones* III, 342) As for the ceiling paintings, such as *Moses Striking the Rock*, 'they are at least distinctly visible without straining the eyes against the light'. (*Stones* III, 343) *Christ before Pilate*, in the Sala dell'Albergo, can be seen to its best advantage, according to Ruskin '... on a dark day, when the white figure of Christ alone draws the eye, looking almost like a spirit; ...' (*Stones* III, 353)

La Gazzetta di Venezia, 22 April 1937, R.S.7, n. 414, http://digitale.bnc.roma.sbn.it/tecadigitale/giornale/CFI0391298/1937/aprile?paginateDetail_pageNum=10; also available in Marcello Brusegan, *Catalogo dei manoscritti del Fondo Mariutti Fortuny* (Venice: Biblioteca Nazionale Marciana, 1997) (Cat. Mss. Marc. 32).

On the quality of the colour Valcanover wrote: 'mosso in un "continuum" senza soluzioni di riverberi e di riflessi e nel contempo attento a rievocare con concreto realismo gli animali della stalla, il coloratissimo pavone, gli umili utensili; nella zona superiore più calmo e riposato, ancorché le ampie campiture si innervino di guizzanti e improvvise filettature luminose' ('painted in a "continuum" without any interruption of reverberations and reflections and at the same time with every possible attention in evoking, with a concrete realism, the animals, the highly coloured peacock, the humble tools; in the upper area it is calmer, even if the great spaces are underlined by sudden and light underlinings'). See Francesco Valcanover, *Jacopo Tintoretto e la Scuola Grande di San Rocco* (Venice: Storti editore, new ed. 2010), p. 61. Ruskin judged the lower part of the painting 'slovenly' (p. 334). In particular Ruskin observes that the peacock is 'sacrificed to the light... is painted in a warm gray, with a dim eye or two in the tail...' (*Stones* III, p. 334).

11 The attribution to Domenico Tintoretto 'non ha ricevuto conferma dal restauro del 1971' ('has received no confirmation from the 1971 restoration'), see Valcanover, *Jacopo Tintoretto*, p. 88. Also Pallucchini and Rossi, *Tintoretto*, vol. 1, p. 204.

These quotations testify to the light — or rather the darkness and lack of light[12] — in the Scuola when Ruskin visited, first in 1845 and then subsequently.

<p style="text-align:center">***</p>

The situation had not changed more than twenty years later, when Henry James arrived in Venice in 1869, and it did not change during James's following visits. James wrote to his brother from Venice in September 1869:

> And then you see him [Tintoretto] at a vast disadvantage inasmuch as with hardly an exception his pictures are *atrociously hung & lighted*. When you reflect that he was willing to go on covering canvas to be hidden out of sight or falsely shown, you get some idea of the prodigality of his genius. Most of his pictures are immense & swarming with figures; All have suffered grievously from abuse & neglect.[13]

Ten years later, in his 1882 essay *Venice*, James wrote:

> It may be said as a general thing that *you never see the Tintoret*. You admire him, you adore him, you think him the greatest of painters, but in the great majority of cases *your eyes fail to deal with him*. [...] At the Scuola di San Rocco, where there are acres of him, there is *scarcely anything at all adequately visible* save the immense 'Crucifixion' in the upper story.[14]

12 Ruskin commented on the *Madonna e Santi* by Giovanni Bellini in Hall 2 of the Accademia: '...you find yourself in the principal room of the Academy, which please cross quietly to the window opposite, on the left of which hangs a large picture which you *will have great difficulty in seeing at all*, hung as it is against the light; and which, in any of its finer qualities, *you absolutely cannot see; but may yet perceive what they are, latent in that darkness*, which is all the honour that the kings, nobles, and artists of Europe care to bestow on one of the greatest pictures ever painted by Christendom in her central art-power. Alone worth an entire modern exhibition-building, hired fiddlers and all; here you have it jammed on a back wall, utterly unserviceable to human kind, the little angels of it fiddling unseen, unheard by anybody's heart. It is the best John Bellini in the Academy of Venice; the third best in Venice, and probably in the world. Repainted, the right-hand angel, and somewhat elsewhere; but on the whole perfect; unspeakably good, and right in all ways.' *Guide to the Principal Pictures in the Academy of Fine Arts at Venice* (1877), in E. T. Cook and Alexander Wedderburn (eds.), *The Complete Works of John Ruskin in 39 vols.* (London: Allen, 1903–12), vol. 24 (1906), p. 151.

13 Pierre A. Walker and Greg W. Zacharias (eds.), *Complete Letters of Henry James 1855–1872*, 2 vols. (Lincoln: University of Nebraska Press, 2006), vol. 2, pp. 116–17, my emphasis. From now onwards *CLHJ 1855–1872*, II.

14 James, 'Venice' (1882) in John Auchard (ed.), *Italian Hours* (University Park: The Pennsylvania State University Press, 1992), pp. 23–24, https://catalog.hathitrust.org/Record/001027550 my emphasis.

James's observations on the darkness reigning in the Scuola di San Rocco extend to other places, as do those by Ruskin. James wrote: 'The churches of Venice are rich in pictures, and many a masterpiece lurks in the *unaccommodating gloom* of side-chapels and sacristies. Many a noble work is perched behind the dusty candles and muslin roses of a scantily-visited altar; some of them indeed, hidden behind the altar, *suffer in a darkness that can never be explored'.*[15]

The bad lighting[16] and the hanging of the pictures, far too high,[17] seem to be a continuous refrain, both as regards Italy in general[18] and the Scuola and the churches and museums of Venice in particular. In the essay 'The Autumn in Florence' (1874) James celebrates the 'strong American light' — as opposed to the darkness of Italian museums — which might make a picture look its best:

> ... I noted here [in the Florence Accademia], on my last occasion, an enchanting Botticelli so *obscurely hung,* in one of the smaller rooms, that I scarce knew whether most to enjoy or resent its relegation. Placed, *in a*

15 Ibid. p. 23, my emphasis.

16 The opening hours of the Accademia in 1856, from 12pm to 3pm, clearly show that there was only natural lighting during that period. See Andrea Querini Stampalia, *Nuova Guida annuale di Venezia* (Venice: Premiata Tipografia di Gio. Lacchin, 1856), p. 133. As for the Museo Correr, it was open on Wednesdays and Saturdays; see p. 134. The room of the drawings at the Accademia was also open only on Wednesdays and Saturdays from 12pm to 3pm The 1867 and 1870 Baedeker guidebooks indicate as the Accademia opening hours 9am to 3pm, and during 1867 and 1870, and during 'festivals', 11am to 2pm. The instruction to enter was given as 'Visitors ring' in both editions (1867, p. 245; 1870 p. 199). The 1879 Baedeker indicates the Correr opening hours as on Mondays, Wednesdays and Saturdays from 10am to 4pm (p. 211).

17 In the Accademia, in Venice, James observes: '...a simple *Adam & Eve,* in the same room, or a *Cain & Abel,* its mate, both *atrociously hung — away aloft in the air'* (my emphasis). James is referring to the hall of the Accademia where there was the *Miracle of St. Mark's, CLHJ 1855–1872,* II, p. 117. Ruskin too observed the excessive height at which the picture of the *Visitation* hung, on the landing of the staircase of the Scuola di San Rocco. Until recently the picture was located on the right side of the main altar on the second floor, on an easel; it has now been placed on the landing wall once again, but with new lighting. As one would expect, Ruskin considered the seventeenth- and eighteenth-century paintings by Zanchi and Negri on the staircase 'utterly worthless' (*Stones* III, p. 332).

18 Obscurity and decay seem to prevail throughout Italy, where, according to James, 'we see a large number of beautiful buildings in which an endless series of *dusky pictures are darkening,* dampening, *fading, failing through the years'* (my emphasis). See James, 'Italy Revisited' (1877) in *Italian Hours* (1909), p. 113. In his important introduction to this edition of *Italian Hours,* John Auchard only observes as regards lighting that it 'has been improved dramatically' (p. xiv).

mean black frame, where you wouldn't have looked for a masterpiece, it yet gave out to a good glass every characterization of one. Representing as it does the walk of Tobias with the angel, there are really parts of it that an angel might have painted. That was my excuse for wanting to know, on the spot, though doubtless all sophistically, *what dishonour*, could *the transfer* be artfully accomplished, *a strong American light and a brave gilded frame would*, comparatively speaking, *do it*. There and then it would shine with the intense authority that we claim for the fairest things — would exhale its wondrous beauty as a sovereign example.[19]

In Venice James again and again laments the darkness of other places, such as the Accademia or the Scuola Dalmata:

> There is one of them [paintings by Giovanni Bellini, the so-called *Pala di San Giobbe*][20] on the *dark side* of the room at the Academy that contains Titian's 'Assumption',[21] which if we could only see it — *its position is an inconceivable scandal* — would evidently be one of the mightiest of so-called sacred pictures. So too is the Madonna of San Zaccaria [1505], hung in a cold, *dim, dreary place, ever so much too high...*'[22]

The same is true for Carpaccio's paintings in San Giorgio degli Schiavoni:[23] 'The place [San Giorgio degli Schiavoni] is small and incommodious, the pictures are *out of sight and ill-lighted*, the custodian is rapacious, the visitors are mutually intolerable, but the shabby little chapel is a palace of art.'[24]

A comment on the darkness[25] of churches appears also in the essay 'Two Old Houses', regarding a church that may be the church of San Stae:[26] 'The old custode, shuffling about *in the dimness*, jerks away, to

19 James, 'The Autumn in Florence' (1874) in *Italian Hours*, p. 244, my emphasis.
20 *Madonna in trono, con il Bambino, con angeli musicanti e i santi Francesco, Giovanni Battista, Sebastiano, Domenico, Giobbe e Ludovico di Tolosa*, known as the *Pala di San Giobbe* (from where it came in 1815), now in Hall 2 of the Accademia, at the time in Hall 1 where Titian's *Assumption* had been placed.
21 As is well known, Titian's *Assumption* was moved to the Accademia in 1816, where it remained until 1919. See the painting by Giuseppe Borsato, *Commemorazione di Canova*, 1822, when Canova's coffin was placed beneath the *Assumption*.
22 James, 'Venice', p. 27.
23 The Scuola Dalmata also now has LED lighting.
24 James, 'Venice', p. 29, my emphasis.
25 See also the description of St. Mark's: 'The church arches indeed, but arches like a dusky cavern'. However, one can 'touch and kneel upon and lean against' things, and 'it is from this the effect proceeds'. Ibid., p. 15.
26 'The obscure church we had feebly imagined we were looking for proved, if I am not mistaken, that of the sisters' parish; as to which I have a but a confused recollection of a large grey void and of admiring for the first time a fine work of

make sure of his tip, the old curtain that isn't much more modern than the wonderful work itself. He does his best *to create light where light can never be*; but you have your practiced groping gaze...'[27]

In spite of these complaints about the darkness of the Scuola and of the churches, James, just as Ruskin, was 'overwhelmed' by the power of Tintoretto's painting. James wrote to his brother William from Venice on 25 September 1869: 'But you must see him [Tintoretto] here at work... to form an idea of his boundless invention & his passionate energy & of the extraordinary possibilities of color...'.[28]

In his 1872 essay, 'Venice. An Early Impression', James wrote:

> It was the whole scene that Tintoret seemed to have beheld in a flash of inspiration intense enough to stamp it ineffaceably on his perception, and it was the whole scene, complete, peculiar, individual, unprecedented, that he committed to canvas with all the vehemence of his talent. [...] You get from Tintoret's work the impression that he *felt*, pictorially, the great, beautiful, terrible spectacle of human life very much as Shakespeare felt it poetically — with a heart that never ceased to beat a passionate accompaniment to every stroke of his brush.[29]

James found in Tintoretto's paintings a world that he himself wished to represent in language: 'I'd give a great deal to be able to fling down a dozen of his pictures into prose of corresponding force and color'.[30]

The Crucifixion, according to James the only picture which could be seen well in the Scuola Grande di San Rocco, was described by the writer in a way that could be interpreted as the program of a poetics:

> It is true that in looking at this huge composition you look at many pictures; it has not only a multitude of figures but a wealth of episodes;

art of which I have now quite lost the identity' ('Two Old Houses' p. 66). San Stae could have been the parish church of the Mocenigo sisters, and could have given the impression of a 'large grey void', as it does nowadays. San Stae was probably in a dilapidated condition in James's time, as it remained a parish church until 1810, and was 'pressocchè abbandonata agli inizi del nostro secolo.' See *Il Patriarcato di Venezia 1974*, ed. by Gino Bortolan (Venice: Tipo-Litografia Armena, 1974), p. 475. After 1810, San Cassiano became the parish church of the area, but it is unlikely that James refers to this church, as it contains one of Tintoretto's Crucifixions, which James loved and described at length. The other possible church may be Santa Maria Mater Domini, which was a parish church until 1897, when it merged with San Stae. But the impressions of a 'large grey void' does not seem to apply to this church.

27 James, 'Two Old Houses' (1889) in *Italian Hours*, p. 70, my emphasis.
28 *CLHJ 1855–1872*, II, 114.
29 James, 'Venice: An Early Impression' (1873), in *Italian Hours*, p. 57.
30 Ibid., p. 63.

and you pass from one of these to the other as if you were 'doing' a gallery. Surely no single picture in the world contains more of human life; there is everything in it, including the most exquisite beauty. It is one of the greatest things of art; it is always interesting. There are works of the artist which contain touches more exquisite, revelations of beauty more radiant, but there is no other vision of so intense a reality, an execution so splendid.[31]

It was not a coincidence that many years later, in the preface to *The Tragic Muse* (1908),[32] James should refer to this very *Crucifixion* as a model in which many stories were presented in the same painting:

A story was a story, a picture a picture, and I had a mortal horror of two stories, two pictures, in one. The reason of this was the clearest — my subject was immediately, under that disadvantage, so cheated of its indispensable centre as to become of no more use for expressing a main intention than a wheel without a hub is of use for moving a cart. It was a fact, apparently, that one *had* on occasion seen two pictures in one; were there not for instance certain sublime Tintorettos at Venice, a measureless Crucifixion in especial, which showed without loss of authority half a dozen actions separately taking place?[33]

It is no wonder that two writers should be shocked into admiration for the wonderful canvasses by Tintoretto. However, one does wonder about their being able to admire Tintoretto when the darkness of the Scuola seemed to prevent a real appreciation of the works by this great master, except for the well-lit *Crucifixion*.

We are therefore confronting a deep admiration for paintings that cannot be seen well because of poor lighting: one could even say that we are facing an aesthetics of darkness (which is nonetheless lamented by both Ruskin and James). This darkness is also recorded by many other, less famous, travellers, such as, for example, Edgar Barclay, who in 1876 complained about the 'bad light' in San Rocco, allowing him to see the paintings only during some hours of the day.[34]

31 Ibid., p. 24.
32 See Anna Laura Lepschy, *Davanti a Tintoretto, una storia del gusto attraverso i secoli* (Venice: Marsilio, 1998), p. 190.
33 'Preface' to *The Tragic Muse*, in Henry James, *Literary Criticism French Writers; Other European Writers; The Prefaces to the New York Edition* (New York: The Library of America, 1984), p. 1107.
34 He also commented on the reflection: 'having the light full in one's eyes' on the upper floor; see *Notes on the Scuola di San Rocco* (London: Spottiswood, 1876), p. 30.

An aesthetics of darkness seems to allow the viewer — or the writer — to construe an imaginative, and totally subjective, story regarding the figures represented in the paintings, as James did in creating a narrative for the young man in Titian's *Portrait of a Young Englishman* (or *Virile Portrait*) or for one of the ladies in Sebastiano del Piombo's *St John Chrysostomos and the Saints Augustine, John the Baptist, Liberal, Mary Magdalene, Agnes and Catherine* in the church of San Giovanni Grisostomo in Venice.[35] The glimpse of a painting, however restricted, seems for James to be like a fragment of a story, sufficient to act on his imagination: 'You do everything but see the picture. You see just enough to be sure it's beautiful. You catch a glimpse of a divine head, of a fig-tree[36] against a mellow sky, but the rest is impenetrable mystery'.[37]

Darkness remains a constant element in the second half of the nineteenth century; it is interrupted only by candles. Even in the 1880s and 1890s, when gaslight was already in use and was on the brink of being supplanted by electric light, candles[38] appear to have been the only source of light in the churches and in the Scuola Grande di San Rocco. They were lit only during ceremonies, and snuffed out immediately afterwards for fear of fires.

James also recalls 'the multitudinous candles' in the Mocenigo sisters' palace at San Stae in his essay 'Two Old Houses', published in 1899. These candles express the historical value of the house: 'It was a high historic house, with such a quantity of recorded past twinkling in the multitudinous candles…'[39]

35 See R. Mamoli Zorzi (ed.), *In Venice and in the Veneto with Henry James* (Venice: Supernova, 2005), pp. 27–28.

36 Ruskin criticized the whole conception of *The Resurrection of Christ*, adding '…the whole picture is languidly or roughly painted, except only the fig-tree at the top of the rock, which, by a curious caprice, is not only drawn in the painter's best manner, but has golden ribs to all its leaves…' *Stones* III, p. 336.

37 James, 'Venice', p. 23.

38 In the *Miscellanea sec. XVIII–XX b.1* of the Scuola Grande di San Rocco one finds several annotations regarding the candles ('candelotti') to be rented ('a nolo', 20-12-1884) at the 'Fabbrica candele di cera di Penso Pasqualin', or to be bought (10-11-1884: 50 candles plus 54 for 300 liras) in the same year. There were also lanterns, which were carried along in the Corpus Domini procession: a lasting ('durevole') restoration of these lanterns is annotated on 10 July 1862; on 15 August 1875 they are registered as restored ('accomodati'). In 1877 we find an expense for oil ('spesa d'olio'), probably used to light a room for meetings.

39 James, 'Two Old Houses' in *Italian Hours*, p. 64

By this time one might imagine that at least gaslight was used in Venice, and in fact it was: a contract had been signed in 1839 and in 1843 the St Mark's area was lit with 146 gas-lit lamps. Ruskin denounced their vulgarity in a letter to his father in 1845:[40]

> ... it being just solemn twilight, as we turned under the arch [of the Rialto bridge], behold, all up to the Foscari palace — *gas lamps!* on each side, in grand new iron posts of the last Birmingham fashion, and sure enough, they have them all up the narrow canals, and there is a grand one, with more flourishes than usual, just under the Bridge of Sighs. Imagine the new style of serenades — by gas light.[41]

Théophile Gautier in his *Italia* (1852) wrote about the St Mark gaslight[42] and so did James in his 'Venice' essay of 1882. In 1820 the streets of Paris were lit by gas lamps, and towards the middle of the nineteenth century gas lighting had spread through Europe. The Philadelphia Theatre already had this type of lighting in 1816, and the London Lyceum Theatre had it in 1817. We know that the Victoria and Albert Museum boasted being the first gas-lit museum in 1857, but we also know that this was not true, since as early as 1816 the Baltimore Rembrandt Peale Museum had installed gas lighting, as Burton Kummerow's essay in this volume tells us.

However, no gaslight was ever used in the Scuola Grande di San Rocco, surely for fear of fires; neither was petrol. In 1877 James recalled a small shrine and an 'incongruous odour' near Florence:

> ... Presently I arrived where three roads met at a wayside shrine, in which, before some pious daub of an old-time Madonna, a little votive lamp glimmered through the evening air. [...] I became aware of an incongruous odour; it seemed to me that the evening air was charged

40 Clegg, *Ruskin and Venice*, p. 57.
41 Letter to his father, 10 September 1845, *Ruskin in Italy*, pp. 198–99. Ruskin found Venice depressing and spoilt by the radical restorations that were going on, such as those on the façade of the Ca' d'Oro or in the mosaics of St. Marks ('It amounts to destruction — ', 11 September, p. 199). The encounter with Tintoretto appears to have changed the tone of the letters, at least partly. See also Clegg, *Ruskin and Venice*, p. 57.
42 'Nous demandâmes qu'on nous conduisît tout de suite à la place Saint-Marc qui se trouvait bien où la ligne de gaz nous l'avait fait supposer la veille.' Théophile Gautier, *Italia* (Paris: Hachette, 1855, 2nd ed.), p. 101. Some areas of the city were lit with oil lamps until 1854. The first experimentation with electric light was tried out on the Giudecca in 1886, and in 1889 it was installed in St Mark's square, see Fondazione Neri, Museo italiano della ghisa, *Storia dell'illuminazione, Origini e storia dell'illuminazione pubblica a Venezia*, [n. p.].

with a perfume which, although to a certain extent familiar, had not hitherto associated itself with rustic frescoes and wayside altars. [...] The odour was that of petroleum[.][43]

These writers were also interested in the poetics of 'decay', in addition to an aesthetics of darkness.

The beauty of decline and decay was an important aesthetic category,[44] as we see in a letter written by James to his mother from Brescia in September 1869, regarding Leonardo's *Last Supper* in Milan: 'I beheld like-wise Leonardo's great *Cenacolo* — the Last Supper — horribly decayed — but sublime in its ruins. The *mere* soul of the picture survives — the form, the outline; but this is the great thing — being as the container to the contained. There's something unspeakably grand in the simplicity of these blurred & broken relics of a magnificent design — a sentence by the way which only half conveys my thought'.[45]

James developed the subject in the essay 'From Chambéry to Milan' (1872), where he wrote: '...we ask whether our children will find in the most majestic and most luckless of frescoes much more than the shadow of a shadow...', concluding however that the fresco remained 'one of the greatest'.[46]

In spite of this aesthetic of decay, both in Ruskin and in James one finds negative comments on the restoration of paintings.[47] The condition of the canvasses of the Scuola Grande di San Rocco was certainly not the best one. According to archival evidence, the condition of the (huge) roof was one of the main worries in the meetings of the Cancelleria.[48]

43 James, 'Italy Revisited' (1878) in *Italian Hours*, p. 104.
44 See Sergio Perosa (ed.), *Ruskin e Venezia. La bellezza in decline* (Florence: Olschki, 2001).
45 *CLHJ 1855-1872*, II, p. 96.
46 James, 'From Chambery to Milan' in *Italian Hours*, p. 85.
47 'It [the art of Italy] is well taken care of; it is constantly copied; sometimes it is 'restored' — as in the case of that beautiful boy-figure of Andrea del Sarto at Florence, which may be seen at the gallery of the Uffizi with its honourable duskiness quite peeled off and heaven knows what raw, bleeding cuticle laid bare'. See James, 'Italy Revisited' (1878) in *Italian Hours*, p. 113. Auchard suggests James might be referring to Andrea del Sarto's *John the Baptist as a Boy*, which was however at the Pitti Palace. See note, p. 104.
48 The papers of the 'Sedute di Cancelleria 1806–1849 (no. 30)' refer often to the repairs of the lead roof of the Scuola (21-5-1843, 27-10-1846, 4-7-1847, 16-7-1848); on 12 August 1849 decisions were taken as regarded the damages caused to the

Regarding his visit of 1846 Ruskin wrote 'the walls have been continually for years running down with rain' (*Stones* III, p. 323). During his 1851 visit, the situation was even worse because of the damage caused by the bombings of 1849:

> ... three of the pictures of Tintoret on the roof of the School of St. Roch were hanging down in ragged fragments, mixed with lath and plaster, round the apertures made by the fall of three Austrian heavy shot. The city of Venice was not, it appeared, rich enough to repair the damage that winter; and buckets were set on the floor of the upper room of the school to catch the rain, which not only fell directly through the shot holes, but found its way, owing to the generally pervious state of the roof, through many of the canvases of Tintoret in other parts of the ceiling.[49]

As regards restoration, it was done very badly[50] — as modern criticism confirms. Suffice it to mention that the restorer Antonio Florian added his own name, very visibly, in 1834, on the stone of the tomb of *Ascension of the Virgin* on the ground floor.[51]

Both Ruskin and James observed with lucidity and grief the danger that the great canvasses of the Scuola could become totally black. James wrote:

> their almost universal and rapidly increasing decay doesn't relieve their gloom. Nothing indeed can well be sadder than the great collection of Tintorets at San Rocco. Incurable blackness is settling fast upon all of

paintings by the bombings of 1848; the subject was discussed again on 16 October 1849, and again on 7 April 1850 (in 'Sedute di cancelleria 1850–1880, no.31'). In the papers titled 'Lavori-Titoli diversi 1808–1894, b.139' there are references to the works affected by an exceptional snowfall (24 June 1826); to the repairing or substituting of the silk curtains ('cortine di seta', 26 April 1857); to the restoration of the great lanterns adorning the great hall, which were used in the processions ('grandi fanali che adornano la sala maggiore di questa arciconfraternita in tutte le funzioni, e che annualmente si portano a San Marco nella ricorrenza della solenne processione del Corpus Domini, danno motivo per la loro antichità ad una continua spesa di riparazione...'). A complete, lasting and proper restoration of the lanterns is proposed (un 'lavoro completo, durevole e decente') on 10 July 1862; to the renovation of the lightning rods (1888).

49 *Munera pulveris* (1872) in *The Complete Works*, XVII, 1905, p. 132.
50 '... a Baptism of Christ by Cima which I believe has been more or less repainted'. James, 'Venice', p. 23, at the church of San Giovanni in Bragora.
51 Ruskin mentions this in the *Stones* III, p. 330. Perhaps Florian 'copied' the notion of putting his name in from the 'Iacobus Tentoretus Faciebat' placed on the basis of the tomb in the *Assumption of the Virgin* in the church of S. Polo, see Pallucchini and Rossi, *Tintoretto*, p. 206, n. 358. Fortunately the name was erased during the 1970s restorations by A. Lazzarin.

Fig. 4.1 Tintoretto, *Ascension of the Virgin* (cropped), Scuola Grande di San Rocco, Venice, 1582–87. Wikimedia. Public domain, https://commons.wikimedia. org/wiki/File:Jacopo_Tintoretto_-_The_Assumption_of_the_Virgin_-_ WGA22601.jpg

them, and they frown at you across the sombre splendour of their great chambers like gaunt twilight phantoms of pictures. To our children's children Tintoret, as things are going, can be hardly more than a name; and such of them as shall miss the tragic beauty, already so dimmed and stained, of the great 'Bearing of the Cross' in that temple of his spirit will live and die without knowing the largest eloquence of art.[52]

The darkness that threatened the great paintings has been defeated, and today Tintoretto's paintings shine in their 'tragic beauty'. Restoration has revealed the original colours that had been blackened, also erasing the unwelcome nineteenth-century additions. 'The angel's black wings' (*Stones* III, 325) in *The Annunciation* now show white and red; the 'variety of hues' (of the *Magdalene*) that had all 'sunk into a whithered brown' (*Stones* III, 329) have come back to life; the water of the brook, the sky lit up in the background, the trunk on the left and the leaves near it, all show their white and bright light. In the *Flight into Egypt* one

52 James, 'Venice: an Early Impression', pp. 57–58.

can now see clearly the house on the right and the mountains, perhaps unmentioned by Ruskin because they may have been invisible (*Stones* III, 326–7). Ruskin's 'unseen rent in the clouds' in the *Baptism* in the upper hall is now clearly visible, and the blue that had disappeared can now be seen both here and in *The Last Supper* ('where there was once blue, there is now nothing', *Stones* III, 338).[53]

When considering the responses of Ruskin and James to the paintings in the Scuola we are confronted with questions of aesthetics, of relationships between Europe and America, and of contrasting views on innovation and conservation. After ignoring the possibility of employing gas and oil lighting in the Scuola di San Rocco, the Cancelleria discussed the possibility of installing electric light in 1910, as documented by Demetrio Sonaglioni,[54] whose work on the history of light in the Scuola is of great importance. It was only in 1937,[55] on the occasion of the great Tintoretto exhibition organized by Nino Barbantini, that Mariano Fortuny[56] was asked to install the patented indirect illumination with

53 Ruskin wrote that the face of the Lord in *Moses Striking the Rock* may have been destroyed and painted over during a restoration of the roof (*Stones* III, p. 344). The painting was restored by A. Lazzarin in 1974; see 'Opere autografe' in Pallucchini and Rossi, *Tintoretto*, vol. 1, p. 202, n. 333.

54 See Demetrio Sonaglioni, 'La nuova luce "dinamica" nella Sala dell'Albergo', and R. Mamoli Zorzi, 'Dal buio alla luce: La Scuola Grande di San Rocco da Ruskin e James a Fortuny', both in *Notiziario della Scuola Grande Arciconfraternita di San Rocco*, 32 (December 2014), pp. 74–87, and pp. 49–73 respectively. See also Sonaglioni's essay in this volume.

55 'Seduta di Cancelleria n. 226 del 20/1/1937 e n. 228 del 15/4/1937', in 'Miscellanea sec. XVIII–XX b.1' the 1933 Regulation on the lighting of theatres is mentioned ('Regolamento [...] sull'illuminazione dei teatri'). It shows that the discussions about the possibility of using electric light were ongoing.

56 Among Mariano Fortuny y Madrazo's (1871–1949) inventions was the dome ('cupola') for the theatres, patented in 1904. Fortuny's experiments of lighting in theatres are amply documented in studies of the artist: see Angela Mariutti de Sanchez Rivero, *Quattro spagnoli in Venezia* (Venice: Ongania, 1957), and the more recent *Immagini e materiali del laboratorio Fortuny*, ed. by Silvio Fuso and Alessandro Mescola (Venice: Marsilio, 1978), or Giandomenico Romanelli, *et al.* (eds.), *Museo Fortuny a Palazzo degli Orfei* (Milan: Skira, 2008). However, the lighting of the Scuola is only mentioned briefly: see Romanelli et al., p. 41. Guillermo De Osma, in *Mariano Fortuny: His Life and Work* (London: Aurum, 1980), dwells on the lighting of the Scuola and quotes a letter by Henriette Fortuny to Elsie Lee in which Henriette underlines Fortuny's satisfaction and joy at having saved from darkness paintings that would be finally visible (p. 186); Maurizio Barberis' study, 'La luce di Fortuny', quotes the 'lampade dal design molto tecnico, come i proiettori che illuminano il Tintoretto' ('the lamps with a highly technical design, as projectors illuminating Tintoretto', p. 45), underlining the effect of the indirect lighting (p. 47), in M. Barberis, C. Franzini, S. Fuso and M. Tosa (eds.), *Mariano Fortuny* (Venice: Marsilio, 1999). For the list of Fortuny's manuscripts bequeathed to the Biblioteca

which he had experimented in several theatres at the beginning of the century.

In spite of further discussions,[57] the new lighting was installed in the three halls in 1937. The Soprintendenza authorized the new lighting, which, according to the Guardian Grando, Count Enrico Passi, gave 'wonderful results that reveal details and beauties in the marvellous paintings, until now invisible due to the unhappy position of the paintings.'[58]

Once the work was finished, Fortuny was given a 'silver medal'.[59] On 14 January 1938 it was decided that the Scuola would retain the electric lighting system designed by Fortuny, which had been considered temporary until then.[60] The same lighting system was used in the same period for Titian's *Assumption* at the Frari (1515–18) and for the Carpaccios in San Giorgio degli Schiavoni.[61]

This was a very late date to acquire electric lighting. Electricity was employed abundantly in Europe and America between 1870 and 1900: a great Fair of electricity at Frankfurt celebrated the new energy in 1891: *Ex tenebris ad lucem*, or *Aus der Finsterniss zum Licht!*, reads the poster of the 'Internationale Elektro-Technische Ausstellung',[62] which published many images of women to signify the new freedom obtained thanks to electric light. Two years later, in 1893, the Chicago World Exposition was lit up by 100,000 incandescent lamps and the pavilions devoted to electricity were among the most popular: it was called 'White City'.

Marciana see Marcello Brusegan, 'Il fondo Mariano Fortuny alla Biblioteca Nazionale Marciana', in *Seta e oro. La collezione tessile di Mariano Fortuny* (Venice: Cassa di Risparmio-Biblioteca Nazionale Marciana, 1997–98), pp. 190–95. See also the dissertation by Marzia Maino, *L'esperienza teatrale di Mariano Fortuny*, Università di Padova, 2001–2002, which mentions an album of fifteen photos of the Scuola (pp. 28) at Palazzo Pesaro degli Orfei.

57 See 'Seduta di Cancelleria' of 3 March 1937, item 2, in which the previous discussions both 'from the artistic and technical viewpoints' are quoted ('Sedute di Cancelleria' 1928–1941, b.9)

58 '... risultati meravigliosi rivelando nei magnifici dipinti bellezze e particolari che per la infelice collocazione dei dipinti stessi erano finora invisibili.'('...wonderful results that reveal details and beauties in the marvellous paintings, until now invisible due to the unhappy position of the paintings') 'Seduta di Cancelleria' of 20 January 1937, item 2.

59 Attributed also to Podestà Alverà, to Superintendent Forlati, to Nino Barbantini, see 'Seduta di Cancelleria' of 15 May 1937, item 2.

60 AMM 1938-42, b.11.

61 *Il museo Fortuny a Palazzo Pesaro degli Orfei*, p. 42.

62 See Jürgen Steen, 'Eine neue Zeit..!' in *Die Internationale Elektrotechnische Ausstellung 1891* (Frankfurt am Main: Historisches Museum, 1991), p. 711.

Nevertheless, many other museums had extensive discussions about whether to install electric light or not, a delay David Nye's essay clarifies. As Holly Salmon documents, Mrs Gardner in Boston thought of lighting up her magnificent Titian, *The Rape of Europa*, with electricity in 1897, in her 'Venetian palace', the future Fenway Court Isabella Stewart Gardner Museum, but she ultimately decided in favour of candles. As Sarah Quill writes, the London National Gallery installed electric light only in 1935, after lengthy debates. Other museums were bolder, such as the Sir John Soane Museum in London, which had electric lighting in 1897.

We are now in the LED era, a type of illumination that allows the visitor to see paintings in a radically different way, according to the use of warm or cold light. It also includes the possibility of modulating the light. These are totally different conditions from those that prevailed in the nineteenth century and previously: they allow the viewer to study the details of the paintings in depth, but they also deprive him of that shadow that allowed Ruskin and James to appreciate the paintings with an inner vision (Ruskin's 'imagination penetrative'), seeing with their imaginations what their eyes could not grasp.

5. Light at the Scuola Grande di San Rocco

Demetrio Sonaglioni

As we have seen in R. Mamoli Zorzi's essay, John Ruskin, Henry James and others agreed that it was impossible to see Tintoretto's paintings clearly and enjoyably at around the middle of the nineteenth century. Electric light did not arrive in Venice until the end of the century; prior to this, lighting in the evening and in the night had depended on oil lamps or candles until the introduction of gas lamps in 1839.

There is no evidence that gas or oil were ever used inside the Scuola but candles certainly were, especially during the frequent religious ceremonies, as testified by the registers in which the expense for candles was carefully annotated. The governing body of the Scuola was immediately interested in the possibilities offered by electricity, and as early as 1910 the Guardian Grando (i.e. the President) Enrico Passi informs the governing body about the continuous complaints of many visitors about the lack of light, especially in the ground-floor hall and therefore suggests to install electric light with due care.[1] The lack of funds and the beginning of World War I interrupted these plans. Not until fourteen years later, in 1924, was the scheme taken up again, when the Guardian Grando proposed the installation of electric light in

[1] Venice, Archivio Scuola Grande di San Rocco [Historical Archives Grande di San Rocco] (ASGSR), *Sedute di Cancelleria*, b. 6, n. 108 del 13/02/1910. See also: A. Ciotti, 'Quaderni della Scuola Grande Arciconfraternita di San Rocco', in *Curiosando sulla Scuola Grande Arciconfraternita di San Rocco. Notizie tratte dagli archivi della Scuola da fine Ottocento a oggi: un secolo di vita*, n. 7, Venice, 2001, p. 35.

 https://doi.org/10.11647/OBP.0151.05

a meeting of the Cancelleria (i.e. the Board) on 8 April 1924. Considering that the Cancelleria had been wishing for a long time to carry out the project of lighting the Scuola with electric light, he proposed to carry out the project not only on the ground-floor hall but also in the upper room of the great *Crucifixion*.[2] Unfortunately, the initiative was forestalled again, this time due to a letter from the Department for Culture that ordered the cessation of the work because of fear of short circuits and the possible ensuing fires.

It was not until 1937, at the opening of the great Tintoretto exhibition organized at Ca' Pesaro in Venice, that the Superintendency and the Municipality decided to install electric light in the Scuola, which was seen as the conclusion of the exhibition. In the minutes of 20 January 1937, the same Guardian Grando Enrico Passi declared that on the occasion of the Tintoretto exhibition the Superintendency had decided an experiment entrusted to Mariano Fortuny, which had given wonderful results, revealing beauties and details that were practically invisible up to that moment.[3]

The delay caused by the two interruptions was perhaps fortunate, as it enabled the involvement of Mariano Fortuny, an eclectic early-twentieth-century European artist. Fortuny was a painter, a photographer, a stage director, a costume designer and a light designer. In his treaty of 1904 about stage lighting Fortuny affirmed that it is not the quantity but the quality of the light that makes things visible and allows the pupil to open adequately.[4]

Fortuny brilliantly solved the problem of giving light and visibility to Tintoretto's canvasses by means of his patented 'diffusing lamps with indirect light', which are still essential components of the lighting system in the upper halls today. These lamps are circular parabolic 'bowls', which diffuse the light in the most uniform way possible. They are visible even now in the 'Sala Capitolare' and in the 'Sala dell'Albergo'. Fortuny's great idea was to light all the paintings by means of few diffusing lamps: two in the 'Sala dell'Albergo', eight in the 'Sala Capitolare' and eight more in the ground-floor hall.

2 ASGSR, *Sedute di Cancelleria*, b. 8, n. 179 del 08/04/1924. See also: A. Ciotti, *Curiosando sulla Scuola Grande*, p. 36.
3 ASGSR, *Sedute di Cancelleria*, b. 9, n. 226 del 20/01/1937 e n. 228 del 15/04/1937. See also: Ciotti, *Curiosando sulla Scuola Grande*, p. 37.
4 M. Fortuny and Madrazo, *Eclairage des scénes par lumière indirecte: 'Système Fortuny'*, 29 March 1904, Paris.

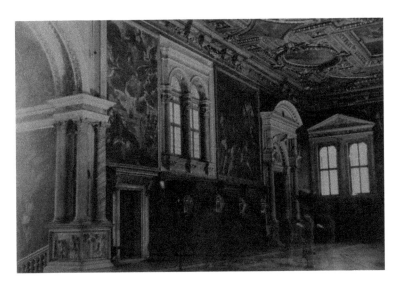

Fig. 5.1 The Sala Capitolare in the Biblioteca Nazionale Marciana, Venice, 1937.
Photo by Mariano Fortuny.

In the two upper halls, the diffusing lamps have a vertical stand and are turned upwards, as we can see even now. In the ground-floor hall they were hooked along the two main beams and turned towards the single painting on the walls. This caused a number of reflections which were to be the cause of their elimination and substitution in the 1980s.

The lamps in the ground-floor hall were maintained until 1987, when, in order to eliminate the reflections on the paintings, it was decided to substitute them with a different system, sponsored by the firm OSRAM, and designed by Prof. Soardo of the Centro Nazionale delle Ricerche, under the control of the Superintendency. This situation remained unchanged until 2011, when the Cancelleria decided to update the lighting of the canvasses by introducing a more modern technology.

These new lamps were designed by Studio Pasetti Lighting and were placed in the same position as the preceding ones. They contain LEDs, which save a substantial amount of energy and, more importantly, they can illuminate the paintings in warm or cold light. This allows visitors to view the paintings in detail and in optimal conditions. This second lighting project of the ground-floor room was also sponsored by OSRAM.

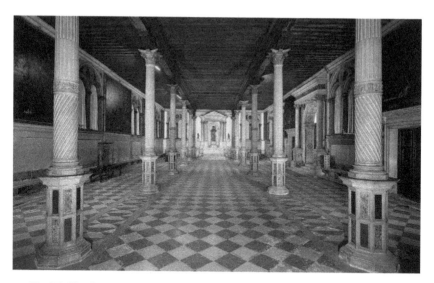

Fig. 5.2 The Ground-Floor Hall of the Scuola di San Rocco, Venice, with the new lighting installed in 2011, CC BY 4.0.

The most recent innovation in lighting Tintoretto's canvasses was carried out in the Sala dell'Albergo and unveiled in September 2014. It was sponsored by the great Swiss watchmaking firm Jaeger Le-Coultre. It was a much more complicated project because the Sala dell'Albergo, even if it is the smallest of the three important rooms in the Scuola, is the most important of them. Tintoretto began his work in it and it houses the grandiose Crucifixion.

This room is illuminated by only two Fortuny diffusing lamps.

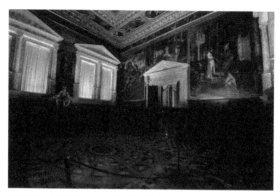

Fig. 5.3 Sala dell'Albergo, Scuola di San Rocco, Venice, CC BY 4.0.

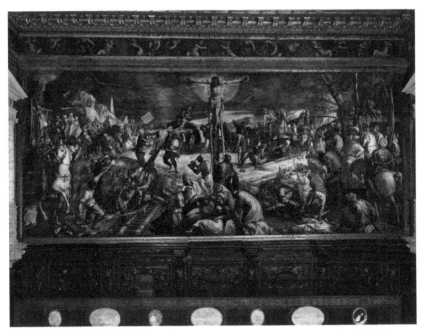

Fig. 5.4 Tintoretto's huge *Crucifixion* (1565) in the Sala dell'Albergo, Scuola di San
Rocco, Venice, CC BY 4.0.

As is well known, the perception of the human eye depends largely
on the spectrum of light interacting with the physical and chemical
characteristics of the painted surface. Every colour and every shade
can be intensified by an adequately calibrated projection of light. To
light a sixteenth-century painting involves an unavoidable compromise
between the desire to optimize its perception with the awareness that
the pigments that form it have irreversibly changed due to centuries
of exposure to light and to environmental agents. As a result, before
carrying out the latest project in the 'Sala dell'Albergo', we arranged
a spectrum-photometric analysis of the paintings. This was done by
the Photometry Lab of the University of Padua, in order to identify the
most important colorimetric characteristics of the materials used by
Tintoretto and in order to indicate the primary light sources that would
obtain the best chromatic perception.

This allowed us to choose the best type and quantity of LEDs for the
projectors, which can be seen in this image:

Fig. 5.5 The new projectors inserted in two Fortuny diffusers, CC BY 4.0.

This has resulted in a definite improvement in our visual perception of the paintings, as well as the addition of a 'light control' that can vary the light flux of the different projectors. This light control has been inserted in the two extant Fortuny lamps and can alter both the intensity and the temperature of the colour produced.

Finally, I would like to underline the total 'architectonic integration' of the system: the Hall had to appear as it was before these developments were completed, and so the new light sources could not be seen. The paintings and the architecture of the Hall were lit by means of the two existing Fortuny diffusing lamps, by now an integral and historical part of the hall. We had to insert all the new necessary LED projectors inside them.

The system is 'an elastic and reversible one' that allows us a better view of the paintings and their details, under different lights. Moreover, in the future, it will be possible to manage the system directly with an electronic tablet.

In conclusion, to provide a better understanding of the complexity of this latter illumination system, I think it useful to make a comparison with the system that was installed in 2014 in Michelangelo's Sistine Chapel in Rome. In this case, 7,000 LEDs were used.

In our 'Sala dell'Albergo' the complexity and the flexibility of the system compelled us to use more than 1500 LEDs; but bear in mind

Fig. 5.6 Tintoretto's *Crucifixion* (1565) in the Sala dell'Albergo, Scuola di San Rocco, Venice. Lit to highlight details: the two left and right backgrounds, CC BY 4.0.

that the dimensions of the Sistine Chapel are ten times those of our 'Sala dell'Albergo.'

6. The Light in the Venice Ducal Palace

Camillo Tonini

The history of the Ducal Palace is also the history of the fires that have laid waste to it: each time the monumental building has been rebuilt, adapting itself to the artistic trends of the moment. The palace was established in a Roman-Byzantine style in the twelfth century, before the 1419 fire ushered in the more agile forms of the Gothic. A little more than fifty years later, after the devastation of the 1483 fire, the courtyard façades to the East (the location of the Doge's apartments and chapel) were made more precious with the addition of the Scala dei Giganti and the masking of the façades with a marble coating that included Renaissance reliefs. The fires that took place in 1574 and 1577 devoured a significant part of the palace in a huge bonfire, destroying the more richly decorated halls, i.e. the Maggior Consiglio, the Senate, the Collegio and Anticollegio. These rooms recovered their magnificent beauty as a result of an iconographic program that was undertaken to celebrate the past pomp of the Republic.

The Palace's vulnerable wooden structures, the huge 'teleri' (canvasses) that completely covered its vast walls, the bundles of papers that the offices (magistrature) of the Republic produced continuously for the good functioning of the State and of Justice: all these represented real and material threats due to the fires that were used for lighting and cooking. Towards the end of the Republic, these dangers were multiplied by the frequent occasions on which the Serenissima Republic would celebrate its civic rites and the increasingly luxurious hospitality afforded to distinguished visitors. However, the most insidious hazards

 https://doi.org/10.11647/OBP.0151.06

lurked in those rooms in the interior of the great pile that housed the everyday inhabitants of the palace, including the Doge and his retinue: these included small candles burning in front of the sacred images of religious devotion, the fireplaces — only eleven in the whole palace — that warmed the rooms during the long, cold winter seasons, or the torches used to light the halls where the magistrates and the guards spent the night.

It was therefore necessary to reduce these risks as much as possible by holding every institutional and celebratory occasion in the daytime: light is therefore the protagonist in the Ducal Palace, which, due to its orientation, receives uninterrupted sunlight on its two main façades. Indeed, there is so much light in the Ducal Palace that the 'teleri' (canvasses) used to be covered with huge curtains so that the paint pigments would not fade. The most important guests — heads of state, diplomats, famous travellers visiting the palace — would be guided into the building according to the way the light fell on a given day and time, in order to intensify the beauty of the architecture and of the great Venetian artworks that acquired splendour from the light reflected by the water of the lagoon. In the early morning it was better to have the guests observe the works in the halls of the Consiglio dei X, of the Bussola and of the Senato; at noon, those of the Maggior Consiglio and the marble decorations of the interior courtyard; in the afternoon the halls of the Scrutinio, of the Collegio and of the Anticollegio.

Of course the Ducal Palace did not lose its complex relationship to light when the Republic ended its State and political role, and the palace, its symbol, was no longer the exclusive home of the Venetian nobility and the splendid dwelling of the Doge. It became the seat of the French and Austrian authorities in the early 19th century, before transforming into the workplace of civil servants and government employees who performed daily administrative work, far from the levers of power. This changed in December 1821, when a new fire endangered the existence of the palace and caused the Emperor of Austria, Francis II, to decree the total removal of the judiciary, financial and administrative offices that the building housed; only the Statuario Veneto and the Biblioteca Marciana, which had moved into the palace from the nearby Libreria Sansoviniana, kept the spaces that had been allotted to them only a few years earlier.

Thus the palace began its transformation into a museum of itself, a place where the memories of a noble past were preserved, frequented by

a few cultured visitors who were accompanied by a simple usher, or, if they were particularly distinguished, by an erudite scholar of Venetian civilization such as Emmanuele Cicogna, who was appointed to show Emperor Franz Joseph and his retinue through the halls of the palace in 1857.[1] Even then there were those who, in preference to the beautiful halls, chose to visit those rooms that were never penetrated by sunshine, fascinated by the horrible prisons and the 'black legend' that cultivated an image of Venice as an implacable executioner and a ruthless avenger in the nineteenth century.[2]

John Ruskin returned to the city in order to prepare his *Stones of Venice* immediately after the defeat of the Republic of San Marco in 1849, when the conclusion of the bloody Austrian siege had left behind a spent and resigned city. His proclaimed passion for the Gothic style and his hatred of Renaissance symmetries led him to admire the Ducal Palace façade overlooking the Bacino di San Marco; he particularly appreciated the irregular position of its windows, established when the façade was rebuilt during the first half of the fifteenth century. However, the architect's main aim had not been to obtain a serene aesthetic balance, but instead to convey light into the interior of the building, so that the gilded surfaces of the woodwork would sparkle and the paintings by the great Venetian artists would shine.

The ceiling of this new room, built in the first half of the fifteenth century, was adorned by the paintings of the best masters in Venice, and it was therefore vital to illuminate that gorgeous ceiling and to maintain a serene quality of light in the Council Chamber. This required the admittance of light in simple masses, rather than in many broken streams. A modern architect, terrified of violating external symmetry, would have sacrificed both the pictures and the peace of the council room, placing the large windows at the same level and introducing smaller windows above, like those of the upper story in the older building. But the old Venetians thought of the glory of the paintings and the comfort of the Senate. The architect therefore unhesitatingly raised

1 Cf. C. Tonini and M. Gottardi, 'Sissi e Venezia. Tre incontri particolari, in Elisabetta d'Austria, Trieste e l'Italia', exhibition catalogue edited by M. Bressan (Monfalcone: Monfalcone, 2000), pp. 52–73.

2 Cf. G. Paglia, 'La paura e il piacere da Palazzo Ducale a Ca' Rezzonico. Visitare Venezia tra leggenda nera e leggenda rosa in Scritti in ricordo di Filippo Pedrocco', *Bollettino dei Musei Civici di Venezia 2014–2015 dedicato a Filippo Pedrocco* (Venice: Skira/Fondazione Musei Civici di Venezia, 2014), pp. 205, 202–09.

the large windows to their proper position in relation to the interior of the chamber, and allowed the external appearance to take care of itself. I believe the whole pile rather gains than loses in effect by the variation thus obtained in the expanse of wall above and below the windows.[3]

Ruskin unsurprisingly disliked the public system that lit Piazza San Marco with the feeble light of 144 gas lamps, established in 1844. Some lights were also installed near the Porta della Carta and along the lower loggia of the Ducal Palace. This was the first timid effort to provide Venice with permanent public illumination in its central areas, although this type of public lighting was already established in the great European cities. The big interior spaces of the Palazzo Ducale, however, could only be seen by its numerous visitors during the day, with the advantage of the favorable light that was to be found at certain times and in the best seasons. Despite the entrance fee that was introduced in 1873, these visitors returned again and again.

In his 1882 essay 'Venice', Henry James, another frequent visitor, left some keen observations that are still valid for the contemporary tourist about when and how to appreciate the Ducal Palace during less crowded periods:

> Fortunately, however, we can turn to the Ducal Palace, where everything is so brilliant and splendid that the poor dusky Tintoret is lifted in spite of himself into the concert. This deeply original building is of course the loveliest thing in Venice, and a morning's stroll there is a wonderful illumination. Cunningly select your hours — half the enjoyment of Venice is a question of dodging — and enter about one o'clock, when the tourists have flocked off to lunch and the echoes of the charming chambers have gone to sleep among the sunbeams. There is no brighter place in Venice — by which I mean that on the whole there is none half so bright. The reflected sunshine plays up through the great windows from the glittering lagoon and shimmers and twinkles over gilded walls and ceilings. All the history of Venice, all its splendid stately past, glows around you in a strong sea-light. Everyone here is magnificent, but the great Veronese is the most magnificent of all.[4]

In 1886, in the City Council, Count Francesco Donà asked that an electrical generator should be built in Venice: some well-known

3 J. Ruskin, *The Stones of Venice* (New York: John Wiley & Sons, 1880), p. 130, https://catalog.hathitrust.org/Record/000455582

4 Henry James, 'Venice' (1882), in in John Auchard (ed.), *Italian Hours* (University Park: The Pennsylvania State University Press, 1992), pp. 7–31 (p. 24).

businessmen, linked with the tourist industry, took up his challenge and built an *officina* (workshop) very near San Marco, which provided electricity to some large hotels and to the chandelier of the Theatre La Fenice.[5] The Ducal Palace was not included in this first electrical project; during this time the palace was undergoing radical restorations that had begun in 1875 and were required to safeguard the statics of the precious building.[6]

Giacomo Boni was among the many technicians who took care of the delicate work of consolidation. He was to become Direttore delle Antichità e Belle Arti at the Rome Ministero. In an 1887 pamphlet of his, titled *Venezia imbellettata*, Boni delivered a heartfelt warning about the danger of fire in the Ducal Palace; this was particularly urgent because the families of many of the guards and the administrators now resided there. It was also home to some public offices, including, from 1891, the Regional Office for the Preservation of Monuments in the Veneto — nowadays the Sovrintendenza — which, at the time, was directed by architect Federico Berchet.

> Originally the fire dangers in the Ducal Palace depended on its function as the dwelling of the Doge and of his family, who needed fires in the kitchens, braziers and lights in the apartments, oil lamps possibly in closed glass lanterns, which, however, burned. If a part of the palace was destroyed, it was sufficient to use the contemporary art and rebuild the burnt part with new materials and forms.[7]

The Palace, declared an Italian National Monument, also accommodated the Biblioteca Marciana, which had originally been located in the Sala dello Scrutinio in the fifteenth century, expanding slowly into the hall of the Maggior Consiglio, of the Quarantine and of the lesser tribunals. The sculptures of the archaeological museum were placed, with all their weight, on the ceiling structures of the doge's apartments. When it arrived in the Palace, the Istituto Veneto di Scienze, Lettere ed Arti expanded from the Magistrato alle Acque on the ground floor to the Torricella of the Consiglio dei X, with its labs and an industrial

5 On the development of public electric lighting in Venice see M. Baldin, *La illuminazione pubblica a Venezia. Il nuovo impianto* (Venice: Tipografia di S. Lazzaro, 1928); G. Pavon, *La nascita dell'energia elettrica a Venezia. 1866–1904* (Venice: Enel Distribuzione, Cartotecnica Veneziana, 2001).

6 Cf. F. M. Fresa, "Monumenti di carta, monumenti di pietra", in G. Romanelli (ed.), *Palazzo Ducale. Storia e restauri* (Verona: San Giovanni Lupatoto, 2004), pp. 205–22.

7 G. Boni, *Venezia imbellettata* (Rome: Stabilimento Tipografico Italiano, 1887), p. 34.

exhibition of wax matches, wallpaper, eye glasses, etc. This change of use created new requirements: not only was the palace to welcome visitors interested in history and aesthetics, but also civil servants and employees who had to carry out their office work. As a result, at least part of the palace had to be lit with electricity, and in 1892 a project was developed with this in mind.

Although the benefits of this decision might seem obvious to a modern reader, the electric incandescent bulbs of the time were not much safer than torches and oil lamps with open burning flames. Keeping in mind this limited technology, it was not unreasonable that the Direction of the Assicurazioni Generali had some doubts, which were expressed in a note of 7 July 1896, sent to the Director of the Regional Office:

> The Insurance Companies have decided that the new illumination does not ensure the safety that most people expected as regards fires (...) This industry, although it has progressed far, is still at its beginning and we trust that it will overcome the present imperfections of the plants.[8]

These safety concerns were particularly pressing since fires had recently been caused by faulty electrification in a nearby jersey firm, in the Molino Stucchi Giudecca plant, and on the stage of the Malibran Theatre.

The project continued, however, and the electrification work in the palace started in 1896. It was limited to some interior staircases, the firemen's station, the guards' rooms, and Berchet's offices, but it nonetheless sparked a strong reaction in the local newspapers and among a large section of the public, who denounced the profanation of the historical building and feared new disastrous fires.

On 13 July 1896, an article by Antonio Vendrasco, titled *La luce elettrica nel Palazzo Ducale*, appeared on the pages of the daily paper *L'Adriatico*, thundering against what seemed to the author a senseless innovation:

> With a feeling not of wonder but of disgust we have seen in these days a work, already quite advanced, which in our opinion is a real nonsense, as it distorts the real nature and cancels the character of the most superb building in the art world, the Ducal Palace. We mean the installation of electric light, which is being set up in the Ducal Palace, with an alacrity worthy of a better cause. In a few days, thus, due to the

8 Archivio Storico della Soprintendenza Belle Arti e paesaggio per Venezia e Laguna, A5-6 Palazzo Ducale — Busta 4, *Pericoli di incendio e luce elettrica in Palazzo Ducale (1892–1915)*.

ignorance of few people and the pecuniary interest of others, in an epoch when electric light was not even imagined, will be lit up with the most powerful product of modern civilization, with an embrace between art and industry which we will call hybrid in this particular case [...] The impulses of these men profaning the most beautiful temple of art, and the work, neither called for or wanted by anyone, should stop, together with the spending of money which should be destined to furnish instead a better culture to many poor people, who often lack mostly a good sense of art and a real and healthy love of the national monuments.[9]

This scorching polemic did not prevent some artists from continuing to visit the palace, looking for the best light conditions in which to paint its interiors. Among them was John Wharlton Bunney, who lived in Venice between 1877 and 1882 and whose sunny work, *Interno della Sala del Senato*, painted in the morning light, is still with us.[10] Another well-known work from this period is John Singer Sargent's glorious *Sala del Maggior Consiglio* of 1898[11] — now in a private collection — in which the warm early afternoon light pours in through the large windows and from the balcony overlooking the Bacino di San Marco, diffusing onto Veronese's bright canvases. In the background, light hits the *Paradiso* by Tintoretto, belying his fame as a 'tenebroso' (gloomy) painter, won thanks to his canvases in the Scuola Grande di San Rocco, which could not enjoy such generous amounts of natural light.

Photographers, who needed so long to expose their plates that their work took almost as long as the painters' laborious brushstrokes, also began to frequent the palace and to learn the secrets of its light. Their aim was to create images that they could sell at an affordable price to the ever-growing number of hurried tourists who visited Venice.

In 1904 the first official inauguration of the city's electric light system took place. From that date, the creation of new itineraries for visitors, the introduction of novel functions for the rooms, the extension of visiting hours past daylight, and the greater number of amenities required to welcome more and more visitors, have necessitated more

9 A. Vedrasco, 'La luce elettrica nel Palazzo Ducale', *L'Adriatico*, 13 July 1896. The debate was also taken up by the author on the 17th of the same month.

10 Ruskin collected this souvenir of Venice, now at the Sheffield Millennium Galleries.

11 *Interior of the Doge's Palace*, property of the Earl and Countess of Harewood and the Harewood Home Trust; see Warren Adelson, William H. Gerts, Elaine Kilmurray, Rosella Mamoli Zorzi, Richard Ormond and Elizabeth Oustinoff (eds.), *Sargent's Venice* (New Haven, CT, and London: Yale University Press, 2006), p. 149, fig. 154.

complex technological solutions that allow everyone to enjoy the palace artworks in every season. Despite the efforts of the palace staff and its director, not all of these solutions have been wholly respectful of this noble palace.

7. Latent in Darkness: John Ruskin's Virtual Guide to the Academy of Fine Arts in Venice

Emma Sdegno

It is a fundamental premise of this essay that the main aim of Ruskin's works was to raise and develop the reader-viewer's awareness and critical attention.[1] His readings of artworks and landscape orient our gaze through an experience that is unique and contingent, rooted in the particular moment in which it takes place. Elements such as a painting's position, setting, and lighting thus have precise rhetorical purposes in Ruskin's discourse, with objective spatial features acting as markers that help the viewer to construct sense and meaning. Pervasive as they are throughout his works, these techniques are of paramount importance in later publications, such as the *sui generis* guides of the 1870s.

In this chapter I shall focus on the *Guide to the Principal Pictures in the Academy of Fine Arts at Venice* published in two parts in 1877. In this much underrated work,[2] Ruskin talks us through the rooms of the gallery using a language that is often unconventional for the genre but is, I hope to demonstrate, carefully and deliberately chosen. Words are used in an

1 I wish to warmly thank Jeanne Clegg for reading a draft of this chapter and for the ongoing stimulating discussions.

2 For a philological reconstruction of the *Guide* see Paul Tucker's introduction to his Italian edition of John Ruskin, *Guida ai principali dipinti nell'Accademia di Belle Arti di Venezia 1877* (Milan: Electa, 2014), pp. 9–66. For the stylistic features of the *Guide* see Emma Sdegno, 'Nota del traduttore', ibid., pp. 67–69, and eadem, 'On Translating Ruskin's Academy Guide', *The Companion* 15 (2015), 48–49.

 https://doi.org/10.11647/OBP.0151.07

expressionistic way so as to fit within a programme of picture viewing that he had been elaborating in several essays since the 1850s, and that he implicitly puts into practice in the *Guide*. 'Dark', 'light', 'bright' and related words prove to be key signifiers in this educational visit. At a time when debates concerning the introduction of artificial light into picture galleries were heating up, Ruskin makes his voice heard against the practice, resisting primarily for conservational reasons,[3] but also, I shall argue, because he sensed that this might bring about dramatic and deleterious changes in the way we perceive and frame the artwork.

1. The Venice Academy and Ruskin's Ideal Museum

By the time Ruskin came to write the *Guide to the Academy* his concerns had shifted from artists — the declared addressees of *Modern Painters* (1843) — to visitors at large. He claimed the purpose of his late guides to Italian cities, such as *Mornings in Florence* (1875–77), the *Guide to the Academy* (1877) and *St. Mark's Rest* (1877–84), was to raise the cultural and spiritual awareness of 'the few travellers who still care for [their] monuments', and offer critical alternatives to mainstream handbooks for travellers.[4] This programme was also related to an evolving theory of picture viewing. As Donata Levi has pointed out, Ruskin's ideas about museums were complex and evolved over time.[5] If in 1844 he privileged 'a mode of picture viewing which was mainly private and isolated in contrast with exhibition spaces which were crowded, noisy and ostentatious', for museums were to be experienced in a 'one-to-one relationship' and 'a quiet attitude of receptiveness',[6] by the 1860s he had come to conceive of the museum as an educational and transformative

3 See Geoffrey N. Swinney, 'The Evil of Vitiating and Heating the Air. Artificial Lighting and Public Access to the National Gallery, London, with Particular Reference to the Turner and Vernon Collections', *Journal of the History of Collections* 15.1 (2003), 83–112 (p. 93). Conservation was the theme of the exhibition: 'Colour and Light: Caring for Turner's Watercolours', The National Gallery of Ireland, 2011.
4 See dedication of *St. Mark's Rest*. E. T. Cook, A. Wedderburn (eds.), *The Works of John Ruskin*, 39 vols. (London: George Allen, 1903–12), XXIV, p. 193. Future references to the *Works* will be included in the text parenthetically.
5 Donata Levi, 'Ruskin's Gates: dentro e fuori il museo', Roberto Balzani (ed.), *Collezioni, museo, identità fra XVIII e XIX secolo* (Bologna: il Mulino, 2006), 68–105.
6 Ibid., p. 76.

place aiming at a 'spiritual advancement in life'.[7] The *Guide* is informed
by this radical purpose. In these apparently fragmentary little volumes
all references to paintings aim to enact this process, to search for, display
and articulate a system of aesthetic, social and spiritual values that looks
back to early Christian art. The *Guide* focuses on the early Venetians and
their Byzantine roots, artists he calls 'painters of the heart' as opposed
to 'painters of the eye'.[8] Linking spiritual values to chromatism, Ruskin
contrasts 'brightness' with 'colourfulness,' and genuine faith with
doubt. In this series of correspondences, the space hosting the painting
is linked directly to modulations of and contrasts between light and
shade, and thus semanticized.

Ruskin had outlined his notion of an ideal gallery in two articles
he wrote for the *Times* in 1847 and 1852, when plans for a museum to
house the Turner bequest were being discussed. The 'two imperative
requirements' he summed up in his 1852 letter were:

> that every picture in the gallery should be perfectly seen and perfectly
> safe; that none should be thrust up, or down, or aside, to make room for
> more important ones; that all should be in a good light, all on a level with
> the eye, and all secure from damp, cold, impurity of atmosphere, and
> every other avoidable cause of deterioration (XII, 410–11).

Largely shared today, he expected that this idea would be received as
odd and revolutionary by his contemporaries:

> I know that it will be a strange idea to most of us that Titians and
> Tintorets ought, indeed, all to have places upon 'the line' as well as the
> annual productions of our Royal Academicians; and I know that the *coup
> d'oeuil* of the Gallery must be entirely destroyed by such an arrangement.
> But great pictures ought not to be subjects of '*coup d'oeuil*' (ibid., p. 411).

In the later pamphlet 'Notes on the Turner Gallery at Marlborough
House, 1856' he reiterates and expands on the subject, listing twelve
detailed 'rules' on picture viewing:

7 Ibid., p. 100. On the 'programme of textual revision and moral reformation'
 informing the *Guide* and Ruskin's late works on Venetian art, see Tucker, *Guida*, p.
 13.
8 Paul Tucker, ed., *Résumé of Italian Art and Architecture (1845)* (Pisa: Scuola Normale
 Superiore, 2003), xli–xlvii.

1st. All large pictures should be on walls lighted from above; 2nd. Every
picture should be hung so as to admit of its horizon being brought on
a level with the eye of the spectator, without difficulty or stooping. A
model gallery should have one line only; and some interval between each
picture, to prevent the interference of the colours of one piece with those
of the rest. […] 4th. There would be a great advantage in giving large
pictures a room to themselves. 5th. It is of the highest importance that the
works of each master should be kept together. […] 8th. Though the idea
of a single line of pictures, seen by light as above, involves externally, as
well as internally, the sacrifice of architectural splendour, I am certain
the exterior even of this long and low gallery could be rendered not only
impressive, but a most interesting school of art. I would dispose it in long
arcades; if the space were limited, returning upon itself like a labyrinth;
the walls to be double, with passages of various access between them,
in order to secure the picture from the variations of temperature in the
external air (XIII, 176–81).

Although we still know little about the disposition of the rooms
composing the Galleries of the Venice Academy and the arrangement
of the paintings within them, which changed continuously, we may be
certain that they did not respond to these requirements.[9] We can infer
something of the lighting conditions, however. In 1877, the year Ruskin's
Guide was published, the Galleries were illuminated solely by natural
light, as were most museums of the time, and were therefore, as Murray's
handbooks announced, open from 12pm to 3pm.[10] In 1864 artificial light
had been introduced to illuminate some of the Academy rooms, namely
those dedicated to the evening life classes. In a lengthy unpublished
letter, Carlo Blaas, professor of Life Drawing at the Academy in the
decade 1856–66, made a formal request for gas lighting in these rooms,
at the same time informing the *Presidenza* of the Accademia di Belle Arti
about the overall lighting conditions of the building, complaining about
over-exposure to light in the statues' rooms (*statuaria*) on the upper
floor, and proposing that the lights (*lanternali*) that had been opened
on the roof of the Church of the Carità when it was adapted to house

9 See Nico Stringa (ed.), *L'Accademia di Belle Arti di Venezia, l'Ottocento*, 2 vols. (Crocetta
 del Montello, TV: Antiga edizioni, 2016). I wish to thank Sileno Salvagnini, general
 coordinator of this work, and his collaborator Sara Filippin, for kindly helping with
 information about unpublished material.
10 John Murray, *Handbook for Travellers in Northern Italy: Comprising Piedmont, Liguria,
 Lombardy, Venetia, Parma, Modena, and Romagna* (London: John Murray, 1869), 11th
 ed., p. 422.

the Schools be covered or closed.[11] In March 1877 the issue of lighting at the Accademia was raised again in a letter written by the painter Augusto Wolf, and signed by thirty-nine artists, who asked for better illumination of the exhibition rooms.[12]

In 1877 the Academy art schools were still on the ground floor of today's Galleries, occupying the former buildings of the Scuola, Chiesa and Convento della Carità. The place was defined as 'a partly casual but magnificent aggregate of former buildings and later additions', 'the appropriate seat of wonderful works',[13] 'which reflected a 'system of correspondences between the art schools on the lower floor and the gallery rooms on the upper one'.[14]

Ruskin had been visiting the Academy since the 1840s, but this system of correspondences had started to interest him only in the 1860s, when he was thinking of new museal forms that would fulfil both a pedagogic and an aesthetic purpose. Moreover, in these years he started commissioning copies of Venetian paintings from young painters, some of whom were students at the Venice Academy, and in 1873 he became an honorary member (*socio d'onore*) of that institution.[15] The Academy had other features that attracted Ruskin's interests in the 1870s, principally the fact that it housed the largest collection of the early Venetian art works that were absorbing his interests and energies in those years, among them Carpaccio's Saint Ursula cycle. But it was far from what he thought an ideal museum should be: its rooms were not devoted to one painter only, paintings were not arranged chronologically, nor were they on the eyeline.

11 Letter dated 15 May 1863, *Accademia di Belle Arti di Venezia, Fondo storico, Atti*, 1860–1870, *Amministrazione, Economato*, VI, B. 1, fasc. 'Illuminazione gas portatile'.

12 See Sara Filippin, 'Fotografie e fotografia nella storia dell'Accademia di Belle Arti di Venezia, 1850–1950', in Nico Stringa, *L'Accademia di Belle Arti*, I, pp. 233–69 (p. 249).

13 See Antonio Dall'Acqua Giusti, *L'Accademia e la Galleria di Venezia. Due relazioni storiche per l'esposizione di Vienna del 1873* (Venice: Visentini, 1873), 'L'Accademia', 5–73; 'La Galleria', 5–29 (p. 56). This historical report provides a census of the artworks exhibited at the Pinacoteca and details about the distribution of paintings in the rooms. See also Murray's plan, in his *Handbook for Travellers in Northern Italy*, p. 422.

14 'Room 2 or *Sala dell'Assunta* was above the School of Ornamentation, the Sculpture room was above the classroom of Architecture, Painting and Life Drawing; [...]. In fact, the Academy and the Gallery were born together and developed in such a connected and interdependent way that the two institutions are to be considered a single whole, just as the building was a single whole', Dall'Acqua Giusti, 'L'Accademia', p. 56. My translation.

15 See Tucker, *Guida*, pp. 14–15, 47n.

One of the most interesting features of the *Guide* is that it seems to trace an itinerary through the Galleries alternative to that which the actual ordering and positioning of the pictures invite the visitor to follow. Ruskin's authoritative and prescriptive mode of directing the visitor orients his gaze in such a way as to virtually reorganize the existing spaces. As in Ruskin's ideal museum, the *Guide* to the Academy constructs a path in which paintings are arranged in a roughly chronological order, and placed one after the other on an ideal eyeline. The viewer is addressed personally and urged to follow instructions: to move from one room to the next, look selectively at paintings, turn, move on, shun and avoid, stop and linger, go back, leave. Once she has accomplished this journey through fourteenth- to sixteenth-century Venetian painting, the visitor will have covered the labyrinthine circular trajectory Ruskin had imagined for his ideal gallery. This reorganization of space is based on a close rhetorical control that also exploits such external signs as the rooms' light and shade, conditions that become signposts, signifiers, and symbolic labels with multiple meanings attached. Let us see how this strategy is enacted.

2. Looking Into Dark Recesses

The *Guide* starts with a conditional and an imperative that together set the tone of the whole discourse:

> In the first place, if the weather is fine, go outside the gate you have just come in at, and look above it. Over this door are three of the most precious pieces of sculpture in Venice; her native work, dated; and belonging to the school of severe Gothic which indicates the beginning of her Christian life in understanding of its real claims upon her (XXIV, 149).

The imperative urges the visitor to go back and notice what s/he might have just neglected, launching a visit that, from the start, takes the form of a journey of discovery of hidden or unseen works. The condition is that there be 'fine weather': it must at least be dry enough for one to be able to look at the sculptures on the façade, but it must also be sunny enough to visit a gallery that was illuminated only by natural light. This apparently trivial detail alerts the viewer that s/he must be receptive to the basic contingent factors that affect a visit to buildings housing

works of art. The viewer must be aware of all the physical factors that intervene and make up the experience.

After drawing attention to this earliest instance of Christian sculpture in Venice, Ruskin leads his reader straight into the building and places him in front of two early paintings in Room I, the *Coronation of the Virgin* by Stefano Plebanus di Sant'Agnese and the *Polyptych of the Madonna* by Bartolomeo Vivarini, 'a picture that contains the essence of Venetian art'. Soon after, in a hasty movement — 'Next, going under it, through the door' — he places him/her in what he laconically calls 'the principal room of the Academy'. This was Room II, known as the Sala dell'Assunta.[16] Stuffed with paintings of different periods and artists, it had been celebrated by Giuseppe Borsato (1757–1822) in his *Commemoration of Antonio Canova* (1824), and in the 1860s it was photographed by Domenico Bresolin and then Carlo Naya.[17] The first room in the Academy of which we have nineteenth-century photos was universally known for containing Titian's *Assumption*. In his *Pinacoteca dell'Accademia* (1830) Venetian art historian Francesco Zanotto had concluded his lengthy treatment of the altarpiece by defining it as 'the sun among minor stars, rescued from the darkness of its former seat in the Frari church and from the damages of candlelight and incense, and restored to the *full light* of the Academy, to shine among the masterpieces of the Veneto School'.[18] Murray repeated this almost *verbatim*.[19]

In introducing his reader/viewer into the room Ruskin shuns the painting by pointing at a 'back wall' where the 'best Bellini in the Academy' lingers:[20]

> [...] you find yourself in the principal room of the Academy, which please cross quietly to the window opposite, on the left of which hangs a large picture *which you will have great difficulty in seeing* at all, *hung*

16 As in Murray, *Handbook for Travellers in Northern Italy*, p. 423.

17 G. Borsato, *Commemorazione di Antonio Canova*, Venezia, Galleria Ca' Pesaro, 1824. For Bresolin's and Naya's photographs, see Filippin, pp. 243–44.

18 Francesco Zanotto, *Pinacoteca della Imp. Reg. Accademia Veneta delle Belle Arti*, 2 vols. (Venice: Giuseppe Antonelli, 1830), I, unnumbered. My translation.

19 Murray, *Handbook for Travellers in Northern Italy*, p. 423.

20 Giovanni Bellini, *Virgin Enthroned with the Child, with Saints Francis, John the Baptist, Job, Dominic, Sebastian, Louis of Toulouse and musicanti angels*, known as the 'San Giobbe Altarpiece', Gallerie dell'Accademia, Venice, ca.1487, see https://commons.wikimedia.org/wiki/File:Accademia_-_Pala_di_San_Giobbe_by_Giovanni_Bellini.jpg

as it is against the light; and which, in any of its finer qualities, you absolutely cannot see; but *may yet perceive* what they are, *latent in that darkness*, which is all the honour that the kings, nobles, and artists of Europe care to bestow on one of the greatest pictures ever painted by Christendom in her central art-power. Alone worth an entire modern exhibition-building, hired fiddlers, and all; here you have it jammed on a back wall, utterly unserviceable to human kind, the little *angels of it fiddling unseen*. Unheard by anybody's heart. It is the best John Bellini in the Academy of Venice; the third best in Venice, and probably in the world (XXIV, 151–52).

Fig. 7.1 Carlo Naya. Sala dell'Assunta, Accademia di Belle Arti, Venice.

Darkness and invisibility here become meaningful signs for the visitor, who will have to decode their implications. Ruskin teaches his viewer to consider the museum as a *semiotic space* in which all signs can convey information about a painting. This implies the proxemic assumption that in order to understand a painting one must consider the place where it is set, the room itself, its relationship with the other paintings, as well as the building in which it is housed. In the second part of the *Guide*, Ruskin deals extensively with the three buildings and institutions of the Carità that form that 'casual but extraordinary assemblage', encouraging his reader to meditate on the origin of this

art gallery and school, and recognise symbolic and spiritual meaning in the expositional buildings as such. To look at the 'dark spot' occupied by Giovanni Bellini's *Madonna*, first and foremost involves avoiding the conventional paths followed by the mass of viewers. Most of the Academy paintings to which Ruskin draws his reader's attention are described as being in shaded or inaccessible positions. At another level, the darkness into which the Bellini has been cast speaks of the museum's approach, and implies criticism of institutional choices, frequent targets of attacks by Ruskin in those years.

In Ruskin's personal semiosis of the Accademia, invisibility is the halo surrounding neglected and valuable works, ultimately 'dark' because of their value. The early Christian association between humility and glory is an implied reference here, an association which helps to explain why what lingers unseen deserves attention, and thus why one should look carefully at Bellini's Madonna.

The hidden position (and glory) of the Bellini is in sharp contrast with Titian's *Assumption*, which Ruskin mentions soon after. Unlike Bellini's, Titian's painting is in full view, with chairs in front of it for visitors to look at it comfortably, turning their backs on the rest of the works in the room. In the Venetian Index (1853) Ruskin had appreciated the *Assumption*, but he had also raised the issue of its visibility: 'The traveller is generally too much struck by Titian's great picture of 'The Assumption' to be able to pay proper attention to the other works in this gallery' (ibid., p. 152), adding that the viewer is deceptively attracted by the painting's technical features: 'on the picture's being larger than any other in the room, and having bright masses of red and blue in it' (ibid.). Now in 1877 he diminishes the value of largeness and bright colour and corrects the viewer's criteria for appreciation: 'the picture is in reality not one whit the better either for being large or gaudy in colour', and urges him/her not to be deceived by size and colour but take 'the pains necessary to discover the merit of the more profound works of Bellini and Tintoret.' Far from being too bright, the *Assumption* is actually not 'bright enough', for it is full of dark spots (ibid., p. 153). Acknowledging that 'as a piece of oil painting, and what artists call 'composition,' with entire grasp and knowledge of the action of the human body, the perspectives of the human face, and the relations of shade to colour in expressing form, the picture is deservedly held unsurpassable', he feels

that this is an art no longer inspired by a genuine belief: '[Titian] does not, in his heart, believe the Assumption ever took place at all':

> [...] a strange gloom has been cast over him, he knows not why; but he likes all his colours dark, and puts great spaces of brown, and crimson passing into black, where the older painters would have made all lively. Painters call this 'chiaroscuro'. So also they may call a thunder-cloud in the sky of spring: but it means more than light and shade (ibid., p. 154).

Brightness is created by other means (golden and luminous surfaces) and of mystical experience. Brightness applies to 'the painters of the heart', to what Ruskin calls 'the Vivarini epoch, bright, innocent, more or less elementary, entirely religious art, — reaching from 1400 to 1480' (ibid., p. 155). Darkness is a mark of the existential condition of the modern painter, and the Gallery now becomes the spatial figure of modernity.

After highlighting the 'dark spots' of the *Assumption*, Ruskin draws attention to 'two dark pictures over the doors', Tintoretto's *Death of Abel* and *Adam and Eve*. Here he establishes a correspondence between the darkness of the space in which the painting is located, which the reader has by now learnt to consider a meaningful element of the Academy's grammar, and the dark colours in the painting itself, as another mark of modernity:

> Darkness visible, with flashes of lightning through it. The thunder-cloud upon us, rent with fire. Those are Tintorets; finest possible Tintorets; best possible examples of what, in absolute power of painting, is supremest work, so far as I know, in all the world. [...] it would take you twenty years' work to understand the fineness of them as painting [...] All that you have to notice is that painting has become a dark rather than a bright art (ibid.).

It was indeed more than twenty years since Ruskin had himself begun to grasp Tintoretto's 'absolute power', and guided readers of *Modern Painters* and the *Venetian Index* through the shadowy spaces of the Scuola di San Rocco and the 'fireflylike' lighting of the canvases it houses.[21] We

21 Ruskin's readings of the Tintorettos in the Scuola Grande di San Rocco are complex and deserve close study. I have discussed some aspects in 'Reading the Painting's Suggestiveness: Remarks on a Passage of Ruskin's Art Criticism', in Jeanne Clegg and Paul Tucker (eds.), *The Dominion of Daedalus. Papers from the Ruskin Workshop held in Pisa and Lucca 13–14 May 1993* (St. Albans: Brentham Press, 1994), pp. 100–14, and more recently in Emma Sdegno (ed.), Introduction to *Looking at Tintoretto with John Ruskin* (Venezia: Marsilio, 2018). On the physical aspects of the illumination of

may also note in passing that when reading paintings housed in other Scuole, which, like those in San Rocco, were conceived specifically for their spaces, Ruskin seems to establish close meaningful connections between subject and illumination. For instance, in *St. Mark's Rest*, the placing of Carpaccio's *Agony in the Desert* in the Scuola Dalmata degli Schiavoni seems to correspond to and guard the mystery of the agony:

> It is in the darkest recess of all the room; and of the darkest theme — the Agony in the Garden. I have never seen it rightly, nor need you pause at it, unless to note the extreme naturalness of the action in the sleeping figures — their dresses drawn tight under them as they have turned, restlessly. But the principal figure is hopelessly invisible (XXIV, 343).

Similarly in the next painting, Carpaccio's *The Calling of Matthew*, bright natural light investing the scene will complete the picture: 'visible this, in a bright day, and worth waiting for one, to see it in, through any stress of weather'(ibid.). Light and darkness are means to aesthetic and spiritual experiences.

In the Accademia, on the other hand, picture viewing is an intermittent process, unfolding through a space that is crammed with heterogenous figures; the viewer must select some and discard others in order to make sense of the experience. The search for an aesthetic and religious vision traced by Ruskin follows a path constellated with many different sensorial forms, a path which leads the viewer to peer into shaded recesses. This dynamic process provides a sensory and aesthetic education: the reader is brought in front of paintings that are presented as visions of mystical experiences.

Ruskin attempts to make this elusive goal accessible by weaving a labyrinthine discourse through the spaces of the Galleries and investing the spaces themselves with an expressionistic function. This is one of his most innovative contributions to art. Ruskin's opposition to artificial lighting did not arise only from concern about the damage it would cause to colours and canvases. In the *Guide*, at least, it betrays something more: a fear that in dispelling the dark conditions created by the positioning of the paintings we might sacrifice the very quality that stimulates the reader to see the brightness latent in that darkness.

the Scuola, see Rosella Mamoli Zorzi, 'Dal buio alla luce: la Scuola Grande di San Rocco da Ruskin e James a Fortuny', *Notiziario della Scuola Grande Arciconfraternita di San Rocco in Venezia* 32 (2014), 49–73.

8. Venice, Art and Light in French Literature: 1831–1916

Cristina Beltrami

The desolation of Venice in the 1830s was something immediately perceptible; the result of decades of decline seemed palpable, particularly for visitors accustomed to the modernity of Paris, where gas lighting had been installed from 1820.

In 1831 Antoine Valery (1789–1847), a French writer specialized in the publication of travel guides, described Venice without pity as a succession of abandoned palaces, a 'cadaver of a city'[1] whose famous gondolas became, by metaphorical association, floating coffins. Valery evokes also a recent view painted by Richard Parkes Bonington (1802–1828) — an English artist who had studied at the École des Beaux Arts in Paris — as the felicitous testimony of the situation in which the city found itself, compared it, in a truly romantic sense, to a beautiful woman faded by age and adversity.[2]

Three years later, Louis-Léopold-Amédée de Beauffort, a cultivated writer and the director of the Bruxelles Museum of Fine Arts, visited Venice in the first days of June 1834. The ruins of the Venetian buildings must have made an impression on the French nobleman as, a good four

1 A. C. P. Valery, *Voyages historiques, littéraires et artistiques en Italie pendant les années 1826, 1827 et 1828; ou, L'indicateur Italien*, 3 vols. (Paris: Le Normant, 1831), I, p. 360, https://babel.hathitrust.org/cgi/pt?id=mdp.39015065285069;view=1up;seq=374

2 Ibid., p. 355: '[…] elles semblent comme un portrait de femme belle encore, mais flétrie par l'âge et le malheur'.

 https://doi.org/10.11647/OBP.0151.08

years later, he was concerned about their conservation.[3] In the same year Alfred De Musset (1810–1857) was also dismayed by the desolation of the city: the poet recalled that in the evenings, on his way to the Fenice, he met no-one and only a few palaces on the Grand Canal showed signs of life.

It is also important to underline that travellers in the 1830s were more concentrated on and struck by the breath-taking natural light of the town rather than by its artificial illumination: the charm of Venice's natural light and its thousands of reflections created by the water, along with the light depicted in its sixteenth-century masterpieces impressed the foreign visitors. Indeed, it was the light portrayed in Titian's *Martyrdom of Saint Lawrence* (1567) that fascinated Caroline de Beaufort (1793–1865) when she visited 'La somptueuse église des Jésuites'[4] in 1836, and then the basilica of Santi Giovanni e Paolo, whose darkness played a key role in her enjoyment of the enfilade of the doges' tombs.[5] So the Comtesse de la Grandville also appreciated that aesthetic of darkness that accentuated the romantic element of Venice and that to some nineteenth-century observers, Ruskin in primis, was more or less indispensable, as Rosella Mamoli Zorzi explains in her essay in this volume.

Another indefatigable traveller, Marie Constance Albertine de Montaran (1796–1870), left in a passage of the same year an image of 'impénétrable obscurité'[6] in a Venice that she felt as '[...] plongée dans un sommeil de mort'.[7]

In March 1837 Honoré de Balzac (1799–1850) stayed at the Hotel Danieli when visiting Venice for the first time, leaving two letters in which he expressed quite contentious opinions about the place. Balzac

3 Philippe Ernest, marquis de Beauffort, *Souvenirs d'Italie, par un catholique* (Paris: Société des beaux-arts, 1839), p. 167, https://archive.org/details/bub_gb_JrR_tOTeLnYC

4 C. de Beaufort (Comtesse de la Grandville), *Souvenirs de voyage, ou, Lettres d'une voyageuse malade*, 2 vols. (Paris: Ad. Le Clère, 1836), II, p. 334 [The sumptuous church of the Jesuits], https://gallica.bnf.fr/ark:/12148/bpt6k1027332/f338.item

5 Ibid., p. 335: 'J'arrive à Saint-Jean-et-Saint-Paul; la sombre obscurité de cette basilique convient admirablement à la multitude de tombes qu'elle protège; cette longue série de sépultures semble en vérité le livre des fastes de la République' [I arrive at Santi Giovanni e Paolo; the sombre darkness of this basilica is wonderfully suited to the multitude of tombs it protects; this long series of graves actually seems like the book of the splendours of the Republic].

6 M. C. A. de Montaran, *Fragmens, Naples et Venise, avec cinq dessins par E. Gudin et E. Isabey* (Paris: J. Laisné, 1836), p. 258, https://gallica.bnf.fr/ark:/12148/bpt6k2059131

7 Ibid.

was not in the habit of writing travel memoirs, but his impressions often appeared in the settings of his novels. Massimilla Doni, the protagonist of the eponymous novella, moves between the Fenice and a palace on the 'Canalazzo' (Grand Canal) by boat, and this act marks her immediately as Venetian.[8] Balzac describes this Palazzo Memmi — that could be identified with Palazzo Memmo, a gorgeous noble building in the quarter of Cannaregio — in which the clear light of the day reveals a collection of objects from all over the world, including Chinese vases and '[…] candelabra with a thousand candles'.[9] And it will be always in Palazzo Memmi that the libertine Clarina Tinti, a singer at the Fenice, disrobes by candle-light, seated at her dressing-table.[10] About twenty pages later the scene moves to the first night of the opera season at the Fenice, as crowded as in every other big city in Italy. Balzac dwells on the description of the boxes, which are not illuminated, as they were in Milan,[11] but where 'The light penetrates from the stage or from timid chandeliers'.[12] The light from the stage illuminates the head of the duchess who occupies a box in the first tier, highlighting her noble features and her resemblance to a portrait by Andrea del Sarto.[13]

There is an undoubted thrill of romance in the description of a shabby Venice, the Republic fallen after centuries of supremacy and political and cultural independence. It is also significant that these authors are French, intent on describing an Austrian Venice, and the memory of the French defeat was still a sore point for some of them. In 1843 Jules-Léonard Belin, an impassioned writer on art, arrived in St Mark's Square and referred regretfully to a time when the horses of the Basilica decorated the Place du Carrousel in Paris and, without jingoism, described the city's history from Attila to Napoleon.[14]

In 1843 the four horses, stolen from the Istanbul hippodrome, have been back on the façade of the Basilica for a long time, and they

8 *Massimilla Doni* was published in Italian in 1921 as part of the series *Racconti d'Italia — L'Italia vista dagli scrittori stranieri* (Milan: Il primato editoriale, 1921).

9 Ibid., p. 21.

10 Ibid., p. 26.

11 Ibid., p. 43.

12 Ibid.

13 Ibid., p. 45.

14 J.-L. Belin, *Le Simplon et L'Italie septentrionale: promenades et pélerinages*, 2nd ed. (Paris: Belin-Leprieur, 1843), p. 213, https://gallica.bnf.fr/ark:/12148/bpt6k106444z. Belin also expresses his admiration for the Gallerie dell'Accademia, which he thinks a museum miracle implemented by Leopoldo Cicognara (p. 235).

reverberate the gas lighting of the square. The same artificial light that allowed a social nightlife in St Mark's Square, described also by Jules Lecomte.[15] Even more impressive is his description of the solemn ceremony of the *Corpus Domini* and the extraordinary use of gilt lanterns:

> On place des torches, des verres de couleurs sur toutes les lignes des frises, balcons, impostes, entablements et corniches des Procuraties. La basilique voit tous les caprices de son architecture dessinés par des lignes de feu, ses coupoles, ses clochetons sont profilés par la lumière, toutes ses sculptures se bordent de cette magique irisation. C'est alors une sorte de gigantesque squelette flamboyant.[16]

Gas lighting turned St Mark's into a big nocturnal drawing room, in which '[…] les lumières brillent de tous cotes'[17] — as Alphonse Royer (1803–1875) recalled in 1845 — until midnight when the gas supply was shut off, when the glow of the moon reinforced the myth of a romantic Venice that Paul Valéry expressed when he wrote '[…] la lune, appelée par les artistes le soleil des ruines, convient particulièrement à la grande ruine de Venise'.[18]

On the contrary the artificial light is so weak in Venice that according to Théophile Gautier (1811–1872), his own shadow could hardly follow him and his companions in their lascivious nights described in *Voyage en Italie* (1850).[19]

In this mid-50s also the Goncourt brothers left their own version of the Venetian night, in which 'Les fenêtres des palais étaient mortes. Le

15 J. Lecomte, *Venise ou coup-d'oeil littéraire, artistique, historique, poétique et pittoresque* (Paris: Hippolyte Souverain, 1844), p. 510, https://gallica.bnf.fr/ark:/12148/bpt6k 106360t

16 Ibid., p. 66 [They put torches, coloured glass on all the lines of the friezes, balconies, shutters, entablatures and cornices of the Procuratie. All the caprices of the basilica's architecture are drawn by lines of fire, its domes, its pinnacles are silhouetted by light, all its sculptures are lined by this magnificent iridescence. It is thus a kind of gigantic flaming skeleton].

17 A. Royer, *Voyage autour de mon jardin et autres romans* (Paris, 1845), p. 26 [the lights shine from all sides]. The passage is also cited in the brilliant study by Florence Brieu-Galaup, *Venise, un refuge romantique (1830–48)* (Paris: L'Harmattan, 2007), p. 6.

18 A. C. P. Valery, *Voyages historiques, littéraires et artistiques en Italie pendant les années 1826, 1827 et 1828; ou, L'indicateur Italien*, 3 vols. (Paris: Le Normant, 1831), II, p. 360, https://catalog.hathitrust.org/Record/000351140
Ibid., p. 398 ['the moon, called by artists the sun of ruins, is particularly suited to the great ruin of Venice'].

19 T. Gautier, *Lettre à la Prèsidente. Voyage en Italie* (1850) (Naples: De l'Imprimerie du Musée secret du Roi de Naples, 1890), p. 31 ['notre ombre avait peine à nous suivre sur les murs'].

ciel était éteint. La lanterne des traghetti dormait'.[20] This idea of a secret city conceals in reality the aesthetics pursued in these writers' Parisian apartments, too. The decadent French literature found in Venice the embodiment of an inexhaustible source of attraction and inspiration.

About twenty years later, Henry Havard (1838–1921) wrote a guide of two cities, geographically far but comparable for the presence of canals and masterpieces of art: if, in Amsterdam, Havard complained about the scarce lighting of paintings displayed in the former home of the merchant Tripp,[21] in Venice he was besotted by Tintoretto's canvases capable of emanating their own light. In particular he lingered on the *Marriage at Cana* (1561) in the Sacristy of the Basilica della Salute, with its coffered ceiling from which hangs a 'lustre garni de bougies'.[22]

Havard's trip continued in the countryside around Venice; he visited the Villa Contarini at Piazzola sul Brenta, near Padua: apart from the grandiosity of the residence, he described the shows in the theatre belonging to the villa, where opera libretti were read by candlelight.[23]

At the end of the century, Guy de Maupassant (1850–1893) undertook a long journey in Italy that he described in *La vie errante* (1890), a publishing success that was reprinted more than twenty-five times in France alone. He claimed that only three religious buildings in the world were able to excite him because they were '[…] inattendue et foudroyante',[24] one being St Mark's basilica, but he does not otherwise dwell on the lagoon city except to report that it is in the hands of the 'populace [rabble]'.[25] At the same time it is at the end of the nineteenth century that the perception of the city started to change, thanks also to the electric lighting of the Doge Palace.

This moment, starting from 1899, coincides also with the arrival at Ca' Dario, the gorgeous palace on the Grand Canal, of a group of French eclectic intellectuals led by Augustine Bulteau (1860–1922). Henri de

20 E. et J. de Goncourt, 'Venise la nuit. Rêve', in *L'Italie d'hier, Notes de voyages, 1855–1856* (Paris: G. Charpentier et E. Fasquelle, 1894), p. 239, https://archive.org/details/litaliedhiernote00gonc ['The windows of the palazzi were dead. The sky was dull. The ferry lantern slept'].

21 H. Havard, *Amsterdam et Venise* (Paris: E. Plon et Cie, 1877), p. 230, https://books.google.co.zm/books?id=OOLy19mudyEC&printsec=frontcover&source

22 Ibid., p. 544.

23 Ibid., p. 400 [chandelier fitted with candles].

24 G. de Maupassant, *La vie errante* (Paris: P. Ollendorff, 1890), p. 208, https://gallica.bnf.fr/ark:/12148/bpt6k104914x [unexpected and dazzling].

25 Ibid., p. 34 [rabble].

Régnier (1864–1936) a symbolist poet and novelist, stayed in Venice at least ten times,[26] at the beginning as guest of Madame Bulteau in Ca' Dario, where he remembered a fine cage lantern, all carved and gilded. In this charming frame they recreated the cosmopolitan circle of Avenue Wagram in Paris: Marie Isabelle Victorine-Ghislaine Crombez, Countess de La Baume Plumivel (1858–1911), Jean-Paul Toulet (1867–1920), Jean-Louis Vaudoyer (1883–1963), Eugène Marsan (1882–1936) recalled in the *Portraits et souvenirs*[27] by Henri de Régnier as Laurent Evrard, literary pseudonym of Baume-Plumivel,[28] were constant presences on the Grand Canal.

It is Ca' Dario that had the *jardin bizarre* described by Régnier in his *Esquisses vénitiennes* in 1906: the magnificent *desero* of Venetian glass, attributed, at least in part, to Giuseppe Briati (1686–1772), on the model of the Mocenigo centrepiece now in the Murano Glass Museum, was the protagonist of complex and poetic lines.[29]

Esquisses vénitiennes was a collection of stories to read as a tribute to the city, to its monuments and of course to its extraordinary brilliance. The writer rejects the idea of a modern Venice, remaining anchored to a decadent image, as in the episode of *L'encrier rouge*, in which a servant accompanies the protagonist to his room by candlelight, because at night the gas supply is shut off.[30]

26 H. de Régnier, often in the company of his wife, Marie, also stayed at the Palazzo Vendramin ai Carmini, then in the more modest Casa Zuliani and finally at the Hotel Regina. On the relationship between the French writer and Venice, see the Italian essay by Loredana Bolzan, 'Una lunga (in)fedeltà. Vite veneziane e non di Henri e Marie de Régnier', in *Personaggi stravaganti a Venezia* (Crocetta del Montello: Antiga, 2010), pp. 43–60.

27 H. de Régnier, *Portraits et souvenirs* (Paris: Mercure de France, 1913), p. 124, https://archive.org/details/portraitsetsouve00rguoft [elevation].

28 In keeping with the custom of the time, both Baume-Plumivel and Madame Bulteau published their writings under a male pseudonym; Laurent Evrard for the former and Jacques Vontade or Foemina for the latter.

29 Ibid., pp. 50–51: 'Il se compose de parterres symétriques, d'allées qui les divisent, de balaustes qui le bordent, de portiques qui les terminent et d'innombrables petits vases d'où jaillissent des fleurs minuscules. [...] enfantin et éternel et il n'a point de saisons, parce qu'il est tout entier fait en verre, en verre de toutes les couleurs'. [It is made up of symmetrical gardens, of avenues that divide them, of balusters that border them, of porticoes that end them and of numerous small vases from which tiny flowers spring. [...] childish and eternal, it is quite without seasons, because it is made entirely of glass, of glass in all colours].

30 H. de Régnier, 'L'encrier rouge', in *Esquisses vénetiennes* (Paris: Collection de l'Art Décoratif, 1906), https://archive.org/details/esquissesvnitie00dethgoog (The edition

In the episode titled *La clé*, the protagonist is attracted to St Mark's by the electric lighting that allows the square to remain lively at night:

'[…] la brillante illumination des galeries où l'électricité fait étinceler et valoir à l'envi les devantures des boutiques de bijoux, de verreries et de dentelles, dans lesquels se vendent les produits, encore charmants'.[31]

In *La tasse* the scene moves to the hall of *l'ancien Ridotto*, lit on the occasion of the carnival by 'des lustres et des girandoles'.[32]

'Girandoles' also illuminated a Vicenza evening in the Palais Vallarciero, where the protagonist of *L'Illusion héroique de Tito Bassi* (1916) moves and which, as the evening proceeds, goes up in flames.[33] The hall of the Teatro Olimpico is lit by 'Des centaines de bougies allumées à des appliques ou à des lustres épandaient la lumière avec une éclatante profusion'.[34]

With the advent of gas, candles were often used to emphasise the elegance of a situation, a kind of status symbol on a par with the considerable use of wax in Chatsworth Castle, as described in the essay by Marina Coslovi and the testimony of Baron Jacques d'Adelswärd-Fersen (1880–1923), who, in Venice, attended a party for which the costumes were inspired by the frescoes on the walls and the evening was lit by the 'flamme rose des lustres et des bougies de Vérone'.[35]

Régnier's wife Marie, also known by a male pseudonym — Gérard d'Houville — published a precious little guide to the main cities in the

to which I refer is of 2015, *La tour verte*, Condé-sur-Noireau, Paris, p. 39, with an introduction by Sophie Basch.)

31 H. de Régnier, 'La clé', in *Esquisses vénetiennes*, p. 73 ['The brilliant lighting of the galleries where electricity makes the windows of the jewellery, glass and lace shops, where objects full of charm are sold, glimmering and incessantly attractive'].

32 H. de Régnier, ibid., p. 62 ['chandeliers and girandoles'].

33 H. de Régnier, *L'Illusion héroique de Tito Bassi* (Paris: Mercure de France, 1916), p. 53, https://archive.org/details/lillusionhro00rguoft: '[…] girandoles et de lampions et on avait placé dans des anneaux de fer de grosses torches de résine qui jetaient une vive lumière, de sorte qu'on y voyait aussi clair qu'en plein midi et que je ne perdais aucun détail du spectacle. Il était magnifique' ['girandoles and street-lamps were placed in rings of iron, big resin torches that gave off a bright light, so that one saw clearly as in full daylight and I did not miss any detail of the show. It was magnificent'].

34 Ibid., p. 153 [Hundreds of lit candles on sconces or chandeliers emitting light with an astonishing profusion].

35 J. d'Adelswärd-Fersen *Ébauches et Débauches* (Paris: Librairie Léon Vanier, 1901), p. 28, https://gallica.bnf.fr/ark:/12148/bpt6k62133x [pink flame of chandeliers and Verona candles].

Veneto, which was later given space in *Le visage de l'Italie*.[36] Capable of visionary prose, Marie Régnier crafted literary images in which the city merges with the very objects that belong to it. In the short poem titled *Verrerie*, she speaks of a Venice that is light, fragile and iridescent like its glass.[37] The reference is obviously to the production of Murano glass, which underwent an extraordinary formal change with the move to gas and subsequently to electricity: prosaically the arms of the chandeliers could now also face downwards, enormously increasing the creative possibilities open to the master glassmakers.

So we have started from the idea of decadent and shady Venice, populated by gondolas floating as coffins; a Venice that was sleeping on its own beauty, feeding the international decadent imagination. A Venice capable to seduce with its natural romantic light and its hidden treasures, but also dark enough to keep the nights of its visitors secret. While the Futurists engaged a battle against the romantic myth of the Venetian moonlight, the arrival of electricity changed habits of life, the shapes of chandeliers and of course the perception of the town and its masterpieces, always under the attentive eyes of writers and painters.

36 See Bolzan, *Una lunga (in)fedeltà*, p. 53.
37 Ibid., p. 54.

PART III

ON LIGHT IN AMERICAN MUSEUMS

9. One Hundred Gems of Light: The Peale Family Introduces Gaslight to America

Burton K. Kummerow

In the spring of 1816, Rembrandt Peale was worried about the future of his new Baltimore Museum. He had come to town during the War of 1812 with big plans, determined to build an even better version of his father's museum in Philadelphia. It was to be the first of its kind, a structure devoted entirely to fine arts and natural history. Peale wanted the bustling Baltimore seaport to enjoy 'an elegant rendezvous for taste, curiosity and leisure.'[1]

With miles of potential harbour and 50,000 souls, Baltimore, the third largest city in America, was sending its trading ships around the world. It was both an influential American centre for arts and culture and a tough, gritty seaport already known as 'Mobtown.' Rembrandt Peale's building, designed by a Baltimore-born, self-trained architect Robert Carey Long, was the first in the western hemisphere built specifically as a museum. Unfortunately, finances were an issue from the start. The Peale Museum, still standing today near the City Hall with its neo-classical frieze and portico, was over budget. And there was another problem.

Peale opened his museum only two months before a large British army and fleet attacked Baltimore. The War of 1812, often called the

1 Rembrandt Peale advertised his museum in local newspapers throughout 1816 and 1817. Peale's Baltimore Museum and Gallery of Paintings is first advertised in the *Baltimore Patriot*, Volume 4, Issue 37, page 3, Tuesday, August 16, 1814.

 https://doi.org/10.11647/OBP.0151.09

'Second American Revolution' and fought between 1812 and 1815, featured the burning of Washington, D.C., in August of 1814. A few weeks later, there was an assault on Baltimore's Fort McHenry with the intent of burning the city, and punishing the 'nest of pirates'[2] that had been preying on British merchant shipping. Baltimore leaders assembled 10,000 American militiamen from Maryland and surrounding states to dig trenches and keep the British from getting into the inner harbour. In September, 1814, Baltimore volunteers, who had run from the British just weeks before, stood and bravely defended the city. They killed the British general, kept the British fleet out of the harbour, and created a song that became the National Anthem.

Rembrandt Peale, however, was a dedicated pacifist. He refused to volunteer for the 1814 defense of Baltimore and won few friends as a result. Two years later in 1816, he was still searching for ways to find customers for his museum and to pay his debts. Museums were still a new concept in America and the Peale family over three generations had not been noted for their business acumen. However, they were to become a major force in the creation of American arts and culture.

Rembrandt Peale's father, Charles Willson Peale, was a humble saddle maker and self-taught painter from Annapolis, Maryland who discovered he had talent and convinced wealthy sponsors to send him to London in 1767. The young, homespun colonial was taught but also intimidated by a giant, cosmopolitan city and a successful American artist, Benjamin West, who had settled in England. After two years studying in London, twenty-seven-year-old Charles Willson tried unsuccessfully to sell prints of a clumsy portrait he painted of the famous Prime Minister William Pitt. He dressed Pitt as a Roman senator, and surrounded him with symbols that were designed to draw attention to a budding colonial rebellion in America that Peale supported. He also briefly decided he could best sell his talents in colonial America as a painter of miniatures.

Peale soon realized, however, that the English love of 'conversation pieces,' successful families painted at their leisure, would work in America. He painted a prototype, an iconic portrait of his family over several generations. The canvas includes a self-portrait with palette in

2 This quote about Baltimore in the War of 1812 is well known and has been published in a variety of sources. There is some controversy if it is a contemporary term or was invented later.

hand overlooking his talented brother James, other family members, his first wife Rachel, his mother, the favorite family dog and some busts of worthies overlooking the proceedings. However, Charles Willson Peale's career as an itinerant portrait artist blossomed only after he painted George Washington for the first time at age forty in his uniform from an earlier British imperial war. His friendship with Washington continued for more than three decades and he chronicled the American hero's career as he became internationally famous. As his personal friend, Peale painted General Washington, a reluctant sitter, from life sixteen times, helping to make him the first great American hero. Peale was endlessly prolific and left behind a large body of work as one of the first truly American painters.

When Charles Willson Peale last painted the aging first president from life in 1795, he brought in several members of his family; the artist Gilbert Stuart commented that General Washington was being 'pealed all around.'[3] Among the throng who captured the president's image that day was seventeen-year-old Rembrandt Peale. He produced a brutally realistic painting, revealing the emerging skill that made Rembrandt perhaps the most talented portraitist in the family. Rembrandt's ability is also demonstrated in his early portrait of his bespectacled brother Rubens, soon to be another player in the story of gaslight.[4]

Charles Willson Peale and his sons were much more than painters. The endlessly curious Charles Willson was a pioneer in natural history. His experiments with the toxic chemicals of taxidermy almost killed him. His interest in horticulture consumed him. But it was in paleontology that he made his greatest contribution. A timeless record of his work, a painting portraying the exhumation of three mastodon skeletons in the Hudson River Valley in 1802,[5] is one of the masterpieces of early American art now exhibited at the Maryland Historical Society in Baltimore. His large family is present to observe the bones emerging from a flooded pit, while an elaborate construction invented by Peale bails water from the pit with limited success.

As early as 1784, Charles Willson was also immersed in creating a museum to bring art and natural history collections to the public, as

3 Richardson, Hindle and Miller, *Charles Willson Peale and His World*, p. 190
4 See https://en.wikipedia.org/wiki/Rubens_Peale#/media/File:Rembrandt_Peale_-_Rubens_Peale_with_a_Geranium_-_Google_Art_Project.jpg
5 Ibid., p. 85. See http://www.mdhs.org/digitalimage/exhumation-mastodon

well as to generate revenue for his perpetually cash-starved family. His first rented space was in the Pennsylvania State House, known to us today as Independence Hall, in the center of old Philadelphia. In one self-portrait late in life, known as *The Artist in His Museum*,[6] the master showman seductively reveals his museum gallery, lifting the curtain on portraits of Revolutionary War heroes, stuffed animals and old bones. In the painting, one flabbergasted female guest is confronted with the centerpiece of the collection, a fully reconstructed Mastodon skeleton just visible under the curtain.

Lighting, however, was an issue both in the museums and on the streets of Philadephia. *The Artist in His Museum* depicts the fashionable Swiss Argand lamp hanging from the ceiling of Peale's museum, but another of his paintings, known as *The Lamplight Portrait*,[7] depicts his brother James peering at one of his miniatures by the inadequate light of an Argand lamp. The inventive Benjamin Franklin had addressed ways to make eighteenth-century Philadelphia street lights more practical with a design including four flat glass panes and a long funnel to draw out the smoke; this kept the lights cleaner and brighter for longer and became adopted as standard. Tallow, pitch and oil, however, which were the main fuels, were smelly, smoked, flamed out too quickly and never adequately conquered the dark. Coal had provided heat for centuries but miners also recognized the dangers of burning coal gas, dangers that they described as choke and fire damp.

In England, William Murdoch had been experimenting with coal gas to light houses in Cornwall as early as the 1790s. Europeans continued these experiments and an 1808 public demonstration of gas street lights in Pall Mall, London, caused quite a stir. Politicians in England soon saw the value of gas lighting on dangerous and dark streets at night, although there were, of course, those who doubted this new technology. One contemporary English cartoon of a gas explosion blowing men into the air includes the comments, 'We shall all be poisoned' and 'What a stink!'

The research and the progress, however, continued. Baltimore had its own pioneer in Benjamin Henfrey, a self-styled 'philosophical exhibitor,'[8]

6 Miller and Hart, *Autobiography of Charles Willson Peale*, illustrations facing p. 213. See https://www.the-athenaeum.org/art/full.php?ID=203526
7 Ibid., p. 213. See https://www.the-athenaeum.org/art/full.php?ID=45597
8 Pennsylvanian Benjamin Henfrey is discussed in https://eh.net/encyclopedia/manufactured-and-natural-gas-industry/

who recommended gas-lit lighthouses to illuminate neighborhoods. But a daunting challenge remained: how could a company reliably generate enough energy to light a city?

Enter the intrepid Peale family, always looking for something new and interesting to support their artistic endeavours. Rubens Peale was the first member of the family to begin experimenting with gaslight, and it was he who had the idea that gas illumination in museum galleries might attract more visitors. His experiments in a Philadelphia neighborhood attracted the attention of the Philadelphia City Council, who threatened to arrest him for generating gas with an obnoxious smell. However, Rubens Peale's plans received a boost from England in 1816 when Dr. Benjamin Kugler arrived in Philadelphia with a practical treatise on gaslight, describing how to generate carbonetted hydrogen gas from coal tar, an idea that he had patented. The rest of the family saw the potential of Kugler's ideas, and Charles Willson Peale enthusiastically sketched the process in a letter to his daughter Angelica.[9]

By May, 1816, the Peales were attracting large, amazed crowds to their gas-illuminated gallery in Philadelphia.

Within a month, the Philadelphia Peales sent Dr. Kugler and his $6,000 patent to brother Rembrandt in Baltimore, where the young man was struggling to establish his Museum. The Baltimore Museum began advertising its own revolutionary illumination 'without Oil, tallow, Wick or Smoke... every evening until the public curiosity be gratified.' On June 11, 1816, Rembrandt Peale turned on the 'carbonetted hydrogen gas' and sparked the ring of '100 gems of light' into action.[10] The assembled guests and dignitaries were amazed. Rembrandt Peale and his history-making illumination attracted the visitors' interest and curiosity, as he intended. The ring of light, however, probably attracted more attention as a parlor trick than the paintings on the walls, the cases of stuffed animals or even the mastodon skeleton that had been shipped down from his father's Philadelphia museum.

All of Baltimore was fascinated and throngs showed up each night for months to pay a few pennies and gawk at the seemingly magical sight. As the mayor and other city leaders came and gaped, Rembrandt

9 Richardson, Hindle and Miller, *Charles Willson Peale and His World*, p. 148.

10 Advertisement in *American Commercial & Daily Advertiser*, Thursday, 11 July 1816.

Peale had another idea. Why not light the dark and dangerous nights with gas streetlights? Why not form a new company to generate gas light in the growing city of Baltimore? Everyone would benefit, from the investors, to the citizens looking for a safe passage through the night.

Peale quickly found four other influential citizens of Baltimore and together, on 17 June 1816, they presented a plan to the mayor and city council. With enthusiastic support from all quarters, the Gas Light Company of Baltimore was chartered to 'provide for the more effectual lighting of the streets, squares, lanes, and alleys of the City of Baltimore.'[11] By the following summer, the first gas streetlight and the gas-lit Baltimore Theater and Peale's Museum illuminated Holliday Street as never before. The talented Rembrandt Peale and his family had brought new attention to his struggling museum and made history in the process.

Unfortunately, Rembrandt proved to be vain, self-indulgent and long on ideas but short on follow through. Within a few years, he had enough of Baltimore businessmen, bringing his brother Rubens in to run his museum and traveling to Italy to recover from his bad experience. First and foremost an artist, Rembrandt Peale had enthusiasm and vision but lacked the temperament and experience to create a long-term business.

Rembrandt Peale continued pursuing his successful career as a portraitist, leaving his experiments in lighting behind. He dabbled in painting neo-classical subjects popular in the era, but to the end of his long life and into the era of photography, he remembered and marketed his earliest days as an artist, when he painted the first president, George Washington. For decades, he sold his many romantic porthole portraits of Washington, advertising his special honour of being the last surviving artist who had painted the now iconic founding father from life.

Rembrandt Peale had helped to create the first utility company in America with a showpiece designed to attract visitors to his museum. Although he focused on his past achievements as a painter, the Gas Light Company of Baltimore slowly grew and developed with the city where it was chartered. In the 1850s, the Company built Spring Gardens, in its day the largest gas manufacturing plant in America. The facility

11 Kummerow and Blair, *BGE at 200 Years*, p. 37.

still operates after a century and a half, storing and distributing liquid natural gas.

The advent of electricity in the 1880s created fierce competition that often led to chaos in city streets. But the Gas Light Company of Baltimore conquered its competition and joined with new electric companies to become the Consolidated Gas Light and Electric Power Company of Baltimore in 1906, a regulated monopoly for most of the twentieth century. Consolidated was the direct ancestor of the present day Baltimore Gas and Electric Company (BGE), which celebrated 200 years in June 2016, America's oldest utility and one of the country's oldest companies. An influential early American family of artists brought light not only to their pioneering museums but also to the streets of American cities.

10. Illuminating the Big Picture: Frederic Church's *Heart of the Andes* Viewed by Writers

Katherine Manthorne

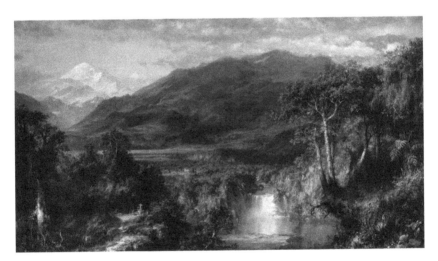

Fig 10.1 Frederic Church, *Heart of the Andes*, Metropolitan Museum of Art, New York, 1859. Wikimedia. Public domain, https://commons.wikimedia.org/wiki/File:Church_Heart_of_the_Andes.jpg

One of America's most renowned landscapists, Frederic Church, based his large-scale *Heart of the Andes* in 1859 (Fig. 10.1) on his two trips to South America in 1853 and 1857.[1] He painted it at his studio in the new

1 For details of Church's South American travels see my *Tropical Renaissance. North American Artists Exploring Latin America, 1839–1879* (Washington, D.C.: Smithsonian Institution Press, 1989).

 https://doi.org/10.11647/OBP.0151.10

Tenth Street Building, which provided artists with large workspaces lit by gas and a central exhibition room two stories high with a large glass ceiling.[2] After the 5 x 10 ft. canvas left the artist's studio it went on a single-picture exhibition tour from 1859 to 1861, during which it was arguably seen by more people and under more varied viewing circumstances than almost any other painting of its day. It opened in New York City, first at Lyric Hall and then in the gallery at Tenth Street; it crossed the Atlantic to German Gallery, London and then to Edinburgh; back to New York's Kurtz Gallery; then on to the Boston Athenaeum and Pennsylvania Academy of Fine Arts, Philadelphia. Heading south, it got only as far as Baltimore. Next it traveled to the Midwest — to Cincinnati, Chicago, and St. Louis — and subsequently Low's Building, Brooklyn. After paying a record $10,000, William Blodgett then enjoyed it briefly at his brownstone at 27 W. Twenty-fifth Street before he lent it to New York's Metropolitan Fair in 1864. It appeared again at New York's Chickering Hall in 1876. At each of those venues the physical space and mode of lighting differed, which in turn affected the look of the picture, as Church was acutely aware. Prior to electricity's advent in 1881, artworks were illuminated via a succession of methods. During daylight hours, sunlight entered the studio or gallery either via a skylight or window, which often provided the north light preferred by most painters. Emanuel Leutze's *Portrait of Worthington Whittredge Painting in his Tenth St. Studio* (1865; Reynolda House Museum of American Art) depicts the artist at work under natural light emanating from a window overhead. If artists toiled into the night or if they wanted to work on overcast or rainy days, however, artificial light was needed. Initially, candles provided illumination, as celebrated in Joseph Wright of Derby's *Three Persons Viewing the Gladiator by Candlelight* (1765; Private Collection). Here the artist makes dramatic use of characteristically strong contrasts of light and shadow, which of course posed challenges when the artist was actually at work. Always quick to embrace new technologies, Charles Willson Peale created the so-called 'Lamplight Portrait' of his brother James Peale painting by the light of an Argand oil lamp (1822; Detroit Institute of Arts), a recent innovation. Then along came the

2 Annette Blaugrund, 'The Tenth Street Studio Building: A Roster', *The American Art Journal*, 14 (Spring 1982), 64–71.

new invention of gaslight, which irreversibly changed modern life, including the creation and display of art. Early gas jets were said to be between six and sixteen times as bright as candle flames and at least three times as bright as the finest oil lamps. Little wonder that artists seized upon gas lighting in their studios and exhibition halls. Using his advanced knowledge of light and optics, Church devised strategies to draw upon their expressive potential and intensify audiences' experiences of his fictive landscapes.

This chapter focuses on the lighting and optical devices that were employed to enhance the illusion that *Heart of the Andes* transported the viewer to South America. Deploying written commentaries by actress and author Fanny Kemble, humorist Mark Twain and bestselling novelist Augusta Evans, we attempt to unravel the magic of Church's techniques for illuminating his big picture. When the painting was shown at New York's Tenth Street building, large crowds lined up to see it. The room was decorated with palm fronds and tropical birds to set the mood. Attendants sold explanatory pamphlets that clarified the details of the picture.

As advertised, the painting was on view from 8am to 5pm, when it could be seen by natural light. But it was also open at night, from 7pm to 10pm. During those evening hours, the picture was made to suffer 'torture by gaslight,' with batteries of burners equivalent to fifteen-watt light bulbs. These had to be kept far enough from the painting so as not to burn it but, from a safe distance, lent it only a sickly yellow cast. As *Heart of the Andes* proceeded on its ten-city tour, Church and his agents further finessed the exhibition apparatus and especially the lighting strategies to enhance the viewer's illusion that she was transported to South America.[3]

By 1859 gas lighting was transforming the urban landscape. To understand the impact that Church's picture made on its spectators, it is helpful to track the contrasts they encountered as they passed through the streets of lower Manhattan into the gallery. Public gas lighting first appeared in the US in 1817, when the Gas Light Company of Baltimore lit a burner at one of the city's major intersections. The southernmost section of New York's Broadway was first lit with gas streetlamps in

3 Kevin Avery, *Church's Great Picture: The Heart of the Andes* (New York: Metropolitan Museum of Art, 1993), p. 36.

1827, initiating its reputation as the city that never sleeps. Other streets followed, while oil-lit blocks — which continued to outnumber those lit using gas until after midcentury — appeared dark in contrast. Novelist George Lippard wrote in 1854 of side streets 'dark as grave vaults' in lower Manhattan, while Broadway was 'defined by two lines of light, which, in the far distance melt into one vague mass of brightness.'[4] New Yorkers heading for a viewing of Heart of the Andes would have traversed prosperous commercial streets and affluent residential neighborhoods glowing with light as well as less traveled side streets shrouded in darkness as they made their way to 51 West Tenth St., between Fifth and Sixth Avenue. The sky overhead, once black and starry, by the 1850s took on a faint reddish glow. Enjoying the freedom to walk the streets of the nocturnal city thanks to these recent advances in lighting, Church's visitors were primed to be dazzled by the prospect of surveying his painting after dark.

Since Church's earlier blockbuster *Niagara* (1857; National Gallery of Art) had previously been on tour, he and his agents had gained some insight into this process. Their decision to bypass the annual exhibitions of the National Academy of Design and instead hire a private space for display was predicated partly on the fact that this gave them the ability to control and manipulate the viewing conditions. But beyond that, it allowed them to create an inviting environment that enhanced the fiction of viewing the scenery first-hand. A frequent visitor to the Paris Salon, artist and writer Zacharie Astruc found that the official exhibition became more unpleasant every year, and likened it to a 'frames fair' and a 'Capernaum.' As an alternative he encouraged his readers to go to the private galleries on Boulevard des Italiens to see 'the new exhibition of modern painting' which he described as an 'intimate salon with a quiet atmosphere and excellent viewing conditions.' The experience was enhanced by a new kind of lampshade, which illuminated the painting without creating any glare for the viewer.[5]

4 Quoted in Peter C. Baldwin, *In the Watches of the Night: Life in the Nocturnal City, 1820–1930* (Chicago: The University of Chicago University Press, 2015), p. 16.

5 Véronique Chagnon-Burke, 'Rue Laffitte: Looking at and Buying Art in Mid-Nineteenth Century Paris', *Nineteenth Century Art Worldwide* 11.2 (2012), 31-54, https://www.19thc-artworldwide.org/summer12/veronique-chagnon-burke-looking-at-and-buying-contemporary-art-in-mid-nineteenth-century-paris

Fig. 10.2 Frederic Church, *Niagara*, Corcoran Gallery of Art, Washington, D.C., 1857. Wikimedia. Public domain, https://commons.wikimedia.org/wiki/File:Niagara_by_Frederic_Edwin_Church,_1857_-_Corcoran_Gallery_of_Art_-_DSC01135.JPG

By the late 1850s a growing number of commercial art galleries showed artworks in their windows. In Paris, poet and art critic Theophile Gautier described their illuminated displays:

> The rue Laffitte is like a permanent Salon, an exhibition of paintings that lasts the whole year round. Five or six shops offer in their windows a constantly changing selection of paintings, which are illuminated by powerful reflectors.[6]

Competing with the annual government-sponsored Salon, commercial galleries drew upon the latest strategies, including methods of display used in the increasingly popular department stores. Living and maintaining a studio in New York City, Church would have observed parallel displays in A. T. Stewart's Dry Goods Store — also known as the Marble Palace — at 280 Broadway. Featuring fashion shows, sales, large display windows and the latest in lighting, it could well have inspired display and marketing strategies employed by Church, who was known to acquire goods from Stewart's. Some visitors applauded the external effects Church deployed while others felt that they detracted from the experience, as our survey of responses to his great painting reveals.

6 Théophile Gautier, 'La Rue Laffitte', *L'Artiste*, 7th ser., 13.1 (January 3, 1858), 10–13, quoted in and translated by Chagnon-Burke, 'Rue Laffitte: Looking at and Buying Art in Mid-Nineteenth Century Paris'.

The distinguished British-born actress and writer Fanny Kemble married the American plantation owner Pierce Mease Butler. After their divorce she continued to travel back and forth between Britain and America, and served as a conduit between the two cultural scenes, which she documented in correspondence and memoirs. In her letters to British artist Lord Leighton, Kemble kept him abreast of art doings in the United States, where he sometimes sent work. From Boston in 1861 she wrote:

> ... here people exhibit their pictures at a shilling a head, i.e. put them in a room hung round with black calico, light up a flare of gas above them, and take a quarter of a dollar from every sinner who sees them. Two of Church's pictures (he is a great American artist, though you may never have heard of him) have been, or rather are, at this moment so exhibiting — his Falls of Niagara, and a very beautiful landscape called the Heart of the Andes. Both these pictures were exhibited in London, I know not with what success; they have both considerable merit, but the latter I admire extremely. Page had a Venus here the other day, exhibited by gas-light in a black room.

She concludes:

> ... indeed, my dear Mr. Leighton, it seems to me as if you never could imagine or would consent to the gross charlatanry which is practiced — how necessarily I do not know — here about all such matters.[7]

While Kemble admits that she greatly admires *Heart of the Andes*, she obviously feels that she has been somewhat taken in by what she calls 'gross charlatanry', an accusation that is underpinned by negative ideas about the relationship between fine arts and popular stage productions.

Since we have no images of the paintings lit by gaslight, images of contemporary theaters with a scenic backdrop illuminated by a row of gaslights placed along the foot of the stage help us to conceive the effect. Theater design and technology changed around the mid-nineteenth century. Candlelit stages were replaced with gaslight and limelight. Limelight consisted of a block of lime heated to incandescence by means of an oxyhydrogen flame torch. The light could then be focused with mirrors and produced quite a powerful light. Theater interiors also

7 Kemble quoted in Malcolm Goldstein, *Landscape with Figures: A History of Art Dealing in the United States* (New York: Oxford University Press, 2000), p. 44. My thanks to Patricia Wadsley for her help with this source.

began improving in the 1850s, with ornate decoration and stall seating replacing the pit. Contemporary accounts mention Church and his wife attending theater and opera, where he studied the dramatic lighting effects that were closest in spirit his own pictorial displays.

Notwithstanding the improvements it brought to the theatre, as the use of gaslight became more widespread and it was employed to illuminate art, it was increasingly equated with deception and charlatanry. Two examples among Church's contemporaries suffice. First, a law was passed in New York forbidding the sale of art by gaslight:

> The latest example of Mr. Abram Hewitt's earnest desire to earn his salt as Mayor of the City of New York, is his revival of an old municipal ordinance, which forbids the sale of pictures by gaslight. He has notified all the art auctioneers of New York that they will no longer be allowed to hold picture sales by gaslight. This, of course, puts an end to evening picture sales, and seriously injures the New York picture trade. The law was passed many years ago, when most of the pictures sold at auction in New York were of the 'shangae' order, and it was designed to protect the public from the wiles of sharpers.[8]

The second involved the maligning of Albert Bierstadt, Church's colleague and painter of the West:

> ... in an evil moment, the showman got hold of him, and it was found profitable to carry his large canvases around the county, fit them up with a frame of curtains, illuminate them by artificial light, and exhibit them to awestruck audiences at twenty-five cents a head. To paint with the object of astonishing uncultivated people, with the aid of glaring lights and theatrical accessories would spoil the greatest artist that ever lived, and, even if it did not spoil the artist, it would ruin his reputation among people of discrimination, so that it is not surprising... that a suspicion of charlatanism fell upon him...This manner of viewing fine-art was, in that day at least, peculiarly profitable; and before advancing public taste had fully decided to disapprove of the theatrical display of pictures, he was able to console himself with a considerable fortune.[9]

The artist walked a tightrope between highbrow and lowbrow, between the desire to provide his visitors with thrilling effects and to maintain the decorum of a professional artist.

8 'Monthly Record of American Art', *The Magazine of Art*, 10 (1887), xliv.
9 'Death of Albert Bierstadt, Landscape-Painter', *The American Architect and Building News*, 75 (8 March 1902), 74.

As a writer who struggled with this same highbrow/lowbrow divide, Samuel Clemens was perfectly positioned to understand Church's great picture. Clemens first saw it in St. Louis in March 1861 and described it to his brother:

> I have just returned from a visit to the most wonderfully beautiful painting which this city has ever seen — Church's Heart of the Andes — which represents a lovely valley with its rich vegetation in all the bloom and glory of a tropical summer...[10]

He continues, providing some specifics of the viewing experience:

> We took the opera glass and examined its beauties minutely, for the naked eye cannot discern the little wayside flowers, and soft shadows and patches of sunshine, and half-hidden bunches of grass and jets of water which form some of its most enchanting features.[11]

His words situate *Heart of the Andes* in the realm of popular entertainment, and especially alongside the panoramas that had been common during the preceding decades. These were large-scale pictures that provided audiences with a grand, sweeping view of far away places that — upon closer inspection — were built up from on-the-spot observation of near detail. Surviving images of J. L. Daguerre's diorama convey something of the physical viewing experience: the seated audience looks to the stage where an extended image is unrolled frame by frame before their eyes, conveying everything from the eruption of Pompeii to the wonders of an archaeological tour. 'I was at the private view of the Diorama,' British artist John Constable wrote; 'it is in part a transparency; the spectator is in a dark chamber, and it is very pleasing, and has great illusion.'[12]

Clemens' own rhapsodic description continues:

> There is no slurring of perspective effect about it — the most distant — the minutest object in it has a marked and distinct personality — so that you may count the very leaves on the trees...[13]

10 Samuel L. Clemens to Orion Clemens, 18 March 1861; rept. in Edgar Marquess Branch *et. al.* (eds.), *Mark Twain's Letters Volume 1: 1853–1866* (Berkeley: University of California Press, 1988), p. 117.

11 Ibid.

12 John Constable, Letter to a Friend, quoted without full citation in Bernard Comment, *The Panorama* (London: Reaktion Books, 1999), p. 59.

13 Samuel L. Clemens to Orion Clemens, 18 March 1861, p. 117.

You cannot 'understand', he concludes, 'how such a miracle could have been conceived and executed by human brain and human hands.'[14]

Unlike others who wrote as if they were taken in by these manipulations, Clemens acknowledges that the artist's 'human brain and human hands' maneuvered the entire extravaganza. But he enjoys the deception. What goes unmentioned by Clemens, but what was alluded to by Constable and was common to panorama shows, was the use and variety of lighting effects. Daguerre and others painted their dioramas on a translucent screen, illuminated from behind by candles or gaslight (Constable's 'transparencies'). Natural phenomena like fires and volcanic eruptions would be shown in reddish-yellow light, lightning in white light. As a young man Church had helped create a panorama of Pilgrim's Progress, so we know he was familiar with this genre of popular imagery.[15] This too would have informed his creation of *Heart of the Andes* and its unconventional use of lighting effects for display.

In 1866 Augusta Evans published *St. Elmo*, which became one of the most popular novels of the Civil War era. Chapter 28 of this bestseller is set in a New York gallery, where a thirteen year old boy named Felix describes his reaction upon encountering *Heart of the Andes*:

> Oh! How grand and beautiful it is! Whenever I look at it, I feel exactly as I did on Easter-Sunday when I went to the cathedral to hear the music. It is a solemn feeling, as if I were in a holy place.[16]

A visual corollary to this description is found in the magnificent interior of the Spanish Colonial Church of San Francisco that the artist visited in 1853 and 1857 while in Quito, Ecuador, the country that inspired *Heart of the Andes*. Felix's words echo the artist's reaction entering the church — set against the backdrop of the Andes Mountains — and beholding the gilded altar glistening as the rays of the equatorial sun struck it through the open door. Church would undoubtedly have been in awe of the sight, unmatched by anything he had seen before.

14 Ibid.

15 See John K. Howat, *Frederic Church* (New Haven and London: Yale University Press, 2005), pp. 19–20 on *Pilgrim's Progress*; this book provides the most accessible biography of Church.

16 Augusta Jane Evans, *St. Elmo: A Novel* (New York: Carleton, 1867), p. 356, available as an ebook: https://docsouth.unc.edu/southlit/evans/evans.html. Subsequent references are to this edition and are given in brackets.

Referencing 'Easter,' 'the Cathedral' and 'a holy place,' Felix conjures up a choir singing, incense burning, and the subdued light of a church interior. In its soaring interior, burning candles illuminate discrete areas, which are reflected off the gold surfaces of the altar treasures to create a mysterious and awe-inspiring atmosphere. Light is simultaneously natural and divine. How, the orphaned boy then queries his governess, does the large canvas have the power to make him feel this way? Edna Earl responds:

> You are impressed by the solemnity and the holy repose of nature; for here you look upon a pictured cathedral, built not by mortal hands, but by the architect of the universe. Felix, does it not recall to your mind something of which we often speak?
> 'The boy was silent for a few seconds, and then his thin, sallow face brightened:'
> Yes, indeed! [he cried] You mean that splendid description which you read to me from *Modern Painters*? How fond you are of that passage, and how very often you think of it! Let me see whether I can remember it.
> Slowly but accurately he repeated the eloquent tribute to Mountain Glory, from the fourth volume of [John Rukin's] *Modern Painters*[…].
> 'Last week you asked me to explain to you what is meant by 'aerial perspective,' Miss Earl resumed, 'and if you will study the atmosphere in this great picture, Mr. Church will explain it much more clearly to you than I was able to do.'
> Yes, Miss Earl, I see it now. The eye could travel up and up, and on and on, and never get out of the sky; and it seems to me those bids yonder would fly entirely away, out of sight, through the air in the picture. But, Miss Earl, do you really believe that the Chimborazo in South America is as grand as Mr. Church's? I do not, because I have noticed that pictures are much handsomer than the real things they stand for. (pp. 356–57)

Felix suggests that one cause of this effect is 'the far-off look that everything wears when painted.' Quoting the poet Thomas Campbell, Miss Earl agrees: 'distance lends enchantment to the view.' (p. 357)

It is helpful to review a photograph of Church's *Heart of the Andes* as it was displayed at the Metropolitan Fair in 1864 as we consider this exchange. Like all realistic landscapes, Church has employed aerial perspective to convey a sense of recession into space on the two-dimensional surface. But the surface of *Heart of the Andes* is quite large — 5 x 10 feet — and requires the viewer to stand a substantial distance away from it to get the full effect. Yet, in the crowded galleries audiences were pushed close to the picture, held back from touching it

only by the railing visible in the 1864 photograph. So other means were necessary to convey this 'far-off look:' Church employed his substantial knowledge of light and optics to lift his viewers out of their own reality, and transport them to the pictured Andes of South America.

The dialogue between Evans's characters goes on for several pages before winding down: 'Perfect beauty in scenery is like the mirage that you read about yesterday,' the governess tells the young boy, 'it fades and flits out of your grasp, as you travel towards it.' (p. 358) They acknowledge the artifice that space and lighting helped to create, and yet they take great pleasure in its illusion.

Miss Earl, Felix and his baby sister leave the gallery and head home. At about 5pm the governess goes on a carriage ride with her gentleman friend, Mr. St. Elmo. The text reads: 'They dashed on, and the sunlight disappeared, and the gas glittered all over the city.' [p. 362] The chapter has come full circle, from the impressive effects of Church's canvas to the artificial illumination of the city streets. Augusta Evans leaves little doubt that Church's light was the more dazzling.

In 1864 *Heart of the Andes* was shown at the Sanitary Fair; it was one among hundreds of artworks, American and foreign. Like Bierstadt's Rocky Mountains, Lander's Peak, it was exhibited without special effects. 'Neither of them looks so well here as when seen by them themselves and surrounded by all the appliances of the skillful picture-hanger,' the New York Times reported. But what did he really mean, given that Church opted for the specially designed frame resembling a windowpane over which hung portraits of Presidents Washington, Jefferson, and Adams? Surely these could be considered the added apparatus? What the reporter obviously missed was the darkened room with the single picture, dramatically lit.

In those few years between 1859 and 1861, curtains, props and especially lighting ensured that those who had paid their twenty-five cents to see the legendary picture would never forget the experience. But in the end those special effects complemented the canvas itself. For the artist orchestrated his own internal light in the painting, including this sunbeam he added to illuminate his signature carved into the bark of the tree at the left of the picture. A testament to Church's success, Mark Twain said it best: 'Your third visit will find your brain gasping and straining with futile efforts to take all the wonder in.'[17]

17 Samuel L. Clemens to Orion Clemens, p. 117.

11. Italian Genius in American Light: The James Jackson Jarves Collection at Yale

Kathleen Lawrence

Perhaps the strangest tale in the annals of nineteenth-century Americans abroad is the history of expatriate collector James Jackson Jarves (1818–1888). His failure to convince fellow Bostonians to accept his priceless collection of Italian art was chronicled by Gilded Age writer Edith Wharton in her novella *False Dawn* (1924), where she fictionalized the consequences of Jarves's misguided passion for late Gothic and early Renaissance painting; an obsession that provoked ridicule from contemporaries, animosity from his wife and daughter and led eventually to financial ruin. In addition to his love for works by duecento, trecento, and quattrocento Italian masters, this Galileo of the art world was driven by the desire to enlighten his American compatriots, whose narrow mercantile existence he aimed to enrich with the visionary spirituality of Renaissance devotional objects. In order to impart intellectual and aesthetic light to culturally bereft citizens, however, Jarves needed literal illumination in a repository that would permit better viewing. Aided by a perspicacious architect and prescient college administrators, Jarves placed his orphaned masterpieces in the first dedicated college art museum, on walls illuminated with sunlight by day and gaslight by night, rescuing these artefacts from what Jarves perceived as the darkness of Italian neglect.

 https://doi.org/10.11647/OBP.0151.11

Jarves's pursuit of art was subsidized by newly acquired industrial wealth from his father's Boston and Sandwich Glass Company, a factory system that married industry to aesthetics and usefulness to beauty. Deming Jarves produced the most sought-after whale oil lamps in America, enabling him to fund his son's search for intellectual and aesthetic illumination with light-emitting objects.[1] Jarves's conflicted psyche mirrored this paradox, as he had what fellow Florentine and expatriate Englishman Thomas Adolphus Trollope (1810–1892) called 'Yankee energy and industry'[2] combined with a love of the transcendent he found in Renaissance Italian painting, which Jarves called 'a spiritual apprehension of life'.[3] Jarves believed that art in America would 'turn the heaviness of Puritan life into a thankfulness and delight'.[4] Ironically, his indefatigable urge to collect masterpieces of the Catholic faith derived from characteristics inherited from dissenting Puritan forbears: unflagging diligence, a love of freedom, and a desire for individual expression.

Jarves's drive to possess, re-hang, and re-light Italian devotional art was tied to teachings imbibed from the American Protestant minister-turned-writer Ralph Waldo Emerson, who preached to the masses not from the pulpit but from the lectern, not in a church but in a great public auditorium. Emerson's radical individualism fused secular American republicanism with liberalized religion, best expressed in his credo 'Trust thyself', granting his listeners and readers the freedom to 'write upon the lintels of the door-post, *Whim*'.[5] Like a true Emersonian, Jarves found meaning where he wanted to, preaching in his books a religion of art for the masses which constituted a reaction to bourgeois American business culture in its means, and an embrace of that same culture in its ends. The critic Sacvan Bercovitch called this American paradox the 'rites of assent', denoting the inherent intellectual collaboration between America's most profound thinkers and the capitalist project at the heart

1 Deming Jarves, *Reminiscences of Glass-Making* (Boston: Eastburn's Press, 1854), p. 46, http://www.gutenberg.org/ebooks/44284

2 Thomas Adolphus Trollope to Charles Eliot Norton, 12 February 1859 in J. J. Jarves, *Letters Relating to a Collection of Pictures Made by Mr. J. J. Jarves* (Cambridge, MA: H. O. Houghton & Co., 1859), p. 25, https://archive.org/details/lettersrelating00jarvgoog

3 James Jackson Jarves, *The Art-Idea: Sculpture, Painting, and Architecture in America* (New York: Hurd and Houghton, 1865), p. 363, https://catalog.hathitrust.org/Record/011535205

4 Jarves, *The Art-Idea*, p. 261.

5 Ralph Waldo Emerson, *Essays. First Series* (Boston: Houghton, Mifflin & Co., 1876), p. 48, https://catalog.hathitrust.org/Record/009775811

of American culture.⁶ As the Boston Courier admonished its own city, Boston was a community 'where wealth and political distinction are so eagerly pursued, neither object of pursuit being very elevating or refining in its effects', therefore 'a public gallery of works of Art would shed a benignant and beneficent influence...'⁷ With the idea of displaying Italian religious art in a Protestant college amidst gleaming modern surroundings, Jarves was joining the profoundly spiritual to the secular, mitigating the crassness of his country's burgeoning industrial culture. Yale itself stood at a crossroads, transitioning from a clerical training ground with emphasis on ancient languages and biblical exegesis to a research university. Its new art school with a museum attached could assess religious art from an interpretive distance.⁸

Jarves first began to appreciate early Italian works after reading Alexis François Rio's *The Poetry of Christian Art* (1836) and Alexander William Crawford, 25th Baron Lindsay's *Sketches of the History of Christian Art* (1847) during his first European sojourn. These books, as well as English critic John Ruskin's *The Stones of Venice* (1851–1853) and Lady Callcott and Augustus Wall Callcott's *Frescoes of Giotto* (1835) were a revelation to Jarves, who suddenly found himself admitted to a rarefied unknown world of spiritual and aesthetic dimensions.⁹ Like his ancestors who broke ties with the 'Old World' to create the new, Jarves considered faith in the future to have supplanted superstition and ritual. Yet he also feared rootless contempt for history and faith. He believed Italian art could build an aesthetic bulwark against the rampant materialism that was encroaching upon post-bellum American society. For Jarves, the American future of enlightened commercialism could appropriate ancient holiness to underpin a creed of individual advancement, a prospect he associated with light. He warned his fellow Americans, 'With us, the public voice is dumb. There is no universal demand for Beauty. Yet the divine spark exists in us, and needs but encouragement

6 Sacvan Bercovitch, *The Rites of Assent* (London and New York: Routledge Press, 1993), p. 36.
7 Anonymous, 'Article from the Boston Courier of 9th of February, 1859', in Jarves, *Letters Relating to a Collection*, p. 29, https://babel.hathitrust.org/cgi/pt?id=hvd.32044 108139858;view=1up;seq=35
8 Joshua Lawrence Chamberlain, John De Witt, John Howard Van Amringe *et al., Universities and Their Sons; History, Influence and Characteristics of American Universities, With Biographical Sketches and Portraits of Alumni and Recipients of Honorary Degrees*, 4 vols. (Boston: R. Herndon Company, 1898), I, p. 351.
9 Jarves, *The Art-Idea*, p. 126.

to grow into a bright and steady light'.[10] Relatedly, T. A. Trollope advised Charles Eliot Norton after having seen Jarves's collection in his Florence palazzo (before it crossed the ocean to Boston and eventually New Haven), that his paintings 'are called upon to perform a civilizing office for the rising world on the other side of the Atlantic'.[11]

In spite of his reverence for Italian artefacts, Jarves displayed the imperious sense of superiority held by many Grand Tourists towards Italy and her museums. Nineteenth-century English and American visitors to Italian cultural sites often registered derisive complaints about the state of Italian institutions, revealing their own lack of comfort with foreignness, extrapolating moral inferiority from material conditions. For example, critic and art historian Anna Jameson (1794–1860) rebuked an aristocratic Roman family in her memoir *Diary of an Ennyée* (1826): 'The Doria Palace contains the largest collection of pictures in Rome; but they are in a dirty and neglected condition and many of the best are hung in the worst possible light...'[12] American writer Henry James (1843–1916) spoke of this dim light in 'The Madonna of the Future' where his protagonists 'wandered into dark chapels, damp courts, and dusty palace-rooms, in quest of lingering hints of fresco and lurking treasures of carving'.[13] In 'Traveling Companions', James's protagonists strolled through St. Mark's Basilica and wandered 'into the dark Baptistery and sat down on a bench against the wall, trying to discriminate in the vaulted dimness the harsh medieval reliefs behind the altar and the mosaic Crucifixion above it'.[14]

In *The Marble Faun* (1860), his novel about American expatriates in Rome and Florence, Nathaniel Hawthorne (1804–1864) suggested that the young American copyist Hilda must correct the deficiencies of Italian galleries: 'If a picture had darkened into an indistinct shadow through time and neglect, or had been injured by cleaning, or retouched

10 J. J. Jarves, *Art Studies: The 'Old Masters' of Italy* (New York: Derby and Jackson, 1861), p. 9, https://archive.org/details/artstudiesoldma03jarvgoog
11 Jarves, *Letters Relating to a Collection*, p. 24.
12 Anna Brownell Jameson, *Diary of an Ennuyée* (Boston: Lilly, Wait, Colman, and Holden, 1833), p. 124 (1826 ed. available at https://archive.org/details/diaryanennuyeby00jamegoog).
13 Henry James, *A Passionate Pilgrim and Other Tales* (Boston: James E. Osgood & Co., 1875), p. 283, https://archive.org/details/passionatepilgri00jameiala
14 Henry James, 'Traveling Companions', *The Atlantic Monthly*, 26 (November 1870), 600–14 (also available at https://en.wikisource.org/wiki/Travelling_Companions_(New_York:_Boni_and_Liveright,_1919)

by some profane hand, she seemed to possess the faculty of seeing it in its pristine glory'.[15] Hawthorne continued, 'From the dark, chill corner of a gallery, — from some curtained chapel in a church, where the light came seldom and aslant, — from the prince's carefully guarded cabinet, where not one eye in thousands was permitted to behold it, she brought the wondrous picture into daylight, and gave all its magic splendor for the enjoyment of the world'.[16] Although this American woman was a mere copyist, through her pure Protestant spirituality — free from intermediaries to distance her from God — she could extract the essence of the painting in question, washing its Italian dirt with her unspoiled American newness. She could thereby achieve a kind of ownership as though the work itself was originally produced at her hands.

Hawthorne might as well have been describing Jarves. In his letters from Italy to Harvard art history professor Charles Eliot Norton (1827–1908), Jarves related that his adventures 'involved an inquisition into the intricacies of numberless villas, palaces, convents, churches, and household dens, all over this portion of Italy; the employment of many agents to scent out my prey; many fatiguing jouneyings; miles upon miles of wearisome staircases; dusty explorations of dark retreats; dirt, disappointment, fraud, lies and money often fruitlessly spent...'[17] He directed his efforts towards a well-remunerated, if not completely noble end: 'all compensated, however, by the gradual accumulation of a valuable gallery'. Casting aspersions on Italian religious orders and repositories, Jarves nevertheless looked for bargains. Treating priceless paintings like liquidation items, he boasted 'In the lumber room of a famous convent I chanced upon a beautiful Perugino, so smoked and dirty as to be cast aside by the monks, who, for a consideration, gladly let me bear it away...' Italy seemed to relinquish her riches for a pittance, and hardly tried to protect them; 'A beautiful full length portrait of a Spanish grandee, by Velázquez, was found among the earth and rubbish of a noble villa, cut out from its frame, crusted with dirt, but beneath in fine preservation...'[18] Darkness, smoke, rubbish, and dirt as described by Jarves seemed to be metonymic symbols for sins that

15 Nathaniel Hawthorne, *The Marble Faun, or the Romance of Monte Beni* (Boston: Ticknor and Fields, 1860), p. 78, https://trail.ge/wp-content/uploads/2017/06/Marble-Faun-c.pdf

16 Hawthorne, *The Marble Faun*, p. 80.

17 Jarves, *Letters Pertaining to a Collection*, p. 6.

18 Ibid.

invalidated Italy's stewardship of the world's art treasures. It was as if Jarves had excavated them cthonically from the earth as the Laocoön had been found in 1506 in a Roman vineyard, thereby conferring rights of ownership on the American archaeologist. Jarves wanted not only to clean but also to sterilize Italy; an ironic stance certainly for a lover of art, and Italian art in particular. In a passage in his early book *Italian Sights and Papal Principles* (1856), Jarves blamed any artist who shirked his duties of civic uplift: 'The obscene gallery at Naples is very properly closed to the public; so should every work of art in which immodesty is obviously apparent…'[19] Jarves applied even more stringent demands to the public. Like the Puritan minister Jonathan Edwards, who demanded his parishioners purge their minds of immodest thoughts, Jarves opined, 'An artist of pure aim should not be held answerable for the imagination of his spectator. It is his business to purify his heart, even as the artist has purified his work, of all gross, earthly elements'.[20] Jarves construed the unsullied appreciation of art as a kind of 'business', wedding the language of enterprise to — and thereby justifying — aesthetics.

Jarves offered further negative assessments of Italian light in his art historical books. For example, discussing Domenico Beccafumi, 1484–1549, Jarves wrote in *Art Studies*, 'His best works, being limited to Siena, and not in a favorable light, particularly the fine frescoes of the Oratory of San Bernardino, …contribute to keep his fame more in shadow than it merits'[21] His next book, *The Art-Idea*, offered specific criteria for organizing museums: 'Until recently, no attention has been paid, even in Europe, to historical sequence and special motives in the arrangement of art-objects. As in the Pitti Gallery, pictures were generally hung without regard even to light, so as to conform to the symmetry of the rooms'[22] By this, he was holding the Pitti Gallery to the standards he was in the process of establishing at Yale, placing the element of light as the primary consideration. Writing to his daughter Amey, still at school in New England, Jarves described their summer surroundings at Bagni di Lucca with the same ambivalence he held towards Italy as a repository

19 J. J. Jarves, *Italian Sights and Papal Principles, Seen Through American Spectacles* (New York: Harper and Brothers, 1856), p. 189, https://archive.org/details/italian sightsan03jarvgoog
20 Ibid.
21 Jarves, *Art Studies*, p. 356.
22 Jarves, *The Art-Idea*, p. 346.

for art. The summer locale was a place where 'the woods are dense, so green and beautiful' and 'the air is perfumed with delicious flowers' that 'we can walk miles under the vines loaded with fruit, forming arbors that make your mouth water to look at them...'[23] He nevertheless prejudiced Amey, who had been born in Florence in 1855, against Italy: 'The people are very poor, notwithstanding they live in such a beautiful country. But that is owing to bad government and a foolish religion. By and by you will read all about the history of your native country, for although you are Yankee at heart, you are Italian by birth'.[24] By contrast, Jarves was a fastidious Yankee who strove to be an Italian at heart; in spite of having devoted his life to accumulating religious art, he scorned the very faith which had produced it.

In Boston, Jarves encountered Yankees more virulent than he; societal leaders, suspicious of art whose strange iconography repulsed them. These wealthy merchants, dubbed 'Brahmins' to reflect their insularity, failed to understand the significance of the duecento and trecento Sienese, Umbrian, and Florentine schools. The mid-nineteenth century was the era when American collectors and patrons revered late-Renaissance, Baroque, and proto-Romantic masters such as the Carracci, Correggio, Albani, Domenichino, Carlo Dolci, Guercino, Guido Reni, Carlo Maratta, Salvador Rosa, Lo Spagnoletto, Sassoferrato, Giulio Romano, and Guido Rossi among others. These were exactly the painters collected by Boston merchant millionaires and by the Boston Athenaeum, whose core collection included works by the Carracci, Correggio, Guido Reni, Lazzarini, Giovanni Paolo Panini, and Francesco Zuccarelli.[25] While a few works in the collection, which Jarves had so diligently assembled, depicted profane subjects, the majority of the images were sacred scenes that appeared strange to Protestant Bostonians: Madonnas with child, births of the saviour, annunciations, martyrdoms, presentations at the temple, circumcisions, and crucifixions. The few secular motifs

23 The James Jackson Jarves Collection (MS 301), Manuscripts and Archives, Yale University Library, Box 1, Folder 20.

24 Ibid. Florence Amey Jarves (1855–1947) was the daughter of Jarves's first wife Elizabeth Russell Swain. She was born in Florence while Jarves was in Boston overseeing the publication of *Art Hints, Architecture, Sculpture and Painting* (1855). See Francis Steegmuller, *The Two Lives of James Jackson Jarves* (New Haven: Yale University Press, 1951), p. 153.

25 Robert F. Perkins and William J. Gavin, *The Boston Athenaeum Art Exhibition Index, 1827–1874* (Cambridge, MA: MIT Press, 1980), p. 216.

represented mostly mythological themes and portraits, for example *Stories from the Aeneid* by Paolo Uccello, a cassone depicting the 'Triumph of Love'; *Venal Love* by Agostino Carracci; portraits depicted aristocratic Italians in finery with less volumetric modelling of the faces than seen in the high Renaissance, as in *The Wife of Paolo Vitelli* by Raibolini of Bologna; portraits of the Gritti family by Giorgione; a portrait of Cassandra Fedèle by Giovanni Bellini; a portrait of a Medici princess by Bronzino, and Cosimo de Medici by Pontormo.[26]

Boston's elite gatekeepers were not only suspicious about the aesthetic value of the works, but they also doubted the accuracy of their attributions. Earlier Baroque and Romantic exhibitions at the Boston Athenaeum, as well as collections of elite New England merchants, had accustomed upper-class Bostonians to seeing paintings in a more pristine state, without the need for restoration. On this matter, Harvard art historian Charles Eliot Norton wrote to Jarves in November 1859 on the eve of a meeting of the Trustees of the Boston Athenaeum: 'The public and many of the proprietors of the Athenaeum consider $20,000 a very large sum to spend for 'old' pictures. They have no conception of their importance to modern artists, and of their essential value as representing the past thoughts and habits of men.'[27] It was because the pictures had dimmed with age or lost layers of paint that Jarves had unfortunately allowed over-zealous cleaning and in-painting by his Florentine dealer and advisor George Mignaty (1824–1895).

A more sinister aspect contributed to Jarves's ultimate failure to secure a home for his collection in Boston. Criticism of the condition of the paintings represented a snobbish estimate of Jarves himself, for although his father was a wealthy industrialist, he was not from the first rank of Boston families; the Appletons, Cabots, Curtises, Forbeses, Lowells, and Perkinses. Indeed, Jarves' dream to endow his native city with the riches of art was scuppered by one of these elite clans — the Perkins family. Edward Perkins, grandson of Boston's wealthiest shipping magnate Thomas Handasyd Perkins, was chair of the Athenaeum Fine Arts committee, thus possessing the power to

26 Osvald Sirén, *A Descriptive Catalogue of the Pictures in the Jarves Collection Belonging to Yale University* (New Haven: Yale University Press, 1916), x–xv, https://archive.org/details/descriptivecatal00sir

27 Charles Eliot Norton to James Jackson Jarves, 17 December 1859, Charles Eliot Norton Collection, Boston Athenaeum Special Collections, Folder 1.

confound Jarves's plans. As Perkins wrote to members of the committee, 'I do not like J., and scarcely know him, but I cannot bear to have Boston victimized & my friends with their generous intentions disappointed. If I could believe J's gallery the thing and his prospectus *bona fide* I should be among the first to rejoice'.[28] This letter was followed by a campaign of slander concerning the condition and authenticity of the paintings which ultimately decided the fate of Jarves's intended trove for Boston. Perkins whispered it abroad that Jarves had had to sell a few pictures — probably just to pay for shipping charges — and Norton was warned by an anonymous letter that 'horse dealing and picture dealing are in the same category [and I] cannot bear to have Boston victimized...'.[29] Jarves heard rumours of this vilification and fought back in his book *The Art-Idea*: 'Boston is a city of extremes. It grows the intensest snobs, the meanest cowardice, the thickest-skinned hypocrites, by the side of saintly virtues, intellectual vigor, general intelligence, and a devotion to the highest interest of humanity'.[30] Ironically, believing Boston to be the 'young Athens of America', T. A. Trollope assumed the collection would go 'unmutilated to Boston' for "the almighty dollar' has already ceased, it seems, to be almighty in Boston'.[31]

Proof that Jarves's unique vision for a religion of art was intended to temper his business-loving country, was his urge to display his paintings in a new kind of gallery, a modern surrounding where late Gothic and Renaissance masterpieces would comprise an exemplary, if not encyclopedic, set. In his original letter to Norton proposing the gallery, Jarves specified the need for proper conditions, for 'hanging, lights, and temperature' as well as for 'efficiency'.[32] In his article 'On the Formation of Galleries in America', Jarves offered the following specifications: 'An edifice for a gallery or museum of art should be fire-proof, sufficiently isolated for light and effective ornamentation, and constructed so as to admit of indefinite extension. Its chief feature should be the suitable accommodation and exhibition of its contents'.[33]

28 Edward Perkins to Charles Eliot Norton Collection, undated letter, Boston Athenaeum Special Collections, Folder 1.
29 Ibid.
30 Jarves, *The Art-Idea*, p. 381.
31 Jarves, *Letters Pertaining to a Collection*, p. 24.
32 Ibid., p. 13.
33 James Jackson Jarves, 'On the Formation of Galleries in America', *Atlantic Monthly*, 6 (July 1860), 106.

According to Jarves's friend and supporter, the architect Russell Sturgis, Jr., his treasures originally resided in 'the private oratory, or where, in a retired place, a room-corner was reserved for the reading-desk and for prayer'.[34] This vestigial religious purpose lent gravitas to these orphaned images once put on display in their new modern context. As Sturgis explained, 'Art could not become nor continue trivial when, in addition to the solemnity of its usual subjects, and to the character of their people strongly disposed toward it, the works to which the artist gave their best strength were of general, almost national concern'.[35] Sturgis found this added sanctity in particular in an altar piece by an unknown painter dated 1370, that showed the Madonna and child enthroned, attended by angels playing upon musical instruments. Sturgis envisioned that *The Deposition from the Cross* by Gentile da Fabriano, circa 1370–1450, a small altar-piece of tempera with gold background on wood, 'was as permanently fixed above its altar as Duccio's great work at Siena...'[36]

While Jarves was unable to convince wary Bostonians to take his collection seriously, the works found their home in Yale's modern, well-lighted space, by the strangest of twists. As announced in the *New York Times* Monday, 6 January 1868, from the *Boston Advertiser*, Dec. 31: 'The entire collection, except three paintings, in all one hundred and nineteen, has passed into the custody and possession of Yale College, which will undoubtedly become, sooner or later, the absolute owner. They are hung in the fine arts gallery belonging to the college, a room seventy feet long by twenty-five broad and about thirty in height. The pictures completely fill it, and as the light is very favorable, they are seen to better advantage than they have ever been before in America'.[37] Jarves oversaw the hanging of the pictures himself, writing to Amey's governess, Miss Barber: 'I expect to sail about Christmas, as soon as the pictures are hung at Yale... I shall be glad even to get to the ocean to rest as I am about worn out, having done nothing for six months but work,

34 Russell Sturgis, Jr., *Manual of the Jarves Collection of Early Italian Pictures Deposited in the Gallery of the Yale School of Fine Arts* (New Haven: Yale College Press, 1868), p. 10, https://archive.org/details/gri_33125006446203

35 Ibid., p. 10.

36 Ibid., p. 11.

37 Anonymous, 'The Jarves Collection at Yale College', *The New York Times*, Monday 6 January 1868, p. 2.

work, without visiting a single place of amusement or my friends even. But I have got through at last'.[38]

Yale's original art gallery was the Trumbull Gallery, built in 1832 to house a collection of history paintings by John Trumbull. Yale next secured a loan exhibition of old masters in 1858 under the auspices of Professor Daniel Coit Gilman. However, the collections soon outgrew it and a new building was completed through the generosity of Augustus Russell Street (1792–1866). Street Hall was begun in 1864 but was delayed due to the Civil War. According to the chapter on Yale University in the compendium *Universities and Their Sons*, it was 'the first serious recognition of the aesthetic element at Yale'.[39] Street Hall opened at last in 1866 and the 'Jarves collection' was deposited there in 1867. Through the efforts of Professor John F. Weir, Dean of the Yale School of the Fine Arts from 1869–1913, the Reverend Noah Porter, who became President in 1871, and Professor Edward Elbridge Salisbury, an arrangement was made with Jarves whereby he agreed to deposit his collection, then consisting of 119 pictures, at Yale for a period of three years. Luther Maynard Jones wrote to Professor Salisbury, June 26, 1867: 'Mr. Charles Eliot Norton in a recent letter expressed his regret at the chance of losing the collection from Harvard or Boston says, 'If Yale were to secure it, it would do more to make it a true University and the leading University in America than could be done in any other way by an equal expenditure of money.''[40] In return for his deposit, the Yale Corporation lent Jarves twenty thousand dollars, the pictures being used as security, with the University reserving the right of buying the collection any time during the three-year interval for fifty thousand dollars. Professor Frank J. Mather, Jr. described this transaction in the *Yale Alumni Weekly* of May 1914, as 'one of the most irregular pieces of University finance on record and certainly one of the most brilliant'.[41]

Light was a key consideration in designing the building. According to the Yale President's Reports for 1868, P. B. Wight of New York, the architect of the building for the Yale School of Fine Arts that originally

38 The James Jackson Jarves Collection (MS 301), Manuscripts and Archives, Yale University Library, Box 1, Folder 20.

39 Chamberlain, *Universities and their Sons*, p. 270.

40 The James Jackson Jarves Collection (MS 301), Manuscripts and Archives, Yale University Library, Box 1, Folder 1.

41 'Little Known Masterpieces', *The Literary Digest*, 48.23 (6 June 1914), 1360–62.

displayed the Jarves Collection, explained that 'As the picture galleries were to be on the upper floor, their position was a matter of small importance, inasmuch as the light for them was to be received through skylights'. The architect continued, 'But the arrangements of the studios with reference to obtaining good light, was not so easy a matter'.[42] As Yale professor Daniel Coit Gilman commented, 'Those who have seen the Jarves pictures in rooms which were poorly lighted, or which were too small to receive the entire number, express themselves delighted that those choice works of art have at last found a home where they can all be seen and satisfactorily examined; and they tell us that the collection has never appeared so well as in its new abode'.[43] Central to Yale's interest in the works was education, compelling administrators to seek illumination for student attendance after dark. Contemporary photographs reveal the installation of gaslight as early as the 1870's with upgrades in the 1880's, allowing students and visitors to view the Jarves masterpieces after dusk.

Jarves succeeded in bestowing upon Yale and America aesthetic and spiritual enlightenment from Italian treasures seen with modern illumination. Given that his gallery became the centrepiece of Yale's prestigious art school, and later its art history program, with liberal hours for public viewing, one could argue that Jarves's visionary project profoundly influenced not only Yale's curriculum but also American cultural history writ large. Jarves could not have foreseen the extent to which his idea mitigated his homeland's narrow mercantile pursuits and sterile rejection of sensuality. Although Italy lost over one hundred native treasures, the genius of her artists radically changed a continent. The literal light made possible by the new gallery allowed for the figurative light that entered the minds of American citizens who viewed the works, students and laypersons alike. This achievement was best summarized by the Yale motto 'Lux et Veritas', for 'Light and Truth'.

42 Yale President's Reports, 1868, pp. 33–36, Yale University Manuscripts and Archives.
43 Daniel Coit Gilman, 'The Jarves Collection in the in the Yale School of Fine Arts', *The New Englander and Yale Review*, 27.1 (1868), 176 (New Haven: Thomas J. Stafford, 1868).

12. Shedding Light on the History of Lighting at the Isabella Stewart Gardner Museum

Holly Salmon

Fig. 12.1 The Gothic Room, Isabella Stewart Gardner Museum, Boston.

In 1897, the great arts patron Isabella Stewart Gardner wrote to art historian Bernard Berenson about her plans for lighting the prized Titian painting, *Europa* (1560–62), which Berenson had recently helped

 https://doi.org/10.11647/OBP.0151.12

her to acquire for her Boston, Massachusetts home.[1] Her letter reads, 'The electrician has come to arrange for Europa's adorers, when the sun doesn't shine. You have no idea how difficult it is to arrange light satisfactorily.'[2] Six years later, when she opened her museum, Gardner abandoned attempts to illuminate her collection with electricity and chose instead to use only natural and flame-sourced light. Like many similar institutions, the progressive history of lighting from that moment until today is complex and ever changing. From bamboo shades to fibre-optic lighting, the Museum has continued to make adjustments to gallery lighting in a quest to find the ever-elusive 'perfect' solution.

Born in 1840, Isabella Stewart married John (Jack) Lowell Gardner in 1860, and three years later they had a son. At just two years old, their son, Jackie, died of pneumonia, sending Isabella Gardner into a deep depression. Doctors advised the couple to travel in order to lift their spirits, resulting in the first of many trips abroad. Their early adventures took them to Europe and then later the Middle East, Asia and through the Americas. Venice quickly became Gardner's favoured venue for vacation abroad and she returned there frequently to stay at the Palazzo Barbaro in the San Marco district.[3] It was on these travels that the Gardners became collectors. Their stately home began to fill with treasured paintings by Rembrandt, Botticelli, Vermeer and Van Dyke, along with historic furniture, decorative arts and sculpture.

In these early years, when Gardner wrote to Berenson about the challenge of lighting *Europa*, she had picture-lights installed over her most-prized paintings, as evidenced in historic photographs of her home. For ambient lighting, she relied on modern lamps and elaborate chandeliers. While there is no further documentation on the use of lighting in the Gardner's Beacon Street home, it is clear that she took a distinctly different approach to lighting when she moved on to build a museum.

In choosing a location to house their collection after Jack died in 1898, Isabella Gardner selected a site in Boston that was, at the time, on the outer edges of the city. Her intention was to have no other buildings

1 https://www.gardnermuseum.org/experience/collection/10978
2 Isabella Stewart Gardner to Bernard Berenson, 1 January 1897. Bernard and Mary Berenson Papers (1880–2002), Biblioteca Berenson, Villa I Tatti — Harvard University Center for Italian Renaissance Studies.
3 https://www.gettyimages.com/detail/news-photo/american-painter-james-mcneill-whistler-his-companion-maud-news-photo/640455773

casting a shadow on her creation. Heavily influenced by her frequent visits to Venice, the building was designed to look like a fifteenth century palazzo, particularly the interior. Three floors of galleries surround a glass roofed central courtyard with the fourth floor reserved for her living quarters (now offices).[4]

Gardner wrote very little about her installations and nothing about the gallery lighting. Interpretation of letters, articles and photographs is required to understand her intentions. Early images were taken by the father and son photographers, Thomas and Arthur Marr, from 1902 to 1926. Known for photographing interiors, Thomas Marr was likely hired by Gardner for his sensitivity to light and atmosphere. The museum administration continued to work with the Marrs even after Gardner's death. Their images provide the most comprehensive documentation of her museum's original appearance.[5]

These images show that she did have electric lighting in some smaller rooms used as waiting rooms or offices, and likely in her fourth floor apartment. However, she relied mostly on natural light from the exterior and courtyard windows in her galleries. She deliberately installed many of her works adjacent to those windows to capitalize on the natural light. For instance the lovely Fra Angelico, *Death and Assumption of the Virgin* (1430–34)[6] is positioned in a far corner, turned away from the entrance to the gallery, in order to be positioned perpendicularly to the window. The effect of sunlight dancing off of the gilding and deep lapis lazuli was more important to Gardner than placing this valuable piece in some prominent location.

After several years of construction and art installation, Gardner opened her museum with an extravagant New Year's Eve gala in 1903. Assuming that all of the candle-based fixtures found in the museum's galleries were lit, over 550 of them would have glowed that night along with paper lanterns hung throughout the courtyard. Unfortunately, there are no photos of the opening; however, Gardner often entertained in her galleries in the evenings and the effect of viewing the museum under candlelight was documented in letters she received from her

4 https://www.gardnermuseum.org/about/building-isabellas-museum#chapter1
5 All photographs referenced are black and white photographs, T. E. Marr and Son, 1903–1926. Isabella Stewart Gardner Museum, Boston, https://www.gardner museum.org/experience/collection/11265
6 https://www.gardnermuseum.org/experience/collection/11697

guests. In a letter comparable to many others written about such an event, Sidney Norton Deane, a curator at the Boston Museum of Fine Arts, wrote, 'I do not know how conditions could have been combined with more beautiful effect — weather, moonlight, flowers, lights, and voices. It was like some magical country, out of the Odyssey.'[7]

Like Deane, in his reference to Homer's ancient Greek poem, other guests wrote that a visit to Gardner's palace transported them to another time. For German art historian Paul Clemen, who wrote of such an evening, it was the Renaissance era:

> How solemn seemed the Dutch Room[8] with these few stiff candles and the courtyard in the dark scarlet of the paper lanterns. I imagine how beautiful the whole palace must be, when all is clear in him and wonderful dressed people move through the rooms like in the days of Giorgione.
>
> The candle light was ghostly beautiful — your precious green jewellery was shining like serpent-eyes and the clear green bracelet on your arm looked like a small vivid Indian Kobra — but still more beautiful all the Rembrandts, Rubens, Holbeins would shine in full light.[9]

Clemen's final remark, however, suggests some disappointment at not being able to see the paintings in daylight. A similar account remarking on both the darkness and beauty found at one of Gardner's events was given by businessman Larz Anderson:

> Mrs. Jack Gardner's party at Fenway Court was like fairyland — rather a dim fairyland, to be sure, for the beautiful rooms of the great house were lighted only by candles and not many at that — and many were left unlighted in their sockets (which was an artistic touch), and the gallery, where two of her choicest pictures are, was so dim that one had to scratch matches to look at the Botticelli and the Della Robbia.[10]

While Gardner probably enjoyed offering her guests both a sense of mystery and a desire to see more, the many scholars and art historians she kept in her circle were likely frustrated at not being able to properly study the fine works in her collection.

7 Sidney Norton Deane to Isabella Stewart Gardner, date unknown. Isabella Stewart Gardner Museum, Boston.
8 https://www.gardnermuseum.org/experience/rooms/dutch-room
9 Paul Clemen to Isabella Stewart Gardner, 20 December 1907. Isabella Stewart Gardner Museum, Boston.
10 Larz Anderson to unknown, date unknown in Isabel Anderson (ed.), *Larz Anderson: Letters and Journals of a Diplomat* (Whitefish: Literary Licensing, LLC, 2011), p. 185.

A charming letter from socialite Sissie Mortimer, extolling the drama of seeing the museum at night, seems to chide such disappointment:

> I am so happy to have seen your most beautiful palace for the first time by candle light — no daylight could ever have lent it half the charm, which the moon & the candle light did and the sense of mystery, of half revealment, added a great deal to the enchantment of the scene. I felt sorry for a few misguided fools, who were grieving, because they could not see each picture & each object more distinctly & I inwardly commented upon their narrow vision.
>
> Is seeing the only thing in life, is feeling nothing? Sometimes I think feeling is so much more than seeing, & thank God, I can feel the beauty of my surroundings & felt them so intensely two nights ago. To me there was no flaw, there was no false note, all was beautiful, sympathetic & harmonious & I thought I had found my way once more into my beloved Italy.[11]

One can imagine that Gardner delighted in receiving this letter as she certainly had been influenced by the architecture of Italy and Venice and, just as importantly, the quality of light she would have experienced in her stays at the Palazzo Barbaro.

The final gallery that visitors reach when making the natural progression through the museum is the Gothic Room,[12] which holds a once-scandalous portrait of Gardner by John Singer Sargent. This gallery was perhaps one of the more mysterious spaces she created because the room, with a giant, bright rose window and contrasting darkly clad walls, was kept off view from most visitors during her lifetime. However, it was also a space that Sargent, her friend, was known to enjoy as a studio. This can be seen in his portrait of *Mrs. Fiske Warren and her Daughter* (1903).[13] In the painting, Sargent captures the play of light off of his subject's dresses and the glints of gold from the Gothic Room sculptures behind them. Interestingly, a photograph depicting Sargent in the process of painting the Warrens shows that he chose to cover the large rose window with a dark cloth, likely to prevent backlighting while he painted.[14]

11 Sissie H. Mortimer to Isabella Stewart Gardner, 18 December 1903. Isabella Stewart Gardner Museum, Boston.

12 https://www.gardnermuseum.org/experience/rooms/gothic-room

13 https://www.mfa.org/collections/object/mrs-fiske-warren-gretchen-osgood-and-her-daughter-rachel-33862

14 https://www.gardnermuseum.org/experience/collection/18194

Just as historic images of her galleries provide a sense of how Gardner curated light, several portraits of her utilize dramatic light and may give some insight into how she wanted to be perceived. Baron Adolf de Meyer, a society and fashion photographer, portrayed her enveloped in a soft, ethereal light, evoking foggy mystery such as she created for her evening events. Anders Zorn, by contrast, captured her passion and joy in his portrait *Isabella Stewart Gardner in Venice* (1894) by highlighting the brightness of her dress and face as she returns from enjoying the view on a Palazzo Barbaro balcony. In both examples, the use of light to convey emotion is highly prevalent and appropriate to what is known of Gardner's character.[15]

Gardner suffered the first in a series of strokes in 1919 and passed away in 1924. Since then, the museum administration has maintained a beloved and challenging stipulation from her last will and testament. It states that the arrangement of objects in her museum must remain unchanged and the collection held in trust, 'as a Museum for the education and enjoyment of the public forever.'[16] Though because Gardner displayed light sensitive works, such as textiles and works of art on paper, immediately adjacent to less sensitive paintings and sculpture, maintaining this permanently installed collection is a daunting task.

During her lifetime, the museum was only open for limited times. When she was not showcasing her collection, the windows would be shaded and the courtyard roof was painted over in the summer. In 1925, the year after Gardner's death, the museum began to open for regular public hours. The administration recognized that this would expose the collection to more harmful light. As Morris Carter's Director's Report from that year explained, 'During the spring [...] the exterior windows of the building were screened and also, at the suggestion of the President, fitted with bamboo curtains which soften and improve the light and reduce heat.'[17]

Not long after, in order to balance out the shaded windows, electric lighting was introduced into the galleries. This process began with

15 See https://www.gardnermuseum.org/experience/collection/24507 and https://www.gardnermuseum.org/experience/collection/10973
16 Will and Codicil of Isabella Stewart Gardner, 9 May 1921, probated 23 July 1924, Suffolk County, Commonwealth of Massachusetts.
17 Isabella Stewart Gardner Museum, Inc., Boston, Annual Report (Portland: Southworth-Anthoensen Press, 1925), p. 5.

electrifying the candle fixtures, which produced mixed results and mixed reception. Board President Harold Jefferson Coolidge commented:

> When it comes to lighting — personally I regret the substitution of electricity for candles wherever it can be avoided, and without knowing how the rest of you feel, I for one think it would be a great mistake to try to light the pictures by any artificial light. For evening receptions the courtyard and the outdoor garden can, and are made, very beautiful by systems of modern illumination, but I very much hope that where the pictures hang we shall use candles alone and as many of them as are needed.[18]

It seems that Coolidge was out-voted as electric lighting was continually added to the galleries. And, the reception from the museum's board continued to be varied. In 1937, in a letter from the assistant director to Carter regarding comments from a trustee:

> The only other matter discussed was the new lighting. On this subject Mr. Pope had a good deal to say, and he was definitely the leader. The lights in the Dutch Room he admitted were all right and an improvement as long as the candles were on at the same time so that the walls were more evenly lighted. The lights in the Tapestry Room he felt very differently about, claiming that they completely changed the room. Apparently Mrs. Gardner had consulted him when she was arranging the room and they had placed everything with an eye to light and shadow. Their arrangement, which he thought nearly perfect, was completely spoiled by the lights.[19]

Gardner's selected trustees were obviously uncomfortable with the introduction of electric lighting but there also seemed to be no going back. Through the years, other attempts at adding light were introduced through modification of existing fixtures or the addition of new ones. Tinted window films, curtains and shades were also added to the windows in order to further control potentially harmful sunlight.

However, a comprehensive approach to managing light in the museum was never utilized until the museum embarked on a capital project to address this in 2004. The Museum designated a team made up

18 Isabella Stewart Gardner Museum, Inc., Boston, Annual Report (Portland: Southworth-Anthoensen Press, 1930), p. 20.
19 Robert Gardner Rosegrant to Morris Carter, 1937. Isabella Stewart Gardner Museum, Boston.

of an independent lighting consultant and members of the operations, conservation and curatorial staffs to design and execute the project. Their aim was to balance atmosphere, such as the characteristic appearance of the museum at night; Gardner's intent for the use of light; conservation concerns and the visitor experience. The $1.65 million project took place over eight years completing with the opening of the museum's Renzo Piano wing in 2012.

Meeting all of the specified targets was a seemingly impossible task. The challenges faced during the project included finding neutral solutions for individually unique galleries, installation of all new wiring and fixtures while the museum remained open to the public, and satisfying the competing nature of the goals. The solutions in each gallery varied from simple to complex, in some cases adding only one fixture to a gallery, in others complete gallery de-installation for new wiring, installation of multiple fixtures and ceiling repair. Recognizing that, in the future, preferences for lighting and standards for energy efficiency will change, many choices were made with reversibility in mind. As with other preservation projects, the team also learned that sometimes the best solution is simply to maintain what already exists.

Despite these efforts, one of the most common complaints from Gardner visitors remains that there is not enough light to properly view the art. One visitor wrote:

> Last week I visited the ISGM for the first time. There were many exhibits that are impossible to appreciate because of the low light intensity. I know you are worried about light damaging the artifacts but I can assure you that your extreme measures are totally ridiculous. I have heard you might be constrained by the will of Mrs. Gardner, which she wrote almost 100 years ago. However, there must be a way of bringing the ISGM into the 21st century. I am sure you have scientific advisers who know what I am saying is true. Is there no way that recent technological developments that were undreamed of in the 1920s can be embraced? I was encouraged to write to you by a story this morning reporting that the ceiling of the Sistine Chapel is now illuminated brilliantly by 7000 LEDs. What is deemed suitable for the works of Michelangelo should be considered by the ISGM.[20]

While the Sistine Ceiling frescos are not as susceptible to damage from light as some of the Gardner collection, this visitor has a valid

20 Anonymous to Visitor Services, 2011. Isabella Stewart Gardner Museum, Boston.

point regarding the many modern advances in lighting. The Gardner Museum staff continues to evaluate and adjust the lighting systems as both technologies and overall perceptions change. To this end, they are installing a new LED system as a part of the 2016–17 project to restore the museum's Raphael Room.[21]

This evaluation process also includes looking at the problem holistically and considering other options for protecting the collection. One solution the museum has used to prevent continual exposure to light is to put reproductions in place for the most-sensitive works. The conservation and curatorial staff focuses on using high quality reproductions and insures that the originals are available for scholarly study or rotation on-view. One such example is an elaborate, flame-stitched embroidery installed behind the fresco of *Hercules* by Piero Della Francesca (ca.1470).[22] The reproduction was hand-stitched by the Textiles conservation staff and volunteers over the course of a year.

In another modern-day perspective, Boston Globe reporter Sebastian Smee wrote:

> Gardner's Museum — layered, cloistered, holding darkness and light in dynamic counterpoise — was designed as an antidote to the waves of modernity washing over American cities. It was to be a sanctuary, a retreat, a place of aesthetic elevation and spiritual consolation.
>
> Anyone who has been to the Gardner knows that Fenway Court, as she dubbed it, is also the opposite of most modern art museums, where an ideal of maximum illumination and transparency holds sway. Gardner's museum, by contrast is opaque from the outside, and as often as not, dismayingly dark inside [...]
>
> But of course, all this 'confusion' is a part not just of the 'charm' of the place, but also of Gardner's special intention for it. She wanted to induce a certain susceptibility to the viewer... she wanted to charge her museum with the kind of mystery and poetry that are, in most cases, conspicuous by their absence from most modern museums. Darkness and shadows were part of her arsenal.[23]

While he is referring to the Gardner Museum of the early twentieth-century, the idea of thinking about the museum today as 'an antidote to the waves of modernity' is one that is embraced in the museum's

21 https://www.gardnermuseum.org/experience/rooms/raphael-room

22 https://www.gardnermuseum.org/experience/collection/11720

23 Sebastian Smee, 'Taniguchi, Ando, and the Allure of Japanese Architecture', *Boston Globe*, 29 November 2014.

mission statement, 'to engage local and global audiences in a sanctuary of beauty and the arts where deeply personal and communal adventures unfold.'[24]

Additionally, the museum continues to support contemporary artists and scholars who, like John Singer Sargent, find beauty and inspiration in the quality of light at the Gardner. As the lighting designer Jennifer Tipton, a lecturer at the museum, put it:

> You go into a room and it is about how the room feels. It isn't about looking at the objects. Sometimes it's very difficult to see the objects, the specific objects in a room here. But it is about the way that a room is and makes you feel. And I've also come to know that Mrs. Gardner was a pretty remarkable lighting designer herself. And that you see the paintings the way she felt they should be seen in the light she felt they should be seen in. And, of course, the Gardner Museum is not a place where you run to, come from out of town and spend a few hours here and then leave. It is a place where you do keep coming back to see the paintings, to see the objects, to see the rooms in a new light each time, if you would. And it makes me so aware of the richness that comes from the light around and on the paintings as well as in the paintings.[25]

The lighting at Isabella Stewart Gardner's museum will likely be both celebrated and challenged for years to come, as it was when she first opened its doors. The museum continues to focus, not just on individual works of art, but on the whole experience of being within Gardner's extraordinary creation. Its staff and visitors will always be influenced by her legacy leaving 'a Museum for the education and enjoyment of the public *forever*.'

24 Board of Trustees, Isabella Stewart Gardner Museum, Boston, 2014.
25 Jennifer Tipton, 'Light and the Mind's Eye', Transcript, Isabella Stewart Gardner Museum, 16 January 1997, p. 4.

13. Seeing Beauty: Light and Design at the Freer Gallery, ca.1923

Lee Glazer

When the Freer Gallery of Art, the first stand-alone art museum of the Smithsonian Institution, opened to the public in 1923, critics were nearly unanimous in their praise of its elegant design, contemplative aura, and abundant natural light.[1] Housing a wide array of Asian antiquities and a narrow range of American art of the Aesthetic movement, the museum was envisioned by its founder, Detroit industrialist Charles Lang Freer (1854–1919) as 'a work of art in itself' and a 'very great ornament to Washington.'[2] Freer believed that 'proper conditions of light, environment, etc.' were fundamental to aesthetic appreciation.[3] He therefore included along with the donation of his collection funds for the construction of a museum building, and he took an active role in every aspect of its design and illumination. As he explained to Smithsonian Secretary Samuel P. Langley when they first began to negotiate the terms of Freer's gift, 'I regard my collections as constituting

1 See, for instance, Gertrude Richardson Brigham, 'Freer Collection Viewed in Private', *Washington Post*, 2 May 1923; Royal Cortissoz, 'The Freer Gallery', *New York Tribune*, 6 May 1923; 'The New Freer Gallery as a Test of Taste', *Literary Digest*, 2 June 1923, 32–33; Harvey M. Watts, 'Opening of the Freer Gallery of Art', *Art and Archaeology* 15.6 (1923), 271–77.

2 Charles Moore to Theodore Roosevelt, 1 November 1905. All correspondence is from the Charles Lang Freer Papers, Freer Gallery of Art and Arthur M. Sackler Archives, Smithsonian Institution, Washington, D.C. (hereafter CLF Papers).

3 'Extracts from Mr. Freer's Paper Read at Trustee Meeting April 14, 1914', Clyde H. Burroughs Records, Detroit Institute of Arts Archives.

 https://doi.org/10.11647/OBP.0151.13

a harmonious whole.' He continued, 'My object in providing a building is to insure the protection of this unity and the exhibition of every object in the collections in a proper and attractive manner.'[4]

Fig. 13.1 Freer Gallery of Art, Installation view of Chinese Gallery, 1923. Charles Lang Freer Papers, Freer Gallery of Art and Arthur M. Sackler Archive, Smithsonian Institution Archives. Image # SIA2015-000819.

A properly aesthetic setting was of particular importance to Freer, since at the time, Asian objects were generally displayed in the United States and Europe either as ethnographic artefacts or exotic bric-a-brac.[5] By presenting Asian works alongside contemporary American paintings in a purpose-built space, Freer hoped to bequeath to posterity what the artist James McNeill Whistler, his aesthetic guide, had called a 'story of the beautiful' — a non-linear visual narrative configured by formal harmonies resonating across cultural and temporal boundaries.[6] A 1909 portrait

4 Charles Lang Freer to Samuel P. Langley, 18 January 1905.
5 See Steven Conn, 'Where Is the East: Asian Objects in American Museums, from Nathan Dunn to Charles Freer', *Winterthur Portfolio* 35.2/3 (2000), 168–73.
6 In *Mr Whistler's 'Ten O'Clock'* (London: Chatto and Windus, 1888), p. 19, https://archive.org/details/tenoclock00whisgoog, the artist proclaimed, 'The story of

of the collector by Alvin Langdon Coburn represents this aestheticist ideal in concrete visual terms. In the photograph, staged in the viewing room of his Detroit home, Freer crouches on the floor, comparing the abraded, iridescent glaze of a twelfth-century Raqqa jar to the soft tones of *Venus Rising from the Sea* by Whistler. The image documents Freer's discerning eye, testifying to his personal transformation from capitalist to connoisseur; it also functioned as a demonstration of the type of aesthetic encounter that Freer hoped to encourage at his still-notional museum. 'For those with the power to see beauty,' Freer maintained, 'all works of art go together, whatever their period.'[7]

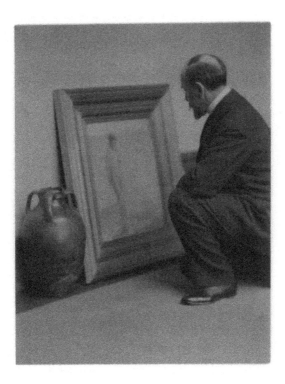

Fig. 13.2 Alvin Langdon Coburn, Charles Lang Freer comparing a thirteenth-century Raqqa ware jar with Whistler's *Venus Rising from the Sea*, 1909. Charles Lang Freer Papers, Freer Gallery of Art and Arthur M. Sackler Archive, Smithsonian Institution.

the beautiful is already complete — hewn in the marbles of the Parthenon, and broidered, with the birds, upon the fan of Hokusai.'

7 Quoted in Charles Moore, *Memoirs*, p. 280, Container 21, Charles Moore Papers, Manuscripts Division, Library of Congress, Washington, D.C.

Freer's assertion suggests that the story of the beautiful would not write itself: for objects on display to be fully appreciated, they must been seen by a particular type of viewer, one whose perceptual stance of total concentration ('the power to see beauty') required, or, perhaps, was constituted by, particular conditions ('proper conditions of light, environment, etc.'). Indeed, Freer seemed to recognize that aesthetic vision — and the perceptual expertise and cultural power that went along with it — was coextensive with the emergence of the art museum as a new form of public institution. Although they hardly existed in the United States at the end of the Civil War, art museums proliferated in the Gilded Age, opening at the rate of one per year between 1875 and 1905. As literary critic Stephen Arata says, art museums generated 'new modes of perception, providing as well the altered medium in which such perceptions are accomplished.'[8] When Freer began to plan the transfer of his personal collection to a public institution, he understood that lighting and design were crucial elements in managing aesthetic experience. Tracing Freer's ideas about lighting his collection from their domestic origins to their institutional manifestation allows us to see how he constructed a context in which the private and privileged 'power to see beauty' might be transferred to a new, public audience of museum visitors.

Before he became a public benefactor, Freer nurtured his aesthetic sensibilities at home, in a modest shingle-style structure that he built in the early 1890s as a retreat from the pressures of business and as a suitable environment for his growing art collection. He worked closely with artist friends and the architect, Wilson Eyre, to ensure an overall unity of design. Thomas Dewing and Dwight Tyron developed decorative ensembles of paintings, frames, wall treatments, and furnishings for adjoining ground-floor living rooms that included garden views, judiciously placed windows, and vine-shaped fixtures for diffused artificial light.

The technological innovations that so radically transformed the illumination of public and private space in the early to mid-nineteenth century had been largely accomplished by the time Freer began to

8 Stephen D. Arata, 'Object Lessons: Reading the Museum in The Golden Bowl', in Alison Booth (ed.), *Famous Last Words: Changes in Gender and Narrative Closure* (Charlottesville: University Press of Virginia, 1993), pp. 199–229 (pp. 202; 200–01).

collect and display art. Electric light was the norm in commercial art galleries and museums, even if its domestic use was limited to affluent homes like Freer's. A Japanese journalist named Nomura Michi spent a week in Detroit in 1908, and she reported that in the evening Freer escorted her through the house, where 'each picture was illuminated with electric light in order to look closely at it.'[9] Later, when planning the museum, Freer stipulated bright, almost clinical lighting for back-of-house storage areas, in order to facilitate the 'uninterrupted study of the objects.'[10]

Freer — and, later, his appointed surrogates John Lodge and Katherine Rhoades — believed that different contexts and different types of viewers required different approaches to lighting. Bright, unconcealed artificial light was associated with the objective, probing eye of the scholar. This type of lighting was appropriate for experts; it was not, however, conducive to purely aesthetic experience. Theatrical lighting and obvious special effects, meanwhile, were associated with the vulgar realm of commodity culture. In Freer's perceptual schema, more subtle effects of lighting were required to bestow 'charm' and induce what Freer called 'sympathy' between the public and the collection.[11]

Even though artificial light had its place in Freer's home and the museum, natural light took on special significance in his approach to illuminating his collection. Freer's correspondence includes numerous accounts of days spent studying paintings and ceramics under changing daylight conditions. Nomura, for instance, recalled that Freer put a different object on the dining room table every day, where they could enjoy it in isolation from the rest of the collection and appreciate it anew at each meal.[12] Freer's colleague Charles Moore described participating in a similar ritual, noting Freer liked to 'place his guests on the broad window seat' in the front hall while the manservant brought out

9 *Nomura Michi, Sekai isshū nikki* [A Trip around the World] (Tokyo: privately published, 1908), p. 68. I am grateful to Takako Sarai of the Freer and Sackler for her translation.

10 Helen W. Henderson, 'The Freer Collection', in her *The Art Treasures of Washington* (Boston: L.C. Page & Co., 1913), pp. 229–51 (p. 242), https://archive.org/stream/cu31924020704619#page/n359/mode/2up

11 For examples of Freer's invocation of 'charm' and 'sympathy' in the context of the museum experience, see 'Extracts from Mr. Freer's Paper' (Detroit) and 'Notes by Mr. Freer', undated autograph fragment, CLF Papers.

12 Nomura, *Sekai isshū nikki*, p. 77.

'paintings or pieces of bronze or pottery one by one and place[d] them' on an empty chair before the visitor.[13] Toward the end of Freer's life, William Bixby, a business associate and fellow collector, recounted an especially memorable day looking at paintings in Detroit: 'Seated in your home with a glass of Scotch,' he wrote, 'we saw your Whistler, the seminocturn [sic] perform its stunt of being five different pictures in twelve hours depending on light & shade.'[14] Bixby's description mirrored Freer's own experience of the collection. He wrote to Dewing, Tryon, and Abbott Thayer of his delight in uncrating a new painting and carrying it from room to room, enjoying the way different qualities of light revealed 'extremely subtle qualities' of colour and texture.[15]

When Freer described this type of visual experience to Tryon, the painter replied, 'If sensations felt in the production are again revealed to the spectator through the completed work... then I feel sure you will not soon exhaust it but will find it respond to many moods.'[16] The aesthetic object, according to this assessment, is understood as an index of subjective visual pleasure, first experienced by the artist in making the paintings, then later by the appreciative beholder, who, Tryon suggests, does not simply 'enjoy' the paintings as static objects, but derives pleasure from a subjective and dynamic perceptual process that mirrors that of the artist, but that is experienced by each beholder as private and unique. Freer continuously reaffirmed his faith in this type of unmediated perceptual experience, stating: 'The pure emotion of the observer should be his first sensation.'[17] How to provide visitors with 'ample opportunity to enjoy their emotional reactions' and maintain 'freshness of vision — simplicity of vision' became a pressing concern in 1908 and 1909, when Freer first began to plan the museum in Washington.

According to one advisor, art historian Langdon Warner, Freer recognized that in a museum 'there could be no intimate dining... and no nectar at one's elbow' to facilitate sympathy between the art and the viewer; he aspired to create 'the ideal museum.' Warner noted, 'Plans were sketched and questions of cases and lighting, storage and cork floors

13 Moore, *Memoirs*, p. 284.
14 William Bixby to Freer, 5 May 1919.
15 Freer to Dwight Tryon, 21 March 1898.
16 Tryon to Freer, 26 March 1898.
17 'Notes by Mr. Freer.'

and labels were threshed out.'[18] To accommodate increasingly frequent requests by students, art critics, and Smithsonian functionaries to see the collection and to test out his theories of exhibition design and lighting, Freer added two formal display spaces to his home: first, in 1906, a picture gallery for Whistler oils that Freer described as 'an informal large living room' and where he posed for the portrait by Coburn.[19] A few years later, he added a second, similarly proportioned viewing room, which served as a laboratory for exploring not only the arrangement and juxtaposition of objects, but gallery lighting and design as well. Both rooms were long and narrow and had leaded glass skylights as the principal means of illumination. Although Freer continued to share his collection with visitors 'comfortably enthroned' in his front hall or dining room, the new rooms became prototypes for the exhibition galleries that would be built in Washington several years later.[20]

As he began in earnest to plan the museum, Freer, always an enthusiastic traveller, ventured beyond Detroit, methodically researching picture galleries, museums, and libraries in the United States and abroad. He admired the severe elegance of neoclassical facades at the Albright Art Gallery in Buffalo and the Archaeological Museum in Athens, but he was less interested in architectural style than 'different methods of heating, ventilating, lighting... and other practical items.'[21] On the whole, he was unimpressed with the grand public temples of art that he saw on a 1909 tour of European institutions. 'The majority of museums are dungeon-like and mere tombs for the treasure they overshadow,' he wrote to his business partner back in Detroit; 'If the artists whose work is so shockingly treated have any influence with the devil, the souls of the architects are surely being well roasted below.'[22] The buildings he believed worthy of emulation were those that subscribed to thoughtful methods of illumination and, often, incorporated views of enclosed gardens into their design. He admired the small picture galleries at the Kaiser-Friedrich Museum in Berlin

18 Langdon Warner, 'The Freer Gift of Eastern Art to America', *Asia*, 23 August 1923, 593–94.
19 Freer to Wilson Eyre, 30 December 1902.
20 Annie Nathan Meyer, 'Charles L. Freer, Art Collector', *New York Evening Post*, 29 September 1919.
21 Freer to Abbott Thayer, 12 August 1912.
22 Freer to Frank Hecker, 8 July 1909.

because of the abundant natural light from windows and skylights; he saved an illustrated guidebook to the Museum Plantin-Moretus in Antwerp and later used its moveable window design as a model for the second viewing room in Detroit.

Freer was also drawn to buildings with open-air courtyards, like those he had seen on his first tour of Italy in 1894, when he followed an itinerary from Charles Adams Platt's illustrated book *Italian Gardens*. Freer returned to Italy at the turn of the century, when he lived in a villa in Capri that he owned with the Michigan attorney and classicist Thomas Spencer Jerome. In 1908, around the time he had begun researching museum architecture but before he had hired an architect, Freer sketched a preliminary building plan that included eight sky-lit galleries for the display of his American paintings. Natural top-lighting, along with an interior courtyard, continued to appear through countless iterations, eventually realised when Freer hired Charles Adams Platt in 1913.

Trained as a landscape painter before joining the architectural firm of McKim, Mead and White, Platt was best known for classically-inspired country houses and garden designs. He and Freer moved in the same social circles and shared an aestheticist belief in the universality of beauty.[23] Freer claimed that he let Platt 'boss' him, and indeed, the collector's failing health kept him from ever visiting Washington to see the construction in progress.[24] Architect and client nevertheless shared a common sensibility, and Platt seems to have been happy to collaborate with Freer on all the details of the museum, just as Wilson Eyre had done on Freer's house. Freer sent Platt reams of preliminary drawings and notes, and the ultimate design for the Freer Gallery, approved by the Smithsonian Regents in 1916, Freer's prediction in 1912 that 'the Italian Renaissance style of most simple lines may eventually be adopted.'[25] Taking his inspiration from the work of Mannerist architect Michele Sanmicheli, Platt designed a single-story block with galleries on the first floor and a raised basement level for art storage, study rooms, and offices. An interior corridor

23 See Keith N. Morgan, 'The Patronage Matrix: Charles A. Platt, Architect, Charles L. Freer, Client', *Winterthur Portfolio* 17.2–3 (1982), 121–34.

24 Quoted in Linda Merrill, 'The Washington Building', in *Thomas Lawton and Linda Merrill, Freer: A Legacy of Art* (Washington, D.C.: Freer Gallery of Art, 1993), pp. 235–53 (p. 251).

25 Freer to Thayer, 15 October 1912.

overlooking an open-air courtyard, links eighteen windowless, top-lit galleries and the Peacock Room at the southeast corner. The floor plan was practical, but it also served an aesthetic function. The interior corridor eliminated foot-traffic through the galleries, ensuring that they would be quiet and free of distractions. Additionally, as visitors moved through the museum, they glimpsed the garden, which Freer and his contemporaries regarded as inherently restorative.

With its restrained decoration and chilly materials, the Freer Gallery lacks what Anne Higgonet has called 'the calculated effects of domesticity' characteristic of other museums based on private collections, such as the Gardner or the Frick.[26] Even so, the intimate scale of the building and aspects of its design reflect the domestic origins of Freer's collecting practice and his fundamentally private, subjective viewing habits. As Linda Merrill has noted, 'Freer's vision of the skylit rooms was probably founded in his new picture gallery in the house on Ferry Avenue, which was somewhat smaller than the galleries he proposed [for his museum], but identically proportioned.'[27] The courtyard, according to contemporary critic Royal Cortissoz, 'brought into the scheme precious elements of light, air, and color' and 'did away with the frigidity so characteristic of museums.' The arrangement, he explained, facilitated concentration, and enhanced aesthetic pleasure: if the visitor 'has been absorbed in Chinese pottery, for example, and wants to go off and restfully think about it, he need not glance on his way at Egyptian glass or American painting. He can give himself up to the mood if he wants.'[28] If museum fatigue — a new-fangled and often-mentioned peril in an age of proliferating art museums — was the plague, the courtyard was the cure.

Among the books in Freer's personal library was Benjamin Ives Gilman's *Museum Ideals of Purpose and Methods*, which offered a physiological justification for Freer's understanding of illumination and its effects on museum-goers. Gilman was an instructor in psychology at Clark University and a curator at the Boston Museum of Fine Arts. (Freer chose another MFA curator, John Ellerton Lodge, as the Freer's first

26 Anne Higgonet, 'Museum Sight', in Andrew McClellan (ed.), *Art and Its Publics: Museum Studies at the Millennium* (Oxford: Blackwell Publishing, 2003), pp. 133–48 (p. 136).

27 Merrill, 'The Washington Building', p. 238.

28 Royal Cortissoz, 'The Freer Gallery,' *New York Tribune*, 6 May 1923.

director.) *Museum Ideals* brought together previously published essays on topics such as 'Museum Fatigue' and 'Glare in Museum Galleries,' which argued that most museums paid too much attention to the effect of light on objects, when the focus should be on how lighting affects the viewer. 'In museums,' Gilman wrote, 'the psychological element is more than half the problem of lighting.'[29] Diagrams accompanying Gilman's essay illustrated how top-lighting often resulted in distracting glare. As a corrective, he proposed a device called a skiascope, collapsible blinders to shut out distractions, eliminate glare, and induce concentration on one thing at a time 'under a moderate intensity of light.'[30] The skiascope never caught on. Gilman admitted that he utilized it to bolster an argument that was largely theoretical and psychological. However, we can see the skiascope as a kind of extreme, literal version of Freer's habit of viewing one work at a time, under perceptually favourable conditions.

When Freer had the director of the Kaiser-Friedrich Museum send Platt a sketch of the picture galleries Freer had so admired on his 1909 tour, Platt emphasized that the quality of light — 'the height and direction, … the exact arrangement of the skylight… pitch of glass, and all that sort of thing' — was more important than the mere quantity of illumination.[31] In order to test Platt's ideas, Freer paid to have a full-scale model of an exhibition gallery erected on the roof of the architect's New York office, and he loaned objects from his collection for Platt to study. Platt maintained that 'for light to fall at the proper angle, the distance from the skylight to the object displayed must not be too great,' and he developed a plan of small, proportionally narrow top'lit galleries that reiterated the basic design of Freer's viewing rooms in Detroit.[32] Freer did not live to see the museum completed, but he expressed satisfaction in Platt's plan for controlled natural illumination: 'a liberal amount of glass' combined with 'practicable appliances' to 'diffuse and direct light.'[33]

With the exception of the Peacock Room, which includes three French windows, all of the exhibition spaces in the Freer Gallery are windowless,

29 Benjamin Ives Gilman, *Museum Ideals of Purpose and Method*, 2nd ed. (Cambridge, MA: Harvard University Press, 1923; 1st ed. Cambridge: Printed by order of the trustees of the Museum at the Riverside Press, 1918, https://archive.org/details/museumidealspur00bostgoog), p. 163.
30 Ibid., pp. 238–48.
31 Platt to Freer, 4 August 1913.
32 Platt to Freer, 14 December 1917.
33 Freer to Platt, 17 December 1917.

with a system of double-paned attic skylights and sandblasted gallery glass. In the early years, visible artificial light fixtures were limited to non-gallery spaces. Blue and white incandescent bulbs and reflectors from the Frink Company (whose ads touted the fixtures' technical sophistication and aesthetic discretion) were installed in the attic skylights, where they were invisible from the galleries. The lights would have been intensely bright, all the same, and so they were probably only used when the days were short or unusually gloomy. A building report submitted before the museum opened noted that 'Little artificial light will ever be needed but whatever is used will come through especially imported glass.'[34]

In order to maintain the sense of an unmediated aesthetic encounter, it was important to minimize the lighting apparatus. A rail was installed all the way around the attic, from which an electric car and a man with a vacuum cleaner could 'keep all the glass in spotless condition.'[35] Ventilighters, expensive trademarked shades made of steel and bronze frames supporting narrow strips of fabric and available in a variety of colours, provided modulation and diffusion.[36] A minor crisis erupted in 1921, when Platt hung khaki-coloured Ventilighters in the Whistler galleries. They imparted a 'bilious' tone, according to Katherine Rhoades, who had been Freer's assistant in his final years and oversaw the installation of the galleries between 1920 and 1923. 'I felt as though I had suddenly put on a pair of yellow spectacles,' she told Lodge.[37] Platt defended his decision by invoking Whistler's use of yellow-toned walls at his infamous one-man exhibitions of the 1880s. Whistler had devised the décor and lighting to complement the art, but his orchestration of a total environment was also a marketing ploy. Platt's allusion to Whistlerian showmanship seems to have unsettled Lodge as much as the intrusive colour of the shades. He told Rhoades, 'Light-vanes and awnings reveal...a situation which has elements of comedy...but also of hopeless tragedy... There will be no more costly experiments.'[38]

34 H. P. Caemmerer, 'The Freer Gallery of Art' (Washington, D.C.), enclosed in letter from Charles Walcott to H. P, Caemmerer, 24 August 1920, CLF Papers.
35 Ibid.
36 See 'The Ventilighter', *American Architect* 116, 17 September 1919.
37 Katherine Rhoades to John Lodge, 18 May 1921.
38 Lodge to Rhoades, 20 May 1921.

Lodge was unhappy with the theatricality of the yellow lighting because it suggested that the power to see beauty was not, in fact, an independent faculty, but was something susceptible to manipulation, a trick of trade to be avoided by a serious art museum. 'The first point in lighting a picture gallery is to carefully select the lamp which gives the whitest light...and to conceal the lamps themselves from view,' declared one trade journal; 'The actual source of the light should be invisible.'[39] Lodge told Rhoades, 'The stimulus is supposed to come from the works of art shown' rather than from decoration or lighting.[40]

The fact that 'all the galleries are adopting yellow in some form as a setting for their exhibitions' only increased Lodge's resolve 'to adopt neither' in the Freer gallery.[41] The yellow shades probably were an infelicitous choice. Yet, Lodge's commitment to the illusion of unmediated aesthetic experience and 'natural' lighting — and his extreme, almost violent, aversion to contrived or vaguely theatrical effects — had a nasty subtext. 'Objects can be most effectively exhibited in a specially devised environment,' he acknowledged to Rhoades, 'for I have many times fallen an unwilling victim to shadow boxes, special effects of lighting and other devices dear to the heart of the Jew dealer.'[42] The significance of Lodge's snobbishness and bigotry is beyond the scope of this chapter — but it is a topic that demands further study, especially now with the museum community finally confronting the persistence of white male privilege in museum leadership, and a lack of diversity among museum audiences. In the more limited context of this essay, we can parse Lodge's remarks as a sign of anxiety about taking aesthetic experience into the public realm, an anxiety that Freer had hoped to quell through obsessive attention to building design and lighting. Those very obsessions, however, affirmed that 'the power to see beauty' was contingent on a variety of technological, psychological and sociological factors. In the realm of private connoisseurship and collecting, those factors include wealth, mobility, and access to experts; in the realm of the public museum, experiential conditions calculated to make the power to see beauty available to all. Freer, Platt, Lodge — and

39 'Electric Lighting for Picture Galleries', *The Telegraphic Journal and Electric Review* 13.93 (7 July 1883), 2.
40 Lodge to Rhoades, 13 April 1921.
41 Lodge to Rhoades, 25 May 1921.
42 Lodge to Rhoades, 26 March 1921.

the subsequent generations of directors and curators — are all every bit as much 'managers of consciousness,' to borrow Hans Haacke's phrase, as the shop window dressers or commercial art dealers that Lodge denigrated.[43] Even today, critics and the public remark on perfection of the museum's lighting, but its history suggests that the Freer Gallery embodied, like most museums, what Daniel Sherman has termed 'the imperfections as well as the highest aspirations of its creators.'[44]

43 See Hans Haacke, 'Museums: Managers of Consciousness', in Matthias Flügge and Robert Fleck (eds.), *Hans Haacke: For Real: Works 1959–2006* (Düsseldorf: Richter, 2006), pp. 271–81.

44 Daniel Sherman, *Worthy Monuments: Art Museums and the Politics of Culture in Nineteenth-Century France* (Cambridge, MA: Harvard University Press, 1989), p. 238.

PART IV

ON LIGHT IN MUSEUM AND MANSIONS IN ENGLAND, FRANCE, AND SPAIN

14. Lighting up the Darkness: The National Gallery, London

Sarah Quill

During the early decades of the nineteenth century most public buildings in Britain, including museums and art galleries, were dependent on daylight for their primary means of lighting. This was usually achieved by means of roof-lanterns, windows or small cupolas, and a perfect example of this in a small museum building was at Sir John Soane's Museum in Lincoln's Inn Fields in London. Glazing was expensive, but after the glass excise tax was abolished in 1845, larger sheets of glass could be afforded for roofing material.[1]

During the second half of the nineteenth century, the museum establishment was split by a long-running debate as to the suitability of artificial lighting in picture galleries: an innovation to which the trustees of the National Gallery were strongly opposed. Their continuing reluctance throughout the nineteenth century and beyond to agree to the use of gas lighting was founded on a number of justifiable fears about environmental damage to the collection.[2]

The fact that by the second decade of the nineteenth century Britain still had no national gallery of art had long been a source of embarrassment for the nation. The British Museum, the first national

1 Richard Redgrave, 'The Construction of Picture Galleries', *The Builder*, 28 November 1857, pp. 689–90.
2 Geoffrey N. Swinney, 'The Evil of Vitiating and Heating the Air: Artificial Lighting and Public Access to the National Gallery, London, with Particular Reference to the Turner and Vernon Collections', *Journal of the History of Collections* 15.1 (2003), 83–112.

 https://doi.org/10.11647/OBP.0151.14

public museum in the world, had been founded in 1753 and the Royal Academy of Arts in 1768, while the Louvre in Paris had been in existence since 1793. But the funding of art galleries in Britain had always been left to private initiative, until the repayment to the British Government of an Austrian war loan meant that the responsibility could no longer be avoided.[3] In February 1824 the Chancellor of the Exchequer, Frederick Robinson, promised 'The establishment of a splendid gallery of works of art, worthy of the nation'. Unlike many museums in continental Europe, the National Gallery was not formed by nationalizing an existing royal collection (the Royal Collection in Britain is still held in trust by the Queen), and Robinson stressed the fact that the works of art involved would not be 'the rifled treasures of plundered palaces or the unhallowed spoils of violated altars'.[4] Instead, the Government purchased the art collection of the recently deceased banker and art collector John Julius Angerstein, with a view to creating the nucleus of a national collection. It consisted of thirty-eight important old master paintings, including works by Rembrandt, Titian, Claude, the Carracci, Velázquez and Reynolds; and Angerstein's house at 100 Pall Mall was also purchased, to become the National Gallery's first home. The relatively small building was compared by satirists with the magnificent spaces of the Musée du Louvre in Paris, and Charles Hullmandel's lithograph of 1830, which illustrated both buildings, bore the title *The Louvre or the National Gallery Paris, and No. 100 Pall Mall or the National Gallery of England*, with a quotation from Hamlet: 'Look here upon this picture, and on this: the counterfeit presentment of two brothers'.[5]

The rooms at Pall Mall were overcrowded and hot. The limitations of the building and the small number of pictures led to mockery in the press, and unfavourable comparisons were drawn with the public art museums of mainland Europe. Nevertheless, visitors flocked to the Pall Mall house at the rate of at least fifty people per hour.[6] Entry to the gallery was to be free, and the trustees stated that '[...] its doors must

3 Jonathan Conlin, *The Nation's Mantelpiece: A History of the National Gallery* (London: Pallas Athene, 2006), p. 52.
4 *Hansard* HC Deb 23 February 1824, vol. 10, p. 316, https://api.parliament.uk/historic-hansard/commons/1824/feb/23/financial-situation-of-the-country
5 William Shakespeare, *Hamlet*, Act 3, scene 4.
6 Brandon Taylor, *Art for the Nation: Exhibitions and the London Public 1747–2001* (Manchester: Manchester University Press, 1999), p. 37.

always be open […] to every decently dressed person […] accessible to all ranks and degrees of men'.[7] But the space was inadequate, and the trustees were soon complaining to the Treasury about the overcrowded picture-hanging; they also pointed out that if further offers of pictures were to be made, it would be impossible to show them to the best advantage, and that potential donors tended to stipulate that their gifts be properly displayed.

A watercolour by Frederick Mackenzie showing the interior rooms at Pall Mall was not entirely accurate in all its details: artistic licence was employed to give a more positive impression. The rooms were not so spacious as they appeared in the picture, in which a non-existent skylight was added to the ceilings of the two rooms, following complaints by visitors that the rooms were too dark and dingy for the proper display of paintings. Evidently Mackenzie's watercolour was made after 1826, when Titian's *Bacchus and Ariadne* (1520–23),[8] a major acquisition reproduced in his picture, was bought by the British Government from the Villa Aldobrandini in Rome.

In 1825, Sir George Beaumont, a painter and art collector who had campaigned for the creation of the National Gallery, presented his own collection to the nation, including Canaletto's *The Stonemason's Yard*[9] a Rembrandt and several Claudes. These were put on display with Angerstein's pictures in Pall Mall until subsidence in the building caused the collection to be moved a few doors away to 105 Pall Mall. There the situation was no better, and the novelist Anthony Trollope described the building as 'a dingy, dull, narrow house, ill-adapted for the exhibition of the treasures it held'.[10]

In 1831 Parliament agreed to construct a building for what was to become the permanent home of the National Gallery, on the north side of Trafalgar Square on the former site of the King's Mews. Designed by William Wilkins, it was completed in 1838 and opened by Queen Victoria, who had come to the throne the year before. The building, which had a wide frontage but measured only one gallery room in

7 G. J. W. Ellis, *Quarterly Review* 31 (April 1824), 210–13, cited in Conlin, *The Nation's Mantelpiece*, p. 53.

8 https://www.nationalgallery.org.uk/paintings/titian-bacchus-and-ariadne

9 https://www.nationalgallery.org.uk/paintings/canaletto-the-stonemasons-yard

10 Anthony Trollope, quoted in G. Martin, 'Founding of the National Gallery', part 7, *Connoisseur*, October 1974, 108–13 (p. 113).

depth, was much criticized, and soon became too small for its purpose. It would also house the Royal Academy in the east wing for thirty years until the Academy moved to Burlington House in 1868. Within thirty years the new National Gallery was already considered too small, and architecturally unworthy of its important site in the centre of London. Adequate daylight was provided by the central dome, skylights, and glass-roofed spaces, but only a year after the opening, there had been complaints to the trustees about the 'heat and the foulness of the air in the rooms and the lack of sufficient ventilation in the Galleries'.[11]

London was a heavily polluted city, partly due to the coal-burning industries based in the city and the increasing consumption of coal for domestic heating.[12] After investigating the grimy state of the pictures, the trustees concluded that the damage was caused by a combination of the soot and smoke expelled from the many chimneys in the area, as well as the high number of visitors, and that gas lighting would only exacerbate the problem. Opening the skylights of the gallery provided some ventilation, but also caused yet more dust and smoke to enter the rooms, so that in 1847 the Keeper, Charles Eastlake,[13] reported to the Trustees that the floors occasionally had to be watered to help lay the dust.[14] The lighting of public buildings by piped gas was being widely introduced, but it was decided that gas lighting at the National Gallery should be avoided, because it was already causing problems in other London buildings.

Sir Charles Eastlake, who had become Director in 1855, travelled widely in Europe to expand the collection, and he was particularly anxious to increase the number of Italian works of art in the gallery. One of his most important acquisitions was purchased from Count Vettor Pisani in Venice in 1857: Veronese's *Family of Darius before Alexander* (1565–70),[15] described by John Ruskin as 'the most precious Paul

11 Minutes of the National Gallery Board of Trustees, April 1839, vol. 1, p. 145.
12 David Saunders, 'Pollution and the National Gallery', *National Gallery Technical Bulletin* 21 (2000), 77–94.
13 Charles Lock Eastlake, PRA (1793–1865), painter, collector, gallery director and writer, was appointed the National Gallery's first Keeper in 1843. Knighted in 1850, he was elected first President of the Photographic Society in 1853, and in 1855 became Director of the National Gallery.
14 Minutes of the National Gallery Board of Trustees, July 1847, vol. 1, p. 356, cited in Saunders, 'Pollution and the National Gallery', p. 77.
15 https://www.nationalgallery.org.uk/paintings/paolo-veronese-the-family-of-darius-before-alexander

Veronese in the world',[16] and of which Henry James would later write, 'the picture sends a glow into the cold London twilight'.[17] It was as well that the picture had its own glow, for there was still to be no lighting by gas at Trafalgar Square, even in the early years of the twentieth century. The trustees of the British Museum were in agreement, continuing to hold out against evening openings and artificial lighting.

The Athenaeum Club in Pall Mall had been an early convert to gas in the 1830s, but the sulphur dioxide emissions were soon causing damage there in various ways — principally to leather book-bindings and pictures, so that the club was forced to increase its membership fees to help cover the high costs of repairs.[18] After 1886 the Athenaeum was lit by electric light, which was still a relative innovation for public buildings in London. The scientist Michael Faraday, who was invited to investigate the problem of smoke and pollution in the National Gallery in 1850, reported on the types of pollutant existing in London, including 'inorganic fumes from chimneys and the organic miasma from the crowds that are in the town'.[19] The avoidance of gas lighting at the National Gallery meant that evening openings were out of the question, and that gallery hours continued to be dependent on available daylight.

But there were other considerations affecting the decision to avoid evening openings: the people. London and the northern cities were awash with public houses and gin palaces; gin was cheap, and drunkenness was a major problem. A programme of civic improvement had followed a Parliamentary Bill of 1834: the intention was to provide recreational and cultural activities that would, it was hoped, help divert the poorer classes away from their undesirable leisure pursuits in the public houses to enjoy more refined and improving pastimes.[20] The report caused some hilarity in the House of Commons and was ridiculed in the Press; the *Spectator* labelled it 'The Report of the Drunken Committee', and wrote,

16 *The Stones of Venice*, vol. II, in E. T. Cook and A. Wedderburn (eds.), *The Works of John Ruskin*, 12 vols. (Library Edition, London 1903–12), XI, p. 359.

17 Henry James, *Italian Hours* (London: Heinemann, 1909), p. 18.

18 Humphry Ward, *History of the Athenaeum, 1824–1925* (London: William Clowes & Sons, 1926).

19 Report from the Select Committee on the National Gallery, 25 July 1850, para 684, cited in Saunders 'Pollution and the National Gallery', p. 77.

20 *Hansard*, HC Deb 5 August 1834, vol 25, pp. cc963–70, https://api.parliament.uk/ historic-hansard/commons/1834/aug/05/committee-on-drunkenness

'It is impossible to read a single paragraph of this document without laughing, it is so rich in absurdity'.[21]

But the hope remained that the high culture and education provided by museums and art galleries might help turn the working man away from drink and dissipation. The National Gallery Keeper, Thomas Uwins, was disconcerted when he came across a family having an impromptu picnic in the gallery, with '[...] a basket of provisions, and who [...] seemed to make themselves very comfortable [...] I suggested to them the impropriety of such a proceeding [...] they were very good-humoured, and a lady offered me a glass of gin, and wished me to partake of what they had provided'.[22] People tended to bring in their entire families, including small babies, and there were the inevitable accidents. Along with misgivings about the behaviour of some of the daytime visitors, there was the worry that the wrong sort of people were likely to be attracted in the evenings, should the gallery hours be extended. Directly behind the gallery in Trafalgar Square were the Charing Cross army barracks, the workhouse at St Martin in the Fields, and the insalubrious areas surrounding Leicester Square and Soho. Trafalgar Square itself was full of rough sleepers at night, and it was feared that drunken soldiers and prostitutes might use the building as a convenient meeting place in the evenings. Fire was another hazard: serious fires in gas-lit theatres frequently broke out, and in 1872 the Drury Lane Theatre burned down entirely. So for a variety of reasons, the trustees of both the British Museum and the National Gallery remained unanimous that they would not allow their collections to be open at any hour that would require gaslight, and they continued to resist evening openings, in spite of repeated calls from both press and Parliament.

From the outset the National Gallery's collection had included works by British artists. By the mid-1840s, the rooms were already overcrowded, and when Robert Vernon presented a large gift of British works to the Gallery in 1847, including four Turners, they had to be displayed elsewhere: first at Vernon's private house, and later at Marlborough House. A further complication was the Turner Bequest

21 *The Spectator*, 9 August 1834, p. 16, http://archive.spectator.co.uk/page/9th-august-1834/16

22 *Report from the Select Committee on the National Gallery: Together with Minutes of Evidence, Appendix and Index* (London: House of Commons, 25 July 1850), para. 82.

itself. J. M. W. Turner, who had died in 1851, left a large number of oil paintings, drawings and watercolours to the National Gallery, including *The Sun Rising through Vapour* (before 1807)[23] and *The Fighting Temeraire* (1839).[24] The Turner Bequest of 1856 was the largest donation of works ever made to the National Gallery, and it imposed certain conditions on the trustees, not all of which could easily be met; Charles Eastlake's directorship was somewhat overshadowed by the inability of the National Gallery trustees properly to fulfil the terms of the bequest. Lack of space was the principal problem: there was not nearly enough room to house the works at Trafalgar Square, and it was decided that the British Collection should be exhibited at the picture galleries of the South Kensington Museum (later to become known as the Victoria and Albert Museum). That decision meant that the National Gallery's British pictures would in fact be exposed to the gas lighting being used by another museum.

The South Kensington Museum (established in 1852 and originally based at Marlborough House in the Mall) had come about as a result of the success of the Great Exhibition of 1851. It was part of the vision of Prince Albert, who had planned the creation of a complex of museums and institutions that would embrace a wide range of educational enterprise in the sciences, engineering, manufacturing and the arts. The new museum, which opened in 1857, was in the rural and desirable area of South Kensington, and could thus afford to take a more enlightened attitude towards gaslight and evening openings. Its ambitious and energetic director, Henry Cole, installed gas lighting at the earliest opportunity, with a system that consisted of open fishtail burners extending from the pipes that supplied the gas.[25]

The working man's day was long, with a minimum of about sixty-five hours a week, and Saturdays were part of the working week. Henry Cole was determined to increase visitor numbers, and he extended the South Kensington Museum's opening hours until 10pm on two evenings a week, to enable working people to visit and thereby provide 'a powerful

23 https://www.nationalgallery.org.uk/paintings/joseph-mallord-william-turner-sun-rising-through-vapour

24 https://www.nationalgallery.org.uk/paintings/joseph-mallord-william-turner-the-fighting-temeraire

25 Geoffrey N. Swinney, 'Attitudes to Artificial Lighting in the Nineteenth Century', University Museums in Scotland, conference paper, Edinburgh, 2002, http://www.umis.ac.uk/conferences/conference2002_%20swinney.html

antidote to the gin palace,' as he wrote.[26] As though to underline the point, Queen Victoria's first official visit for the South Kensington Museum's opening in 1857 took place in the evening at 9.30pm.

John Ruskin, who had undertaken the enormous task of cataloguing almost 20,000 of Turner's sketches and drawings for the National Gallery, had strong reservations about the advisability of gas lighting, and in 1859 he wrote to *The Times*, 'I take no share in the responsibility of lighting the pictures of Reynolds or Turner with gas [...] on the contrary, my experience would lead me to apprehend serious injury to those pictures from such a measure; and it is with profound regret that I have heard of its adoption'.[27] And Ralph Wornum, the National Gallery Keeper at the time, noted in his diary, 'I suspect he is right: it dries the air too much'.[28] Two years earlier, in 1857, Ruskin had proposed that Turner's drawings be stored in cases for their protection against dust and light, and exposed only infrequently to the light.[29]

Following continuing public criticism of the lack of space in the gallery rooms, the National Gallery building was extended by the architect Edward M. Barry between 1869 and 1876. He added seven new galleries at the east end, and arranged the five main 'Barry Rooms' in the form of a Greek cross, with the large octagonal domed room no. 36 at the centre. The extension created much needed extra space and light, and it also meant that the British pictures being exhibited at the South Kensington Museum could be returned to Trafalgar Square. (At the end of the nineteenth century, many of them, including those from the Vernon and Turner bequests, made their way to the Tate Gallery, which was established in 1897 as a new national gallery of British art, and which later became independent of the National Gallery.)

The question of Sunday openings was another issue that split the museum world and provided good material for satirists and illustrators. Where the National Gallery was concerned, the trustees continued to resist pressure, and to hold out against illumination by gas. There were to be many years of debate before Sunday opening was eventually

26 Henry Cole, Alan Summerly Cole (Donor.), *Diaries, 1822–1882* (1857), held in the National Art Library, Victoria and Albert Museum, MSL/1934/4117-4159.
27 John Ruskin, *Works* XIII, p. 339.
28 Ralph Wornum, *Diary* 1855–77, National Gallery Archive, NG 32/67.
29 Saunders, 'Pollution and the National Gallery', citing Minutes of the National Gallery Board of Trustees, 9 February 1857, vol. 4, p. 77.

introduced at the gallery in 1896, although it had already come into effect in many other London galleries.[30]

In 1880 the South Kensington Museum introduced electric lighting into its galleries, and the British Museum followed suit in 1890.[31] The decision to install electric light at the National Gallery was made much later (in 1914), but it was not until 1935, under the directorship of Kenneth Clark, that the gallery, having bypassed gas lighting altogether, installed electric light in all the rooms and finally introduced evening opening hours for three nights a week until 8pm. But so far as visitor numbers were concerned, it was already too late: new leisure distractions had taken over, and the biggest attraction in the 1930s was the cinema. For the time being, the mass audience was lost to the museums and galleries, many of which were forced to reduce their evening opening hours, or to abandon evening openings altogether.

By the start of the second decade of the twenty-first century, the National Gallery had become a leader in the field of lighting systems for museums and galleries, and was the first institution to use LED lighting in conjunction with an automated system of adjustment of roof-light blinds. These blinds open and close gradually, in accordance with the amount and angle of sunlight that enters, and the new system ensures that an even and diffused light reaches the galleries through UV-filtered roof light glazing, so that the natural light is augmented only when necessary. The National Gallery has continued to expand its collection, with a combination of public expenditure and private gift, and has held to its original aim: to care for the national collection of paintings, and to keep it free of charge for the public to visit.

30 Conlin, *The Nation's Mantelpiece*, p. 236.
31 Ibid., p. 238.

15. Sir John Soane

Helen Dorey

When the architect Sir John Soane died in January 1837 he left his house at 13 Lincoln's Inn Fields in London, which was also his private museum, library and architectural office, to the nation. He achieved this by means of a private Act of Parliament (passed in 1833, the year of his 80th birthday) which stipulated that it must be preserved 'as nearly as possible' as it was left at the time of his death: this requirement is still in force today.

Most of Soane's Museum has remained largely unchanged for the last 180 years, including iconic interiors such as the Roman inspired Library-Dining Room, brilliantly inventive Picture Room (with its ingenious 'moveable planes'), mock-medieval Monk's Parlour and Monk's Yard and also Soane's architectural office. At the heart of the building is the 'Museum' — what Soane called the 'Dome' — an area piled high with a Piranesian arrangement of fragments and casts, presided over by Francis Chantrey's bust of Sir John Soane himself.

Soane was his own architect, demolishing the previous building on the site and constructing No. 13 in 1812–13, continuing to modify its design and add ever more items to his collections until his death in 1837. He was always seeking to enhance the poetic and picturesque qualities of his interiors as the setting for arrangements of works of art that he intended should embody 'the union of Architecture, Painting and Sculpture'. Soane was Professor of Architecture at the Royal Academy, and at his very first lecture in 1809 he issued a public invitation to his Academy students to visit his house the day before and the day after

 https://doi.org/10.11647/OBP.0151.15

each of his lectures. From 1812 the house was referred to publicly as an 'academy of architecture',[1] but it was also a museum and Soane's home and architectural office as well.

Soane was an architect of light. One of the great characteristics of his buildings is that they are designed to maximise natural light, usually through top lighting via skylights of varying forms and sizes, often used in combination to light a single interior. While earlier architects had used top-lighting, in his complex, intricate use of skylights in the domestic interior Soane was an innovator.

Soane was inspired by seminal early experiences of buildings in Italy on his grand tour during 1778–80, when he wandered through the ruins of Rome, open to the sky, and explored the top-lit subterranean passages of the Villa Adriana at Tivoli. The Pantheon provided direct inspiration as can be seen in Soane's later Rotunda at the Bank of England, which features natural light pouring in not just through the drum in the centre of the dome but also through a series of large Diocletian windows. There is no sign of any fixed lighting — nor does any appear in the many other surviving watercolour perspectives of the interiors of the Bank, which show clerks at work serving customers in brilliant natural daylight. Of course the Bank of England was not normally open at night[2] but presumably oil lamps were used on the desks on dark afternoons.[3]

Soane's *bravura* manipulation of natural light is equally beautifully demonstrated by his Law Courts at Westminster, constructed on such a constricted site that most of them had no windows. His Court of Chancery featured a spectacular cut-away oculus over the central space and numerous skylights and windows at the upper levels to allow light to penetrate to even the darkest corners of the court. One Soane building that we know was used at night was the Freemason's Hall, of which Joseph Gandy painted a spectacular night-time watercolour showing it

1 *The European Magazine*, vol. 62, November 1812, p. 388.
2 Drawing SM 1/8/7 is a night time view of the troops of the Bank of England Volunteer Corps having dinner in the Consols Dividend Office; the sketch for it (SM Vol.69/34) is dated 10 September 1799. This shows candles around the walls on small sconces and also arranged on two levels of the iron stove in the centre of the room. However, these were probably temporarily put out for the occasion — no fixtures are shown in any other views of this interior.
3 Late-nineteenth and early-twentieth-century photographs show lamps placed on the desks in the Bank offices.

lit by argand oil lamps (each one with four burners) hanging from the corners of the canopy at the centre of the ceiling.

So what did Soane do to light his own house? As in his other buildings the prime source of light was the sun — daylight — brought into the Museum at the back of the house through a series of skylights of different forms. From the beginning the scenography of this lighting — which Soane's friend, the novelist Barbara Hofland, described as 'exquisite hues and magical effects' — was very important to him. A section through the Museum drawn in 1817 by one of Soane's pupils captures beautifully the effect and atmosphere that he was aiming to create.

By the end of his life Soane's house and Museum incorporated fifteen windows, five doors, two skylights and one glazed screen containing pieces of historic stained glass — bought at the sale-rooms. A further eleven doors and windows and ten skylights contained coloured glass — combining either light yellow, dark yellow or etched white glass with painted coloured glass borders of various patterns.[4] This manipulation of the light had a profound effect on the appearance of Soane's collections and on the emotional impact of his arrangements of works of art — as it continues to have to this day. In his use of coloured and stained glass he was inspired by earlier collectors such as William Beckford at Fonthill and Horace Walpole at Strawberry Hill, and by the picturesque movement as well as the effects created in the theatre and for popular entertainments.[5]

Soane was inspired by Sir William Chambers' description of how an architect should regulate 'the quantity of light introduced' into any building 'so as to excite gay, cheerful, solemn or gloomy sensations in the mind of the spectator according to the nature and purposes for which the structure is intended'.[6] The idea of architecture creating different moods was developed by the French theorist Le Camus de Mézières

4 The stained and coloured glass in the house at the time of Soane's death is recorded in the *AB Inventory*, 1837, SM Archive.

5 For a more detailed discussion of the influences on this aspect of Soane's lighting see Helen Dorey '"Exquisite Hues and Magical Effects": Sir John Soane's Use of Stained Glass at 13 Lincoln's Inn Fields' in *The Journal of Stained Glass*, special issue Sandra Coley (ed.) *The Stained Glass Collection of Sir John Soane's Museum* 27 (2004), 7–36.

6 William Chambers, *A Treatise on the Decorative Part of Civil Architecture*, 2 vols. (Cambridge: Cambridge University Press, 2012), II, p. 353.

who emphasised the key role played by light, particularly in making buildings 'mysterieux ou tristes' [mysterious or sad]. Soane translated a whole passage from Le Camus when preparing his Royal Academy lectures, as follows: 'a well lighted and well aired building, when all the rest is well treated becomes agreeable and cheerful. Less open, less sheltered, it offers a serious character: the light still more intercepted, it is mysterious or gloomy'. In his eighth Royal Academy lecture he spoke vigorously in support of the '*lumière mysterieuse*, so successfully practised by the French Artist [...] [which] is a most powerful agent in the hands of a man of genius', adding 'its power cannot be too fully understood, nor too highly appreciated. It is, however, little attended to in our architecture [...] [because] we do not sufficiently feel the importance of character in our buildings, to which the mode of admitting light contributes in no small degree.'[7]

The desire to evoke mood is seen in Soane's earliest designs for the natural lighting of Lincoln's Inn Fields. An early design perspective for the central dome area drawn by his pupil James Adams in June 1808 depicts a strong contrast between the well-lit upper part of the Museum with its sunny atmosphere and the gloomy crypt in the basement beneath. The contrast in mood expressed in this early design was put into words many years later, in Soane's own *Description of the Residence of Sir John Soane* (published in 1835):

> looking downwards [...] we behold the catacombs pale and shadowy in their solitary crypt; looking upwards, the beams of golden light fall on [...] lovely specimens of art.[8]

Only spaces where good light was essential for working, such as Attic rooms and the kitchens, the province of the servants, contained no coloured glass at all. Two spaces that required excellent daylight — the architectural office and the Picture Room — have skylights filled with clear glass for good natural light, not distorted by colour. Soane took full advantage of their strong lighting by using it to create atmosphere in adjoining or adjacent spaces, by contrast. For example in the Picture

7 David Watkin, *Sir John Soane: Enlightenment Thought and the Royal Academy Lectures* (Cambridge: Cambridge University Press, 1997), p. 598.

8 Sir John Soane, *Description of the Residence of Sir John Soane, Architect* (London: Printed by Levey, Robson, and Franklyn, St. Martin's Lane, 1835), https://archive. org/details/gri_descriptiono00soan/page/n12.

Room clear light through lantern lights is provided for optimum viewing of important pictures. On the south side of the Picture Room great doors or 'planes' open to enable visitors to view the spectacle of a statue of a nymph perched above a model of one of the façades of the Bank of England. The effect is like that of opening the doors to a shrine where the goddess stands with offerings at her feet. A half-round skylight above is filled with primrose-yellow glass causing the arrangement to be lit by strong yellow light to create maximum theatrical impact, in contrast with the Picture Room itself.

Soane very often augmented his beautifully nuanced natural lighting effects with mirrors, as in the Library-Dining Room and Breakfast Room where convex and flat mirrors are combined with coloured glass and stained glass.[9] The convex mirrors augment the effect of mirror glass lining the backs of niches containing plaster busts (as a student Soane sketched mirror glass lining niches in which statues were displayed in the *salone* at the Villa Albani in Rome[10]). In the Breakfast Room mirrors are inserted into the ceiling and doors in a manner probably inspired by his early experience of their use at the Villa Palagonia in Sicily.[11] Similar effects are found in the recently restored private apartments on the second floor[12] where convex mirrors are installed in doors leading into the Model Room, creating unusual views of the room that alter depending on the angle of the door.

The mirrors had the added benefit of not just amplifying the effects of natural light but of enhancing the impact of candles. Soane would have used white wax candles such as those glimpsed in a watercolour view of his Library-Dining Room on the ground floor. Two candlesticks in the form of reclining female figures, each with

9 See *The Journal of Stained Glass* 27 (2004), 'The Stained Glass Collection of Sir John Soane's Museum', *op. cit.* for a fuller account of Soane's use of stained and coloured glass.

10 Soane's sketch is in the Victoria and Albert Museum, V&A 3436.189.

11 Soane never forgot the spectacular effects he had seen in the palace at Bagheria where mirror glass is set into vaulted ceilings and is also used in smaller panes in doors producing the effect of multiplying mirrors. In the appendices to his 1830 *Description* of his house he refers to the 'wonderful performances of the Prince of Palagonia in the decoration and furniture of his palace' (*Description of the Residence of John Soane, Architect,* limited edition published privately, 1830, p. 53).

12 The restored apartments opened in 2015 and feature numerous windows and doors filled with ancient panels of stained glass purchased by Soane and installed in combination with coloured or etched glass borders.

one small candle-arm, are visible on the mantelpiece to the left as are two pots containing spills for lighting candles. By the time Soane died the same candlesticks were in the private apartments on his bathroom mantelpiece. A pair of smart ormolu vases that Soane had on the mantelpiece in the Breakfast Room has lids in the form of flames that invert to become candle-holders.[13] A pair of brass 'chamber' (bedroom) candlesticks was in the Model Room at the time of Soane's death. Two tall wooden candlesticks in the Monk's Parlour contain timber candles, painted in imitation of wax, which are recorded as present in the earliest inventories of Soane's collection and were presumably therefore always ornamental and considered part of the collection of works of art.[14] Only three candlesticks remain that do not appear in the early inventories — they are probably the remnants of those everyday ones that were kept down in the domestic offices and brought out when required.[15]

Soane also had large candle chandeliers in his two drawing rooms on the first floor, regularly used for evening events. The one surviving original chandelier is now converted to electricity.

Apart from the watercolour of his Library-Dining room mentioned previously, the only other image from Soane's lifetime showing a candle in use is the frontispiece for John Britton's guide book to Soane's house, *The Union of Architecture, Sculpture and Painting,* published in 1827, clearly staged. It shows a burned down candle on the desk in the Monk's Parlour in the basement. We still use candles in the Museum at times today for special events and on very dark winter afternoons: however, they are in heavy glass jars, bedded in sand, rather than in the domestic fittings of Sir John Soane's time.

The main source of artificial light at night in Soane's day was colza oil lamps, kept in a lamp closet in the basement[16] and brought up into the various rooms as required. Two views that were drawn by Joseph Michael Gandy in 1811 show night-time effects in the Museum. The lighting effects Gandy shows in these evocative watercolours may have

13 SM BR20 and BR24 see www.soane.org/collections
14 SM MP280 and MP282.
15 SM X155, X128 and X129.
16 Plan SM 32/2C/1 shows a *Lamp Closet* on the east side of the basement staircase hall. This plan is one of a set that was drawn just after Soane's death in 1837.

been achieved with the use of reflectors, perhaps themselves mirrored. Just such a reflector is illustrated in a later watercolour showing a group of Soane's built works in an imaginary Soanean interior. It illustrates beautifully the powerful effect created by a lamp behind a reflector, which seems to be on an elaborate stand (incidentally, with Soane's coat-of-arms on it). Sadly it is not clear whether this stand actually existed or if it was a figment of Gandy's imagination.

We know very little about where Soane placed lamps routinely in the Museum. We do know that there were only two fixed lamps inside the house at the time of his death — both oil lamps — one in the Monk's Parlour in the basement and one on a bracket at the curve of the stairs at second floor level, where the bedrooms were. Unfortunately neither is shown in surviving views of the house.[17] However, one fascinating clue we do have about Soane's use of candles and lamps at night relates to the celebrations he held to mark the acquisition of his greatest treasure, the ancient Egyptian sarcophagus of Pharaoh Seti I, which he placed at the heart of his basement in the 'Sepulchral Chamber' in May 1824. Ten months later, in March 1825, he invited 1,000 people over three nights to view the sarcophagus 'by lamplight'.

The lighting of the Museum for the three evenings was very carefully planned and the bill for the special temporary installation that was created using hired lamps gives an insight into how Soane envisaged his house being lit for an evening function.[18] As well as purchasing eight pounds (weight) of 'Palace wax lights' and three pounds of wax candles from *Davies' Candle, Soap and Oil Warehouse*, Soane engaged outside contractors to supply additional lighting. John Patrick was paid £24.15s 'To illuminate the outside of the house with 182 Glass Bucket Lamps and 74 Glass Barrel Lamps, 3 nights @ £8.5s per night'.[19] These must have been placed on all the window sills on the front façade and, perhaps, lined the curb around the front courtyard and flanked the front steps. William Collins, manufacturer of stained glass and dealer in lighting appliances, was engaged to provide (on hire) 108 lamps, chandeliers and

17 The fitting from which the hanging lamp in the Monk's Parlour was suspended, in the centre of a beam on the south side, survives. This enabled us to identify its location and install an authentic hanging argand lamp (electrified) there in 2000 (the gift of Mr. Christopher Hodsoll, SM XF321).
18 SM Archives 7/7/46 and 7/8/35-36.
19 SM Archives 7/7/46.

candelabra to be placed or suspended around the ground floor rooms and in the basement. The upstairs rooms do not seem to have been open to the guests.[20] Soane himself must have supervised the placing of all the lamps and Collins' bill reflects the detailed attention given to this to exploit to the full all the contrasts of light with gloom around the house and to create the maximum romantic atmosphere in which to appreciate the sarcophagus.

The Entrance Hall was well lit with a lantern with two-light burner and two French lamps with pedestals. The Library (the main ground floor reception room) was allocated two large four-light candelabra, two two-light antique lamps, two single-light rich pedestal lamps and two single-light bronze lamps. Additionally, three lamps were placed outside the Dining Room window in the Monument Court, which would have enabled guests to see the sculpture on the parapets above and to view the *Pasticcio* (a dramatic column of architectural fragments) in the centre of the yard. The domed Breakfast Room was lit by two rich five-light candelabra which were probably placed on the two tables, although one may have been on the desk in the window.

In the main Dome Area at the back of the Museum, four three-light lamps were suspended above the sarcophagus. These lamps would have illuminated the sarcophagus very well from above. The large hooks from which they were suspended are almost certainly still *in situ* today. There were also four single-light French lamps (presumably on the balustrades) and two one-light bracket lamps (these were perhaps fixed to two of the dome piers). In the basement Soane had much less light, in keeping with the romantic, funereal atmosphere he wished to create. In the Monk's Parlour, he placed four two-light pedestal lamps, two single-light French lamps and two single-light bronze lamps but the basement passages and the catacombs were not lit at all.

Around the sarcophagus were placed a two-light pedestal lamp, a single-light pedestal lamp with reflector and seven 'japanned lamps'. Some of these were actually inside the sarcophagus, which, the *Morning Chronicle* reported, 'seemed to be of a red colour, owing to the red light of the lamps by which it was illuminated.[21] The *Chronicle* was under a

20 This information is based on an analysis of the archive bills for the hire of lights, SM Archives 7/8/35-36.

21 *The Morning Chronicle*, 25 March 1825, p. 3.

misapprehension: the lamps placed in the sarcophagus did not need to be red to turn the coffin crimson — this extraordinary effect occurs as a result of the light passing through the translucent stone. This obviously became a party piece. The celebrated German art historian and museum director Gustav Waagen visited London in the 1830s, and described the access to and lighting of the Museum:

> I must say a few words of one of the most celebrated curiosities of London, the museum of the architect Sir John Soane to which in the most praiseworthy manner, he permits persons to have access several times a week [...] the principal part has the appearance of a mine with many veins, in which instead of metallic ores, you find works of art. Thus in most apartments a broken light falls from above, which heightens the feeling of the subterranean and mysterious. This is increased to the highest degree by the most celebrated of all the sarcophagi found in Egypt which adorns the middle [...] The stone is so transparent that when a candle is put into the sarcophagus, it appears of a beautiful red.[22]

When we cleaned the sarcophagus a few years ago the underside was found to be covered with soot, so it is possible that candles were put under it to create this effect at times. Modern experiments have recreated something like the effect of having lamps in the sarcophagus by using massed candles.

The total cost of Collins' lighting was £80.9s and the lamps consumed '36 Gallons of best oil' over the three evenings.[23]

Another unusual aspect of lighting preserved in the Museum is a group of four obelisks that originally supported oil lamps in Lincoln's Inn Fields.[24] Soane collected them when they were removed as street lighting and replaced with gas in about 1820, placing one pair outside in his Monk's Yard and the other in the basement. He seems to have begun to use gas himself from January 1828.[25] The earliest receipt from the Gas,

22 Gustav Waagen, *Works of Art and Artists in England,* 3 vols. (London: John Murray, 1838), II, p. 179.
23 Soane Museum Archives 7/8/35-36.
24 SM M441, M445, MY30 and MY31. A number of similar obelisks can still be seen outside buildings in Lincoln's Inn Fields and elsewhere in London, for example, around the perimeter of the grounds of Westminster Abbey. Their use as oil lamps is illustrated in an imaginary design perspective for the north side of Lincoln's Inn Fields, 1813, SM 74/4/1.
25 SM Archives 7/11/23 bill from John Archer records 30 January 1828 an item for *Gaslight Apparatus furnished and fitted up.*

Light & Coke Company for rent is for two quarters due in March 1828 and from then onwards there are regular bills for quarterly rent (and for coke supplied separately by them). A bill from John Archer for work in early 1828 tantalisingly refers to experiments with gas lighting in the 'Monk's Wilderness' — the romantic yard filled with medieval ruins that Soane created for his imaginary monk 'Padre Giovanni'. The bill records that he was paid to move the lamps to face in a different direction as part of the work and 'to shew the effect in that situation'.[26] However, the equipment was removed after just a few weeks and plainly the experiment was a failure. Soane's *Note Book* for 5 May 1828 records 'Discontinue Gas in Monk's Garden'.[27]

Soane did install two gas lamps permanently, both outside, in the same year. He converted his porch lantern (formerly oil) to gas and installed a gas lamp on the north windowsill in the Monument Court. The men put it up first 'without lantern' so Soane could 'see the effect'. It is shown in views of the Breakfast Room window. Soane never used gas inside in his own residence and this may have been because it would have been extremely noxious smelling.[28] However, interestingly, John Britton, in the *Union* of 1827, refers to a gas installation done by Soane for one of his clients noting that: 'In a banqueting or ball room, a transparent ceiling, effectively lighted by gas, could not fail to be a very striking piece of decoration. In the house of the Earl of St. Germain, St. James's Square, Mr. Soane has erected a dining-room which is lighted by gas, concealed in the dome'.[29]

After Soane's death, the Museum continued to be lit by a combination of lamps and gas lights. A few gas lighting fixtures were installed inside in the 1850s but only in the basement and in areas where resident staff lived. Unfortunately, complaints that the Museum was dark led to damaging alterations that took place in about 1890 — sadly just a few years before electricity was installed in 1897 (relatively early for a London house).[30]

26 SM Archives 7/11/23 and duplicate copy 7/11/44.
27 SM Archives Soane Note Book entry for 5 May 1828.
28 It is also interesting to note that the gas pipes were unprotected and uninsulated in his day.
29 Britton, *op cit*, p. 4.
30 Electricity was introduced at the Houses of Parliament in 1859.

The last thirty years have been spent restoring Soane's arrangements of works of art and undoing changes to the building that had eroded many of Soane's original lighting effects, for example the removal of several light shafts. The most modest of these provided a single shaft of light via a glass door in a cupboard in the Picture Room to light a medieval carved wooden crucifixion scene in the Monk's Cell in the basement.[31] Another much larger aperture in the floor of the 'Lobby to the Breakfast Room' has been re-opened to enable light to pour down onto an arrangement of cinerary urns in the reinstated 'Catacombs' below, as Soane intended.[32] The most dramatic light shaft, introduced by Soane in the late 1820s, brought natural light into the heart of the second floor. The light was admitted through a skylight on the main roof, below which the timber-panelled shaft punched through the third floor rear attic room to let light down into Soane's Book Passage. This shaft was dramatically hung with framed watercolours and a portrait of the young Soane himself, all of which could either be viewed from below or from the front attic via a pair of double doors.

In running Sir John Soane's Museum for the benefit of modern visitors we are determined not to flood the Museum with light. By reintroducing the blinds Soane had on every window and reducing the glare caused in some places by too much light we can keep the levels low and enable Soane's magical natural daylight effects to be seen and appreciated. We have judiciously introduced electrified argand lamps in some spaces to replicate at least the correct position of the kinds of light Soane was working with without the fittings being intrusive. Professor Foscari's remarks elsewhere in this volume are very pertinent to the Soane. In order to keep Soane's museum 'permanently magical', as one of his friends called it, we must, at least to some extent, keep it dark.

31 This arrangement was recorded in a drawing of 1839, SM 32/3/19 and reinstated in 1990.

32 This work was carried out in 2015–16.

16. Chatsworth, a Modern English Mansion

Marina Coslovi

Chatsworth House, in Derbyshire, is the home of the Cavendish family, who were given the title of Dukes of Devonshire in 1694. For those of you who may believe you are not familiar with Chatsworth, let me remind you: Chatsworth was one of the models for Jane Austen's fictional Pemberley in *Pride and Prejudice* (1813), and we know what an important part Darcy's mansion plays in that novel. Indeed, it was while reading one of the best spinoffs based on Jane Austen's novel, P.D. James's *Death Comes to Pemberley* (2011), that I was first made aware of the quantity of candles needed in order to illuminate such a palace (all the crucial scenes in the novel spell out the inordinate number of candles required to provide light).[1]

'The Palace of the Peak,' as Chatsworth was called, was one of the main stops for travellers on the Grand Tour of England in the nineteenth century. It had been built to be a statement of power and wealth, and a public space. It was also, in the nineteenth century especially, a sign that power in England could be married to progress and that meant an openness to new technology. Since the transformation of the original Elizabethan house into a palatial mansion in the late seventeenth century, the Dukes of Devonshire had opened it up not only to the aristocracy and their personal guests, but also, and liberally, to 'the people'. As Black's guidebook noted in 1868, 'As the hour of eleven arrives, there are

1 P. D. James, *Death Comes to Pemberley* (New York: Alfred A. Knopf, 2011).

 https://doi.org/10.11647/OBP.0151.16

generally several parties outside the richly gilded gates of iron, waiting for the time of admission.'[2]

In 1864 the American philanthropist and social activist Elihu Burritt introduced Chatsworth by remarking that 'If England has no grand National Gallery like the French Louvre, she has works of art that would fill fifty Louvres, collected and treasured in these quiet private halls [...] and in no other country are the private treasure-houses of genius so accessible to the public as in this.'[3]

There were several attractions at Chatsworth: the grounds shaped by 'Capability' Brown; the gardens and Conservatory created by Sir Joseph Paxton; the gigantic Emperor Fountain; but its art collection, the work of generations of Cavendishes, and the richest to be found in a private residence in England, was certainly an important reason for visiting.

The gems of the Chatsworth collections were — and still are — the Old Masters' drawings and the sculptures. The drawings had been mostly acquired by the second Duke (1672–1729), and by the fourth Duke (1720–64) by way of marriage (he married Lady Charlotte Boyle [1731–54], who inherited her father's — the third Earl of Burlington's — collection). The sculptures, some ancient but mostly modern, were acquired by the sixth Duke, the Bachelor Duke (1790–1858). Much admired and discussed by visitors were also the paintings, by old masters and modern artists, the frescoes, and the wood carvings by Samuel Watson and Grinling Gibbons.

With virtually no exception, nineteenth-century visitors were struck by the modern character of Chatsworth. As Baedeker's handbook put it, Chatsworth was 'redolent of modern'.[4] Many American visitors like Margaret Fuller, typically looking for 'old' medieval England, were impressed by Chatsworth's 'fine expression of modern luxury and splendor' but left cold by it; they felt that the palace was too big and too opulent.[5]

2 Llewellynn Jewitt (ed.), *Black's Tourist's Guide to Derbyshire: Its Towns, Watering Places, Dales and Mansions, With Map of the County, Plan of Chatsworth and Haddon Hall* (Edinburgh: A. and C. Black, 1868), p. 86, https://catalog.hathitrust.org/Record/009789947

3 Elihu Burritt, *A Walk from London to John O'Groats, with Notes by the Way*, 2nd ed. (London: Sampson Low, Son, & Marston, 1864), p. 248, https://archive.org/stream/walkfromlondonto00burr#page/248/mode/2up

4 Karl Baedeker, *Great Britain. Handbook for Travellers* (Leipzig: Karl Baedeker Publisher, 1890), p. 501, https://archive.org/details/greatbritainhan07firgoog

5 Margaret Fuller Ossoli, *At Home and Abroad or Things and Thoughts in America and Europe* (Boston: Brown, Taggard and Chase, 1860; 2nd ed. New York: The

One of the features of modernity and opulence was the abundance of light. Not only were artificial light, candles and lamps lavishly provided thanks to the Duke's wealth, but there was also plenty of natural daylight regulated by the architecture of the building itself.

At a considerable cost, since at the time a tax on windows was still enforced, the Bachelor Duke opened additional windows that diminished the dimness of the Great Hall. He also replaced sash windows with single pane glass windows, which he considered 'the greatest ornament of modern decorations'.[6] These modern windows were admired by visitors both for the effect they created and for the views they admitted.[7]

Daylight was also at the heart of the Bachelor Duke's vision and his most important project, the new north wing that incorporated a sculpture gallery.

The Duke's love for sculpture had bloomed during his 1819 visit to Rome. Here he had met and befriended Antonio Canova, and commissioned works from him and other sculptors of his circle. One of the Duke's most powerful memories of this visit was being taken by Canova himself to see his recumbent *Venus* by torchlight, a fashionable thing to do, as Madame de Stael's novel *Corinne, or Italy* (1807) confirms.[8]

The Duke enjoyed this romantic aesthetic experience by torchlight, and replicated it at times at Chatsworth; nevertheless he developed different, more modern ideas about the perfect setting for his growing collection of sculptures. He worked closely with his architect Sir Jeffrey Wyatville, and together they created an innovative gallery that made the best use of daylight, and thus helped to inspire the later design of public museums in the nineteenth century.[9] They did not

Tribune Association, 1869), p. 165, https://babel.hathitrust.org/cgi/pt?id=miun.abx8370.0001.001

6 Chatsworth House Trust, *Your Guide to Chatsworth* (Leicester: Streamline Press Ltd., 2011), p. 58.

7 William Adam, *Description of Buxton, Chatsworth, and Castleton*. From Adam's *Gem of the Peak* (Derby Henry Mozley and Sons, and W. & W. Pike, 1847), p. 47ff., https://babel.hathitrust.org/cgi/pt?id=hvd.32044102827607

8 James Lees-Milne, *The Bachelor Duke. A Life of Spencer Cavendish 6th Duke of Devonshire 1790–1858* (London: John Murray, 1991), p. 46. On the Bachelor Duke and Canova see also Alison Yarrington, 'Under Italian Skies, the 6th Duke of Devonshire, Canova and the Formation of the Sculpture Gallery at Chatsworth House', *Journal of Anglo-Italian Studies* 10 (2009), 41–62 (pp. 50–51).

9 The Duchess of Devonshire, *Treasures of Chatsworth. A Private View* (London: Constable, 1991), p. 63.

choose marble but 'humble' opaque local sandstone for the floor and walls, thus avoiding reflected light. They designed skylights that took into consideration the fall of the directional natural light as the sun moves from east to west through the day, and which provided an even level of illumination from the top down.[10] Thanks to this innovative illumination the statues were bathed in a soft light that created a very different effect from the dramatic shadows cast by lack of light or artificial light (see Fig. 16.1).

Fig. 16.1 *The Sculpture-Gallery, Chatsworth,* drawing by Joel Cook (1882), in Joel Cook, *England, Picturesque and Descriptive. A Reminiscence of Foreign Travel* (Philadelphia: Porter and Coates, 1882), p. 84, https://www.gutenberg.org/files/29787/29787-h/29787-h.htm

This feature of the light streaming down from the roof was so striking that it was commented upon by virtually all travellers and guidebooks. For example, here is a 1897 response by Alfred Henry Malan, a passionate photographer, writing for *The Pall Mall Magazine*:

> The lusterless sandstone-backing shows off the statuary to great advantage in any light: but the very best time for coming here, albeit in uncanonical hours, is about nine on a summer morning, for then the diffused sunshine flowing in through the clerestory windows imparts a beautiful bloom and tender half-tone to the sculpture, to be met with at no other time of day, though the electric light is said to be an effective substitute.[11]

10 Yarrington, 'Under Italian Skies', p. 50.
11 Alfred Henry Malan, 'Chatsworth', *The Pall Mall Magazine* 11.46 (1897), 169–83 (pp. 175–76).

Malan visited Chatsworth before electricity was installed, but when work had already started, which may explain his final speculation (about which more later). What is interesting here is that sixty years after its creation, the illumination provided by the skylights for the statues was still surprising and noteworthy.

Ordinary visitors would see the sculpture gallery by day, and special guests could have access to it even before the canonical hour of 11am. However, the gallery was displayed also on the occasion of grand receptions, of which there were many at Chatsworth, and these typically took place in the evening. The skylights let in moonlight, of course. But until 1862, when coal gas works were built, lamps and candles were still the main source of night-time illumination.

In 1822 the Duke bought two magnificent candelabra, which were supplemented by static and hand-held candlelight. A candlelit tour of the sculpture gallery remained for some the ultimate aesthetic experience. Here is how William Haig Miller, the editor of *The Leisure Hour*, recounted a memorable evening visit in 1853:

> Another set of attendants were busily employed in lighting up the statue gallery [...] No one who has not seen statues by the well-disposed and artistically-managed light of numerous wax-tapers can have an idea of the surprising effects that are thus produced [...] There is an effect, as the rays of artificial light fall on the soft contour of the limbs, that daylight cannot give, and which seems almost to impart to the white cold marble some of the glowing and life-like attributes of painting.[12]

Whether one preferred the diffuse daylight that imparted 'bloom and tender half-tones' to the sculptures, or the more dramatic effects of candle light on marble, one thing is clear: thanks to the innovative illumination by day, and to the affluent consumption of candles and

12 William Haig Miller, 'A Day at Chatsworth', *The Leisure Hour: a Family Journal of Instruction and Recreation* 83 (28 July 1853), 490–93 (p. 492). Miller must have had Madame de Stael's *Corinne* in mind while visiting the gallery. Compare what Madame de Stael wrote in 1807: 'Corinne and Oswald finished the day by visiting the studio of the great Canova. The statues gained much by being seen by torchlight, as the ancient must have thought, who placed them in their Thermes, inaccessible to the day. A deeper shade thus softens the brilliant uniformity of the marble: its pallor looks more like that of life'. Madame de Stael, *Corinne; or, Italy*, trans. by Isabel Hill (London: Richard Bentley, 1838), p. 138, https://books.google.co.uk/boo ks?id=6kxgAAAAcAAJ&printsec=frontcover&dq=corinne,+or+italy+1838&hl=en& sa=X&ved=0ahUKEwjV8eaw4tjdAhXMKMAKHbCfBVkQ6AEILzAB

lamps by night, at Chatsworth visitors were offered a distinctive aesthetic experience.

Turning from the sculptures to the paintings: Chatsworth's rich collection was on display throughout the palace. Visitors' responses to paintings fell into two categories: admiration at their beauty, and complaints about the difficulty of seeing them, because of their position, and/or because of bad lighting.

In 1833 Orville Dewey observed that: 'There is a large number of paintings [...] a Henry VIII by Holbein, a Holy Family by Murillo, a piece by Salvator Rosa, but in so bad a light as to be lost, if it is anything.'[13]

Sixty years later, Alfred Henry Malan had a different kind of complaint about the pictures in the Picture gallery: 'It must be allowable just to remark that the perception of their merits will very largely depend upon that degree of skill with which you can manage to dodge those tiresome reflections from the opposite windows'.[14]

Too little light could obscure the merits of a painting, but too much light could be worse.

Malan was more satisfied by the interplay between natural and painted light in the chapel 'Verrio's masterpiece [...] seems cleverly painted to suit its position, the lighting of the composition, diagonally downwards from left to right coinciding with, but not wholly being due to, the slanting light from the end window'[15]

The Drawing Collection

Chatsworth's Old Masters drawing collection spans European art from the Renaissance to the seventeenth century, and is still the most comprehensive private collection in England, second only to the Royal Collection.

13 Orville Dewey, *The Works of the Reverend Orville Dewey D.D.* (London: Simms and M'Intyre, 1844), pp. 626–27, https://archive.org/details/worksoforvillede00dewe
14 Malan, 'Chatsworth', p. 172. Malan does not specify which paintings were affected by the tiresome reflections, but at least with reference to the Salvator Rosa, the problem seems to have been still there in 2012, judging from Scottish artist Judith Bridgeland's comments in her blog: 'the lighting was really bad with lots of reflection' Judith I. Bridgeland, 'Salvator Rosa's 'Landscape with Jacob's Dream'', 18 July 2012, http://jibridgland.blogspot.co.uk/2012/07/
15 Malan, 'Chatsworth', p. 171.

It presented special lighting challenges. The drawings by Raphael, Michelangelo, Leonardo da Vinci, Parmigianino, Barocci, Dürer, Rubens, Van Dyck, Rembrandt, Lorraine and others were originally kept at Devonshire House in London, where scholars and artists were granted access to them. Later they were moved to Chatsworth. As the Bachelor Duke himself explained in a 1844 *Handbook*, the drawings 'hardly ever saw the light of day in my Father's time, nor in mine often, till I rescued them from portfolios, and placed them, framed, in the South Gallery below.'[16]

In 1890 Baedeker praised the fact that the drawings in the Sketch Room were 'admirably lighted.' Unfortunately, light exposure causes fading and is the number-one enemy of drawings. In 1893 the drawings still hung in the gallery but were covered by protective blinds. In the early twentieth century they had to be put back in portfolios to prevent further fading. Deborah Mitford, one of the famed Mitford sisters who became the eleventh Duchess of Devonshire, has a fine description of what happened to the collection at this stage: 'Granny used to get them out now and again, more as a housekeeper's duty than for pleasure, flip through a box of Raphaels, put them back, snap the fastener and say, 'There — *they've* been aired for the year.''[17] The drawings were kept in special cabinets in the library, but family guests, if not casual visitors, could still enjoy them freely.

Let's return to the time of the Bachelor Duke. He was an art lover and a connoisseur of sculpture, but in the *Handbook* he admitted that it was beyond him 'to make any description of the merits of this rich and valuable possession.' He added that in the task of cataloging the collection, he would value the help of someone he could really trust; not an amateur, who 'would run into fanciful theories' nor an artist, who 'would be prolix', but someone like Madame de Mayendorff (the wife of Baron de Meyendorff, Russian diplomat and ambassador). And it is at this point of his description that the Duke gives us a glimpse into what must have been the perfect enjoyment of a perfect drawing made possible by perfect illumination: Madame de Meyendorff, the Duke writes, '*used to copy here at daybreak in the summer mornings,* and

16 The Duchess of Devonshire, *Treasures*, p. 7.
17 Ibid., p. 8.

her admiration of the sketches was without bounds'.[18] One almost wishes a Carpaccio, or a Ruskin, had been there to catch forever this timeless moment when an art lover tenderly copied an old master in the luminous stillness of a summer dawn.

But aesthetics were constantly placed alongside innovation by the Cavendishes. On 29 November 1861 the *Sheffield and Rotherham Independent* announced: 'The Duke has recently had gas works erected at the south end of the kitchen garden, for the purpose of lighting Chatsworth House, stables, &. c. [...] the house is now illuminated with gas throughout.'[19] Chatsworth's Archives accounts show that the use of gas lighting dramatically reduced the expenditure for oil and candles, and that gas was used into the 1920s, decades after the introduction of electricity.[20] However, 'gas lighting appears to have been used primarily in the kitchen, passages and stairs and above outside doors',[21] which might explain why this innovation seems to have had no noticeable impact on the visitors' enjoyment of the art collection. The general public was admitted during daylight anyway, and receptions still used oil lamps and candles for illumination. There might have been also an element of snobbery-gaslight seemed to have been perceived as functional and cheaper, something to be used in the kitchen. Indeed, this was the beginning of a controversy between old and new that broke out forcibly as electricity became more widely used.

Electric Light

Electricity was introduced into country houses with much more enthusiasm than gas had been. It had clear practical advantages (for instance, it did not produce damaging fumes). At the forefront of modernity, in 1893 Chatsworth was one of the first country houses to make its own electricity (with water-powered turbines), following the example of Cragside, Northumbria, and of Hatfield House, Hertfordshire in 1881. As archives show, works started in the spring and were finished by November of that year.

18 Ibid., p. 7. Emphasis added.
19 'Gas at Chatsworth', *Sheffield and Rotherham Independent*, 29 November 1861, p. 3.
20 Ian Watt, "Worthy of the Palace of Aladdin?' The Introduction of Gas and Electricity to the Country House', in Marilyn Palmer and Ian West (eds.), *Technology in the Country House* (Stanford: Paul Watkins Publishing, 2013), p. 113.
21 Chatsworth Archives, personal communication on 19 June 2015.

On 16 December 1893 readers of the *Nottinghamshire Guardian* read:

'The old order changeth, giving place to the new' is a truism applicable
to everything. Chatsworth house [...] is one of the latest, and certainly
one of the most noteworthy, examples. In this case, the change has taken
the form of the substitution of electric light for the previous means of
lighting. Those who have grown to love the many beauties associated
with Chatsworth will possibly feel a creeping of the flesh at the
announcement, and look upon it as a piece of unpardonable Vandalism.[22]

As the article indicates, the innovation was not universally welcomed
by all. To begin with, there was a fear that, in order to accommodate
the new technology, havoc would be wreaked on the house, and that its
beauty and artistic treasures would be affected forever.

This explains why articles announcing electricity at Chatsworth
were partly devoted to reassuring readers that the new electric fittings
(by Drake and Gorham, the leading electrical engineers of the day)
were perfectly harmonized with the pre-existing decoration. Here is
an example:

With such consummate skill has the electric light been introduced, where
hitherto candles and lamps had reigned; and in such entire appreciation
of all the surrounding has every addition been made; that were a
stranger from another sphere shown through the rooms and told that
the light was put in when the house was erected, he would not dream
of questioning the accuracy of the statement. Indeed, whenever possible
all the existing standards, brackets, chandeliers and so forth have been
utilized, and where there were none the incandescent lamp has been
introduced to look as if it had been there from the beginning.[23]

The writer goes on to marvel at the special imitation electric candles,
almost impossible to distinguish from the real thing, and at lamps
'skillfully embedded in oak carving' and 'almost invisible in the
daytime.'

Articles announcing electricity at Chatsworth were typically focused
on the way in which electricity was produced and electric fittings had
been blended in; the effect of the new light on the art collection was
less talked about. However, one does learn that some artistic treasures
had especially gained from the new illumination: 'The chapel has been

22 'The Electric Light at Chatsworth', *Nottinghamshire Guardian*, 16 December 1893, p. 5.
23 'Electric Lighting at Chatsworth', *Sheffield and Rotherham Independent*, 9 December
 1893, p. 6.

lighted in exquisite taste [...] the chandeliers are in perfect harmony with their surroundings, and enable the exquisite marble work and oak carving to be seen to the best advantage.'[24]

Likewise, the writer of 'The Electric Light at Chatsworth', who emphasizes 'the disadvantages under which the interior has hitherto been seen by night,' closes his piece by promising that all 'who see the house with its new illumination will see a thousand excellences they never suspected to exist.'[25]

These reporters, like the Dukes, represent enthusiasts for modern technology; and we might recollect also how Malan, the 1893 visitor to the sculpture gallery, optimistically speculated on the potential for electric light to reproduce the magical effects of summer light at dawn.

But the feelings of those who resented such innovation were also strong. I will mention just one influential commentator, Edith Wharton, who in her 1893 *The Decoration of Houses* wrote that

> The proper light is that of wax candles. Nothing has done more to vulgarize interior decoration than the general use of gas and of electricity [...] Electric light especially, with its harsh white glare [...] The soft, evenly diffused brightness of wax candles is best suited to bring out those subtle modellings of light and shade to which old furniture and objects of art owe half their expressiveness.[26]

Chatsworth records show that the cost for the consumption of oil and candles in the house dropped to zero in 1894,[27] which suggests that the Duke and Duchess totally embraced the modern mode of lighting that, according to Wharton 'makes the salon look like a railway-station, the dining-room like a restaurant.'[28] I have not been able to ascertain whether Wharton ever visited Chatsworth; maybe she shunned it.

To conclude: for better or for worse, the fortunes of the art collection at Chatsworth have been linked to the fortunes of the Cavendish family — in its illumination as in every other respect. Being a private collection housed in a residence, it has been moved around and

24 Ibid.
25 'The Electric Light at Chatsworth', p. 5.
26 Edith Wharton and Ogden Codman, Jr., *The Decoration of Houses* (New York: Charles Scribner's Sons, 1897), pp. 126–27, https://babel.hathitrust.org/cgi/pt?id=coo1.ark:/13960/t3320hg54
27 Ian Watt, 'Worthy of the Palace of Aladdin?', p. 114.
28 Wharton, *The Decoration of Houses*, p. 126.

accommodated to the tastes and needs of the family; the optimal visibility and conservation of the art works were not necessarily a priority. Not all of the Dukes had the same degree of interest in art; and even the Bachelor Duke ended by unwittingly damaging some of the drawings in the Old Master collection by 'rescuing' them from the darkness of the portfolios.

On the other hand, the Chatsworth art collection has benefited from the wealth and openness to modernity of the Dukes of Devonshire. As long as candles and oil lamps where the main means of illumination, they could afford plenty of them — and testimonies show that they spared no expense, especially during receptions. The Bachelor Duke increased illumination by incurring the expense of opening new windows and installing modern windowpanes. Most importantly he built a gallery that guaranteed the best possible illumination for his unique collections of neoclassical statues. When the era of electricity came, Chatsworth was one of the first country houses to adopt it, at a time when some looked down on it as a 'nouveau riche' thing to do.

If we need light to enjoy art works, Chatsworth has always offered plenty of it.

Now that Chatsworth House has become a Trust, and the Duke and Duchess of Devonshire pay a rent to live in it, new ways of making money to keep the establishment going must be explored. Indeed, its appeal as a film set has guaranteed a new visibility to its art collection. In the successful 2005 film version of *Pride and Prejudice*, Chatsworth/Pemberley and its art treasures are beautifully photographed. The moment of epiphany in the novel, when Elizabeth Bennett roams Pemberley and sees Darcy's likeness, takes place in the sculpture gallery. Here the camera follows Elizabeth's gaze, and in the artificially enhanced summer light it lingers with loving admiration on the beautiful statues. I am not sure what kind of lighting technology was used, but I am certain that the result would have pleased the Bachelor Duke.

17. Daylight and Gold: In the Galleries With Henry James

Paula Deitz

As an avid reader while traveling, by chance I once selected Henry James's *The American* (1877) to accompany me on a trip to Paris and thereby had an unusual convergence of circumstances. Knowing little in advance of the story, except that it took place in Paris, I felt like I was following the novel around, or vice versa. While the *hôtel particulier*, in the French sense, of the aristocratic woman the American sought to marry was on Rue de l'Université, so was our hotel, and for many chapters we were walking the same streets. No sooner had I visited the Louvre than I discovered in chapter one the opening scene in the Louvre's high square gallery called the Salon Carré:

> On a brilliant day in May, in the year 1868, a gentleman was reclining at his ease on the great circular divan which at that period occupied the centre of the Salon Carré, in the Museum of the Louvre. This commodious ottoman has since been removed, to the extreme regret of all weak-kneed lovers of the fine arts; but the gentleman in question had taken serene possession of its softest spot, and, with his head thrown back and his legs outstretched, was staring at Murillo's beautiful moon-borne Madonna in profound enjoyment of his posture.
>
> He had looked, moreover, not only at all the pictures, but at all the copies that were going forward around them, in the hands of those innumerable young women in irreproachable toilets who devote themselves, in France, to the propagation of masterpieces; and if the truth must be told, he had often admired the copy much more than the original.
>
> But listless as he lounges there, rather baffled on the aesthetic question, and guilty of the damning fault [...] of confounding the merit of the artist

 https://doi.org/10.11647/OBP.0151.17

with that of his work (for he admires the squinting Madonna of the young lady with the boyish coiffure, because he thinks the young lady herself uncommonly taking), he is a sufficiently promising acquaintance.

At last he rose abruptly, put on his hat, and approached the young lady. He placed himself before her picture and looked at it for some moments, during which she pretended to be quite unconscious of his inspection. Then, addressing her with the single word which constituted the strength of his French vocabulary, and holding up one finger in a manner which appeared to him to illuminate his meaning, *'Combien?'* he abruptly demanded.[1]

Shortly after my return to New York, I happened by chance to come across a watercolour in the Lucien Goldschmidt Gallery on Madison Avenue painted the very same year, 1868, by Emanuel Stöckler, a court painter of Vienna, depicting the identical scene, with a gentleman observing a copyist of the Murillo painting in the Salon Carré.

Fig. 17.1 Emanuel Stöckler, *The Salon Carré of the Louvre in Paris*, 1868. Watercolour on paper, 54.6 x 53.3 cm. Private collection: photograph by Beth Phillips. Reprinted by permission of the owner.

1 Henry James, *The American*, with an afterword by Leon Edel (New York: A Signet Classic, published by The New American Library, 1963), pp. 5–8.

The first question that obviously came to mind was whether James himself had ever seen this painting, perhaps on view in Paris before it entered the collection of Queen Olga of Württemberg. But I was struck by the fact that, in the painting, the gallery was illuminated by an immense skylight that bounced light off the gilded cornices, which do not necessarily reflect this light but animate the entire space with a glow as do gilded frames for pictures. In general, James called it an 'endless golden riot'.[2]

In James's autobiographical memoir, *A Small Boy and Others* (1913), he writes about his boyhood visits to the Louvre with his brother and his earliest memory of the Galérie d'Apollon and its subsequent appearance in a frightening nightmare. But he also comments on the general influence of the museum foretelling the future bliss of his inner life. In his description of what he calls 'the house of life' and 'the palace of art', he expounds on 'the pictures, the frames themselves, the figures within them, the particular parts and features of each, [and] the look of the rich light'.[3] He also singles out in his memoir what he calls the 'treasures of the Salon Carré'.[4] First, the painting observed by the American of the novel, which James calls the moon-borne Madonna, was Murillo's *Immaculate Conception of Los Venerables* (Museo del Prado, ca.1678),[5] hauled back to France from Spain and eventually brought to the Louvre by one of Napoleon's marshals. It was returned to the Prado in 1941. He refers to the *Mona Lisa* (Musée du Louvre, 1503–06), then displayed there, as 'Leonardo's almost unholy dame with the folded hands'.[6] Finally, the vast Veronese, *The Meal in the House of Simon the Pharisee,*[7] originally painted for the Servite Convent in Venice in 1570 and given to Louis XIV as a present from the Doge, hung at the Louvre during the period James visited across from Veronese's *The Wedding at Cana* (Musée du Louvre, 1563)[8] and is now back at Versailles. Both of

2 Henry James, *Autobiographies, 'A Small Boy and Others'*, Philip Horne (ed.) (New York: The Library of America, 2016), p. 208.
3 James, *Autobiographies*, p. 211.
4 Ibid.
5 https://www.museodelprado.es/en/the-collection/art-work/the-immaculate-conception-of-los-venerables/76179d81-beaf-4f9e-9a05-ef92340a00d1
6 Ibid.
7 https://artsandculture.google.com/asset/the-feast-in-the-house-of-simon-the-pharisee/oQGdwswf313O7g
8 https://en.wikipedia.org/wiki/The_Wedding_at_Cana#/media/File:Paolo_Veronese_008.jpg

these can be seen on view in an 1861 painting by Giuseppe Castiglione, *View of the Grand Salon Carré in the Louvre* (Musée du Louvre)[9] when the central divan was still in place. The *Mona Lisa* appears in an earlier painting of the Salon by the American artist Samuel F. B. Morse: *Gallery of the Louvre* (1831–33, Terra Foundation for American Art).[10]

Although the Salon Carré has retained its ornate figures within the coved ceiling and the cornice medallions celebrating the arts, the gallery today, with a protruding partition and a hanging frame of fluorescent light, no longer has the presence suggested by James, despite the large-scale masterpieces that presently hang there.

On my own trip to Paris, what drew me further into the Louvre was the luminous space beyond the Salon Carré, which James calls that 'interminable and incomparable Seine-side front of the Palace',[11] the 875-foot long Grande Galerie, shown in a print, also from 1868, depicting art students and copyists by the American artist Winslow Homer.

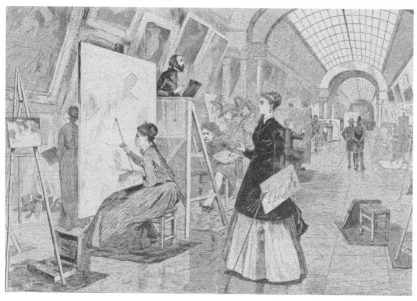

Fig. 17.2 Winslow Homer, *Art-Students and Copyists in the Louvre Gallery*, Paris, 1868. Wood engraving, 23.3 x 35.2 cm. Brooklyn Museum, gift of Harvey Isbitts, 1998.105.102

9　　https://upload.wikimedia.org/wikipedia/commons/2/22/Giuseppe_Castiglione_-_View_of_the_Grand_Salon_Carr%C3%A9_in_the_Louvre_-_WGA4552.jpg
10　http://faculty.washington.edu/dillon/Morse_Gallery/
11　Ibid.

Essentially the gallery, which joined the old Louvre with the Tuileries Palace, has a long history that came to fruition when the artist Hubert Robert was placed in charge. He made innumerable paintings, both of its existing state, such as his ca.1805 work, and with his proposed renovations, which he suggested as early as 1796, with pitched skylights at the peak of coffered vaults.

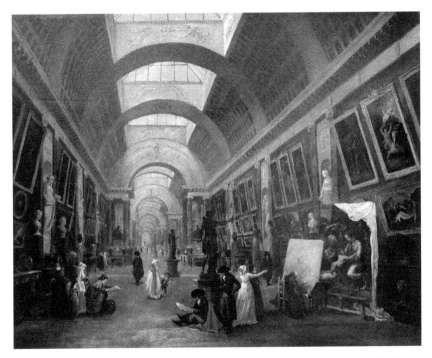

Fig. 17.3 Hubert Robert, *The Project for the Grande Galerie of the Louvre*, 1796. Oil on canvas, 112 x 145 cm. Inv. RF1975-10. Photo by Jean-Gilles Berizzi. Musée du Louvre. © RMN-Grand Palais/Art Resource, NY.

By 1947, Robert's vision had become a reality. Today, the gallery is hung with elegant spareness under silvery light from arched skylights. But he created another painting, also in 1796, that depicted the gallery as a ruin from antiquity, open to the sky above, and therefore flooded with maximum light.

In James's novel *The Wings of the Dove* (1902), we come across more descriptions concerning light that embellish the famous scene in which the coterie of characters we come to know in London accompany Milly Theale, the mysteriously ailing American heiress, on an excursion to

Matcham, the country house of Lord Mark, ultimately her suitor. The
high point of this visit is the viewing of a painting by Bronzino, untitled
in the book but identified as the portrait of Lucrezia Panciatichi by
Angelo Bronzino (Gallerie degli Uffizi, ca.1545),[12] in which Milly sees
her resemblance. James writes of the portrait:

> [...] all magnificently drawn, down to the hands, and magnificently
> dressed; a face almost livid in hue, yet handsome in sadness and crowned
> with a mass of hair rolled back and high, that must, before fading with
> time, have had a family resemblance to her own. The lady in question, at
> all events, with her slightly Michaelangelesque squareness, her eyes of
> other days, her full lips, her long neck, her recorded jewels, her brocaded
> and wasted reds, was a very great personage — only unaccompanied
> by a joy. And she was dead, dead, dead. Milly recognised her exactly in
> words that had nothing to do with her. 'I shall never be better than this'.[13]

In his physical description of the scene, for our purposes, James
observes that '[t]he Bronzino was, it appeared, deep within, and the long
afternoon light lingered for them on patches of old colour and waylaid
them, as they went, in nooks and opening vistas'.[14] And in addition
to what he also calls this 'splendid midsummer glow',[15] the painting
itself was 'aloft there in the great gilded historic chamber'.[16] Milly, in the
'presence of the pale personage on the wall, whose eyes all the while
seemed engaged with her own [...] found herself suddenly sunk in
something quite intimate and humble and to which these grandeurs
were strange enough witnesses'.[17]

The original portrait actually hangs in Florence in the Uffizi's
octagonal Tribune Gallery, which is also animated by the richness of
gilded frames and daylight that flows across the walls from clerestory
windows above.

In his *A Little Tour in France* (1884), James confesses, 'I have a weakness
for provincial museums — a sentiment that depends but little on the
quality of the collection. The pictures may be bad, but the place is often

12 https://en.wikipedia.org/wiki/Portrait_of_Lucrezia_Panciatichi#/media/File:
 Lucrezia_Panciatichi_by_Angelo_Bronzino.jpg
13 Henry James, *The Wings of the Dove* (Baltimore: Penguin Books, 1976), Book Fifth, p.
 144.
14 Ibid., p. 143.
15 Ibid., p. 144.
16 Ibid., p. 147.
17 Ibid.

curious [...]'[18] And so, on a day of ceaseless rain in Avignon, he took what he called 'a horizontal dive [...] to the little *musée* of the town'.[19] I traced the building to the Musée Calvet, whose former antiquities have been moved to another museum, but whose building remains intact as James knew it then and on previous visits. He writes:

> It has the usual musty chill in the air, the usual grass-grown forecourt, in which a few lumpish Roman fragments are disposed, the usual red tiles on the floor, and the usual specimens of the more livid schools on the walls. I rang up the *gardien*, who arrived with a bunch of keys, wiping his mouth; he unlocked doors for me, opened shutters, and while (to my distress, as if the things had been worth lingering over) he shuffled about after me, he announced the names of the pictures before which I stopped [...][20]

Once the *gardien* opens the shutters along the gallery, the interior is flooded with glorious daylight pouring through the tall windows. Later in a poetic description, James notes: 'Then there were intervals of silence, while I stared absent-mindedly, at haphazard, at some indistinguishable canvas, and the only sound was the downpour of the rain on the skylights'.[21] In this way, he directs our eye immediately to the skylights washing the gallery walls with light from above along with the romantic sound of the rain.

Those of us enamoured of James thrive on the long, intuitive descriptive passages as his plots move slowly along, leading perhaps to a single climax that itself goes quickly by and often happens without our actually seeing it. We simply learn of it in the next chapter. His novel *The Ambassadors* (1903) was once my bedtime reading, so it stretched over a long period of time, and I was only too happy to learn in James's preface that he urged readers to read it slowly as in real time, making me his ideal *lecteur*.

Near the end, I came to the scene in which Lambert Strether, the middle-aged protagonist from Massachusetts sent to Paris by his fiancée to urge home her son Chad, is taking a short excursion to the countryside by train. His object is to experience, as James writes,

18 Henry James, *A Little Tour in France*, foreword by Geoffrey Grigson (Oxford: Oxford University Press, 1984), p. 73.
19 Ibid., p. 150.
20 Ibid.
21 Ibid., p. 151.

'French ruralism, with its cool special green, into which he had hitherto looked only through the little oblong window of the picture-frame'.[22] Strether is remembering a small painting by Emile-Charles Lambinet, sadly beyond his means, 'that had charmed him, long years before at a Boston dealer's [...] in the maroon-coloured, sky-lighted inner shrine of Tremont Street'.[23] He recalls it as 'the special-green vision, the ridiculous price, the poplars, the willows, the rushes, the river, the sunny silvery sky, the shady woody horizon'.[24]

In a period photograph of a Tremont Street gallery, perhaps the very one, paintings line its walls chock-a-block, illuminated by a skylight above in addition to an electric ceiling fixture. One can even see against the far back wall similar kinds of bucolic landscapes. Lambinet, who studied with Charles-François Daubigny and Jean-Baptiste-Camille Corot, was cited by James in his same boyhood memoir as one of the 'three or four so finely interesting landscapists' of that mid-nineteenth century period.[25]

Once disembarked from the train, Lambert recognizes the view as if the painting has come to life:

> The oblong gilt frame disposed its enclosing lines; the poplars and willows, the reeds and river — a river of which he didn't know, and didn't want to know, the name — fell into a composition, full of felicity, within them; the sky was silver and turquoise and varnish; the village on the left was white and the church on the right was grey; it was all there, in short — it was what he wanted: it was Tremont Street, it was France, it was Lambinet.[26]

Finally, we come to Venice and the Palazzo Barbaro, where James placed the fictional abode of Milly Theale in the later chapters of *The Wings of the Dove*: 'fronting the great canal with its Gothic arches. The casements between the arches were open, the ledge of the balcony broad, the sweep of the canal, so overhung, admirable, and the flutter toward them of the loose white curtain an invitation to she scarce could have said what'.[27]

22 Henry James, *The Ambassadors*, ed. with intro. by Harry Levin (New York: Penguin Books, 1986), Book Eleventh, III, p. 452.
23 Ibid., p. 452 f.
24 Ibid., p. 452.
25 James, *Autobiographies*, p. 205.
26 James, *The Ambassadors*, p. 453.
27 James, *Wings of the Dove*, p. 292f.

Earlier in this scene, Lord Mark on a visit remarks on Milly's reclusiveness and suggests she go out, alluding to that tremendous old staircase in her court: 'There ought of course always to be people at top and bottom, in Veronese costumes, to watch you do it'[28] — imagining, of course, both *The Wedding at Cana* (1563) and *The Feast of the House of Levi* (Gallerie dell'Accademia, 1573)[29] that are referenced again in the dazzling soirée that crowns her Venetian sojourn.

For Milly, though, the adventure of life lies in not stirring at all and listening instead to 'the plash of the water against stone' from the grand salon.[30] James's description of this room and its surrounding ambience is very like it appears in Ludwig Passini's 1855 watercolour painting, *The Salone of the Palazzo Barbaro* (private collection),[31] with a woman seated at her desk by the window:

> Not yet so much as this morning had she felt herself sink into possession; gratefully glad that the warmth of the Southern summer was still in the high, florid rooms, palatial chambers where hard, cool pavements took reflections in their lifelong polish, and where the sun on the stirred sea-water, flickering up through open windows, played over the painted 'subjects' in the splendid ceilings — medallions of purple and brown, of brave old melancholy colour, medals as of old reddened gold, embossed and beribboned, all toned with time and all flourished and scolloped and gilded about, set in their great moulded and figured concavity (a nest of white cherubs, friendly creatures of the air), and appreciated by the aid of that second tier of smaller lights, straight openings to the front, which did everything [...][32]

Here the light comes not only from above but is also reflected from the shimmering waters below, so that, inside or outside, there is nothing in the world more beautiful than Venetian light.

28 Ibid., p. 292.
29 https://en.wikipedia.org/wiki/The_Feast_in_the_House_of_Levi#/media/File: Banquet_in_the_House_of_Levi_by_Paolo_Veronese_-_Accademia_-_Venice_ 2016_(2).jpg
30 Ibid.
31 https://commons.wikimedia.org/wiki/File:Ludwig_Passini_-_The_Salone_of_the_ Palazzo_Barbaro.jpg
32 James, *Wings of the Dove*, p. 282.

18. Remarks on Illumination in Nineteenth-Century American Travel Writings on Madrid's Prado Museum

Pere Gifra-Adroher

The foreign travelers who wrote about Spain in the nineteenth century left a notable corpus of observations on Madrid's Prado Museum that now constitutes, as Javier Portús observes, a 'written memory' of this institution.[1] A significant number of Americans contributed to this effort. This essay seeks to analyze their reaction to Madrid's chief museum by focusing on some of the nearly fifty published travel texts in which it is mentioned. Former studies have refered to the activities of American artists in Spain (Osborne, Boone), the different forms of museum-going exhibited by cosmopolitan bourgeois tourists in Madrid (Afinoguénova), and the ideological constraints and religious prejudices with which certain Yankee visitors often scrutinized the works of the Spanish masters at the Prado (Kagan).[2] Here I will instead examine the writers' responses to the lighting of the museum and how this affected their aesthetic

1 Javier Portús, *Museo del Prado, memoria escrita, 1819–1994* (Madrid: Museo del Prado, 1994), pp. 227–60.

2 Carol M. Osborne, 'Yankee Painters at the Prado', in Suzanne L. Stratton (ed.), *Spain, Espagne, Spanien: Foreign Artists Discover Spain, 1800–1900* (New York: Equitable Gallery, 1993), pp. 59–77; Elizabeth Boone, *Vistas de España. American Views of Life and Art in Spain, 1860–1914* (New Haven: Yale University Press, 2007); Eugenia Afinoguénova, 'Art Education, Class, and Gender in a Foreign Art Gallery: Nineteenth-Century Cultural Travellers and the Prado Museum in Madrid', *Nineteenth-Century Contexts* 32 (2010), 47–63; Richard L. Kagan, 'Yankees in the Prado: A Historiographical Overview', *Boletín del Museo del Prado* 25 (2007), 32–45.

 https://doi.org/10.11647/OBP.0151.18

perambulations. I argue that illumination, to use Eugenia Afinoguénova's words, constituted one of the various elements which these travel writers employed 'to present themselves as aristocratic connoisseurs,'[3] and to legitimize their aesthetic experience within an American context where the middle class struggled to consolidate its cultural status.

Most nineteenth-century American travelers who wrote about the Prado, with the exception of a few southerners, were prosperous white men from the Northeast. Some journeyed with their wives, daughters, or sisters, who in turn wrote about the Prado in diaries or notebooks that eventually became published. Such was the case, for example, for Harriet T. Allen, Julia L. Barber, Sarah R. Haight, and Caroline Cushing; though few women traveled alone (the journalist Kate Field was an exception in this regard). These women shared similar views on art, accepted the existence of well-defined national schools of painting, and used common sources to support their artistic observations. Their texts are peppered with topoi that situate them within the textual practices of nineteenth-century bourgeois tourism.[4] Many, for example, highlight the Prado as 'one of the finest picture galleries in the world,'[5] a commonplace assessment that virtually nobody challenged. Another textual convention involves the notion of cultural pilgrimage, which served to justify the long journey to the heart of Spain. Charles Dudley Warner explains that a visit to the Prado 'compels and repays a pilgrimage from any distance,'[6] whereas Fanny Bullock Workman, who cycled across the Peninsula with her husband, affirms that such an idea makes anyone 'desirous to return after leaving Spain.'[7] The cultural capital which travelers were able to bank after a visit to the Prado upheld the validity of an idle practice — the journey abroad — which was still frowned upon by hard-nosed moralists at home.

These texts also employ a decidedly emotional diction to express the traveler's bewilderment before a wealth of masterpieces. To Kate Field,

3 Afinoguénova, 'Art Education', p. 48.
4 Afinoguénova, 'Art Education', pp. 51–55.
5 Louise Chandler Moulton, *Lazy Tours in Spain and Elsewhere* (Boston: Roberts brothers, 1896; repr. 1897), p. 18, https://babel.hathitrust.org/cgi/pt?id=yale.390020 07650568;view=1up;seq=34
6 Charles Dudley Warner, *A Roundabout Journey* (Boston: Houghton, Mifflin, 1883), p. 320, https://babel.hathitrust.org/cgi/pt?id=nyp.33433082478334;view=1up;seq=332
7 Fanny Bullock Workman, *Sketches Awheel in Modern Iberia* (New York: Putnam's, 1897), p. 190, https://archive.org/details/sketchesawheeli00workgoog/page/n220

a visit to the Prado signifies an 'absolutely stupefying' and 'gradually fascinating' experience that leaves the visitor 'spell-bound,'[8] while to Joseph Warren Revere, the very act of naming the titles of so many great paintings 'makes the eyes of the connoisseur glisten with delight.'[9] William Cullen Bryant engages himself in a similar vein. Under a sort of Stendhal syndrome, he explains how for three days he wandered the galleries of the Prado 'amazed,' 'bewildered' and 'intoxicated by the spectacle.'[10] Only when his soul became capable of absorbing so much beauty did he begin to appreciate the great pictures serenely. Perhaps no voice resorts so candidly to sentimental language as that of southern American Octavia W. Le Vert, who painfully mixes aesthetic pleasure and personal psychological suffering in experience of the Prado. She provides a touching description of a canvas by Murillo, where she beheld 'the exact resemblance' of her lost child. The contemplation of such beauty, she explains, triggered a flow of tears and helped her, above all, to keep deathly thoughts at bay.[11] Her account not only posits the visit to the Prado as a pleasurable, culturally enriching pursuit, but also as a therapeutic experience capable of healing personal wounds.

A profound fascination with the Spanish school of painting equally characterizes American travel writing on the Prado, which responded to Spanish art, Richard Kagan notes, following two main strains of criticism. The first, based on Burke's aesthetic categories, highlighted the principal traits of individual artists like Murillo and Velázquez, focusing on their idiosyncratic styles. Meanwhile, the second, being more politically inflected, emphasized the otherness of the Spanish school, contending that its cultural exceptionalism, unequalled in the western world, had been produced by centuries of monarchical despotism and religious fanaticism.[12] Often the travel texts also contain remarks on other museum-related issues that transcend the aesthetic

8 Kate Field, *Ten Days in Spain* (Boston: Osgood, 1875), p. 132, https://babel.hathitrust. org/cgi/pt?id=nyp.33433070304823;view=1up;seq=158;size=150

9 Joseph Warren Revere, *Keel and Saddle* (Boston: Osgood, 1872), p. 67, https://babel. hathitrust.org/cgi/pt?id=uc2.ark:/13960/t56d5q33j;view=1up;seq=87

10 William Cullen Bryant, *Letters of a Traveller. Second Series* (New York: Appleton, 1859), p. 133–34, https://babel.hathitrust.org/cgi/pt?id=nyp.33433082467998;view=1 up;seq=139

11 Octavia Walton Le Vert, *Souvenirs of Travel*, 2 vols. (New York & Mobile: Goetzel, 1857), II, p. 18, https://babel.hathitrust.org/cgi/pt?id=hvd.32044017976267;view=1u p;seq=32

12 Richard L. Kagan, 'Yankees in the Prado. A Historiographical Overview', pp. 37–40.

and ideological value of the artistic holdings. They refer, for example, to the Prado's architectural grandeur, to the impossibility to see the collection in a single visit, to the inadequate arrangement of the pictures in certain rooms, or to the illumination of the building. The latter point became especially relevant not only because a poor or good reception of light in the halls might affect the visitor's perception of shapes, colors and nuances, but also because, by offering remarks on illumination, the traveler could take sides and engage in artistic debates.

Today, projects like 'Lighting up the Prado' — launched in 2015 to gradually change the museum's old halogen lamps for energy-efficient LED technology — remind us that lighting remains a capital issue for this institution, but the readiness to adapt the gallery to new forms of illumination cannot belie the fact that seeing the paintings in the Prado sometimes could become an arduous task in the nineteenth century. Such problems existed because the building — designed by Juan de Villanueva in 1785 and originally meant to house the Cabinet of Natural History — relied on a system of daylight illumination which proved unsatisfactory once the museum was inaugurated in 1819. The restoration of the edifice had begun in 1813 after the withdrawal of the Napoleonic troops, and soon became, in Andrew Schulz's words, 'an expression of national pride' to the crown.[13] In the initial years of operation, only the northern pavilion was opened and 311 works were on display. Then, over the course of the following decades, the growth of the collection made it necessary to tackle serious rehabilitations. The first work had focused principally on mending important roof leaks and repairing structural problems, but little concern was then shown about illumination. This seemed satisfactory enough in the post-war context, but over time the contrasts between gloomy and light spaces posed problems because the illumination of Villanueva's initial project — carefully planned by means of rotundas, domes and high windows — became affected by a number of reforms.[14] The central gallery linking the north and south pavilions was finally completed in late 1826 and new rooms were gradually opened to accommodate a

13 Andrew Schulz, 'Museo Nacional del Prado, Madrid: Absolutism and Nationalism in Early-Nineteenth-Century Madrid', in Carole Paul (ed.), *The First Modern Museums of Art* (Los Angeles: The J. Paul Getty Museum, 2012), pp. 237–60 (p. 242).

14 Margarita de Luxán García de Diego, 'Restauración de la iluminación natural', *Informes de la construcción* 40 (1989), 37–41 (pp. 38–39).

growing collection, which by 1872 already boasted well over a thousand pictures on display. Villanueva's original dome was preserved — with some changes — and eight skylights were opened, but it was then decided that it was better to cover the high windows with curtains to block the slanted light. The outcome was a hall bathed by zenithal and slanted daylight that, according to early testimonies such as that of French writer Prosper Merimée, dazzled the viewer and at times required the use of a hat for the proper contemplation of the paintings.[15]

Years later, in 1852, further renovations enlarged and unified the skylights, leaving two big apertures on each side of the central gallery. Also in this decade Queen Isabella II planned to isolate the Prado by ordering the demolition of all the constructions within its perimeter that might obstruct the entrance of light.[16] This long project, not fully resolved until the late 1880s, gradually ameliorated the brightness of the upper and lower galleries, strengthening the function of daylight and rendering the use of artificial systems of illumination unnecessary. In contrast to other contemporary museums like the Peale Museum in Baltimore, which had already implemented gas lighting in 1816, the Prado did not adopt this new illumination despite the fact that it became customary in the streets of Madrid starting in 1832 and was used in the local theaters starting in the 1840s.[17] Documents held in the Prado archives reveal the use of wax torches outside the building on certain festive occasions, and bills issued in later decades prove the purchase of oil for lamps or coal for the heaters that warmed up the spacious halls, but no records confirm the supply of gas. Electricity was not fully implemented until well into the twentieth century.

American travel writers began to express divided opinions on lighting when they visited the Prado. Lieutenant Alexander Slidell Mackenzie, who had already been in the museum during his first sojourn to Madrid in 1826, returned there in 1834 and found it 'admirably arranged for the exhibition of the pictures and the accommodation of the public,' but nevertheless regretted that 'The light perhaps might have been more

15 Prosper Merimée, 'Les grands maîtres du Musée de Madrid', *L'Artiste* 1 (March 1831), 73–75 (p. 74).

16 Pedro Moleón Gavilanes, *El Museo del Prado. Biografía del edificio* (Madrid: Museo del Prado, 2011), pp. 64, 80–84.

17 Juan P. Arregui, 'Luminotecnia teatral en la primera mitad del siglo XIX: de la herencia barroca a la introducción del gas', *Stichomythia* 3 (2005), 1–49 (pp. 29–30).

favorably introduced from above.'[18] Despite these remarks, though, other travel writers after him applauded the brightness of the rooms, especially the central hall. In general they claim that there the paintings are 'shown to the best advantage'[19] and look either 'well lighted,'[20] 'well lighted from above,'[21] or 'well-lighted from the top.'[22] Other authors even employ the phrase 'beautifully-lighted.'[23] Following the same vein, Charles Augustus Stoddard, editor of the *New York Observer*, stresses how much the museum benefits from its location: 'the atmosphere of Spain is dry and clear; [and] there is always light, which adds so much to the charms of color.'[24] These positive remarks notwithstanding, not everyone seemed to be pleased by the effects of daylight from above and the atmosphere created within.

The uneven lighting, which left the central hall fully illuminated and some of the other rooms poorly lit, emerges as a complaint in other texts. Sinclair Tousey, founder and president of the American News Company, laments that many unknown gems of the Prado hang 'in rooms most miserably lighted, and in positions where they can hardly' be seen,[25] an opinion shared by journalist Edward Smith King, for whom '[m]any of the corridors and halls are badly lighted, and insufficiently fitted for the display of the splendid canvases which adorn them.'[26] Occasionally, as John Hay laments in *Castilian Days*, the problem did not reside exclusively

18 Alexander Slidell Mackenzie, *Spain Revisited*, 2 vols. (New York: Harper Brothers, 1836), I, pp. 227–28, https://babel.hathitrust.org/cgi/pt?id=uc2.ark:/13960/t51g0p101; view=1up;seq=239

19 Charles Rockwell, *Sketches of Foreign Travel, and Life at Sea*, 2 vols. (Boston: Tappan & Dennet, 1842), I, p. 286, https://babel.hathitrust.org/cgi/pt?id=uc1.$b42004;view=1up;seq=316

20 Edward Everett Hale, *Seven Spanish Cities* (Boston: Little, Brown, 1883), p. 226, https://babel.hathitrust.org/cgi/pt?id=nyp.33433070305119;view=1up;seq=234

21 Henry Willis Baxley, *Spain. Art-remains and Art-realities*, 2 vols. (New York: Appleton, 1875), II, p. 262, https://babel.hathitrust.org/cgi/pt?id=hvd.hn5fir;view=1up;seq=276

22 William Howe Downes, *Spanish Ways and By-Ways* (Boston: Cupples, 1883), p. 59, https://babel.hathitrust.org/cgi/pt?id=uc1.$b48828;view=1up;seq=63

23 James Albert Harrison, *Spain in Profile* (Boston: Houghton, Osgood, 1879), p. 275, https://babel.hathitrust.org/cgi/pt?id=loc.ark:/13960/t1jh4f09f;view=1up;seq=289; John Hay, *Castilian Days* (Boston: Osgood, 1871), p. 137, https://babel.hathitrust.org/cgi/pt?id=loc.ark:/13960/t6543kj6m;view=1up;seq=149

24 Charles Augustus Stoddard, *Spanish Cities* (New York: Scribner's, 1892), p. 69, https://archive.org/details/spanishcitieswit00stodrich/page/69

25 Sinclair Tousey, *Papers From Over the Water* (New York: American News Company, 1869), p. 54, https://babel.hathitrust.org/cgi/pt?id=nyp.33433082470877;view=1up;seq=66

26 Edward Smith King, *Europe in Storm and Calm* (Springfield: Nichols, 1885), p. 111, https://babel.hathitrust.org/cgi/pt?id=loc.ark:/13960/t3dz0rn4j;view=1up;seq=121

on the illumination of a room but rather on the effects of the light on a single canvas placed too far away from the spectator's gaze. This occurs with Tintoretto's *Death of Holofernes*, he remarks, which could not be duly appreciated because it hung higher than it should be and accordingly 'a full light is needed' for optimum aesthetic pleasure.[27] Even though such critical appraisals might present the writers as fastidious onlookers, they only really endowed their texts with an aura of authority only attainable by careful scrutiny and personal presence. In other words, by making remarks on the illumination of the Prado, no matter how superficially, the American travel writers were consolidating their status as middle-class art devotees pursuing cultural tours abroad.

While on particularly bright days, as seen in the previous examples, some travelers complained about the dazzling sun, and on other occasions bemoaned the darkness of certain galleries; the case was different on overcast or rainy days, as the dim, variable light could hamper the careful scrutiny of details. Samuel Irenaeus Prime, founder of the New York Association for the Advancement of Science and Art, observes that when it rained the museum was 'always shut,' not only because 'visitors will soil the floors with their shoes' but also because 'the gallery is so badly lighted that in gloomy weather some of the pictures are quite invisible.'[28] In further elaborating the invisibility of certain pictures, he comments that 'scattered through these long apartments, in narrow halls and basement rooms, in bad lights, and some almost in the dark, are many gems of rare value, 'blushing unseen' and worth a better place, and deserving wider renown.'[29] The thrill of discovering and standing before an unknown masterpiece, for all the lighting difficulties it posed, made the visit ultimately worthwhile. Other travellers, equally aware of the illumination problems caused by the changing weather, chose not to complain and instead sought solutions. Take, for example, Mary Nixon Roulet, who recommends a visit to the museum simply at the time of the day when the light is 'fine,'[30] or the anonymous author of *Traces of the Roman and the Moor*, nicknamed 'A Bachelor,' who relies

27 Hay, *Castilian Days*, p. 136.
28 Samuel Irenaeus Prime, *The Alhambra and the Kremlin* (New York: Randolph, 1873), pp. 48–49, https://babel.hathitrust.org/cgi/pt?id=loc.ark:/13960/t90873x5f;view=1up; seq=78
29 Ibid., p. 51.
30 Mary Nixon Roulet, *With a Pessimist in Spain* (Saint Louis: Herder, 1897), p. 215, https://babel.hathitrust.org/cgi/pt?id=loc.ark:/13960/t0xp7vp5f;view=1up;seq=237

on the museum's staff to overcome the inadequate lighting in some rooms.[31] Now and then the museum's assistants would open and close the shutters of certain rooms to modulate the presence of light, thus solving with ingenuity whatever lighting problems might have arisen.

The fact that the museum staff performed such a role connected to the illumination of the building may have gone unnoticed in some texts, but those who record it express a high opinion of the museum's aides, believing that their competence, affability and cordiality deserve true recognition. The 'white-haired door-keeper' who receives the visitors was a very amiable fellow, explains James Albert Harrison, 'one of the most gracious specimens of his kind that I have ever met [...] and smiled radiantly at each individual visitor as he entered.'[32] Likewise, Julia Langdon Barber, wife of asphalt magnate Amzi Barber, comments that the museum custodians are 'uniformly courteous' and seemed 'actually glad' to see a group of Americans because they 'represented some nation that was as a sealed book to them.'[33] No author, however, fully summarizes the positive views on the Prado's staff with the exactitude of Edward Everett Hale. 'They like to have you come, and they are sorry to have you go away,' affirms the Unitarian minister, further adding that 'It is not as in the Louvre, or in galleries I have seen nearer home, where they wish there were no visitors to the gallery [...]. On the other hand, everybody is pleased that more visitors have come.'[34] The tribute that he pays to the personnel of the Prado is exceptional and, stretching the terms of our discussion, could metaphorically stand for another sort of illumination present in the museum: human light. The staff's friendly rapport brightened the visitors' faces, adding a glow of happiness to their artistic pursuits and making them feel like quasi-patrician art lovers pampered by a host of foreign attendants.

Nineteenth-century American travel writers, in short, expressed mixed views on the illumination of the Prado Museum. Their texts bear witness to the lack of artificial lighting systems in Villanueva's reformed building and the prevalence of a natural type of light that,

31 Bachelor, *Traces of the Roman and the Moor* (New York: Lamport, Blakeman & Law, 1853), p. 138, https://babel.hathitrust.org/cgi/pt?id=hvd.hn1lu8;view=1up;seq=156
32 Harrison, *Spain in Profile*, p. 274.
33 Julia Langdon Barber, *Mediterranean Mosaics* (New York: privately printed, [1895]), p. 13, https://babel.hathitrust.org/cgi/pt?id=hvd.hnuuba;view=1up;seq=25
34 Hale, *Seven Spanish Cities*, p. 227.

whether lateral or partially intercepted, created atmospheres and effects, shades and reflections. Occasionally the weather conditions and time of the day hindered the natural perception of the pictures under normal daylight, but then, as discussed before, they could rely on the museum's dependable personnel to solve such problems. In some cases, the somewhat irregular lighting that obscured several rooms, opened new possibilities of artistic exploration in uncharted spaces with hidden gems. In other cases, the accidental dimness led some writers to feel an 'indefinable air of severity and gloom,'[35] especially in Spanish religious painting, that boosted old anti-Catholic biases. Whatever the situation, however, let me conclude by suggesting that, apart from lending authority to their texts, writing on the illumination of the Prado not only became another one of the travel writers' subtle ways of participating in the cultural and ideological debates of contemporary America but also a handy tool to maintain their status as middle-class art lovers on tour.

35 Hay, *Castilian Days*, p. 130.

PART V

ON LIGHT IN ITALIAN MUSEUMS

19. To Look (and to See) in the Nineteenth Century: At the Uffizi and Elsewhere

Cristina Acidini

The many museums in Florence each have different histories and characteristics. After the Franceschini reform by the Ministero dei Beni e delle Attività Culturali e del Turismo in 2014, the state art museums, formerly united as the Polo Museale Fiorentino, were subdivided into distinct functional units: the Archaeological Museum and the Opificio delle Pietre Dure, the museums of the 'Opere', at the service of great ecclesiastic compounds, the museums depending on the 'enti locali', starting with those of the Municipality, the University Museums, the autonomous scientific Galileo Museum, the museums of Foundations and of private parties.

Almost all of these museums were established in places that were not purpose-built, for example in private palaces, convents, buildings belonging to the church, villas, and other spaces all created in a pre-industrial age. These buildings originally had lighting systems based exclusively on natural light or on flame ignition.

Almost nothing has been written about light in museums. The main problem lies with the sources: it is difficult to find evidence about lighting at all, let alone the systems that existed before the twentieth century. The museum catalogues of the nineteenth and twentieth centuries, which one might have expected to be helpful, actually omit any information on this subject, offering only a historical introduction and a description of

 https://doi.org/10.11647/OBP.0151.19

the artworks and objects, dwelling on the most interesting exhibits. Not even the Florence guidebooks contain any information on the subject, however detailed, up-to-date and numerous they might have been in the nineteenth century; instead, they concentrate on the changes in government and the status of Florence as the capital of the Kingdom of Italy from 1865 to 1871. This is true of the Galleria degli Uffizi, an exemplar of Italian museums, whose printed descriptions of specific halls — such as the Tribune, the Cabinet of Inscriptions, the hall of the Niobe and other rooms with special collections — give no information on the modes and criteria for lighting.

It seems that the most useful sources of information can be grouped as follows: the internal museum documents including memorials, reports, requests, projects, expense documents, and budgets, which can be found in the archives; old photos and other historical images; and reports by attentive, usually foreign, travellers, which sometimes contain incidental allusions to characteristics of the lighting and its aesthetic effects on rooms and objects.

An excellent example is found in this passage by S. Hippolyte Taine, written while Florence was the capital, on a clear April morning: '... le jour est beau; le vitres luisantes jettent un reflet sur quelques blanches statues lointaines, sur un torse rosé de femme qui sort vivant des noirceurs de l'ombre' [the day is beautiful; the glistening windows cast a reflection onto some distant white statues, onto the pink body of a woman who comes alive from the darkness of the shadow].[1]

Taine is like a painter with words, evoking a complex luminescent picture in which the rays of light coming in through the windows — the large windows of the corridors, which even today look onto antique sculpture — caress the surfaces of the statues, revealing their whiteness or flesh-colouring, and making them stand out of the shadows. This is around 1864, when Impressionism was in its embryonic stages (the Salon des Refusés was in 1863): the author's sensitivity to the ways that rays of colourful light can shape form was soon to become the mood of the day.

We find a contrasting observation, no less precise and intriguing, in Henry James, who, despite his admiration for the Galleria degli Uffizi, found it more satisfying to observe the paintings by Andrea del

1 Hippolyte Taine, *Voyage en Italie* (Paris: Hachette, 1874), 1889 edition, p. 59.

Sarto 'in those dusky drawing-rooms of the Pitti Palace [...] In the rich insufficient light, where, to look at the pictures, you sit in damask chairs and rest your elbows on tables of malachite, the elegant Andrea del Sarto becomes deeply effective'.[2] On the one hand, through the refined, though snobbish, perspective of Henry James, we catch a glimpse of a museum experience characterized by the privilege afforded only to an international élite. On the other hand, we also perceive the underlying truth that limited lighting or even the penumbra of historical rooms constitute the best lighting conditions in which to view the works of art; the conditions for which they were originally created, and in which they lived for centuries before the advent of electric lighting.

The Italian translations for 'dusky' in the rooms of the Galleria Palatina can vary from 'ombroso' to 'scuro' to 'buio', and similarly 'fosco' and 'tetro', which can be summarised by James's admirable oxymoron 'rich insufficient light'.[3] The scarcity of light was counterbalanced by the density of the chromatic tones — suffused with the presumably red reflections of the damasks and the overpowering green reflections of the malachite — which satisfied the observer, stimulating aesthetic emotions where sight could not gather complete information.

A few decades earlier, the relationship between light and shadow had been quite differently expressed by other visitors to Florence. Mary Shelley wrote that 'during the misty and darker days of this *unsouthern* winter, I have gone [...] to warm my heart and imagination by the golden hues of a sunnier and purer atmosphere'.[4] While Shelley's warm sunlight was more of a symbolic, psychological condition, the similarly appreciative observations of the American lawyer-writer George Stillman Hillard described the real sunlight that illuminated the rooms of the Galleria Palatina: '[...] there are no gloomy vaults of shade and cold [...] but the sun streams in through spacious windows in rich and enlivening masses'.[5]

It is beyond the scope of this chapter to discuss the many nineteenth-century travel narratives that require substantial scholarly attention. For

2 Henry James, *The Non-Fiction of Henry James* (*Annotated with Biography*) (Golgotha Press, 2011).

3 These Italian terms range in meaning from 'shadowy', to 'gloomy' and 'dark'.

4 Mary Shelley, *Rambles in Germany and Italy 1840, 1842 and 1843* (London: Edward Moxon, 1844), part III, vol. II, p. 156. Shelley's italics.

5 G. S. Hillard, *Six Months in Italy* (Boston: Ticknor, Reed, and Fields, 1853), vol. I, p. 95.

the time being, however, it is worthwhile to examine the documentary texts available regarding a few Florentine 'cases', which deal with ancient and modern museums and their lighting arrangements as they change over the centuries, particularly through the 1800s.

It is appropriate to begin with the abovementioned Galleria degli Uffizi, the first museum opened to the public in Florence thanks to the enlightened Grand Duke Peter Leopold Habsburg-Lorraine; this was part of a long process that followed the French Revolution and the subsequent sharing of privileges formerly enjoyed solely by the sovereigns of the *ancien régime*. In the second half of the eighteenth century, the Galleria degli Uffizi underwent a radical re-arrangement. It had been a *Wunderkammer* of famous antique treasures, modern works of art, artificial and natural wonders; nourished, organized and finally mixed up, over the course of the two Medici centuries. This rearrangement had been long overdue, and was carried out by the Grand Duke with the help of directors and antiquarians, as has been recently reconsidered in specialized publications.[6] Directors Antonio and Raimondo Cocchi, Giuseppe Pelli Bencivenni and Luigi Lanzi, each in his own field, brought about innovations and modifications to rationalize the exhibition layout, preparing at the same time the removal of important collections, which would continue in the following century.

From the many published documents there are some — but very few — references to the Galleria lighting arrangements. These were exclusively natural for reasons of safety and practicality, considering the presence of highly inflammable materials, and it was not possible to light the Galleria evenly while attracting regular visitors, who could be suspicious of flame-lit galleries (the only available form of artificial lighting). Flame lighting was known to alter the perception of colours, softening them into a deceptive and indistinct mass that confuses the judgement, conferring on the paintings an elusive grace. 'Né donna né tela a lume di candela' [One should not marry a woman nor buy material by the light of a candle] is a proverb that exists in at least fifteen versions in the different Italian dialects; even if 'tela' [canvas] does not

6 M. Fileti Mazza, B. Tomasello, Antonio Cocchi, *Primo Antiquario della Galleria Fiorentina: 1738–1758* (Modena: Panini, 1996); M. Fileti Mazza, B. Tomasello, *Galleria degli Uffizi 1758–1775: La Politica Museale di Raimondo Cocchi* (Modena: Panini, 1999); M. Fileti Mazza, B. Tomasello, *Galleria degli Uffizi 1775–1792: Un Laboratorio Culturale per Giuseppe Pelli Bencivenni* (Modena: Panini, 2003).

refer to a painting (as art historians tend to take for granted) but only to the material itself, the advice not to conduct aesthetic evaluations under uncertain and flattering light still holds.

In 1773 Raimondo Cocchi tried to make the viewing of medals easier by moving the collection 'nell'ultima stanza sul lungarno dalla parte occidentale, libera e luminosa [...] le altre tutte hanno tropp'eccezioni per quest'uso, specialmente del lume, e son troppo fredde per starvi a sedere a studiare come si fa sulle medaglie [...]' [to the last room on the Lungarno in the west wing, empty and luminous [...] the other rooms all have too many faults for this use, especially the lack of light and its being too cold to sit down to study the medals, as it is usually done],[7] softening and regulating the light of the big window with a curtain of white cloth with a flounce. In the same year, Francesco Piombanti made a suggestion to the Grand Duke to install the cabinets of the bronze objects taken from Palazzo Pitti in a 'piccola stanza che resta a mezzogiorno dietro l'arsenale vecchio' [small room looking southward behind the old arsenal] having previously 'ingrandire la finestra unica che c'è in tre luci immediatamente prossime una all'altra per avere il lume bisognevole' [enlarged the only existing window into three windows next to one another in order to have the necessary light]. Cocchi underlined in one of his writings that 'i bronzi hanno bisogno di molto e vivo lume'[8] [bronze objects need a lot of strong light].[9]

Artists could sometimes choose the location of their painting according to the lighting they desired. In 1778, the Castellamare painter Giuseppe Bonito, who wished to add his own self-portrait to the collection of self-portraits at the Galleria, was told by the director Giuseppe Pelli Bencivenni that a favourable location would be found:

7 Cf. Mazza e Tomasello, *Galleria degli Uffizi 1758–1775*. In a letter to the Grand Duke of 18 January 1773, Raimondo Cocchi gave the drawing of the glass panes (p. 69); on 5 July 1773 he stated he had ordered to be placed over the window 'al finestrone una tenda di tela bianca con suo falpalà' [a white cotton curtain with its flounce] (p. 81).

8 Mazza e Tomasello, *Galleria degli Uffizi 1758–1775*. In a document of 7 July 1773, Cocchi observed that 'i bronzi hanno bisogno di molto e vivo lume' [bronze objects need a strong and lively light] (p. 83).

9 Mazza e Tomasello, *Galleria degli Uffizi 1758–1775*. In a letter of 9 July 1773 to the Grand Duke, Francesco Piombanti informed him of the arrangement of the bronze objects in the wardrobes in a special cabinet, and suggested they should 'ingrandire la finestra unica che c'è in tre luci immediatamente prossime una all'altra per avere il lume bisognevole' [enlarge the only window existing into three sources of light one next to the other in order to have the necessary light] (p. 170).

'[...] il signor Giuseppe Bonito può rispetto al lume, scegliere quello che troverà più favorevole all'idea che concepirà nel colorire il proprio, mentre io nel collocarlo a suo tempo gli destinerò il luogo che gli converrà meglio' [Mr Giuseppe Bonito can choose, as regards light, that which he finds most favourable to his own colouring of the portrait, while I will position it in the most suitable place in due time].[10]

Abbot Luigi Lanzi was pleased that the light of the Tribuna could be regulated by means of curtains in order to suit copyists: the space of the Tribuna was 'alto, cerchiato intorno da gran numero di finestre, presta col ministero delle tende ad ogni oggetto que' gradi appunto di luce, che a ben vederlo e a ben disegnarlo son richiesti' [high, surrounded by a great number of windows, offering to each object, with the help of curtains, those degrees of light which are required in order to see, and make a drawing of it].[11]

In the past, the only lighting available to the Galleria visitors and scholars was from natural sources. This not only allowed for variations of intensity and tone depending on the time of the day, the seasons, and the weather, but also created a stark contrast between intensely lit rooms and those which were shadowy, sometimes dark. The staff were required to adjust the technical systems ('impiantistici') — as we would call them today — in order to balance the light intensity and soften the contrast that was integral to the great building.

The excessive luminosity of several rooms, and especially of the great Corridors (the second of which is lit up, north and south, by a series of large windows constructed of several panes) was juxtaposed with the darker interior rooms, which had medium-to-small windows and modest skylights. In the Corridors, which were originally open loggias, the detailed drawings of Benedetto Felice-Vincenzo De Greyss were made reality in 1749 on the orders of Francis Stephen Lorraine. This involved the installation of distinctive glass panes made 'a rulli', that is, formed by disks of blown glass held together by lead:[12] the presence of this type

10 Mazza e Tomasello, *Galleria degli Uffizi 1775–1792*, p. xlv, note 54: report by Giuseppe Bencivenni (formerly Pelli) of 18 May 1778.

11 L. Lanzi, *La Real Galleria di Firenze accresciuta e riordinata* (Firenze: Franc. Moücke, 1782), p. 170, http://www.memofonte.it/home/files/pdf/lanzi_realgalleria.pdf

12 'Dell'inventario figurato furono realizzati quattro volumi in due stesure, una a matita ed una toccata in penna. Le parti completate raffiguravano i tre corridoi, la sala delle iscrizioni, cinque pareti della tribuna e la stanza degli autoritratti. Questi disegni sono conservati al Gabinetto disegni e stampe degli Uffizi (stampe

of glass pane is confirmed by the illustrations of *Viaggio pittorico della Toscana* by Francesco Fontani (1801–03). The same technique was used for the Tribuna windows, during the restoration that was completed in 2012, in order to evoke the 'invetriate di spere venitiane' [window panes made of Venetian glass disks] of 1590. In archival documents there is little evidence of the decision to substitute the 'a rulli' panes with big modern windows, made of wood and glass panes, shielded by curtains.

Over the course of the nineteenth century, the Galleria — like other Florentine and Italian collections — underwent the traumas of the French and Napoleonic occupation, which involved the seizure and subsequent return of antiques and art works; the Restoration; the unification of Italy in 1861; the period when Florence was the capital (1865–71); the departure of the government for the new capital, Rome, in 1871; and finally, it metamorphosed from princely gallery to public state museum. Political events inhibited or delayed architectural and technical renovations. When the Senate left the Uffizi, the Galleria reclaimed its place in the old Medici theatre, which became the Botticelli hall in the twentieth century.

A closer examination of nineteenth-century lighting choices, pending more targeted research in the archives of the Galleria degli Uffizi, can be undertaken using Enrico Ridolfi's account of his time as director of the Gallerie Fiorentine, and therefore also of the Uffizi, from 1890 to 1903.[13] This has not received much attention from scholars, and perhaps not even from those who work there (excepting the excellent use made of it by Luciano Berti in his general catalogue of the Uffizi), but it certainly merits examination.

Another text one might expect to reward attention is Aurelio Gotti's ponderous work devoted to the Florentine Galleries in the form of a

in volume, nn. 4492–4588), eccetto quelli relativi alla sala degli autoritratti che, sia nella prima versione sia in quella definitiva, si trovano nella Biblioteca nazionale di Vienna' [Four volumes in two versions of the illustrated inventory were made, one in pencil and one in ink. The completed parts presented the three corridors, the room of the inscriptions, five walls of the tribune and the room of the self-portraits. These drawings are preserved at the Gabinetto disegni e stampe degli Uffizi (stampe in volume, nn. 4492–4588), except for those referring to the room of the self-portraits, which, both in their earlier version and in their final version are now at the Vienna National Library]. (*De Greyss, Benedetto Felice*, in 'Dizionario Biografico degli Italiani' Volume 36, 1988.

13 E. Ridolfi, *Il mio direttorato delle regie Gallerie fiorentine: Appunti* (Firenze: Tipografia Domenicana, 1905).

report to the Ministry of Public Education; it covers the crucial period when Florence was the capital but there is no consideration of lighting, even though the report deals with the formation of new museums, the reorganisation of existing ones, and the study, arrangement and enlarging of the collections. It is therefore to Ridolfi's book I shall turn.

In his descriptions of the projects he had overseen, Ridolfi underlined the critical situations he had had to put right and the improvements he had introduced or tried to introduce. He also wrote an essential foreword, with which anybody would still agree: 'Non bisogna dimenticare che il locale degli Uffizi non era sorto a uso di Galleria: a tal uso fu poi destinato, ed aumentato quindi a poco a poco, e formato nella maggior parte di piccole sale illuminate da finestre' [One should not forget that the premises of the Uffizi were not originally used as a Gallery: they were geared to this use later, slowly increasing the space, formed mainly by small rooms lit up by windows].[14]

It must be remembered that until the arrival of the fourteenth- and fifteenth-century painted masterpieces, the Galleria was best known and appreciated for its statues, archaeological marble and bronze works, the collection of self-portraits and the cabinets of special collections, such as bronze objects, antique ceramics, vases, gems, etc. In the corridors, a *promenade* of antique sculptures and reliefs, which had been the pride of the Medicis — including the series of famous historical characters known as 'la Gioviana', and that of the Medicis and their relatives known as 'l'Aulica' — imposed themselves on the visitor. A polychromatic counterpoint was offered by the vaults (whose bays were frescoed with *grottesche* and other sixteenth-to-eighteenth-century decorations) and by the paintings hung high up on the interior and external walls. In order to present the statues in the second corridor at their best and eliminate the reflection caused by the large windows to the north and south, one side of the corridor had been shielded with canvas curtains. Intending to improve this effect, Ridolfi arranged a test, covering the curtains with a series of tapestries portraying histories of Cleopatra: 'per nascondere con quella ricca tappezzeria le grossolane tele che vi si vedevano destinate a coprire le invetriate da un dei suoi lati, onde la luce non venisse da più parti togliendo effetto alle gentili statue dispostevi' [in order to hide with those rich tapestries the coarse

14 Ibid., p. 8.

curtains, which were used to cover the windows on one side, so that the light would no longer come from several directions, diminishing the effect of the lovely statues exhibited].[15] But apparently the test was not convincing.

Conversely, the gloominess of many of the rooms, especially those lacking windows, was to be illuminated by means of different devices. For instance, a large glazed interior window reflected the light pouring in from the Sala dell'Ermafrodito into the adjacent and otherwise dark Ricetto delle Iscrizioni, enhancing the strong *chiaroscuro* contrasts between the statues in relative shadow and the luminous background.

The need to adjust the presentation of the collections according to their location resulted in a display that aimed to use the different rooms to best effect. Thus, Ridolfi explained, paintings were exhibited

> soltanto nelle sale interne per esser quei locali di maggior decoro e illuminati da luce più favorevole perché scendente per quanto fosse possibile dall'alto, o venendo almeno da un sol lato; mentre la luce che illumina la parete dei grandi corridoi venendole dai vetratoni che si aprono rimpetto a quelle, riesce poco favorevole ai dipinti e molto invece agli arazzi, alla cui esposizione pertanto e a quella dei marmi e dei disegni sarebbero stati i grandi corridoi riservati. ([...] only in the interior rooms, as those were the most decorous rooms, lit by a more favourable light coming as much as possible from high up, or at least from one side only; while the light illuminating the wall of the great corridors, and coming from the big glazed windows opening in front of them, is not very favourable to paintings although it is favourable to tapestries, which were therefore exhibited, together with marble works and drawings, in the corridors.)[16]

The interior rooms were generally equipped with skylights, which Ridolfi enlarged in order to convey the best light: a cold and almost unchanging light and therefore ideal, as in artists' studios and homes, to view works of art and especially paintings.

According to Ridolfi, 'i lavori di mutamento e di rifinimento delle nuove sale [...] e il restauro di molte delle antiche' [the work done to change and finish the new rooms [...] and the restoration of many of the antique rooms] was especially carried out in order to 'illuminare dall'alto tutte quelle che potevasi col mezzo di lanterne, o per ampliare

15 Ibid., p. 34.
16 Ibid., p. 36.

quelle lanterne che già vi esistevano, ma insufficenti a dar luce bastevole nelle giornate non splendide' [illuminate from high up all those that could be lit by means of lanterns, or in order to enlarge the already existing lanterns; this was insufficient, however, to shed enough light on the duller days].[17] He decided to install 'altra lanterna nella volta' [another lantern in the vault] in the Ermafrodito-Vestibolo area; the decision to 'rialzare i soffitti e aumentare la luce'[to make the ceilings higher and to increase the light][18] was taken for other rooms. Ridolfi used 'lantern' according to its architectonic meaning, referring not so much to its morphology (generally shaped like a small temple on top of a dome) as to its function, as a technical device that sends natural light downwards. The desire to enlarge one of the existing large windows in one of the four rooms that housed the self-portraits clashed with the risk of altering the stability of the structure.[19]

In 1899 the arrival of an important set of works of art from the Arcispedale di Santa Maria Nuova, regularly purchased, required new adaptations. Thus the *Tryptich* by Hugo van der Goes was installed in a room that was 'convenientemente illuminata dall'alto' [conveniently lit up from the top],[20] requiring the 'modern' — more recent — self-portraits to be moved, even though they had been there for several years. If the light had to be softened, this was done with the usual shielding by curtains, which were altered to fit the style of the time in addition to their functionality. In the Gabinetto delle Gemme, rearranged during Ridolfi's tenure, 'la finestra della sala fu munita di tenda d'antica stoffa' [the window of the room was provided with a curtain made of ancient material][21] and in the Sala della Niobe 'le sconvenienti tende di tela bianca che stavano appese alle finestre ornatissime, si cambiarono in seriche tende di stoffa giallognola' [the unseemly curtains of white

17 Ibid., p. 11.
18 Ibid., p. 35.
19 '...vedendo come la maggiore di esse [quattro stanze], designata a contenere i ritratti più moderni, riusciva debolmente illuminata nella parte estrema opposta al finestrone, né potendo ormai ampliar questo maggiormente senza nuocere [...] alla robustezza dell'edificio, [l'architetto] raccorciò di una terza parte la sala...' [... since most of the rooms [four rooms], designed to hold the more modern portraits were weakly lit up far from the big window, and it not being possible to enlarge this without endangering [...] the solidity of the building [the architect] shortened the third part of the room...]. Ibid., p. 25.
20 Ibid., p. 33.
21 Ibid., p. 20.

canvas hanging on the most ornate windows were changed for yellowish silk ones].[22]

Two types of objects collected by the Gallerie were permanently damaged over the course of time by their being exposed to strong and constant light, which was originally believed to be favourable: drawings and tapestries. The distribution of many drawings (which were earlier kept in closed drawers) throughout various rooms on the second floor started in 1854, when the director Luca Bourbon del Monte — to use Aurelio Gotti's words:

> provvide con savio pensiero a disporre con pubblica mostra nella Galleria delle statue [degli Uffizi] alcuni dei migliori disegni che potessero soddisfare alla giusta curiosità del pubblico, e dare agli artisti un saggio della importanza di tutta la collezione, della quale per l'avanti nulla mostravasi se non a qualche dotto straniero, o a qualche principe, o a chi si fosse procacciato autorevoli commendatizie. Riuscì, tutta insieme, una bella e ricca mostra, nelle tre sale che erano state inalzate al dorso della gran terrazza ('wisely provided a public exhibition in the Galleria delle statue [degli Uffizi] of some of the best drawings that could satisfy the well-placed curiosity of the visitors, and offer to the artists an example of the importance of the whole collection, no piece of which was previously shown except to some foreign scholar or some prince or to those who managed to obtain authoritative recommendations. The result was on the whole a beautiful and rich exhibition in the three rooms that had been erected on the big terrace').[23]

In 1866, when Florence was the capital and the king lived in the Pitti, il Corridoio Vasariano was altered with the purpose of 'distendendovi una buona parte dei disegni, delle stampe e degli arazzi che rimanevano sempre chiusi in cartelle, o disposti nei magazzini demaniali' [exhibiting there a good number of the drawings, prints and tapestries that were always kept in folders in the *demanio* (state-owned) storage spaces].[24] By 1867 this exhibition had already finished; it had included the large and exquisite still-life drawings by Jacopo Ligozzi. Further along the Corridoio, down the big staircase annexed to the third corridor and along the section that runs parallel to the Lungarno Archibusieri

22 Ibid., p. 21.

23 A. Gotti, *Le Gallerie di Firenze. Relazione al Ministero della Pubblica Istruzione in Italia* (Firenze: Cellini, 1872), p. 223.

24 Ibid., pp. 254–55. There is no reference to the lighting of these art objects that had just been exhibited, taking them out of protected storage.

were hung prints that had never been previously exhibited; later, the drawings collected in the three rooms near the Terrace were moved to the section of the corridor above the Ponte Vecchio — which was the most illuminated section, since the western windows had been enlarged on the occasion of a pre-unification visit by Vittorio Emanuele di Savoia, at the time king of Piedmont and Sardinia (not for the visit of Hitler and Mussolini as the legend has it). Thus the 1716 drawings could be exhibited. These 'exhibited' drawings, which were grouped in one of the categories where the GDSU[25] (E) drawings were listed, suffered serious damage,[26] even though the damage was caused by accident; it was noted and communicated to the press by the connoisseur and aesthete Ugo Ojetti. In describing the future layout of the Uffizi in 1904, Ojetti foresaw some solutions for the location of the statues in the corridors, but above all he recognized the damage already done to the exhibited drawings:

> le statue e i gruppi classici di marmo che adesso ricevendo luce solo di faccia sembrano appiattiti contro il muro saranno posti nel mezzo dei corridoi [...]. Molti dei disegni adesso sono esposti lungo le vetriate dei corridoi [...] è impossibile lasciarli, come le stampe, eternamente lì, dove il bistro s'illanguidisce, la biacca s'ossida, la punta d'argento sbiadisce, e la carta s'ingiallisce e fiorisce [the statues and the marble classic groups that now receive the light only from the front, and therefore look flat, will be placed in the middle of the corridors [...]. It is impossible to leave many of the drawings and prints where they are [...] along the windows of the corridors, where the *bistro* pales off, the *biacca* gets oxidized, and the paper becomes yellowish and spotted].[27]

The tapestries hanging in the Corridoi of the Uffizi, also exhibited during the previous century, were suffering damage that was more difficult to spot. They were removed from the Corridoi degli Uffizi only in 1987, since such prestigious and decorative objects were usually kept where they were unless their relocation was deemed to be essential. It was extremely fortunate that there was insufficient money or space to carry out Ridolfi's intentions:

> congiungere alle mostre di antiche stoffe e ricami che trovansi alla Crocetta [il palazzo ex Mediceo della Crocetta presso la SS. Annunziata,

25 Gabinetto delle stampe degli Uffizi.
26 Gotti, *Le Gallerie di Firenze*, p. 255. See also Anna Maria Petrioli Tofani, *Gabinetto disegni e stampe degli Uffizi. Inventario. Disegni esposti*, 2 vols. (Firenze: Olschki, 1986).
27 Ugo Ojetti in the 'Corriere della Sera', 14 December 1904.

oggi sede del Museo Archeologico], le molte e belle stoffe del legato Carrand non mai potute esporre nel Museo Nazionale per mancanza di spazio, o esposte in luoghi ove è difetto di luce [to add to the ancient materials and embroideries exhibited in the Crocetta [the former Medici palace of the Crocetta near SS. Annunziata, now the seat of the Museo Archeologico] the many and beautiful materials belonging to the Carrand bequest, which were never exhibited in the Museo Nazionale due to lack of space or exhibited in places where there was little light].[28]

The Carrand textiles collections were left protected in dark rooms, or, to their greater benefit, in the drawers of the Museo Nazionale del Bargello.

Two more short observations on two Florentine cases.

If one exits the Galleria degli Uffizi and the Complesso Vasariano, one comes across a complex and fascinating case (although on a lesser scale) in the Cappella dei Magi by Benozzo Gozzoli in the Medici Riccardi palace. The chapel, part of Michelozzo di Bartolomeo's plan for the palace, was finished by 1459. It was made of wood and grey sandstone, with polichrome marble decorations, and Benozzo Gozzoli painted scenes on its walls including the *Journey of the Magi*, *The Annunciation to the Shepherds* and *The Adoration of the Angels*. Today, these scenes converge towards the altar and the *Adoration of the Child*, a painting ascribed to Pier Francesco Fiorentino, which took the place of the original painting by Filippo Lippi that had hung there and was sold and exported in the nineteenth century. Gozzoli finished them in 1464, when he left Florence. From its very origin the chapel must have been in perpetual shadow due to the lack of natural light, which was admitted only through a western oculo (overlooking a narrow courtyard), an eastern oculo (overlooking an entrance, now a small corridor), and from two small western windows in the small lateral vestry. These circumstances, linked to the position of the chapel at the heart, as it were, of the monumental pile, had an impact on the artist's decisions when it came to the chromatic, tonal and luminous rendering of the frescoes. During the illumination tests of 1992, when artificial light was reduced to an absolute minimum, one could see (and enjoy) the clear and well-defined shapes of the equestrian statues stand out of the shadows; the thick applications of ultramarine blue and red lacquer, gold, and silver shone more strongly, creating an effect of diffused luminosity, while the

28 Ridolfi, *Il mio direttorato delle regie Gallerie fiorentine*, p. 27.

impressions of distance were heightened by the semi-darkness, which deepened the observer's view until it lost itself in an indistinct darkness.

The tapestry effect caused a flattening, with a vertical ascent of the composition, criticized by some famous art critics such as Bernard Berenson; this is softened and disappears while the light balance evokes the situation during the pre-industrial past.

There were various attempts to compensate for the lack of light in the chapel. Before 1650, on the orders of the Medicis, two rectangular windows with round glass panes were opened on both sides of the original entrance, but they admitted only a pale and indirect light since they looked onto another interior room. One of the two windows was destroyed during the structural modifications during the ownership of the Riccardi family from 1269, when architect Giovan Battista Foggini built a staircase that obtruded onto the left-hand-side of the chapel and caused it to be remodelled. The original functions of the chapel, as both the religious heart of the palace and evidence of the supreme wealth of the Medicis, were less important to the new owners who did not hesitate to carry out heavy alterations. In 1837 — after the Riccardis had sold Filippo Lippi's *Adoration of the Child* in 1814 — the new owners, the Lorraines, installed a wide arched window on the altar wall, which allowed a wave of light to wash over the altar and, from there, to irradiate the room. Two of the four symbols of the Evangelists painted by Gozzoli, St. Mark's Winged Lion and St. Luke's Winged Bull, were lost. Finally, during the 1929 restoration of the chapel, the window was bricked up, the wall was rebuilt and painted blue, and another Adoration was placed on the altar, a painting attributed to Pier Francesco Fiorentino, almost certainly taken from one of the convents that had been suppressed in the city: darkness returned to the chapel.[29] However, artificial light solved the problem at its root. The troubled (and in its own way disastrous) history of the chapel is certainly an interesting case study, which offers a unique perspective on our changing perception, over the centuries, of (and in) artistic spaces.

I will conclude my chapter with one of the rare cases of a Florentine museum space built from scratch (*ex novo*), that is, the Tribune dedicated to Michelangelo's *David*, located in what was initially (in 1873) the

29 Cf. C. Acidini Luchinat (ed.), *I restauri nel Palazzo Medici Riccardi. Rinascimento e Barocco* (Cinisello Balsamo, Milan: Silvana, 1992).

Galleria d'Arte Antica e Moderna, and which is nowadays the Galleria dell'Accademia, formerly the Ospedale di San Matteo.

A hall in the form of a temple, the Tribuna was built according to plans by Emilio de Fabris in 1873 (and in preparation for the four-hundredth anniversary of Michaelangelo's birth in 1875), after a special committee had decreed the removal of the marble colossus from the Piazza della Signoria and its exhibition in a museum. It was constructed at the heart of the big block which still had green spaces and cloisters, even if it was already the seat of the Conservatorio Musicale 'Luigi Cherubini' and of the Opificio delle Pietre Dure, the heir of the 'Galleria dei Lavori' removed from the Uffizi by the Lorraines of the Restoration. The *David* was not placed in the centre but it was partially set under the apsidal arch of the new structure, covered by a vast glazed dome. The Galleria was originally a teaching place for the nearby Accademia di Belle Arti with its 'ancient and modern' paintings (later moved partly to the Gallerie degli Uffizi and to the Arte Moderna at Palazzo Pitti). Towards the end of the nineteenth century, the director Ridolfi fitted out three rooms in order 'collocare in miglior luce' [to place in a better light][30] Botticelli's *Primavera* and other of his masterpieces, as well as paintings of the increasingly beloved 'quattrocentisti'. Ridolfi took great care of the rooms adjoining the *David*. In the *crociera* of the Tribuna 'si rifecero i finestroni in modo e forma convenienti' [the big windows were rebuilt in the proper manner and shape] and 'furono poi meglio illuminate e decorate le altre sale cui da qui si accede' [then the other adjoining rooms were better lit and decorated].[31]

The idea to allow natural light to fall on Michelangelo's marble statue from high up (filtered by glass panes) had at least one important precedent: the exhibition of the *Barberini Faun* for Ludwig of Bavaria in the Munich Glyptothek, placed in a specially built hemicycle structure in 1820. However, the most important and authoritative model of light falling though a ceiling into a space lacking windows was, then as it is now, the Pantheon, which has lost nothing of its inspiring power.

It has been observed of this mode of lighting that:

il sole, nel suo quotidiano itinerario privato del rapporto con l'orizzonte, assume un carattere trascendente, metafisico. Si partecipa del sorgere e

30 Ridolfi, *Il mio direttorato delle regie Gallerie fiorentine*, p. 12.
31 Ibid., pp. 12 and 14.

del tramontare: solo l'intensità luminosa e la profondità delle ombre ci riporta ad una dimensione reale. Uno spazio privo di finestre e dotato di aperture sommitali si trova in una condizione estraniata, disorientata: lo spazio galleggia, inconsapevole, tra sotto e sopra, ipogeo e epigeo [the sun, in its daily journey deprived of its relationship with the horizon, takes on a transcendent and metaphysical character: One is part of sunrise and sunset: only the light's intensity and the shadow's depth takes one back to a dimension of reality. A space with no windows and equipped with summit openings is in a disoriented, alienated condition: space floats, unconsciously, between above and below, between hypogeum and epigeum].[32]

In this as in other instances, one should never underestimate the power of light to create particular psychological conditions for the visitors of museums and other exhibition spaces: strong emotions, in front of overpowering masterpieces, can indeed cause disorientation, wonder, and finally alienation. It is not a coincidence if the psychological phenomenon known in literature as 'Stendhal syndrome' has been identified and studied in relation to the *David*, a naked giant, glaring white in a light of perfect abstraction.

32 www.luigifranciosini.com/download/labo1/la%20casa%20studio.pdf

20. Ways of Perceiving:
The Passionate Pilgrims' Gaze in
Nineteenth-Century Italy

Margherita Ciacci

Fig. 20.1 Carlo Canella, *Veduta di Piazza della Signoria dalla Loggia dei Lanzi*, Cassa di Risparmio di Firenze, 1847. Wikimedia. Public domain, https://commons.wikimedia.org/wiki/File:Carlo_canella,_veduta_di_piazza_della_signoria_dalla_loggia_dei_lanzi,_1830,_01.jpg

https://doi.org/10.11647/OBP.0151.20

Traveling and writing are practices that involve both a 'horizontal' dimension across spaces and pages and a 'vertical' one, in which time seems to be suspended and sensitivity is heightened by the awe of specific events, discoveries, epiphanies. Thus, Michel Butor, in an influential paper written in the 1970s, addresses writing and traveling: he considers both as those sign-tracing activities that have accompanied human beings along the paths of history, allowing narratives and shared meanings to develop. The fabric of culture and the features of the known world are thus enveloped within the skeins of the written accounts and the visual renditions produced by human agents — according to the idiosyncratic cognitive and cultural backgrounds of those agents — while on their exploratory rounds at given moments in history.[1]

It is through such an interpretive lens that we too may look upon the traveling and 'writerly' deeds of the emerging American leisure classes from the East Coast who were engaged in their discovery of Europe during the nineteenth century. From the end of the War of Independence to the eve of the Civil War — a period that has been dubbed the 'Homeric Age' of American cultural history — incessant flows of 'passionate pilgrims' made it across the Atlantic.[2] A rich literature has covered the many-faceted forces that have been held responsible for the phenomenon.[3] Artists and writers, emerging professionals and ruthless adventurers, intellectuals and academics, all were spurred toward Europe as if in search of the 'historic' identity that could complete their self-image. The 'lure of Italy' celebrated throughout the eighteenth century (and even earlier) by northern European aristocracies and their scions had inscribed the peninsula within a mythical frame. Literary renditions of Italian travel experiences were

1 Cf. Michel Butor, 'Voyage et récriture', *Romantisme* 4 (1972), 4–19 (special issue 'Voyager doit être un travail sérieux').

2 The notion of 'passionate pilgrims' was made popular by Henry James in his novella of the same name first published in 1871 in *The Atlantic Monthly*. Many of James' inspirational motifs already appear therein.

3 For cursory references to some classics of the genre, see: Paul R. Baker, *The Fortunate Pilgrims: Americans in Italy. 1800–1860* (Cambridge, MA: Harvard University Press and Oxford University Press, 1964); Van Wyck Brooks, *The Dream of Arcadia: American Writers and Artists in Italy, 1760–1915* (London: Dent, 1959); Natalia Wright, *American Novelists in Italy. The Discoverers: Allston to James* (Philadelphia: University of Pennsylvania Press, 1965); A. W. Salomone, 'The Discovery of Nineteenth-Century Italy: An Essay in American Cultural History', *The American Historical Review* 73.5 (1968), 1359–91. For more recent contributions to the field see, for example, Theodore Stebbins (ed.), *The Lure of Italy: American Artists and the Italian Experience, 1760–1914* (Boston: Museum of Fine Arts, 1992).

increasingly hailed by Anglophone cultural milieus.[4] Byron's stanzas had evoked the Italian voyage as an initiatory pilgrimage while William Hazlitt declared in 1822 that the soul of a journey is liberty: 'we go on a journey chiefly to be free of all impediments and of all inconveniences; to leave ourselves behind, much more to get rid of others'.[5] The fashioning of oneself through traveling — key to the emergence of the psychological disposition demanded of the new English urban classes — was at the core of the 'tourist' craze that swept over Europe at the close of the Napoleonic wars. Set itineraries were identified and canonical sites were chosen in an effort to realize the travelers' desire to imbue every aspect of their Italian voyage with prized ancient associations.

Across the Atlantic it was almost 'natural' for the 'first new nation' elites, obsessed with the foundational ideas that had hitherto accompanied their struggle for independence, to turn to a mostly imagined 'eternal Italy': a myth–laden place made meaningful by the creative lives of past generations.[6] Besides, as James Fenimore Cooper had made clear, 'all who travel know that the greatest pleasure is in the recollections'.[7] The richer the palimpsests of the past, the more memorable the visiting experience.

4 One important example is represented by Lady Sydney (Owenson) Morgan: she not only authored *Italy*, 2 vols. (London: Henry Colburn and Co, 1821), I, https://babel.hathitrust.org/cgi/pt?id=mdp.39015020085299;view=image, II, https://babel.hathitrust.org/cgi/pt?id=nyp.33433000262190;view=1up;seq=11 whose merits were acknowledged by Lord Byron himself, but also wrote *The Life and Times of Salvator Rosa*, 2 vols. (London: Henry Colburn, 1824), I, https://babel.hathitrust.org/cgi/pt?id=uc2.ark:/13960/t53f4n474;view=1up;seq=7, II, https://babel.hathitrust.org/cgi/pt?id=mdp.39015073730742;view=1up;seq=7. The book exerted great influence over American artists of the time: such was the case of Thomas Cole. See, for instance, Cole's *Salvator Rosa painting banditti* (1832–40), Boston, Museum of Fine Arts, https://www.mfa.org/collections/object/salvator-rosa-sketching-banditti-33726

5 William Hazlitt, 'On Going a Journey,' in *Table-Talk, or, Original Essays* (New York: Chelsea House, 1983), pp. 249–61.

6 The phenomenon was already present in colonial America. Since 'for Americans at this time, the leisurely pursuits of connoisseurship and antiquarianism as well as the more frivolous recreations and amusements which constituted an important part of the Grand Tour were generally beyond their grasp both financially and practically. Those who did travel abroad generally were in pursuit of advanced *training* [italics added] in their professions of a sort not available at home, with the result that their journeys were frequently of a far more serious tenor than those of many of their fellow travelers from the mother country'. See Arthur S. Marks, 'Angelica Kauffmann and Some Americans on the Grand Tour', *The American Art Journal* 12. 2 (1980), 4–24.

7 James Fenimore Cooper, *Excursions in Italy*, 2 vols. (London: R. Bentley, 1838), I, p. 34, https://archive.org/details/excursionsinita00coopgoog/page/n11

Poet Lydia Sigourney — upon returning from her European tour in 1840 — was of a similar opinion: 'among the pleasures of travelling are the emotions of traversing the spots that antiquity has hallowed'.[8] What lessons might one learn from Italy's glorious past? What had been the reasons for the ascent and subsequent decline of a formerly all-powerful civilization? The five-part allegory *The Course of Empire* (1833–36) painted by Thomas Cole upon his return from Europe, seems to capture the concerns of many enlightened American citizens while also warning about the fate of an increasingly materialistic society, oblivious of its original moral and religious bearings.

Back in 1833 (the same year that painter Samuel Morse completed his 'pedagogical' *The Gallery of the Louvre*, representing the Salon Carré, rich in visual examples of the importance of copying artworks), Ralph Waldo Emerson had extolled the value of traveling as a tool for improving one's own judgment in order to measure, as it were, the tension between historical 'authority' (as represented by classical antiquity and the dream-like aura of a distant age) and the 'new' pilgrims' Puritan individualism. The achievement of what Emerson called a 'finished character' represented one of the main goals that American travelers of the earlier part of the nineteenth century had more or less consciously set for themselves.[9] The sonnet composed by William Cullen Bryant 'To an American Painter Departing for Europe' (addressed to Thomas Cole on the occasion of his first journey to Europe in 1829) reveals, however, some of the fears that accompanied such exposure: would the pristine eye and the 'innocent' sensitivity of American artists be tarnished by the confrontation with consummate European sophistication?

While seeking to enhance their own self-reliance, some travelers were also prompted by idealistic motives: such was the case of journalist and first American female public intellectual Margaret Fuller, a close follower of Emerson's Transcendentalist teachings and a passionate supporter of the Italian Risorgimento during the 1848–49 years, which were crucial for the movement's struggle to unify the peninsula under the rule of the House of Savoy. Fuller's tragic death off the coast of Fire

8 Lydia H. Sigourney, *Pleasant Memories of Pleasant Lands* (Boston: J. Munroe & Co., 1842), p. 89, https://en.wikisource.org/wiki/Pleasant_Memories_of_Pleasant_Lands
9 R. L. Rusk (ed.), *The Letters of R. W. Emerson*, 6 vols. (New York: Columbia University Press, 1939), I, p. 375.

Island on her journey back to America in July 1850 marked a shift in the cultural climate that affected the minds of the growing numbers of American 'new pilgrims'. The choice of Italy as a destination for one's own 'travels', 'journeys' or 'rambles' was becoming less an elitist emblem of those personal virtues that might have hitherto been acquired by direct confrontation with the classical world. Rather, because of the rapid and tumultuous growth undergone by the American economy and its attendant vibrant social dynamism, by the end of the Civil War, visiting Italy had become a matter of social distinction, a way of confirming one's own social status and personality. If art appreciation and the mastering of Old Masters' skills had motivated the Italy-bound 'rambles' of a number of American travelers and artists in the earlier decades of the century, the booming American economy during the latter half and the destabilizing psychological effects of swifter social mobility encouraged new social tactics of collecting artworks, as well as all sorts of novel taste-making practices. The proliferation of material goods made the choice of tasteful objects and authentic artworks extremely complex. One's own refinement and social standing was no longer gauged by knowledgeable appreciation, but rather by the rituals of purchase, possession, and display of goods that were perceived as belonging to meaningful hierarchies. In America, the diffusion of John Ruskin's precepts (via his admirer and friend Charles Eliot Norton at Harvard University) generated an 'aesthetic craze' whose influence would continue to haunt the ambitions of the leisured classes later evoked by Thorstein Veblen.

The fun poked by Mark Twain at his 'innocents abroad' (1869) epitomizes the hedonistic and utilitarian ethos that increasingly seemed to pervade most Americans' traveling experiences, turning them into a trite proto-consumerist ritual.[10] As William W. Stowe observes, education was all very well and a little polish never hurt anyone, but the new American travelers of the sixties, seventies and eighties were

10 Mark Twain (pseud. of Samuel L. Clemens), *The Innocents Abroad, or the New Pilgrim's Progress* (1869). The subtitle of Twain's best-seller refers to John Bunyan's celebrated text, *The Pilgrim's Progress from this World to that Which is to Come* (1678). The English theologian's intentions are obviously opposite to Twain's ironic mood. See also the satirical account of American travelers' deeds in Italy by the Canadian James B. De Mille, *The Dodge Club or Italy in 1859* (Philadelphia: published for private circulation, 1869), https://catalog.hathitrust.org/Record/000285095.

not about to 'purchase choice bits of European culture and experience'
on any terms but their own.[11] An indirect indication of the increasing
sophistication of American travelers may be gleaned by considering
William D. Howells's humorous yet negative review of the recently
published *Harper's Hand-Book for Travelers in Europe and the East* by W.
Pembroke Fetridge (1862). Howells claimed that its 'chatty' tone did
not recommend it as a guidebook but rather as a 'New York Odyssey
describing with Homeric freshness and simplicity the travels of a
metropolitan Ulysses'.[12]

The above broad sketch is meant to provide a sort of roadmap for
loosely organizing various instances of travel literature produced (and
used) by those Americans who visited Italy throughout the nineteenth-
century. The places they went to admire — in the present case we will
briefly skirt around Florence and Rome — and even the thoughts and
the emotions they were expected to formulate and to feel were, from the
earliest trips, fashioned along the lines of previous visitors' accounts
or by the engraved images illustrating guidebooks, travel memoirs,
family correspondence, novels and literary essays. The reports of one's
own experiences were magnified by the cumulative knowledge that
grew around specific sites whose explorations had acquired an almost
prescriptive quality. Collective stereotyping quickly ensued (and still
prevails), generating an endless mirroring effect: 'slanted' representations
of places almost becoming a substitute for the 'experience' of actual
sites. For the increasingly broad middle class of the later decades of
the nineteenth century, tourism represented a path for enculturation
into an elite endowed with a rational, managerial perspective. Both
nature and foreign culture became sites on which American travelers
could deploy the 'tourist gaze', which was, in John Urry's definition, a
'socially organized gaze, constructed through difference'.[13] Tourism had
inadvertently become part of a *Bildung* project: namely the achievement
of a national subjectivity fashioned through culture that was initially

11 William W. Stowe, *Going Abroad: European Travel in Nineteenth-Century American
 Culture* (Princeton: Princeton University Press, 1994), p. 34.

12 William D. Howells, 'Review of Harper's Handbook for Travellers in Europe
 and the East by W. Pembroke Fetridge, 1867', *The Atlantic Monthly* (March 1867),
 380–83, https://catalog.hathitrust.org/Record/100150512 Howells was familiar with
 American traveling habits and moods having himself lived in Europe (and Italy) for
 extended periods of time.

13 John Urry, *The Tourist Gaze: Leisure and Travel in the Contemporary Age*, 2nd ed. (New
 York: Sage, 2002).

spurred by a north-eastern elite and that encouraged the growing participation of women.[14]

Selected instances of American odeporic literature offer evidence of 'out-of-the-ordinary' travel discoveries: the 'vertical' dimension evoked by Butor being subsequently translated by means of the 'horizontally' inscribed pages that reveal the observers' 'perceptual distances'. Which were the main discoveries? What did the 'passionate pilgrims' look at? What did they actually see? What did they perceive as 'strange' during their Italian itineraries? Why did visitors increasingly complain about the poor visibility of art collections? Did they expect to get at deeper meanings or hidden messages had the artworks been more clearly visible? Was the assumption that darkness is not the absence of light, but rather the outcome of the interaction of light *and* darkness unfamiliar to American learned travelers? Darkness was condemned inasmuch as it hampered the visibility of the artworks, and yet some travelers' reports show the misgivings of those who complained about getting 'white light enough'. Paraphrasing notions of the 'visual brain' as developed by neurobiologist Semir Zeki, might one assume that the lamented darkness shrouded an otherwise inadmissible feeling of 'perceptual distance'?[15]

Given the essentially 'aesthetic' nature of the visitors' endeavors, aspects such as landscape and the built environment, even varieties of skies and 'atmospheres' as well as artworks and monuments became all items for scrutiny within a process of selective cultural appropriation. The very basic element of light is instrumental to the construction of subjectivity and makes observation possible according to different perceptual habits.[16] This was all the more so at a time when scientific and technological innovations were rapidly producing new geographies of 'enlightened' standards. The following pages represent an attempt to register the perceptual experiences recorded by some of the American

14 B. Bailey, 'Gender, Nation, and the Tourist Gaze in the European 'Year of Revolutions': Kirkland's 'Holidays Abroad', *American Literary History* 14.1 (Spring 2002), 60–82.

15 Semir Zeki, *Inner Vision: An Exploration of Art and the Brain* (Oxford: Oxford University Press, 1999).

16 I have borrowed the expression 'perceptual habits' from the paper by Claus C. Carbon and Pia Deininger, 'Golden Perception: Simulating Perceptual Habits of the Past', *i-PERCEPTION* 4 (2013), 468–76. The authors present research data about the different perceptual experiences observed when viewing paintings depicted on gold-leafed backgrounds under different lighting conditions.

travelers who, throughout the nineteenth century and for many different reasons, were engaged in 'doing' Italy.[17]

The 'strong American light' evoked by Henry James represents the standard by (and through) which nineteenth-century North American travelers tended to observe and interpret their new surroundings. The 'light of reason' reflected in the eighteenth-century European Enlightenment's learned arguments had successfully reached colonial America and had shaped the making of the new republic. The positive associations binding the newly born political regime to economic entrepreneurial success were founded on a reading of the Bible that did away with superstition and received knowledge. The exploitation of immensely rich natural resources through the 'rational' adoption of profit-oriented behaviors had quickly borne its fruits. Incessant innovations in the industrial field had ensured constant economic and social development. The memory of the Old World's Dark Ages was being outdone by the unprecedented successes leading toward the Gilded Age, symbolized by the growing, if 'unromantic', glare of urban lights. The perceptual habits revealed in many nineteenth-century American travelers' reports often reveal value judgments about Italy's lack of civic culture and overall 'backwardness'. This was not uniformly the case: some travelers of the earlier part of the nineteenth century (such, as for instance Washington Irving) enthusiastically considered 'every moldering stone a chronicle' and looked forward to treading in the footsteps of antiquity.

17 This was the case of poet William Cullen Bryant: see, for instance, his *Letters of a Traveller: or Notes of Things seen in Europe and America* (First Series) (New York: G. P. Putnam, 1851), pp. 24–28. One is reminded of the impressions of an earlier American traveler who maintained that in Italy 'the rays of the Sun glowing through a mass of transparent vapour, gild all objects with tints that almost realize the visionary light with which the imagination of Virgil has illuminated the ideal scenery of his Elysium'. Cf. James L. Sloan, *Rambles in Italy in the Years 1816–17* (Baltimore: N. G. Maxwell, 1818), p. 5 and *passim*. Also James Fenimore Cooper, during his Italian sojourns, had mused about the 'liquid softness of the atmosphere' and the 'softened sublimity' lending 'prismatic colours' to the landscape. See James Fenimore Cooper, *Gleanings in Europe. Italy by an American*, 2 vols. (Philadelphia: Carey, Lea & Blanchard, 1838), II, p. 36, https://archive.org/details/gleaningsineuro01coopgoog/page/n10 In a similar vein, William W. Story observed that: 'Nothing can be more exquisite than these summer nights in Italy. The sky itself, so vast, tender, and delicate, is like no other sky. The American sky is bluer, but harder, more metallic. There is all the difference between the two that there is between a feeling and an opinion'. Cf. William W. Story, *Roba di Roma*, 2 vols., 5th ed. (London: Chapman and Hall, 1866), II, p. 14.

The fascination with ruins and decay ensued from the Romantic appreciation for individual emotions and feelings. Ruins stood as silent yet powerful reminders of the passing of time; their 'picturesque' decay embodying the natural cycle of life.[18] Again, in the words of James L. Sloan: 'The ruins of palaces and temples are dressed with the choicest offerings of Flora and the twice blooming rose of Paestum glows with undiminished beauty in the midst of scenes of decayed beauty'.[19] Yet the somber hues enveloping celebrated art venues and their precious contents marred many of the American visitors' experiences. Complaints such as the ones worded by Philadelphia artist Rembrandt Peale on his visit to the Tribuna in the 'far-famed Florentine' Gran Duke's Gallery were not infrequent: 'The little windows that surround the cornice [of the Tribuna] afford an imperfect or injurious light upon most of the objects'.[20] Besides, while many of the gallery's pictures are 'excellent, curious and interesting', Peale deprecates their being crowded in poorly lit rooms. Sloan himself comments to the same effect, observing that 'the distribution of the gallery at Florence is strikingly objectionable, and is as little pleasing to the sense of vision as it is gratifying to the understanding'. In fact statues are best observed by moonlight 'whose paleness gives so eloquent an expression to marble, and in which the divine forms of sculpture appear to become animated'.[21]

The display of statues (the most prized art *exempla* from antiquity) received much attention from American travelers. As Margaret Fuller perceptively observed:

> The facts of our history, ideal and social, will be grand and of new import; it is perfectly natural to the American to mould in clay and carve in stone. The permanence of material and solid relief in the forms correspond to

18 The term 'picturesque' was originally used in eighteenth-century English cultural debates over issues of aesthetics, by, amongst others, William Gilpin and Uvedale Price. For the latter, see his *Essays on the Picturesque as Compared to the Sublime and the Beautiful* (1794). Travel literature's later semantic appropriation of the term has almost equated it to kitsch.

19 Sloan, *Rambles in Italy*, p. 3.

20 Rembrandt Peale, *Notes on Italy, Written During a Tour in the Years 1829 and 1830* (Philadelphia: Carey & Lea, 1831), pp. 202–05.

21 Sloan, *Rambles in Italy*, pp. 269–70. We may notice here one example of the contradictions voiced by sensitive travelers: poorly lit paintings were objectionable inasmuch as they revealed the keepers' careless ignorance and did not allow for satisfactory visibility. Yet, in some cases, glaring lights could spoil the emotional side of the visitors' experience.

the positiveness of his nature better than the mere ephemeral and even tricky methods of the painter — to his need of motion and action, better than the chambered scribbling of the poet. He will thus record his best experiences, and these records will adorn the noble structures that must naturally arise for the public uses of our society.[22]

A number of American sculptors, who shared Fuller's views, did come to Italy — some settling in Florence, some in Rome — with the aim of mastering the art and improving their training in academic environments.[23] Marble quarries at Carrara and Serravezza provided the prized medium favored by the Neoclassical taste that then prevailed, which was the raw material for much of the statuary needed to stress the symbolic importance of the young democracy's public buildings. Skilled local craftsmen and carvers, necessary for the labor-intensive process of enlarging and translating sculptural compositions into marble, were easily available at minimal wages; copying from antiquity was highly inspirational. It also became quite fashionable for leisured American travelers to have their likenesses rendered in marble by their 'expat' compatriots.[24]

22 Margaret Fuller Ossoli, Letter XXVII, February 1849, *At Home and Abroad: Things and Thoughts in America and Europe, Edited by her Brother Arthur Buckminster Fuller* (Boston: Crosby & Nichols, 1856; 2nd ed. New York: The Tribune Association, 1869).

23 This was the case of Horatio Greenough, the 'first American sculptor', whose colossal statue of George Washington for the American Capitol was sculpted in Florence over the 1832–40 period, as well as that of Hiram Powers: both had their *ateliers* in Florence. Sculptresses Harriet Goodhue Hosmer, Edmonia Lewis and Emma Stebbins (members of the 'marmorean flock' mocked by Henry James), as well as Thomas Crawford and William W. Story. amongst others, had their studios in Rome. Also some American painters settled for more or less lengthy periods of time in Italy — Florence being one of the favored destinations. For instance during the early 1830s Thomas Cole, John Cranch and his brother Christopher Pearse Cranch, Samuel F. B. Morse and the Greenough brothers shared Florentine living arrangements, first at what is today known as Via Valfonda and then on via San Sebastiano, today via Gino Capponi. For an interesting account of these abodes, cf. Giovanna De Lorenzi, '1831–2: Horatio Greenough e Thomas Cole alla "Casa dei Frati"', in Cristina De Benedictis, *et al.* (eds.), *La Palazzina dei Servi a Firenze: da Residenza Vescovile a Sede Universitaria* (Florence: Edifir, 2014), pp. 51–68. The topos of foreign artists' responses to the Italian setting figures prominently in some of Henry James's early short stories and novels: e.g. *The Madonna of the Future* (1873) and *Roderick Hudson* (1875). Besides, at the time, quite a number of American artists who had visited Italy penned their recollections (for instance the Greenough brothers, John Cranch, William W. Story, Elihu Vedder etc.) allowing for a multi-faceted rendition of their experiences.

24 Some spirited travelers were of a different mind, such as journalist Caroline M. Kirkland, who was against the fashion of having one's own bust sculpted, declaring

The deeds of the foreign sculptor inspired by the Italian ambiance were turned into a cultural icon of pre-Civil War America by the prose of Nathaniel Hawthorne in his novel *The Marble Faun* (1860). Statues came alive in the *Notes* penned by 'Mrs. Hawthorne' during the extended visit she paid to Florence — a 'city of dream and shadow' in her husband's words — when the whole family at first resided downtown and later up at Bellosguardo. Sophia Peabody Hawthorne was an attentive observer: on one occasion she saw a band of musicians standing in the Loggia [dei Lanzi] and performing symphonies of the great composers, 'which made all the marble figures seem to live and breathe and move.'[25]

The new aesthetic theories made popular by the Enlightenment considered art primarily as a type of illusion and emphasized the role of the beholder's imagination. The latter was expected to 'complete' the work of art, turning it into something truly 'alive'. Visits by torchlight to antique sculpture galleries and monuments were meant to enhance the visitors' experience: this practice, which had been made popular by the eighteenth-century Grand Tour, became a much apreciated experience for American travelers.[26] The following quotes by George Stillman Hillard are revealing:

that 'one of the glories of art is that it carries us outside of ourselves; it is the very antagonist of petty egotism'. Caroline M. Kirkland, *Holidays Abroad: Or Europe from the West*, 2 vols. (New York: Baker & Scribner, 1849), I, p. 63.

25 Sophia Peabody Hawthorne, *Notes in England and Italy* (New York: Putnam and Sons, 1869), p. 345. As is well known the same visit to Italy was inspirational for her husband's novel *The Marble Faun or, the Romance of Monte Beni* (Boston: Houghton, Osgood & Co., 1860), https://catalog.hathitrust.org/Record/001027404. (The quotes in the text are drawn from Vol. IV of the *Centenary Edition of N. Hawthorne's Works* published by Ohio State University Press, 1968).

26 Claudia Mattos, 'The Torchlight Visit: Guiding the Eye through Late Eighteenth- and Early Nineteenth-Century Antique Sculpture Galleries', *RES: Anthropology and Aesthetics* 49 (Spring-Autumn, 2006), 139–52. In this respect and closely linked with the growing scientific interests of the age, it is worth mentioning some of the works by British painter Joseph Wright of Derby, who was active in the later decades of the eighteenth-century and a learned member of the Lunar Society whose meetings were attended also by Benjamin Franklin. See, for instance, J. Wright of Derby, *The Academy by Lamplight* (1769) (New Haven: Yale Center for British Art). Although there are no explicit accounts of torchlight nocturnal visits to any of the Florentine galleries according to the historical Archives of the Polo Museale Fiorentino, we may infer that such visits did occur. Dating from 1865 there are specific Archive entries reporting night guardianship expenses sustained for the Galleria delle Statue at the Uffizi: one may speculate that such visits to the gallery were accompanied by on-duty guards (and torch-bearers).

As a matter of course, everybody goes to see the Colosseum by moonlight. The great charm of the ruin under this condition is, that the imagination is substituted for sight; and the mind for the eye. The essential character of moonlight is hard rather than soft. The line between light and shadow is sharply defined, and there is no gradation of color. Blocks and walls of silver are bordered by, and spring out of, chasms of blackness. But moonlight shrouds the Colosseum in mystery. It opens deep vaults of gloom where the eye meets only an ebon wall, but upon which the fancy paints innumerable pictures in solemn, splendid, and tragic colors [...] By day, the Colosseum is an impressive fact; by night, it is a stately vision. By day, it is a lifeless form; by night, a vital thought.

The author then displays his mixed feelings:

It was my fortune to see the Colosseum, on one occasion, under lights which were neither of night nor day. Arrangements had been made by a party of German artists to illuminate it with artificial flames of blue, red, and green. The evening was propitious for the object, being dark and still, and nearly all the idlers in Rome attended. Everything was managed with taste and skill, and the experiment was entirely successful [...] But, from the association of such things with the illusions of the stage, the spectacle suggested debasing comparisons. It seemed a theatrical exhibition unworthy of the dignity and majesty of the Colosseum. It was like seeing a faded countenance repaired with artificial roses, or a venerable form clothed in some quaint and motley disguise, suited only to the bloom and freshness of youth. Such lights, far more than sunshine, 'gild but to flout the ruin gray'.[27]

The fascination with statues turned almost into 'living' entities by waterworks was also remarkable. Thus 'expat' sculptor William Wetmore Story, when visiting patrician villas at Frascati, described the combined effects of sculpture and fountains' *jets d'eau*:

Great fountains tower shivering with sunshine into the air, and fall into vast basins surrounded by balustrades, where carven masks, half hidden by exquisite festoons of maidenhair, pour their slender, silver tribute. Down lofty steps, green with moss, the water comes bounding and flashing like a living thing, to widen below into a pool, where glance silver and gold fish.[28]

27 George Stillman Hillard, *Six Months in Italy* (Boston: Ticknor Reed & Fields, 1853), p. 190. The quote within the quote is from Sir Walter Scott's *The Lay of the Last Minstrel* (1805).

28 Story, *Roba di Roma*, II, p. 185.

The effect of statuary upon bridges is memorable, wrote Henry Tuckerman, while observing the statues upon the bridge of Santa Trìnita at Florence, bathed in moonlight, their outlines distinctly revealed against sky and water.[29] The insidious, irresistible mixture of 'nature and art, nothing too much of either, only a supreme happy resultant' in Henry James's words, does indeed evoke a 'divine tertium *quid*'.[30]

American visitors' viewing of paintings seems to have been more problematic. Not only did guidebooks warn about visiting churches and museums (only) on fine days and equipped with opera-glasses, but a common complaint about the poor visibility of the artworks exudes from most travelers' accounts and literary endeavors. The question of optimum lighting had already been raised in the eighteenth-century — at a time when light-as-metaphor played a major role in Enlightenment debates. That was also the period when the first important theoretical statements on aesthetics were being circulated in Europe. Enlightened rulers were spurred to reorganize their private collections by turning them into art galleries open to the public. Collecting became synonymous with the political and public identity of those rulers who were increasingly attentive to their subjects' intellectual improvement. Besides, cultivation of the mind could soften the rigors of the law, or so it was believed. Consequently, at that time, artworks were mostly displayed within existing buildings whose magnificence was thought sufficient to frame statues, paintings, fossils and exotica in a neutral manner.

Major Florentine art museums (the Uffizi and the Palazzo Pitti) developed along the same lines.[31] As is well known, Anna Maria Luisa de' Medici, the Electress Palatine — the last scion of the House of Medici — at her death in 1743 bequeathed the centuries-old family

29 Henry P. Tuckerman, *The Italian Sketch-Book* (Boston: Light, Stearns & Cornhill, 1837), p. 181, https://catalog.hathitrust.org/Record/007675127

30 James, 'The Autumn in Florence' (1873), *Italian Hours*, p. 244.

31 During the nineteenth century the Uffizi were generally known as the Galleria del Granduca whereas Palazzo Pitti hosted both the grand ducal family residence and their private art collections. Neither of these buildings had been originally planned as museums for the display of artworks. Only the Tribuna, commissioned by Grand Duke Francesco I to Bernardo Buontalenti in 1581–84, was conceived specifically for the display of the choicest artworks in the collection. It is worth observing that the octagonal room receives natural lighting from above through two sets of windows in the drum and in the lantern. Although this architectural solution at the time was deemed innovative, many of 'our' American travelers' accounts are quite negative about it.

art collections to the Tuscan Grand Duchy on the condition that no part of them should be moved from Florence: their role being one of 'decoration for the State, for the utility of the public, and to attract the curiosity of the foreigners.' The decision was further implemented by the Grand Dukes of the House of Lorraine (especially by enlightened reformer Grand Duke Peter Leopold). The princely art treasures were thus enshrined within the Florentine palaces' 'dark piles' where their visibility had never been the keepers' top priority, nor had it been one that preoccupied the Romish Church and the religious custodians of its artworks.

In the eyes of most American visitors the display of art-works in Italy was mostly inappropriate and irrational: this judgment may have been influenced both by objective conservation conditions and by an awareness of the ideological and political differences that separated sensitivities and perceptual habits across the Atlantic. Henry James himself complained about the 'ducal' saloons of the Pitti being 'imperfect as show-rooms'.[32] His fastidiousness in such matters is perhaps nowhere better displayed than in the description of his visit to the Academy in Florence — where he relishes finding fewer tourists, fewer copyists and fewer 'pictorial lions'. However here he discovers:

> An enchanting Botticelli so obscurely hung, in one of the smaller rooms, that I scarce knew whether most to enjoy or to resent its relegation. Placed in a mean black frame, where you wouldn't have looked for a masterpiece, it yet gave out to a good glass every characteristic of one [...] That was my excuse for my wanting to know [...] what dishonour, could the transfer be artfully accomplished, *a strong American light* (my emphasis) *and a brave gilded frame* would, comparatively speaking, do it'.[33]

Likewise the journalist Caroline M. Kirkland, after visiting the Uffizi, declared in her *Holidays Abroad*:

> The Tribune, with all its splendors of marble and mother-of-pearl, is a miserable place for seeing the wonders of art which it enshrines. There is so little light, that it is only on very bright days that one can see the pictures at all; and the statues are so arranged that it is difficult to view them at the requisite distance. Then the pictures are crowded, for the

32 Henry James, *The Madonna of the Future*.
33 James, 'Florentine Notes' (1874) in *Italian Hours*, p. 270.

sake of thrusting in several which ought never to have been there — such as the 'Endymion' of Guercino, so unfavorable a specimen of that master that he would have blushed to see it in its present position. The same remark is true of some other pictures by great names, exalted thus conspicuously; while a part of the precious space is given to the works of artists unknown to fame — a circumstance almost condemnatory in our day of research and criticism [...] The sculptures show to tolerable advantage under the perpendicular light of the Tribune [...] This want of distance is the general complaint throughout the galleries of Italy, but it is, perhaps, nowhere felt so keenly as in the Tribune, the very heart of all this wondrous world.[34]

The fate of the art lover did not meet with more favorable conditions when entering churches and chapels. Such was the case of Nathaniel Hawthorne when visiting the church of the Badia in Florence:

There were likewise a picture or two, which it was impossible to see; indeed, I have hardly ever met with a picture in a church that was not utterly wasted and thrown away in the deep shadows of the chapel it was meant to adorn. If there is the remotest chance of its being seen, the sacristan hangs a curtain before it for the sake of his fee for withdrawing it. In the chapel of the [del] Bianco family we saw (if it could be called seeing) what is considered the finest oil-painting of Fra Filippo Lippi. It was evidently hung with reference to a lofty window on the other side of the church, whence sufficient light might fall upon it to show a picture so vividly painted as this is, and as most of Fra Filippo Lippi's are. The window was curtained, however, and the chapel so dusky that I could make out nothing.[35]

Visitors' eyes became 'owlish' in the attempt of viewing the Florence Baptistery's mosaics. The only satisfying illumination within religious buildings seems to have been that filtering through 'pictured windows'. Hawthorne's treatment of the light transmitted through painted glass is famously penned in *The Marble Faun* where he has Kenyon, one of the main characters, muse about the 'miracle':

34 Kirkland, *Holidays Abroad*, I, p. 205.
35 Nathaniel Hawthorne, *Passages from the French and Italian Notebooks*, Sophia Peabody Hawthorne (ed.) (Boston: Houghton, Mifflin, 1871), p. 371. Hawthorne here may have been referring to the painting by Filippino Lippi, *Apparition of the Virgin to St Bernard* (1486) originally commissioned by a member of the Del Pugliese family for their chapel in the church of the Campora (no longer extant) and later moved to the church of Badia. Artworks are often misattributed by visitors. The phenomenon might be a fruitful research topic, to assess degrees of (suspended) attention on the part of visitors and/or changed scholarly attributions and overall tastes.

It is the special excellence of pictured glass, that the light, which falls merely on the outside of other pictures, is here interfused throughout the work; it illuminates the design, and invests it with a living radiance; and in requital the unfading colors transmute the common daylight into a miracle of richness and glory in its passage through the heavenly substance of the blessed and angelic shapes which throng the high-arched window.[36]

He admits Kenyon's borrowing the expression 'dim, religious light' from Milton's *Il Penseroso*. However he also has Kenyon wonder whether Milton, although he had once been in Italy, 'ever saw but the dingy pictures in the dusty windows of English cathedrals, imperfectly shown by the gray English daylight' and thus continues:

He would else have illuminated that word, 'dim,' with some epithet that should not chase away the dimness, yet should make it glow like a million of rubies, sapphires, emeralds, and topazes. Is it not so with yonder window? The pictures are most brilliant in themselves, yet dim with tenderness and reverence because God himself is shining through them.[37]

The metaphor of Christian faith as a grand cathedral 'with divinely pictured windows' stresses the somber colors of the worldly exterior: only by entering the sacred precinct 'the celestial radiance will be inherent in all things and persons'. Might we infer that Hawthorne's Transcendentalism-inspired gaze encouraged the inner/outer viewing metaphor when approaching religious sites? Of course the issue is open to speculation but offers itself to some further questioning if we follow Hawthorne's steps into the church of Santa Croce. Here he happens to observe that the many-hued saints' images lose their mysterious effulgence when 'we get white light enough' and that it is like admitting 'too much of the light of reason and worldly intelligence into our mind, instead of illuminating [it] wholly by some religious medium'.[38]

36 Hawthorne, *The Marble Faun* (1860), pp. 304–06. The following quotes are from Hawthorne's report about visiting the Florence Cathedral (almost in John Milton's footsteps): 'Its windows of painted glass, throw over its tombs and altars a *dim religious light* [my emphasis], which accords with the mysteries of religion and the solemnity of prayer'. We find a similar description in John Cranch's travelogue: 'Near sunset we went into the Duomo, the Church of Santa Maria del Fiore. It was beautiful and holy at this hour, the sun illuminating all the rich old stained glass windows, and shooting down level bars of light from the dome'. John Cranch, *Italian Journal 1831–33*, Reel 3569, Smithsonian, Archives of American Art.

37 Ibid.

38 Hawthorne, *Passages from the French and Italian Notebooks*, p. 340.

Further obstacles to the enjoyment of artworks came in the shape of the 'hordes' of copyists 'who infest[ed] the galleries of Europe.'[39] Travelers who wished for some tangible souvenirs of their voyages — originals and photographs often being unavailable — resorted to full-size or scaled-down casts and Old Masters' copies. These tokens would signal both the travelers' cultural refinement and their altruistic dispositions — in case they graciously decided, upon returning home, to lend their copies for pedagogical purposes to the nation's institutions, which were still lacking in original Old Masters.

The crowds of copyists were such that it was a common complaint that their easels and materials impeded the circulation of visitors and did not allow the viewing of pictures on the walls. When visiting the Uffizi, Rembrandt Peale observed that: 'In one of these long corridors, a number of artists had their easels copying pictures, which they were permitted to have taken from the walls, and placed near them at the windows.'[40]

Connoisseurs and art lovers were not the only ones who suffered from such state of affairs. Henry James describes the toil of an 'aged Frenchman of modest mien perched on a little platform' beneath the 'finest of Ghirlandaios — a beautiful Adoration of the Kings at the Hospital of the Innocenti [...] behind a great hedge of altar-candlesticks'. His surprise at seeing the admirable copy, just completed under such difficult conditions, induces the novelist to consider the copyist's

39 Jacqueline M. Musacchio, 'Infesting the Art Galleries of Europe: The Copyist Emma Conant Church in Paris and Rome', *Nineteenth-Century Art Worldwide* 10.2 (2011), n.p. See also the 'Art-students and Copyists in the Gallery of the Louvre' etched by Winslow Homer and published by *Harper's Weekly*, 11 January 1868. Requests to copy artworks (and eventually to export them) had to be made well in advance to gallery administrators. Apparently copying Raffaello's *Madonna della Seggiola* in the Pitti Gallery was so popular that people were on waiting lists for as much as five years. Interesting information about American copyists in Florentine galleries may be found in Carol Bradley, 'Copisti Americani nelle Gallerie Fiorentine', in M. Bossi and L. Tonini (eds.), *L'Idea di Firenze: Temi e interpretazioni dell'arte straniera dell'Ottocento* (Florence: Centro Di, 1989), pp. 61–67. For a more recent assessment see Shirley Barker, 'The Female Artist in the Public Eye: Women Copyists in the Uffizi, 1770–1859', in T. Balducci and H. Belnap Jensen (eds.), *Femininity and Public Space in European Visual Culture, 1789–1914* (Farnham, Routledge, 2016), pp. 65–77.

40 Such was the case of Rembrandt Peale, himself a busy copyist in the Florentine galleries, who proudly declared that 'a correct copy is next in value to the original itself'. He also donated copies painted by himself to the Peale Museum he had established in Baltimore in 1812. Cf. Rembrandt Peale, *Notes on Italy, Written During a Tour in the Years 1829 and 1830* (Philadelphia: Carey & Lea, 1831), p. 208.

performance 'a real feat of magic' brought about by the 'old art-life of Florence that still at least works spells and almost miracles'.[41]

Finding one's own way at night was no small feat for the *forestieri*. Street lighting, the use of candles and of lamps of various types were the frequent objects of American travelers' accounts throughout nineteenth-century Italy. The topic may provide us with more or less direct metaphoric allusions to the darkness/light conceptual pair whose semantics are spelled out in terms of economic backwardness vs. more affluent lifestyles; obscurantism and authoritarian rule vs. patriotic self-determination and democratic assertiveness. In Florence the first gas lights appeared in September 1846 — the inaugural lamps being lit on the Via Maggio — as an evident homage to the Granducal family living at the nearby Palazzo Pitti.[42]

Precise timetables were drawn up and street lamps were not lit during a full moon. In June 1858 Sophia Hawthorne still enjoys the sight of the gas-lit Lungarno glimmering in the dark waters below and thus comments: 'The Lung-Arno was lighted with gas along its whole extent, making a cornice of glittering gems, converging in the distance, and the reflection of the illuminated border below made a fairy show. No painting, and scarcely a dream could equal the magical beauty of the scene.'[43]

A few years later (1873), *Baltimore American* editor Charles Carroll Fulton thus extols 'Florence by gas–light':

> We reached Florence in time to take a stroll through its streets and view the city by gas-light. The streets all through the heart of the city were literally thronged with promenaders, and the stores and cafés brilliant with gas-jets. Such a shining scene would never be seen in an American city, except on the eve of some national holiday.[44]

Gas obtained from English imported coal, however, was quite expensive and by the end of the century electric street lighting was gradually introduced. (Only well into the twentieth century were State museums

41 James, 'Autumn in Florence', in *Italian Hours*, p. 246.
42 Archivio Storico Comune di Firenze, *Lavori e servizi pubblici, Illuminazione a gas*. 1845–1862, 8750. Thanks are due to Silvia Ciappi (KHI Associate, Florence) for this reference.
43 Peabody Hawthorne, *Notes in England and Italy*, p. 842.
44 Charles C. Fulton, *Europe through American Spectacles* (Philadelphia: J. B. Lippincott, 1874), p. 225.

provided with electricity). Private lodgings and hotels (not to mention churches and other museums) were still lit by candles, kerosene or Argand lamps throughout most of the nineteenth century. A whole literature about the uses (and abuses) of candlesticks is contained in travelers' accounts. The following is but one example:

> The moment we alighted, the tall host lighted two as tall wax candles, and preceded us upstairs, in the orthodox way, meaning to charge one franc per candle though we should burn but an inch. These candle-tricks have afforded us no little amusement [...] Sometimes we immediately blow out one of each pair; sometimes burn them as long as we like, and then gravely put the remains in our carpet-bags in the morning, in order that we may have a double supply without extra cost at the next lodging-place — nobody daring to object, as the whole candle has been paid for. When we sit down to write our journals, we thus have a grand array of light, doubtless to the great astonishment of our entertainers. We have proposed publishing these journals with the title of *Candle Ends, or Light-Reading,* in memory of the resolute ingenuity with which we have withstood this petty imposition — gambled against by all travellers, but usually submitted to.[45]

Reports of 'candle-tricks' played at the travelers' expense suggest the kind of behavior that almost by definition juxtaposes narratives about the *forestieri* and the natives. Suspicions about being cheated by *vetturini*, hotel managers, sacristans, museum guards and *cicerones* often surface in travelers' accounts. However, reports about the enjoyment of the physical closeness brought about by the festive mingling with the crowds celebrating the traditional contest, the *moccoletti*, during the Roman Carnival reveals a different side of the relationship — one characterised by empathy and spontaneous appreciation for local folk life. Margaret Fuller recorded her own perception of the 'patriotic' atmosphere surrounding the Roman celebration of the 1849 Carnival season:

> Although less splendid than the Papal one — with fewer foreigners than usual, many having feared to assist at this most peaceful of revolutions — the 'Republican Carnival' was not less gay — with flowers, smiles and fun abundant.[46]

45 Kirkland, *Holidays Abroad*, II, p. 213.
46 The years 1848–1849 represent a crucial moment during the Italian Risorgimento. Pope Pius IX had to quit Rome under mounting requests for democratic rule. A Republican government was elected (February-July 1849) but was quickly

The amusement normally consisting in all the people blowing one another's lights out, the rulings of ordinary norms being suspended during the festival season, Fuller seems to perceive in the 1849 Carnival's popular enthusiasm also the symbol of a reversal ritual, almost an anticipation of the deep political transformations under way in the peninsula. Thus she continues:

> This is the first time of my seeing the true *moccoletti*; last year, in one of the first triumphs of democracy, they did not blow out the lights, thus turning it into an illumination. The effect of the swarms of lights, little and large, thus in motion all over the fronts of the houses, and up and down the Corso, was exceedingly pretty and fairy-like [...] It is astonishing the variety of tones, the lively satire and taunt of which the words '*Senza moccolo, senza moccolo*', are susceptible from their tongues. The scene is the best parody on the life of the 'respectable' world that can be imagined. A ragamuffin with a little piece of candle, not even lighted, thrusts it in your face with an air of far greater superiority than he can wear who, dressed in gold and velvet, erect in his carriage, holds aloft his light on a tall pole. In vain his security; while he looks down on the crowd to taunt the wretches *senza moccolo*, a weak female hand from a chamber window blots out his pretensions by one flirt of an old hand-kerchief.[47]

A few years earlier, James Fenimore Cooper had been struck by the same street scene and the superficial alteration of social hierarchies it afforded: 'Everyone is privileged to extinguish his neighbour's light. Common street-masquers will clamber up on the carriage of a prince, and blow out his taper, which is immediately re-lighted, as if character depended on its burning.'[48] However, the novelist had not (yet) perceived the episode's potentially political disruptive meaning. He simply dismissed it as a remnant of the Roman Saturnalia. Pagan rites and queer traditions were ready at hand for the Puritan imagination to seize on as explanations for the 'strange' behaviors of the local population. The Roman Carnival's popular scenes, which took place

overthrown by an international coalition that the Pope had formed. Margaret Fuller's quote chronicles events that took place under the brief rule of the short-lived Republican Triumvirate. The Risorgimento eventually culminated in the unification of the country under the rule of the House of Savoy in 1870, Rome being the capital of the new kingdom.

47 Fuller Ossoli, *At Home and Abroad*, pp. 346–47.
48 Fenimore Cooper, *Excursions in Italy*, II, p. 166, https://archive.org/details/excursionsinita00coopgoog/page/n11

along the Corso, kept drawing the attention of American visitors even after gas lighting ('with its white flame') had been adopted. The contrasts perceived by some observers between the swarms of lit tapers — suggesting 'the thought that every one of those thousands of twinkling lights was in charge of somebody who was striving with all his might to keep it alive' — and the illumination by gas light, 'not half so interesting as that of the torches, which indicated human struggle', provide us with an unexpected cue. Its fuller meaning may be gleaned by Hawthorne's concluding remarks: 'The lights vanished, one after another, till the gas-lights, which at first were an unimportant part of the illumination, shone quietly out, overpowering the scattered twinkles of the *moccoli*. They were what the fixed stars are to the transitory splendors of human life.'[49]

Indeed, as with everything that is transitory, the centuries-old illumination provided by candles and torchlights that had contributed to the 'softened sublimity' of the insidious and mellow, if ambiguous, charm experienced by nineteenth-century American travelers, was on the wane. The roadside Tuscan shrine whose little votive lamp glimmered through the evening air provides Henry James with the disconcerting awareness of an 'incongruous odour' that 'had not hitherto associated itself with rustic frescoes and wayside altars'. James soon realizes that:

> The odour was that of petroleum; the votive taper was nourished with the essence of Pennsylvania. I confess that I burst out laughing, and a picturesque *contadino*, wending his homeward way in the dusk, stared at me as if I were an iconoclast [...] to me the thing served as a symbol of the Italy of the future.[50]

About fifty years earlier, the evening walks of another Yankee had been accompanied by a different sight best described in James L. Sloan's own words:

> Nor did the night disclose a spectacle less wonderful, than that of the day had been beautiful. The atmosphere swarmed with the large fire-fly of Tuscany, which rose from the neighbouring fields, and filled the air with particles of living fire.[51]

49 Hawthorne, *Passages from the French and Italian Notebooks*, p. 282.
50 James, 'Italy Revisited' (1877), in *Italian Hours*, pp. 104–05.
51 Cf. Sloan, *Rambles in Italy*, p. 291.

Tuscan fireflies and petroleum-fed votive tapers: two light sources marking a fifty-year timespan. The meaning suggested by this loose measure of the passing of time points toward an inexorable disenchantment of the world — even of the one that had persistently made Italy such a picturesque destination for the rambles of so many passionate pilgrims.

21. 'In the Quiet Hours and the Deep Dusk, These Things too Recovered Their Advantage': Henry James on Light in European Museums

Joshua Parker

Now over a century removed, popular thought often imagines impressionist and expressionist painting as counter-reactions to nineteenth-century photographic techniques, a sudden urgent stretching of art's limits in the face of new chemical and mechanical technologies of reproduction, much as if to say, 'You may have beaten us when it comes to base verisimilitude — yet look here! — we still trump you.' Neglected in such notions is that impressionists and *plein air* painters also began painting, as Angela Miller writes of nineteenth-century American atmospheric luminists and pre-impressionists, the 'empty' spaces of 'light, space and air,' rather than hard, stable surfaces themselves, just as electric lighting became more common in Europe and America.[1] They began leaving their studios to work outside just as interiors — at least urban interiors — were being more often and better illuminated with light that was, if not always brighter than candle- or oil-lamp light, at least cleaner and more even.

1 Angela Miller, *The Empire of the Eye: Landscape Representations and American Cultural Politics, 1825–1875* (Ithaca and London: Cornell University Press, 1993), p. 243.

 https://doi.org/10.11647/OBP.0151.21

Henry James, aside from some work outlining his early criticism of impressionist painting in the 1870s,[2] and later seeming praise of works like those of Édouard Manet, James Abbott McNeill Whistler, Edgar Degas and Claude Monet in the 1890s,[3] is an author not often directly associated with impressionism in the visual arts. He was, instead, sometimes highly critical of the movement. Of Whistler's work, in *The Nation* in 1878, he snidely suggested while it 'may be good to be an impressionist,' on the evidence of Whistler's own efforts, 'it were vastly better to be an expressionist,' suggesting impressionism might be better off expressing anything at all than the nothing it did.[4] This, from an American writer who would be lauded by modernists for his use of 'the unsaid' and his techniques of depicting 'reality as perceived in an instant.'[5] Meanwhile, in the popular imagination, James is likely as not to be imagined much as his contemporary E. M. Forster's protagonist Lucy Honeychurch imagines her spurned lover in *A Room With a View* (1908), 'When I think of you it's always as in a room.' Or, as Ralph Ellison wrote, as an author who had lived in 'some sort of decadent hothouse,' an interior space removed from the palpable work-a-day world of real things 'as they existed.'[6]

But, much like impressionist and expressionist painters, James's later work often seems to inscribe circles around his central subjects, focusing on atmosphere to take up sparkling reflections instead of subjects themselves with any hard line of outline. He became, likewise, in almost all he published after leaving America, something of an arbiter of — at least readerly — cultural relations, and refractions, between England, the Continent and the United States. While living and working in Europe from about 1868 to 1916, James published often about his personal experiences in European galleries and museums, while setting extensive sections of his fiction in them, and if his descriptions of electric lighting are not as copious as those of the natural lighting of museums and other spaces in which mid- to late-nineteenth-century visitors

2 Ian F. A. Bell, *Henry James: Fiction as History* (Lanham: Rowman & Littlefield, 1985), pp. 141–42.
3 Daniel Hannah, 'James, Impressionism, and Publicity', *Rocky Mountain Review of Language and Literature* 61.2 (2007), 28–43.
4 Quoted in Bell, *Henry James*, pp. 141–42.
5 Jean Pavans, *Heures jamesiennes* (Paris: Éditions de la Différence, 2008), p. 136.
6 Ralph Ellison, 'The Novel as a Function of American Democracy', in his *Going to the Territory* (New York: Random House, 1986), pp. 308–20 (pp. 313–14).

experienced art, they are almost as well-commented on by scholars following his work over the last century.

Though not himself a visitor to the 1893 World Exposition in Chicago, famously the first in which such a vast amount of electric lighting was first visible (two hundred thousand bulbs), James received news of it by letter from his brother in America. According to Kendall Johnson, the 1893 Exposition illustrated, with its shocking abundance of electric light, 'the coherence of America's economic expansion,' a system 'industrial in its character and private in its ownership.'[7] James's most famous descriptions of the effects of electric lighting, with its 'blinding whiteness,' for Johnson, come in his *What Maisie Knew* (1897), which Kenneth Warren describes as containing 'exquisitely ambiguous critiques of capitalism and racism.'[8] What Deitmar Schloss calls James's suggestions of the 'obliterative effect of modern American capitalism' homogenized culture much as electric light, in the full effect of its illumination, rendered every surface it touched with a glaring evenness, yet still only surface.[9] James's early impressions of electric illumination's use as an Americanizing influence in Europe were tied to his general mistrust of what he held to be Americanization's less positive qualities — industrialization, cultural homogenization and rampant, uncontrolled capitalism as an end in itself.

Ambiguous, or ambivalent, as his fictional references to electricity were, James himself was evidently one of the last tenants in his London apartment building to have his apartment wired for electricity in 1895, and probably had his Lamb House in Sussex wired for electricity during renovations undertaken in 1897. He was, according to his correspondence, quite pleased, finding electric lighting in his own home to be 'one of the consolations & cleanliness of existence.'[10] James's experiences of and writings on lighting in museums during his travels were no less ambivalent. This essay outlines two recurrent themes in his descriptions, those of dark and light in his movements though European spaces exhibiting painted works of art. Underlining a development

7 Kendall Johnson, *Henry James and the Visual* (Cambridge: Cambridge University Press, 2007), p. 138.

8 Kenneth W. Warren, 'Still Reading James?', *The Henry James Review* 16.3 (1995), 282–85 (p. 284).

9 Dietmar Schloss, *Culture and Criticism in Henry James* (Tübingen: Gunter Narr Verlag, 1992), pp. 121–22.

10 Quoted in Kaplan, *Henry James*, p. 410.

and constancy over the course of his career in his published work, it examines some of James's earliest writings describing museums and ecumenical or private collections of paintings, from the 1870s to the end of the nineteenth century, particularly those in which lighting — or the lack of it — is noted or described. His work, published in American weekly or monthly magazines, likely inspired or discouraged hundreds, if not thousands, of American and British travelers to the Continent's museums, galleries, palaces and churches in the latter half of the nineteenth century, and presumably guided many thousands more who would never visit in their understanding of fine art, the illumination of space, and of what purposes visits to museums or other spaces of display could be assumed to serve, what sensations they might be expected to elicit, and to what standards such institutions could be held.

James was insistent on light, or the lack of it, in writings drawn from his early travels through Italy. In descriptions of an 1869 tour of Italy, published as 'Venice: An Early Impression' (*Italian Hours*) (1872), he wrote that '[n]othing indeed can well be sadder' than the series of Tintorettos of the Scuola Grande di San Rocco. This was not criticism of the paintings themselves, but of their lack of visibility. 'Incurable blackness is settling fast upon all of them,' James complained, leaving Tintoretto's work in the Scuola to

> frown at you across the sombre splendour of their great chambers like gaunt twilight phantoms of pictures. To our children's children Tintoret, as things are going,' he projected, 'can be hardly more than a name; and such of them as shall miss the tragic beauty, already so dimmed and stained, of the great 'Bearing of the Cross' in that temple of his spirit will live and die without knowing the largest eloquence of art.[11]

Crying out in defense, and presenting himself as defender for future generations of images he himself was barely able to see in San Rocco's rooms, James complains not only of San Rocco's lack of lighting, but of the smoky state of its paintings. Lack of light is noted as near-constant irritant during James's first Italian tour — most particularly in churches, in both Venice and Florence.

In Florence's Convent of San Marco (probably some time in 1873), James passed 'the bright, still cloister,' paying his respects 'to Fra Angelico's Crucifixion, in that dusky chamber in the basement.' He

11 Henry James, *Italian Hours* (New York: Grove Press, 1965), pp. 59–60.

'looked long; one can hardly do otherwise.'[12] James looks long at the painting because of its genius — but perhaps also, as he seems to suggest, because of basement chapel's dim light. Moving his readers up the stairs into the Convent's upper rooms, his descriptions of its paintings become comparatively much more detailed and elaborate.

In Venice a decade later, in 1882, his complaints of lack of light become more pointed and strident. Here, while Venice's churches 'are rich in pictures,' many of their best works lurk 'in the unaccommodating gloom of side-chapels and sacristies,' or hang

> behind the dusty candles and muslin roses of a scantily-visited altar; some of them indeed, hidden behind the altar, suffer in a darkness that can never be explored. The facilities offered you for approaching the picture in such cases are a mockery of your irritated wish. You stand at tip-toe on a three-legged stool, you climb a rickety ladder, you almost mount upon the shoulders of the *custode*. You do everything but see the pictures. You see just enough to be sure it's beautiful. You catch a glimpse of a divine head, of a fig-tree against a mellow sky, but the rest is impenetrable mystery.

Readers of James's fiction in the following years might reasonably have directed similar complaints toward his own plots and figures — or ascribed to his avoidance of complete revelation an artistic complexity more positive than negative.

James himself, meanwhile, goes on complaining in Venice in 1882. Before Cima da Conegliano's *Baptism of Christ* in San Giovanni in Bragora, he asserts,

> You make the thing out in spots, you see it has a fulness [sic] of perfection. But you turn away from it with a stiff neck and promise yourself consolation in the Academy and at the Madonna dell'Orto, where two noble works by the same hand — pictures as clear as a summer twilight — present themselves in better circumstances.

For anyone using James's articles as an actual guide to Venice, the paintings recommended as being most satisfying are frankly those best-visible in terms of material circumstances. Meanwhile, James returns to his previously-voiced complaints of poor lighting in the Scuola Grande di San Rocco, with its nearly invisible Tintorettos, evidently unimproved

12 James, *Italian Hours*, p. 292.

in the intervening years since his last visit: 'It may be said as a general thing that you never see the Tintoret,' James writes.

> You admire him, you adore him, you think him the greatest of painters, but in the great majority of cases your eyes fail to deal with him.' In this vast, dim space, one seems almost to swim in an aura of majesty without any direct visual contact, as here, among the 'acres of him [Tintoretto], there is scarcely anything at all adequately visible save the immense 'Crucifixion' in the upper story.[13]

'Fortunately,' James writes, in the Doge's Palace 'everything is so brilliant and splendid that the poor dusky Tintoret is lifted in spite of himself into the concert.' At one o'clock in the afternoon, he writes, there is 'no brighter place in Venice—by which I mean that on the whole there is none half so bright. The reflected sunshine plays up through the great windows from the glittering lagoon and shimmers and twinkles over gilded walls and ceilings.' Here, '[a]ll the history of Venice [...] glows around you in a strong sea-light.' Veronese 'swims before you in a silver cloud; he thrones in an eternal morning.'[14] For James, the light of the room in the palace and the light depicted in the painting seem almost to magically overlap, the atmosphere in the room and that of the canvas merging, its own light flowing out into the room as that of the room plays on its surface.

Finally, in Florence's Uffizi, James finds a light redeeming the museum despite itself. Beguiled by the Uffizi's 'long outer galleries,' he focuses on their 'continuity of old-fashioned windows, draped with white curtains of rather primitive fashion, which hang there till they acquire a perceptible tone.' Never mind that the curtains are dusty and likely could use a good wash or replacement. The sunlight, 'passing through them, is softly filtered and diffused,' resting 'mildly upon the old marbles' and 'projected upon the numerous pictures that cover the opposite wall,' imparting 'a faded brightness to the old ornamental arabesques upon the painted wooden ceiling,' and making 'a great soft shining upon the marble floor.' On his visits, he wrote, he could rarely resist a stroll through the windowed galleries, despite their '(for the most part) third-rate canvases and panels and the faded cotton

13 Henry James, 'Venice', in Morton Dauwen Zabel (ed.), *The Art of Travel* (Garden City, NY: Doubleday Anchor, 1958), pp. 404–06.
14 *Ibid.*

curtains.' It is the lighting itself which seems to attract him, rather than what it illuminates.

> 'Why is it,' he asks, 'that in Italy we see a charm in things in regard to which in other countries we always take vulgarity for granted? If in the city of New York a great museum of the arts were to be provided, by way of decoration, with a species of verandah enclosed on one side by a series of small-paned windows draped in dirty linen [...] surmounted by a thinly-painted roof, strongly suggestive of summer heat, of winter cold, of frequent leakage, those amateurs who had had the advantage of foreign travel would be at small pains to conceal their contempt.'[15]

The Uffizi, if shabby, is enchanting because of its lighting, James suggests. Yet if 'the great pleasure' afforded in Florence is a visit to the works blooming 'so unfadingly on the big plain walls of the Academy,' sometimes even darkness does not preclude enjoyment.[16]

Moving across the Arno to the Pitti Palace, James finds Andrea del Sarto's work 'in force, in those dusky drawing-rooms' accessed by 'the tortuous tunnel' of the Vasari Corridor. 'In the rich insufficient light of these beautiful rooms, where, to look at the pictures, you sit in damask chairs and rest your elbows on tables of malachite, the elegant Andrea becomes deeply effective,' he writes.[17] Here, James's complaints of dim lighting at last subside, whether because of the comforts of the palace's furniture, or because dimness itself seems to aid in del Sarto's appreciation. So, in his journalism and essays, James responds to the joys of finding good natural lighting in galleries or other spaces where paintings are displayed — particularly when the canvas surfaces and the natural light seem to correspond, align, or even merge — and complains bitterly of darkness and obscurity, yet sometimes finds a bit of 'duskiness' seems to aid or encourage one's appreciation.

Indeed, as Kendall Johnson notes, outside museums themselves, the older, narrow streets and alleys of Florence's medieval center offered James 'dusky perspectives' which refined, 'in certain places, by an art of their own, on the romantic appeal.'[18] For all James's complaints of dimly-lit galleries and chapels, Johnson suggests he 'fixates on these dusky spaces as portals to the classical past,' as their shadows 'enhance

15 James, 'Florence', in *The Art of Travel*, pp. 381–82.
16 Ibid., p. 382.
17 Ibid.
18 James, *Italian Hours*, p. 535.

his historical sensitivity and hone his receptivity to the passing of Florence's and Italy's triumphal epoch in the westward course of empire.'[19] Certainly in some of the passages cited above, as, for example, in the Doge's Palace or the Pitti Palace, lighting in particular seems to allow one to inhabit the historical spaces represented by the paintings hanging on the walls as if they had filtered into the rooms themselves. Almost as if the frames around the canvases, like the diegetic framing of their images, had become vaguely opaque.

In James's fiction of the same period, we find similar descriptions of museum interiors, slightly more romantic. In his short story 'Travelling Companions,' written in 1870, set in Milan, Florence, Venice and Padua, the narrator's 'memory reverts with an especial tenderness to certain hours in the dusky, faded saloons of those vacant ruinous palaces which boast of 'collections'.'[20] The story revolves around conversations between a young, single male and a young female tourist, who meet in cultural spaces while following similar tours of Italy, commenting on the art. At one point, the male protagonist becomes infatuated with a small portrait of a woman he hopes to buy, which he sees in a private home 'on a table near the window, propped upright in such a way as to catch the light, was a small picture in a heavy frame.'[21] But his real interest, deferred, is the acquisition of his traveling companion herself as a wife. What begins as a tale of cultural acquisition and appreciation limited to museal space becomes one of human acquisition and extends to the 'real world' of human relations and domestic matters. As the two companions become more companionable, light becomes more palpable, first, again, in the Doge's Palace, 'that transcendent shrine of light and grace' with its 'masterpiece of Paul Veronese,'[22] while in Padua's Scrovegni Chapel, 'ample light flooded the inner precinct, and lay hot upon the course, pale surface of the painted wall,'[23] bringing its figures into the present's light much as the female love-object becomes more available to her narrating companion. In James's 'The Sweetheart of M. Briseux' (1873), again, light depicted in paintings' canvases and

19 Johnson, *Henry James*, p. 46.
20 Henry James, 'Travelling Companions', in *Complete Stories 1864–1874* (New York: The Library of America, 1999), p. 507.
21 Ibid., p. 509.
22 Ibid., p. 525.
23 Ibid., p. 529.

that filtering into the gallery seem to merge, this time not in a positive manner. Here, in a fictionalized French town's municipal museum (probably Montauban): 'the very light seems pale and neutral, as if the dismal lack-lustre atmosphere of the pictures were contagious.'[24]

Finally, perhaps James's strongest insinuation of a bond between viewer and museal objects is strengthened by a space's lighting is in his short story 'The Birthplace' (1903). Here, the newly-appointed curator of Shakespeare's 'birthplace' in Stratford-upon-Avon, now arranged as a museum, is initially put off by '[t]he exhibitional side of the establishment.' The rooms of the house-cum-museum 'bristled overmuch, in the garish light of day, with busts and relics, not even ostensibly even *His* [Shakespeare's], old prints and old editions, old objects fashioned in His likeness, furniture 'of the time' and autographs of celebrated worshippers.' The 'garish' daylight here, illuminating the relics on display, seems to preclude any personal bond or connection with the articles or the space itself. Lingering, however, James's curator finds that

> [i]n the quiet hours and the deep dusk, none the less, under the play of the shifted lamp and that of his own emotion, these things too recovered their advantage, ministered to the mystery, or at all events to the impression, seemed consciously to offer themselves as personal to the poet.[25]

'What is it then you see in the dark?' he is asked.[26] It is in the darkened rooms — or even in total darkness — that James's curator feels closest to the soul of the artist represented by the redundant relics on display. Lamplight here casts an illusion — an illusion necessary for immersion in the aura and ambience of the motley items displayed. These gather their full force not in the light of day, but only at dusk, offering the 'impression' of a past that, of a living world it is their task to evoke, in effect a 'sort of 'oversaying' saturated with concealed intentions masked by their very simultaneity, much like the vital multiple currents of reality as perceived at the moment.'[27] Much as the curator here is

24 Henry James, 'The Sweetheart of M. Briseux', in *Complete Stories 1864–1874* (New York: The Library of America, 1999), p. 767.

25 Henry James, 'The Birthplace', in *Complete Stories 1898–1910* (New York: The Library of America, 1996), p. 455.

26 Ibid., p. 458.

27 Pavans, *Heures jamesiennes*, p. 136.

originally a librarian, now turned carnivalist in his new role, for James fiction competes with reality, using whatever tricks it can. In James's 'shifted lamp' here, a hand-held torch turned *away* from its subject in order to better sense of it, there is an almost Romantic mode of thought, reminiscent of popular nineteenth-century moonlight tours of Roman ruins, in which the imagination is kindled as much by the shadows as by what is actually illuminated.

James often derides a lack of light, while sometimes applauding the mystery afforded by a bit of dimness, suggesting that the only way, after all, to attain connection with the figures depicted on the surfaces of canvases — or with the past they depict and themselves still inhabit — is through fleeting impressions, impressions best encouraged by a touch of dusk, an ambiguous light which is, in a sense, one of the repeated themes and even qualities of his own oeuvre.

22. 'Shedding Light on Old Italian Masters': Timothy Cole's Series for *The Century*

Page S. Knox

Arguably the most popular journal of the late 1800s, *The Century Magazine* regarded itself as an important vehicle of the arts to its upper middle class American audience. One of its central missions was the education of its readership in all things cultural, as its editor in chief, Richard Watson Gilder, sought to make the magazine a 'work of art.' With a widely regarded art department, led by Alexander Drake, and a reputation as one of the most visually appealing periodicals in America, driven by the innovations of printer Theodore deVinne, the magazine was deeply committed to the specialty of wood engraving and employed the best illustrators of the day to fill its pages with extensive and lavish imagery.[1] In the 1880s, *The Century*'s educational effort moved beyond an awareness of contemporary American art, and sought to introduce many of its readers to the entire Western artistic tradition. As a central part of this agenda, Gilder, Drake and deVinne agreed to publish Timothy Cole's illustrations of 'Old Italian Masters,' a compendium of the great works of the Italian Renaissance. Cutting each engraving in front of the original work, Cole brought rare images from numerous museums, churches and galleries throughout Italy to Americans who had never before experienced them (Fig. 22.1, a-e).

1 For more on the history of *The Century Illustrated Monthly Magazine* and its predecessor *Scribner's Monthly*, see Page S. Knox, 'Scribner's Monthly 1870–1881: Illustrating a New American Art World', Ph.D. dissertation, Columbia University, 2012, http://academiccommons.columbia.edu/item/ac:146372

 https://doi.org/10.11647/OBP.0151.22

DEATH OF ST. FRANCIS, BY GIOTTO.

FRESCO IN THE BARDI CHAPEL, SANTA CROCE, FLORENCE.

a

MADONNA AND CHILD, BY GIOVANNI BELLINI.

DETAIL FROM THE ALTARPIECE IN THE SACRISTY OF STA. MARIA GLORIOSA DE' FRARI, VENICE.

b

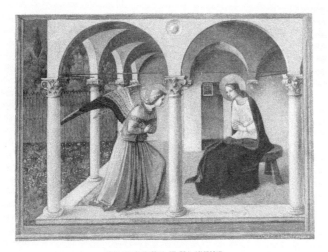

THE ANNUNCIATION, BY FRA ANGELICO.

IN THE MUSEUM OF SAN MARCO.

c

ST. AGNES, BY ANDREA DEL SARTO.

IN THE PISA CATHEDRAL.

d

DELPHIAN SIBYL, BY MICHELANGELO.
FROM THE FRESCO ON THE CEILING OF THE SISTINE CHAPEL, ROME

Fig. 22.1 (a-e) Timothy Cole, selected engravings from *Old Italian Masters Engraved by Timothy Cole with Historical Notes by W. J. Stillman and Brief Comments by the Engraver* (New York: The Century Co., 1892), Public domain.

Cole would go on to engrave Old Masters for *The Century* in France, Spain, the Netherlands and England, creating the largest and most monumental art historical project in print media during the late nineteenth century. This chapter presents Cole's body of work during his years in Italy, from 1884 to 1892, during which time he engraved sixty-seven reproductions of Italian Renaissance mosaics, paintings and altarpieces for monthly publication in the periodical, and considers his first-hand descriptions of the environments in which he toiled. While the series is recognized for introducing the work of artists from Cimabue to Correggio to the American public, it also offers a unique window into the conditions that Cole labored under and provides an extraordinary account of the challenges he faced in providing accurate reproductions.

Emerging from a coterie of woodcarvers for the periodical industry in the 1870s, Timothy Cole established himself early on as the premier engraver of his time. Cole was recognized for his 'new style of engraving' which sought above all else to provide a literal translation of the image he was reproducing. In 1883, when asked by *The Century's* Art Department to engrave an image by a popular French painter from a photograph, Cole, always searching for greater realization of the artist's intent presciently inquired, 'Why don't you have me do these things from the original pictures instead of the photographs?'[2] When they considered the impact on their audience of Cole's images from the contemporary art world, *The Century* editors immediately saw the possibilities. Cole was sent to Europe for a full year with a mandate to engrave the work he encountered. Little did he know that this one-year assignment would lead him to relocate his family to live in Florence, Orvieto and Venice, or that he would become immersed in the art of the Italian Old Masters, particularly those of the early Tuscans and Sienese (Fig. 22.2, a-b).

SAINT AGNES.

a

2 Alphaeus P. Cole and Margaret W. Cole, *Timothy Cole Wood Engraver* (Dublin, New Hampshire: William L. Bauhan, Publisher, 1935), p. 36.

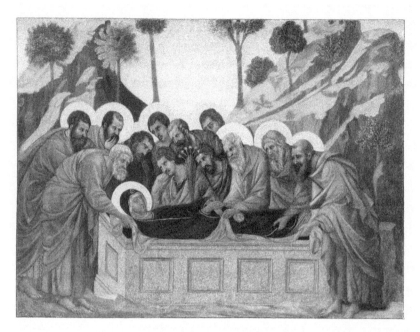

BURIAL OF THE VIRGIN, BY DUCCIO.
SMALL PANEL PAINTING, COMPLETE. OPERA DEL DUOMO, SIENA.

Fig. 22.2 (a-b) Timothy Cole, selected engravings dedicated to Byzantine and
Trecento Renaissance Painting, from *Old Italian Masters Engraved by
Timothy Cole with Historical Notes by W. J. Stillman and Brief Comments
by the Engraver* (New York: The Century Co., 1892), Public domain.

Upon arriving in Paris in November of 1883, instead of engaging
with contemporary art, Cole went straight to the Louvre and began
engraving Botticelli's *Madonna and Child* (ca.1465–70), along with
Leonardo's *Mona Lisa* (ca.1503–06) and Titian's *Man With a Glove*
(ca.1520). Upon receipt of these blocks, *The Century* decided to make a
serious investment in Cole's new found obsession, agreeing to publish
a series on old Italian Masters that would appear on a monthly basis
and later be compiled in book form.[3] Cole moved to Florence in August
of 1884 and began the job in earnest.

In keeping with the periodical's mandate for cultural edification,
William J. Stillman was chosen as the author of the accompanying

3 *Old Italian Masters Engraved by Timothy Cole with Historical Notes by W. J. Stillman and
 Brief Comments by the Engraver* (New York: The Century Co., 1892), https://babel.
 hathitrust.org/cgi/pt?id=nyp.33433071001907

text for the illustrations. A product of his years as an acolyte of Ruskin and an admirer of the Pre-Raphaelites, Stillman provided background information on the life of each artist and his style, while also reviewing the scholarship on these artists to date. Frequently quoting and discrediting Vasari while referencing Morelli, Crowe, Cavalcaselle and other well known academics, Stillman brings a clear Ruskinian approach to his critical discussion, which enhanced the series' reception as art history. He also introduced Cole to the Trecento and Byzantine painters, a group with which most Americans were entirely unfamiliar and whose inclusion required a strong appeal to the editors of *The Century* on the part of both critic and engraver. Their work was often found in the most difficult conditions for reproduction, thus adding to their allure and mystique. Aware that the engraved line practiced by Cole captured this type of work most effectively, Stillman underscored in the text the affinity that emerged between Cole and this group of early Tuscan and Sienese artists over the course of the project (Fig. 22.2).[4]

The more cerebral criticism of Stillman was balanced by Cole's straightforward description of the works he reproduced and the conditions he encountered in the process. The introduction to the series provided a thorough account of Cole's method, describing how he selected images that not only resonated with him aesthetically but were also acceptable for engraving. Hiring local photographers to document the chosen piece, its photograph was then copied on to the wood block, allowing the block to become its own proof when printed. Essential to Cole's process was his commitment to engrave the block in front of the original work. Prior to Cole, all of the line engravings made from old masters had been done from black and white drawings; no reproduction by engraving directly from the original pictures had ever been attempted. Between the photographic image and the method of wood-cutting, which allows for delicately modeled forms and subtle textures, Cole's method was unique in its ability to call into play both the black line (the positive element in engraving) and the white line (the negative element). Further, the use of wood engraving allowed for an unlimited circulation of high quality images thus far never available to the general public. Cole believed that the method allowed him to act

4 For more on Stillman see Stephen Dyson, *The Last Amateur: The Life of William J. Stillman* (Albany: State University of New York Press, 2014).

as an organ through which the mind and hand of the original artist were made present; that the method made a true representation of the original intent possible.[5] According to Cole: 'I have always had pleasant experiences while working in the galleries and many favors have been shown me, and I should judge that Italy, of all places in the world, is the ideal spot for an engraver.'[6]

When Cole arrived in Florence in August of 1884 he immediately went to the town officials and received 'permission to copy here, which gives entrance into all public and private galleries to work. It is not necessary to have permission to copy in the churches as they are free at all times.'[7] He began work in the Uffizi, and continued throughout the winter with the aid of a 'scaldino,' a small tin box with a perforated cover and rests for the feet, which is filled with a light charcoal called a 'braca' (sic) made of twigs. The braca produces little or no smoke and, when kindled by sprinkling a small amount of live ash on the top, burned downward and became a glowing hot mass that stayed warm for ten to twelve hours. According to Cole, were it not for these little stoves it would have been impossible to work in the museums, and all of the artists used them.[8]

Cole often became overwhelmed by the intense history and beauty of his surroundings, noting for example that the Pitti Palace 'is the most stupendous thing in the world. It bursts upon one from the narrow streets like a glorious vision.'[9] Discussing his work on the engraving of Titian's *Bella* (ca.1536) Cole recounts,

> they allow me fifty days in which to complete it, during which time I have the picture solely to myself. It is a fixture on the wall, but can be swung out on hinges and so adjusted to the light. They have given me a high fine table and a padded stool which brings me nearly on a level with the picture [...] I must do many of the portraits here in the Pitti; how startling and impressive it is![10]

5 W. J. Stillman, 'Cole and his Work', in *The Century* 37 (November 1888), 57–59, http:// ebooks.library.cornell.edu/cgi/t/text/pageviewer-idx?c=cent;cc=cent;rgn=full%20 text;idno=cent0037-1;didno=cent0037-1;view=image;seq=0067;node=cent0037-1%3A9

6 Timothy Cole, 'Engraver's Note to the Preface', in *Old Italian Masters*, p. xi.

7 Letter from Thomas Cole, 8 August 1884, quoted in A. Cole, *Timothy Cole*, p. 42.

8 Letter from Thomas Cole, 12 February 1885 quoted in A. Cole, *Timothy Cole*, p. 47.

9 Ibid., p. 48.

10 Letter from Thomas Cole to Alexander Drake, August 1885 quoted in A. Cole, *Timothy Cole*, p. 52.

Apparently in his early months in Florence he became so engaged with the art and the staff of Florence's museums that he fell behind his commitment to one block a month, and a long term tension developed between the artist and the business editors of *The Century*. According to letters, Cole stated that he was 'greatly helped by the directors of the Italian museums who had no hesitation in removing from the walls any picture I might select for reproduction and placing it on an easel in a good light.'[11] Given his method of engraving the block in front of the original, the issue of light was of prime importance to Cole. While museum directors sought to help Cole whenever possible, gallery conditions were not always conducive to the work.

In Venice, Cole was forced to deal with the lack of light in the Sala dell'Assunta of the Accademia in his reproduction of Tintoretto's *The Death of Abel* (ca.1551–52). His method of photography was ineffective given the painting's high placement on the ceiling and the positioning of the light which, falling from above, cast a glaze over the surface of the painting. Unable to remove it for copying, Cole worked on the outline of the photograph, and engraved the block in the well-lit adjacent room of drawings. There he was able to see the original better through its reflection in a mirror that he brought for that purpose, and with the use of an opera glass. He cut Tintoretto's *Miracle of St. Mark* (1548) using the same method.[12] According to Cole, Veronese's images in the Sala del Collegio of the Doges Palace were remarkably well preserved and much more easily reproduced, as the light shone brightly into the room to reveal the image of *Venice Enthroned with Justice and Peace* (1575–78) 'in all its regal splendor.'[13]

One of Cole's greater challenges was the reproduction of the Benozzo Gozzoli frescoes in the Riccardi Chapel. He writes extensively of the unique circumstances of the room, which preserved the painting well but also created conditions that made engraving almost impossible. The fresco occupies two sides and the entrance to the small chapel and in all probability there was originally no window as the one in situ appears to have been installed later (see Acidini's essay in this volume). Cole notes that even with the new window the image was difficult to see. The

11 Ibid., p. 51.
12 Timothy Cole, 'Tintoretto, Notes by the Engraver', in *Old Italian Masters*, p. 273.
13 Timothy Cole, 'Veronese, Notes by the Engraver', in *Old Italian Masters*, p. 268.

Procession of the Magi (ca.1459), which includes a number of Florentine personages of the day in contemporary costume on foot and horseback, had a great deal of detail that Cole found extremely challenging to capture with the low level of light available. This required a bit of ingenuity on his part:

> As it also is in a dark corner I have it lighted, first by means of a white sheet hung upon the opposite wall of the court outside upon which the sun shines, the reflection of which is increased powerfully this way. Then, inside, I have a large mirror, which is so placed as to bring down the blue sky, otherwise not visible, and then I have six other reflectors which light up my subject.[14]

In a letter Cole describes his process in the chapel:

> I am working standing on the altar, which brings me to a sufficient height to see these frescoes well. The light from the large window in front is very good in the afternoon, as the sun shining against the outside walls of the courtyard causes a fine soft reflection, and the picture is lighted as well from the reflection of a large mirror which is used for that purpose, and which makes it as light as its companion on the opposite wall which receives the full benefit from the light outside. Here each day for two short fleeting hours I am rapt in ecstasy.[15]

Rather than attempting to recreate the entire fresco, Cole chose specific groupings within the larger scene, featuring a group of angels as well as Gozzoli's self portrait. Cole used this method frequently when attacking large and complex canvases, as seen in his single images of Botticelli's *Flora and the Three Graces* in a full engraving versus the outline form of the larger *Primavera* (ca.1482), as well as the Virgin and Child from the larger *Adoration of the Magi* by Gentile da Fabriano (ca.1423).

In his letters, Cole described the conditions under which he worked in the churches of Florence, where it was impossible to have a picture removed from the walls of a chapel. Often the subjects he sought to reproduce were in dark places above an altar with numerous candles obscuring the view, although according to Cole, 'fortunately the priests were glad to do what they could to assist the man who was endeavoring to make Italy's masterpieces known to the New World.'[16] Cole described

14 Letter from Timothy Cole, August 1885, quoted in A. Cole, *Timothy Cole*, p. 53.
15 Ibid., p. 52.
16 A. Cole, *Timothy Cole*, p. 51.

his situation while engraving Filippino Lippi's *Vision of St. Bernard* (1480) in the Badia Church:

> Working on top of the altar in the church in order to get at the devils which are strangely not visible from below, a thousand and one beauties reveal themselves from this elevation and I am an object of wonder if not of adoration for those who come to worship. I certainly have a monopoly of Filippino Lippi.[17]

Cole notes that his position on the altar allowed him the single view of the two satanic creatures hiding behind St. Bernard, which he sought to make visible in his engraving; he also mentions that since that time the painting was rehung in a better light to allow observers to view these unique details. When Cole learned that panels from Duccio's Altarpiece were being moved from the cathedral to the Opera del Duomo, he decided to postpone their engravings as the light was so greatly improved in the new location. Cole's time in Italy in the early 1880s marked a period when many works were being removed from their original environments in chapels and churches in order to be seen in improved lighting conditions.

Stillman was quite critical of the situation in Venice, where he complained that altarpieces still in the city's churches were dangerously exposed to the smoke of the altar candles; Stillman mentions specifically the Titian of S. Salvatore whose lower portion of the canvas was splattered all over with the wax of the candles of the altar. Further, he implies that the popular opinion in Venice was that the priests actually encouraged the intense use of candles near paintings, intensifying the risk of fire, to punish the government for the removal to the Accademia of so many of their pictures![18]

Also disconcerting was the somewhat savage dismantling of pictures for distribution and sale. While beginning to work on the Duccio Altarpiece in the Siena Cathedral (1308), Cole describes how the back of the large wooden panel was sawn in half with the pictures on the reverse divided up to be sold separately. A close friend and colleague of Cole's, John Fairfax Murray, worked tirelessly to collect these missing panels and reassemble them in the Museum of the Opera del Duomo and was

17 Letter from Timothy Cole to Century Company, 27 October 1885, quoted in A. Cole, *Timothy Cole*, p. 52.

18 W. J. Stillman, 'Giovanni Bellini', in *Old Italian Masters*, p. 131.

also responsible for moving the Duccio there as well. Cole decried the dismantling: 'I would hang the man who would dare tamper with these inestimable and sacred treasures, for here is holy ground indeed.'[19]

In addition to the lighting, Cole also had to respond to uniquely American concerns over issues such as nudity. He entered into a major argument with *The Century* over the engraving of Mantegna's *Circumcision* (1460–64) in his triptych in the Tribune of the Uffizi:

> It was my intention originally on account of the difficulty and loss of time that would attend the engraving because of the poor light in the Tribune, to change this subject in preference for one which hung in a splendid light for engraving, and which indeed I might have had on an easel at my elbow; but after careful comparison of the two and much reflection, I felt impelled to do the 'Circumcision' though it entailed three times the labor as I sat in the next room to it and had to keep running in and out continually while doing it.[20]

If this process of running back and forth from one room to the next in the Uffizi was not enough, upon receipt of the block, the art editor took great exception to the noticeable penis, obviously an important part of the narrative of the story. Cole begged,

> If you alter it, cut off its left side and blue the penis you will damn the whole thing [...] let me beseech you my dear Drake to not do this thing. Do not alter the block. There is not a human being on the face of the globe who would be so brazen faced as to quibble at this subject. They would not dare to. The subject is too sacred.[21]

Surprisingly, Cole got his way and the image was reproduced with true fidelity to the original.

'Old Italian Masters' also reflects the frequent misattributions of the time, with an entire essay devoted to the *Madonna of the Rucellai Chapel* (ca.1286), believed to be painted by Cimabue. The painting was soon to be attributed to Duccio by Franz Wickhoff in 1889, and would later be moved to the Uffizi in the mid 1950s. In his discussion of the viewing conditions of the altarpiece in Santa Maria Novella, Cole describes the space as

19 Letter from Timothy Cole to Century Company quoted in A. Cole, *Timothy Cole*, p. 67.
20 Timothy Cole, 'Mantegna: Notes by the Engraver', in *Old Italian Masters*, p. 126.
21 Letter from Timothy Cole to Alexander Drake, 1 December 1888, quoted in A. Cole, *Timothy Cole*, p. 67.

Dingy and veiled by the dust of centuries in an unimposing, almost shabby chapel, probably where Dante saw it, its panel scarred by nails which have been driven to put the ex votos on, split its whole length by time's seasoning and scaled in patches, the white gesso ground showing through the color.

In spite of the poor conditions, or possibly because of them, Cole became drawn to the Madonna as well as the art of the Trecento, seeing in the supposed Cimabue

An inexplicable magnetism, which tells of the profound devotion, the unhesitating worship, of the religious painter of the day; of faith and prayer, devotion and worship, forever gone out of art. And the aroma of centuries of prayer and trust still gives it, to me, a charm beyond that of art.

Unable to work for long periods in front of the original because of the dark conditions, Cole noted that

It should be known that the best time for seeing the Cimabue here (Santa Maria Novella) is between 5 and 6 PM on a sunny day in summer, and in the winter an hour or so earlier. At that time the sun shines through the windows of the Strozzi Chapel, directly opposite, with such force as to light up the picture admirably and only then can the fineness of its details be seen. Many visitors coming in the morning to see the picture quit the place summarily, disappointed and declaring the place too dark for anything.

Cole noted that it was necessary to get as near to the painting as physically possible and that this was done by asking any one of the guardians for permission to ascend the altar, which he was readily granted. Apparently a set of portable steps was always kept in a corner of the chapel for this purpose; one had to place the steps against the altar and, having ascended, lift them up behind oneself, and place them securely on the altar so that one could ascend even farther. This position allowed the viewer to inspect the details of the drapery and to fully discover the beauty and coloring of the piece, which Cole described at length in his account. He labored over the writing of each and every essay, attempting to capture the essence of the image in the text as well as advising readers as to the best times of daylight to experience these pieces in their original environments.[22]

22 Timothy Cole 'Cimabue: Notes by the Engraver', in *Old Italian Masters*, pp. 15–18.

In conclusion, Cole's mission to 'shed light' on these iconic works both in a literal and a metaphysical sense is best described in Stillman's remarks to readers in the first installment in *The Century* of the 'Italian Old Masters':

> The undertaking to which THE CENTURY is devoting its resources in this series of works on which Mr. Cole has been for several years engaged, is therefore in the widest sense of the term a great education work. For such a work, on a scale which permits popularization, there is no method comparable to the work of this engraver — a more appreciative lover of early Italian art than he I have never known.[23]

Cole's engraving and discussion of the sixty-seven reproductions of mosaics, paintings and altarpieces not only provide us with a first-hand account of lighting conditions in Italy's galleries, collections and churches in the late nineteenth century, but also reveal Cole's deep commitment to enlighten Americans about the artistic treasures of the Italian Renaissance.

23 W. J. Stillman, 'Cole and his Work', in *The Century* 37 (November 1888), p. 58, https://babel.hathitrust.org/cgi/pt?id=coo.31924079618934;view=1up;seq=68

23. 'Into the Broad Sunlight': Anne Hampton Brewster's Chronicle of Gilded Age Rome

Adrienne Baxter Bell

> And thou didst shine, thou rolling moon, upon
> All this, and cast a wide and tender light,
> Which soften'd down the hoar austerity
> Of rugged desolation, and fill'd up,
> As 'twere, anew, the gaps of centuries;
> Leaving that beautiful which still was so,
> And making that which was not, till the place
> Became religion, and the heart ran o'er
> With silent worship of the great of old! —
> The dead, but sceptred sovereigns, who still rule
> Our spirits from their urns. —
> 'Twas such a night!

George Gordon Lord Byron, *Manfred* (1816–17), from Act III, Scene IV

The name of the American expatriate art critic and novelist Anne Hampton Brewster (1818–92) has been long forgotten. Her work has not been adequately analyzed in histories of American art; there is no mention of her even in histories of important nineteenth-century American women. The omission is astonishing and unwarranted. In fact, Brewster was a literary and proto-feminist pioneer. During an era in which the cares of home and family monopolized the lives of women, she courageously left America to develop a career as a foreign correspondent in Rome. Her timing couldn't have been better; the

https://doi.org/10.11647/OBP.0151.23

twenty-four years in which she lived abroad witnessed the unification of the Kingdom of Italy and the influx of thousands of American artists, who sought inspiration from Italy's storied sites and landscapes, as well as patronage from its Grand Tour visitors. During this dynamic period, Brewster provided the American public with around-the-clock, detailed accounts of life in Italy and, specifically, the latest events in the worlds of art and politics in Rome.

Fig. 23.1 Fratelli D'Alessandri, *Anne Hampton Brewster,* photograph, Rome, ca.1874. Print Collection, The Library Company of Philadelphia.

Brewster wrote frequently and exhaustively for a variety of American journals and newspapers, including the *Philadelphia Evening Bulletin,* the *Daily Evening Telegraph* (Philadelphia), the *Boston Daily Advertiser,* the *Chicago Daily News,* the *New York World,* and the *Newark Courier.* The quantity of her work matched the specificity of her observations; she habitually visited artists' studios and consulted leading Roman archaeologists, who promptly informed her of their projects and discoveries. Brewster rarely referenced the subject of light *in museums*

in her articles for a simple reason: she examined works of art long before they entered public collections. Nevertheless, light in its many incarnations played a crucial role in her work as a journalist and novelist. She first saw Rome by moonlight, which organically shaped her relationship to the city. On multiple occasions, she witnessed Rome as it capitalized on light's spiritual, even metaphysical properties. In her fictional identity, she experienced the lighting of Naples during annual religious festivities. Finally, she was present when much of ancient Rome was 'brought to light' during the Gilded Age. As Rome was illuminated for her, she illuminated Rome for her readers, as she does for us today.

Anne Hampton Brewster was born in Philadelphia as the second child of Maria Hampton and Francis Enoch Brewster. She was descended from William Brewster (1568–1644), an English official and passenger on the *Mayflower*. Elder Brewster, as he was known, led the Plymouth Colony; a great deal of his courage seems to have migrated to his descendent. Anne was educated by her mother, who instilled in her a love of writing from a young age. She read voraciously but, like most women in antebellum America, received little formal education. Her brother, Benjamin, by contrast, was educated at Princeton University and became a distinguished lawyer. Fortunately, Anne developed a friendship with the actress Charlotte Cushman (1816–76), a champion of female independence, who encouraged her to pursue her writing. As a result, she published a novel, *Spirit Sculpture* (1849), and at least twenty-two short works of fiction by the age of thirty-one.

Brewster's early literary success, however, was neither financially rewarding nor personally fulfilling. After her father died and left his entire estate to two illegitimate sons, her brother contested the will and had the estate divided between himself and his half-brothers. Although Benjamin promised to support her, Anne was excluded from the proceedings. Unable to tolerate dissension with her brother, she left America in May 1857 for Switzerland and Naples. While she would receive a small inheritance from some rental properties for the rest of her life, she depended financially on herself. Inspired by such successful writers as Anna Jameson, Lydia Sigourney, and Margaret Fuller, she set out to create a career as a professional writer. In 1868, she made an arrangement with George W. Childs, the publisher of the Philadelphia

Public Ledger, and publishers of several other American newspapers to pay her for weekly or monthly 'Letters from Rome'; as a foreign correspondent, she would become the spokesperson for a city that was, in her words, 'the centre of interest to all the world.'[1]

Roman Antiquities Seen by Moonlight

Brewster arrived at the newly constructed train station in Rome on 2 November 1868. 'I stood there alone,' she writes in her journal. 'It was a desolate outlook.' Her despair was short-lived. The novelist and portraitist Thomas Buchanan Read (1822–72) and his wife introduced her to the city. Brewster later recorded her oneiric impressions of Rome, which she first saw by moonlight via carriage ride. She described the fountain surrounding the obelisk at the Piazza del Popolo as follows:

> The full moon shone on streams of water that poured out steadily as if supplied by some eternal source from the lion's mouth at the base of this four thousand year old Egyptian mystery. The two hemicycles of the vast piazza adorned with fountains and statues, the paths leading up the slopes of the Pincio with marble figures and architectural decorations, trees and shrubbery made another Piranesi picture, or a Claude without the colour.

Her carriage ride continued to the Forum. Recalling Byron's description of Rome, she observed that 'the moon outlined with 'a wide and tender light' all the columns and architectural fragments [...] that [stand] on that hill of hills.' She arrived at San Giovanni in Laterano to see

> the Roman Campagna, divine in the solitude, its undulating surface and fine horizon of Sabine and Latium hills enveloped in the mystical light of the moon. The silence and grandeur of the scene! A soft breeze blew up and made the tops of some tall cypresses that stood in a neighboring villa nod sleepily in the night air.

'As long as I live,' she avowed, 'I shall remember this wonderful drive, this divine view of Rome by midnight.' She credits Buchanan Read, an 'artist poet,' for making this landmark experience possible.[2]

1 Quoted in Denise M. Larrabee, *Anne Hampton Brewster: 19th-Century Author and 'Social Outlaw'* (Philadelphia: The Library Company of Philadelphia, 1992), p. 25.
2 All citations in this paragraph are from the Journal of Anne Hampton Brewster, 4 November 1868–92, Box 4, folder 2, Anne Hampton Brewster Manuscript Collection, The Library Company of Philadelphia.

Light's Metaphysical Properties

During the nineteenth century, religious events in Rome often involved the careful manipulation of light's physical and metaphysical properties. On one evening, Brewster observed 'a torch light funeral procession' across the Piazza di Spagna. She was taken by the 'ghastly picturesqueness' of the scene, in which 'the torch bearers were clothed in sackcloths with hoods that covered the heads and faces.'[3] On 24 June the next year, she witnessed the Festival of St. John the Baptist, which she described as 'a sort of Walpurgis night.'[4] En route to the Via San Giovanni, she described preparations for the festivities: 'Flambeaux [blazing torches] were fastened against the walls' and '[g]ay booths stood on either side of the road, all the way up to the church; they were ablaze with candles...'[5] As a crowd gathered around the church, she saw people carrying torches against the moonlight and noted, 'the mingling of moonlight and heavy shadow, the flashing of the torches, the merry cries of the gay mob, created a strange, weird effect.'[6] Brewster's account reveals that eccentric light effects created by the intermingling of myriad forms of light — moonlight, candles, and torches — sustained and nourished longstanding, public religious festivities in Rome.

Several years later, in 1881, Brewster witnessed one of the annual requiems in honour of Victor Emmanuel II (1820–78). On a dreary, rainy afternoon, she entered the Pantheon and braced herself against the cold. She took her seat on the highest platform of the chapel altar to observe the ceremony that honoured Italy's first king. Her description features the extraordinary play of different forms of light at the event and reads, in part, as follows:

> This huge catafalque was lighted on Saturday with blazing tripods at the summit, at the base of the little temple, and at the grand base of the whole: also with rows of tall large wax candles, so arranged that their flames formed interlaced garlands. At the four corners of the catafalque stood candelabra. [...] Blazing tripods like ancient pagan altars stood on top of all the altar façades of the temple, and were arranged in groups of three

3 Ibid.
4 Anne Brewster, 'Letter from Rome', *Philadelphia Evening Bulletin*, 28 June 1869.
5 Ibid.
6 Ibid.

around the marble attic. [...] The *lucernario,* or great circular opening in
the dome, was covered with a transparency, on which was painted the
shield and red cross of Savoy. Some pale rays of sunlight crept in at this
opening for a few moments, then faded away as life in the presence of
death, and all the morning a grey, cold, unearthly light streamed faintly
down on the richly decorated temple, and created a strange effect. The
tripod flames shot up pointed and tongue-like, trembling in the damp,
cold atmosphere. The large pendant gold and silver lamps [t]hat hung
in front of the many chapels threw out small yellow rays; the myriads of
wax candles were like fiery sparks.[7]

Brewster understood the evocative power of light. Her meticulous
description centers on the combination of different forms of
light — light from tripods, wax candles, and candelabras, and pale
sunlight seeping through the Pantheon's legendary oculus — that
generated the resplendent atmosphere of the ceremony. In short, light
in the Pantheon captured the spectacle of mourning and the sublimity
of death.

Brewster also experienced the joyful expression of Roman light. On
24 February 1877, she reported to the *Philadelphia Evening Bulletin* on the
last days of the annual Carnival, which immediately preceded Lent. She
was especially taken with the *moccoletti,* the event's trademark candles
(see Fig. 23.2). She describes how,

at the beginning of night-fall on the last day, thousands and thousands
of little wax-tapers are lighted in the streets and balconies. Every one
stops throwing *confetti* and begins a new piece of fun, which consists in
each one trying to put out his or her neighbor's candle. Long poles, with
cloths fastened on their ends, are brandished about.

Brewster took pleasure in describing how every car had Bengal lights 'of
every color in it: red, green, lilac, blue, with all their curious reflections,'
and how they 'threw a strange, almost devilish light over the crowd.
[...] [F]rom half-past five o'clock to seven o'clock the brilliancy and
gayety can hardly be described with justice.'[8] In this case, the frenzied,
even meteoric quality of the lights fueled the festive revelry.

7 Anne Hampton Brewster, 'Italian Notes', *Philadelphia Daily Evening Telegraph,* 17
 January 1881, p. 8.
8 Anne Brewster, 'Correspondence. Letter from Rome. The Last Days of the Carnival',
 Philadelphia Evening Bulletin, 24 February 1871.

Fig. 23.2 Ippolito Caffi, *I moccoletti al Corso*, tempera on paper, 83.8 x 121.8 cm., Museo di Roma, Trastevere, Rome.

In a chapter entitled 'Sky-Rockets' from her novel *St. Martin's Summer* (1866), written on the eve of her permanent expatriation to Italy, Brewster portrays the dramatic effects of fireworks in Naples. The character of Ottilie, a likely stand-in for Brewster, recounts the activities of a small group of women who travel around Switzerland and Italy for the summer. After the group settles in Naples, Ottilie describes the festivities on Trinity Sunday, when the city is elaborately illuminated. Buildings are scaffolded and then strung up with 'parti-colored glass cups' that are 'half-filled with oil, on which floats a taper. [...] At nightfall these lamps are lighted and the scaffoldings removed, with a celerity that seems hardly possible.'[9] Ottilie portrays the rest of the illuminations as follows:

> The church façade then looks like a fairy scene, with its twinkling, sparkling, brilliant-hued letters and devices, and as they begin to pale and drop out, one by one, the attention of the crowd is attracted by the firing-off of petards [small bombs] and the sending up of remarkably fine fireworks. The pyrotechnical displays in Naples seem inexhaustible: there is one called the Girandola, which is remarkably beautiful; it is formed by a simultaneous discharge of numberless rockets, that fall back from a centre as they explode, looking like fiery petals of a gigantic lily-cup or bell.[10]

9 Anne M. H. Brewster, *St. Martin's Summer* (Boston: Ticknor & Fields, 1866), p. 277, https://catalog.hathitrust.org/Record/008658127
10 Ibid., 277–78.

In this sublime scene, light takes on both physical and metaphysical properties. The fireworks recall the harrowing Plinian eruptions of Vesuvius, whose mass lay within the narrator's field of vision. A few minutes later, she observes gas jets mounted on the base of the dome of the Church of San Francesco di Paola, a massive church in Naples' main square. For Ottilie and her friends, the 'cross of fire' created by these gas jets immediately evoked the visionary cross and empyrean inscription, 'Conquer through this,' that (according to Eusebius) Constantine famously saw before the Battle of the Milvian Bridge.[11] Having visited Naples in 1857, Brewster could now transform personal experience into fiction to show how pyrotechnical displays there seamlessly intertwined secular revelry and ecclesiastical history — history at the root of Italy's Catholic identity.

Antiquities Brought to Light

Some of Brewster's finest contributions to American and European newspapers consist of detailed reports on antiquities excavated during the late nineteenth-century in Rome and surrounding cities. Fluent in Italian and French, adept at reading German, Latin, and Greek, and possessing a relentlessly inquisitive mind, Brewster was also captivated by Italian archaeology. She befriended a number of leading excavation directors and found ways of seeing works of art only days after they had been unearthed. She was, in this regard, an invaluable witness to the original condition of ancient objects and buildings.

One of her closest friends was Rodolfo Lanciani (1845–1929), the prolific archaeologist and writer. The change in the salutations of his letters to her over the years reflects their growing camaraderie. At first, he writes to her in French — the *lingua franca* of the nineteenth century — as 'Chère Mademoiselle Brewster.' As the friendship develops, she is 'Dear Miss Brewster.' He addresses his final set of letters, written in Italian, to 'Cara Anna.' The detailed reports that he sent to her — almost as a colleague working synchronically with him — testify to the considerable trust he put both in her devotion to his work and her ability to interpret the information he provided. She, in turn, often reproduced parts of his letters word for word in her reports to American newspapers.

11 Ibid., 278–79.

Brewster also befriended the archaeologist Andrea Fraja, who published his findings in the *Giornale degli Scavi di Pompei* (1861–65).[12] Through introductions from him, she spoke to the excavators who, in July 1875, discovered the *tabellae ceratae*, or wax tablets (56 CE), from the tomb of a Pompeiian banker, which were written by Marcus Alleius Carpus. The wooden tablets, coated with wax, had been stored in a wooden box, which was now, according to Brewster, 'completely carbonized'; when brought to light, it 'crumbled to pieces at the first touch.' The box contained between 300 and 400 little tablets bound together in packages of three. Brewster published the Latin inscription on one — a record of the repayment of a loan — and translated it for her readers. Tragically, the tablets had been discovered on a very hot day and they proceeded, as she put it, to 'crack or snap.' They were rushed to the National Archaeological Museum in Naples at night to try to preserve them from the damaging rays of the sunlight but some eventually decomposed.[13] Brewster's account endures as a testimony of their appearance.

The sublime Hellenistic *Seated Boxer*, which may have been displayed at the Baths of Constantine, had been carefully buried in late antiquity, possibly to preserve it against invasions that ravaged Rome in the fifth century CE; Lanciani discovered it on the Quirinal in 1885.[14] Shortly thereafter, he brought Brewster to the site. 'It is impossible to describe the emotion it caused to all present,' she wrote in a subsequent article. 'Laborers, guards, contractors, builders, each and all, were as excited and as full of joy as the scholarly Superintendent and my humble self. I sat down on a stone and watched the men lift the earth carefully away from the precious bronze.'[15] Brewster was also one of the first to study the sarcophagus of Larthia Sciantia (3rd century BCE), a masterpiece of Etruscan art, shortly after it had been found in Chiusi and brought to Rome for analysis. (It is now in the National Archaeological Museum of Florence.) In her report on the discovery to the *Boston Daily Advertiser*,

12 Fraja also contributed research to Karl Zangemeister, *Inscriptiones Parietariae Pompeianae, Herculanenses, Stabianae* (Berolini: G. Reimer, 1871), https://archive.org/details/inscriptionespar41zang

13 All quotations from this paragraph are from Anne Brewster, 'New Treasures Brought to Light at Pompeii', *Boston Daily Advertiser*, recorded on 7 August 1875; published on 21 August 1875.

14 http://www.metmuseum.org/exhibitions/listings/2013/the-boxer

15 Anne Hampton Brewster, 'A Landmark in Rome', undated journal clipping, Anne Hampton Brewster Manuscript Collection, Historical Society of Pennsylvania.

she described in extraordinary detail every facet of the sarcophagus, including the noblewoman's expression ('a dazed, half-wondering look, as if death had just opened to her vision sights of marvellous import'), the acorns on the figure's earrings, the veil she holds over her head, the cushions that support her, even the five rings on the fingers of her left hand. She described the woman's elaborate clothing, including her stockings and sandals, and the large rosettes on the base of her casket. Brewster even surmised that the Greek physician Areagathus was summoned to help this noblewoman as her illness was 'taking her away in her youth.' 'His medical aid was useless,' she decided, 'the Etruscan Fates had cut her thread of life.' Brewster concluded: 'Now, two thousand years after her long rest, the dust and ashes of her body, the portrait-statue with its curious beauty, is upturned from this solemn tomb, brought out into the broad sunlight.'[16]

Anne Hampton Brewster was an eyewitness to Roman history. The hundreds of articles that she sent to American and Italian newspapers from Rome represent the richness of her experiences and observations. Light played a central role in these experiences. By seeing Rome first by moonlight, she established the personal, poetic tenor of her relationship to The Eternal City. It seemed to have been lit only for her. She experienced the uncanny, somewhat supernatural light of the Festival of St. John the Baptist and the incandescent, sepulchral performance of the Italian King's annual requiem. She was there, too, when Rome let loose at Carnival; lights — Bengal lights and *moccoletti* — took center stage at a time of dissimulation and clemency. She processed these images not only through the objective format of the newspaper article but also poetically through the fictive world of the novel. In this space, she could tease out the uncanny intersections between geological eruptions, religious festivities, and revelry. Sublime, nearly intoxicating experiences always seemed imminent. Finally, Brewster was present at the gradual, systematic revelation — the bringing to light — of ancient Rome. We would be hard pressed to find a more systematic, devoted, and capable interpreter of these discoveries. Given its importance to our understanding of Italian and American art history, the work of Anne Hampton Brewster, long overshadowed by her male counterparts, must now be brought to light.

16 Anne Brewster, 'The Old Monuments — A Remarkable Etruscan Statue — Memorials of an Ancient Lady — Interesting Speculations', *Boston Daily Advertiser*, 1 January 1878.

PART VI

ON LIGHT IN MUSEUMS IN JAPAN

24. In Praise of Shadows: Ernest Fenollosa and the Origins of Japanese Museum Culture

Dorsey Kleitz and Sandra Lucore

We take as our starting point a metaphorical understanding of 'darkness into light' as it explains the historical situation of mid-nineteenth century Japan and as it highlights the seminal role played by Ernest Fenollosa, the Boston Orientalist and art historian, in promoting what Alice Tseng calls 'the invented concept of Buddhist art'.[1]

Until Commodore Matthew Perry's 'black ships' appeared on the eastern horizon in July 1853, Japan was, for all intents and purposes, closed to Western contact. In *Moby-Dick*, Herman Melville famously refers to Japan as 'that double-bolted land.'[2] Indeed, the Japanese characters for this self-imposed isolation policy of *sakoku* initiated by the Tokugawa government in the 1630s literally mean 'locked country': 鎖国. Although during this period trade took place on a limited basis between Japan and the outside world, no Westerner could enter Japan nor could any Japanese leave, on penalty of death. There was no Grand Tour for travelers in search of Japanese art and culture, no Baedeker guide to advise on the delights and dangers of Kyoto and Nara. Indeed, until the Meiji era there was no museum and not even a Japanese word for 'art' as conceived in the West.

1 Alice Y. Tseng, *The Imperial Museums of Meiji Japan: Architecture and the Art of the Nation* (Seattle: University of Washington Press, 2008), p. 19.

2 Herman Melville, *Moby Dick: Or The Whale* (Evanston: Northwestern University Press, 2001) p. 110.

 https://doi.org/10.11647/OBP.0151.24

With the restoration of the emperor in 1868 Japan entered a chaotic period of rapid change. The old feudal system supported by what Van Wyck Brooks calls 'thoroughly worm-eaten though externally lacquered and gilded pillars' was abandoned.[3] Japan's fast-paced modernization was greatly influenced by the Western phenomenon of world's fairs. Participation in these international expositions promoted official discussion of the role of Japanese art in shaping a new national identity. Intended to facilitate the growth of an international market, expositions were organized around a hierarchy of participating countries. The upper tier was composed of industrialized Western nations, while at the opposite end of the spectrum were their colonial possessions. In between these two extremes were independent nations that had more recently embarked on industrialization, including China and Japan, whose governments were faced with the problem of demonstrating at world's fairs both modernization and an independent, indigenous identity. In Japan, government-sponsored expositions were also intended to encourage the growth of a viewing public.

From the 1860s the ambitious and pragmatic Japanese government recognized that Japanese arts and crafts could serve as an important way to attract Western interest and thus participation in world's fairs increasingly highlighted Japanese crafts. Moreover, government desire to cultivate a Euro-American taste for Japanese arts and crafts had a profound impact on how these artifacts were conceptualized. During the Tokugawa period, Japanese arts and Japanese crafts had not been distinguished from each other; rather, painting, icon making, calligraphy, pottery, and lacquerware, were seen as fields of aesthetic production in their own right. The word for art, *bijutsu*, was coined during the Meiji period as a Japanese translation of the German term *schöne Kunst* (fine arts), which appeared in the entry rules formulated for the 1873 Vienna International Exposition clarifying the Western definition of art.[4] Anything that did not fit this definition of art fell into the category of manufactures.

World's fair politics dictated that non-Western countries were regularly invited to submit entries to the industrial and technological

3 Van Wyck Brooks, *Fenollosa and his Circle* (New York: Dutton, 1962), p. 4.
4 Noriko Aso, *Public Properties: Museums in Imperial Japan* (Durham: Duke University Press, 2014), p. 31.

divisions but not the arts division, since so-called undeveloped countries were thought to be incapable of producing anything of sufficient quality. Having caught on quickly to this insult, the Japanese state set about rectifying the situation, calling for increased production of objects that would fit the Western concept of art. The dimensions of Japanese aesthetic production were redefined, in order to find a place within a Western context.

In 1877 Japan's First International Industrial Exhibition was held in Tokyo. The centerpiece, the Fine Art Building, the first building in Japan to be called a *bijutsukan* and a precursor to today's National Museum, attracted large crowds. Though gas streetlamps, which first appeared in Tokyo in 1874, were used in the grounds, the building's interior, modeled on Western galleries, relied on natural illumination from above. A *ukiyo-e* triptych by the well-known artist Ando Hiroshige shows the main room of the Fine Art Building packed with Japanese and foreign visitors.[5] The pictures, hung Western style in tiers from floor to ceiling, consist mostly of portraits, landscapes, and scenes from nature, several of which echo Hiroshige's own work. Outside the open door a gas streetlamp visible in the distance reveals the development of Japanese lighting technology. In a country in thrall to fireworks since the early eighteenth century, the play of light and darkness was of great popular interest. Indeed, five years later electric arc lighting entranced pedestrians on the streets of Ginza and the 1907 Tokyo Industrial Exposition included a spectacular array of outdoor electric illuminations that inspired Natsume Soseki to write, 'If there is even a spark of life in you and you seek evidence of that spark, look then, at the illumination — one cannot but be astounded by it. Those paralyzed by civilization have only to be astounded thus, to realize that they are indeed alive.'[6]

Buddhist icons proved particularly useful in the effort to define Japanese art because they offered a domestic form that matched Western notions of fine art in terms of genre (sculpture) and concept (religious) that sidestepped Western criticisms aimed at early Japanese efforts to make their art look Western. While the initial efforts of the

5 For Hiroshige's triptych see https://www.tnm.jp/modules/r_free_page/index. php?id=149&lang=en (it is the middle image on the right-hand side).

6 Natsume Soseki, quoted in Miya Elise Mizuta, 'Tokyo' in Sandy Isenstadt, Margaret Maile Petty, and Dietrich Neumann (eds.), *Cities of Light: Two Centuries of Urban Illumination* (London: Routledge, 2014), pp. 109–14 (p. 111).

Meiji government to promote the native Shinto religion at the expense
of Buddhism were devastating to Buddhist sculptures and icon makers
in the late 1860s and early 1870s, the desire to demonstrate their nation's
cultural achievements on the world stage resulted in a dramatic change
of course. The anti-Buddhist destruction and disposal of temple treasures
ceased. Government officials began to view Buddhist sculptures as
part of a Japanese artistic heritage and initiated surveys of treasures in
Buddhist temples and Shinto shrines that eventually led to the founding
of art museums and state sponsored art education. Art that was initially
promoted for its utilitarian and economic value was superseded by a
notion of art as an expression of a universal ideal equally applicable
to West and East. Ultimately, this change was reflected in institutional
change: the government closed the Technical Art School and opened the
Tokyo School of Fine Art in 1888, an institution that Ernest Fenollosa
was instrumental in founding.

At this point Fenollosa had already been in Japan for nine years. Born
in 1853 in Salem, Massachusetts, Fenollosa studied philosophy and fine
arts at Harvard before being recruited by Edward S. Morse in 1878 to
teach philosophy and political economics at the Imperial University
in Tokyo. He quickly turned his attention to collecting and studying
Japanese art, ultimately helping to establish not only the Tokyo School
of Fine Arts, but also the Imperial Museum in 1888. The myth is that
Fenollosa entered a void and singlehandedly saved Japanese art from
widespread destruction in the rush to modernize. In the hyperbolic
words of Frank Lloyd Wright describing the Meiji era:

> Japan went into hysterical self-abnegation and began to destroy her
> beautiful works of art, casting them upon sacrificial bonfires: virtually
> throwing her civilization upon these fires as on a funeral pyre, a national
> form of that Hara-kari [sic]. A young American helped save many of the
> proofs of their great culture from this wanton destruction. His name was
> Ernest Fenollosa.[7]

The reality, however, is that Fenollosa arrived in Japan once the anti-
Buddhist sentiment was on the wane, during a period of intense
activity that aimed to preserve and promote the native artistic heritage.
Fenollosa was not the first nineteenth-century Orientalist to 'discover'
or 'save' Japanese art, but his preeminent position derived from the fact

7 Kevin Nute, *Frank Lloyd Wright in Japan* (London: Chapman & Hall, 1993), p. 76.

that he placed objects from the past in a context that gave meaning to contemporary concerns, as well as his efforts to establish the idea of art as an expression of cultural heritage. Remarkably, the general content and nature of Japanese art history that Fenollosa and his associate, Okakura Kakuzo, promoted has not changed significantly and continues to serve today as the prevailing narrative.[8]

Fenollosa's philosophical basis of art developed from the American aesthetic movement, with its foundations in the writing of Ralph Waldo Emerson, James Jackson Jarves, and the English art critic John Ruskin. Although Fenollosa is sometimes called the Ruskin of Japan, because of his efforts to bring Japanese art out of obscurity and to the attention of a larger public both in Japan and in the West, in fact he blasted Ruskin for his emphasis on a materialistic, mimetic realism that denied the emotional and spiritual nature that according to Fenollosa gave meaning to art: 'And did God create only the material world, and not also the human soul?'.[9] As Fenollosa's ideas about Japanese art developed, he identified three key characteristics: line, color, and *notan*. Fenollosa's appreciation of Japanese art foregrounds the concept of *notan*, the harmony between darkness and light, harmony he believed was key to art's emotional and spiritual nature. In the 1890s, when Fenollosa was curator of oriental art at the Boston Museum of Fine Arts, he was befriended by the artist and art educator, Arthur Wesley Dow, who was fascinated by the collection of *ukiyo-e* at the museum. Fenollosa introduced Dow to Japanese aesthetics, including the idea of *notan* that subsequently became one of the cornerstones of his popular teaching manual, *Composition*, which influenced a generation of modern American artists who carried his ideas into abstract art. Different from the Western artistic principle of chiaroscuro, *notan* conveys the idea of abstract harmony-building rather than portraying the effects of lighting on an object. In the words of the Japanese novelist, Tanizaki Junichiro: 'Find beauty not only in the thing itself but in the pattern of the shadows, the light and dark which that thing provides'.[10] For Fenollosa the art historian, then, Japanese art in itself was less important than what it had to teach about the nature of art in general.

8 Stefan Tanaka, *New Times in Modern Japan* (Princeton: Princeton University Press, 2004), p. 102.

9 Ernest Fenollosa, 'The Nature of Fine Art', in Kevin Nute, *Frank Lloyd Wright in Japan* (London: Chapman & Hall, 1993), Appendix E, p. 202.

10 Junichiro Tanizaki, *In Praise of Shadows*, trans. by Thomas J. Harper and Edward G. Seidensticker (Sedgwick: Leete's Island Books, 1977), p. 30.

Armed with imperial permission, Fenollosa and Okakura contributed to a comprehensive inventory of the Japanese treasures in temples and shrines that were suitable for preservation and display. The transmutation of Buddhist treasures from a lived past to a past that informs the present can best be illustrated through Fenollosa and Okakura's unwrapping in 1884 of the famous Guze Kannon, the Buddhist goddess of compassion, at Horyuji temple in Nara.[11] Fenollosa describes the event in detail:

> I had credentials from the central government which enabled me to requisition the opening of godowns and shrines. The central space of the octagonal Yumedono was occupied by a great closed shrine, which ascended like a pillar towards the apex. The priests of the Horiuji confessed that [...] it had not been opened for more than two hundred years. On fire with the prospect of such a unique treasure, we urged the priests to open it by every argument at our command. They resisted long alleging that in punishment for the sacrilege an earthquake might well destroy the temple. Finally we prevailed, and I shall never forget our feelings as the long disused key rattled in the rusty lock. Within the shrine appeared a tall mass closely wrapped about in swathing bands of cotton cloth, upon which the dust of ages had gathered. It was no light task to unwrap the contents, some 500 yards of cloth having been used, and our eyes and nostrils were in danger of being choked with the pungent dust. [...] But it was the aesthetic wonders of this work that attracted us most. From the front the figure is not quite so noble, but seen in profile it seemed to rise to the height of archaic Greek art. [...] But the finest feature was the profile view of the head, with its sharp Han nose, its straight clear forehead, and its rather large — almost negroid — lips, on which a quiet mysterious smile played, not unlike da Vinci's *Mona Lisa*'s. Recalling the archaic stiffness of Egyptian Art at its finest, it appeared still finer in the sharpness and individuality of the cutting. In slimness it was like a Gothic statue from Amiens, but far more peaceful and unified in its single systems of lines.[12]

Here Fenollosa is the authority, the art expert, battling against the anachronistic priests to bring the Guze Kannon from the darkness and shadows of the Yumedono (Hall of Dreams) to the daylight reality of nineteenth-century Meiji Japan. For the priests, the significance of the

11 For an illustration of the Guze Kannon see https://commons.wikimedia.org/wiki/File:GUZE_Kannon_Horyuji.JPG

12 Ernest Fenollosa, *Epochs of Chinese and Japanese Art*, 2 vols. (New York: Dover, 1963), I, pp. 50–51.

Kannon is in the religious meaning of the place, not the statue itself, in the harmonious synthesis of the two. By contrast, Fenollosa's Kannon is meaningful here largely as an artifact. He compares it to archaic Greek sculpture, notes the similarity to Chinese art, links its smile to the *Monna Lisa*, its stiffness to Egyptian traditions, and its slender beauty to French Gothic cathedral sculpture in a conscious effort to bring the statue into the mainstream of Western art historical discourse. Art of course is not Western in origin, but collecting, cataloguing, and displaying is. The event highlights Fenollosa's key contribution to Japanese art: not 'discovering' it, but making it conscious of itself by putting it into a larger context.

The consequent inevitable loss of its original context, and the transformation of Japanese art into a new idiom, is immediately reflected in Fenollosa's domestic environment. Photographs of Fenollosa's Tokyo residence show a typical Victorian interior crowded with Western-style heavy drapery and over-stuffed furniture.[13] On closer inspection, however, the room is chockablock with Japanese wall-hangings, sculptures, and artifacts many of which ended up in collections in the United States, notably the Boston Museum of Fine Arts and The Freer Gallery of Art.

In 1933 Tanizaki Junichiro, one of Japan's greatest twentieth-century novelists, published *In Praise of Shadows*, a meditation on traditional Japanese aesthetics. Sometimes viewed as tongue-in-cheek because of its quirky appreciation of Japanese toilets, *In Praise of Shadows* is in fact a paean to a distinctly Japanese love of understated nuance, everything softened by shadow and the patina of age. Born in Tokyo in 1886, when Fenollosa was at the height of his collecting activity and influence, Tanizaki experienced firsthand the Meiji Era world of opposites, embracing Western ways in his early life before abruptly moving to Kyoto and turning to traditional Japanese culture in his later life.

In *In Praise of Shadows* Tanizaki criticizes the functional, over-illuminated harshness of the West in nostalgic response to what had been lost in the rush to modernize. The beauty of a Japanese room, he claims, relies on the play of shadows, dark shadows and light shadows:

13 See https://commons.wikimedia.org/wiki/File:Houghton_MS_Am_1759.4_(7)_-_Fenollosa.jpg

Westerners are amazed at the simplicity of Japanese rooms, perceiving
in them no more than ashen walls bereft of ornament. [...] Of course
the Japanese room does have its picture alcove [*tokonoma*], and in it a
hanging scroll and a flower arrangement. But the scroll and the flowers
serve not as ornament but rather to give depth to the shadows. We value
a scroll above all for the way it blends with the walls of the alcove, and
thus we consider the mounting quite as important as the calligraphy or
painting. Even the greatest masterpiece will lose its worth as a scroll if it
fails to blend with the alcove, while a work of no particular distinction
may blend beautifully with the room and set off to unexpected advantage
both itself and its surroundings. Wherein lies the power of otherwise
ordinary work to produce such an effect? Most often the paper, the ink,
the fabric of the mounting will possess a certain look of antiquity, and
this look of antiquity will strike just the right balance with the darkness
of the alcove and room [...] We find beauty not in the thing itself but
in the patterns of shadows, the light and the darkness that one thing
against another creates.[14]

Tanizaki concludes his essay:

We Orientals tend to seek our satisfactions in whatever surroundings
we find ourselves, to content ourselves with things as they are; and so
darkness causes us no discontent.[...] But the Westerner is determined
always to better his lot. From candle to oil lamp, oil lamp to gaslight,
gaslight to electric light — his quest for a brighter light never ceases, he
spares no pains to eradicate even the minutest shadow.[15]

The idea of *notan*, the harmonizing effect of the interaction of light and
shadow, in spite of the adoption of Western conventions remains an
abiding aesthetic concept, especially in the contemporary display of
Buddhist sculpture, the starting point of our discussion.

At the Japanese architect Taniguchi Yoshio's Gallery of Horyuji
Treasures, part of the Tokyo National Museum, Fenollosa's Guze
Kannon has, metaphorically speaking, been returned to the shadowy
interior of the Yumedono. Taniguchi's sleek modern design combined
with the museum's state of the art technology and particularly its
lighting, by the well-known minimalist light designer Toyohisa Shozo,
provides the perfect environment to elucidate the beauty and meaning of
Buddhist icons to contemporary museum audiences.[16] The understated

14 Tanizaki, *In Praise of Shadows*, pp. 18–19, 30.
15 Tanizaki, *In Praise of Shadows*, p. 31.
16 See http://www.kirikou.com/japon/Tokyo/Tokyo_National_Museum/Horyuji_
 Treasures/1F/1F.htm

traditional Japanese aesthetic is here seen in striking contrast to the Western expressionism of the dramatic lighting, which characterizes the display of Japanese Buddhist sculptures in the Museum of Fine Arts in Boston. Here, the focal point of the dark sculpture room, *Dainichi, Buddha of Infinite Illumination*, seated on his lotus blossom, is brightly lit from several discrete points creating a complex experience of overlapping light and shadow.[17] One wonders how Fenollosa would view this postmodern sensibility.

17 See http://www.mfa.org/collections/featured-galleries/japanese-buddhist-temple-room

POSTSCRIPT

25. Premonitions:
Shakespeare to James

Sergio Perosa

As I was preparing to write this essay, a line of Shakespeare, right at the beginning of *Macbeth*, kept ringing in my mind:

All. Fair is foul and foul is fair. (I, i, 10)

In his sonnets, poems, and plays, Shakespeare works almost obsessively on the tension, interplay, and sometimes interpenetration of darkness and light(ing), as two almost interchangeable poles of a semantic and existential system, a dichotomy that verges on unity. (Two scenes down, Macbeth himself: 'So foul and fair a day I have not seen', I, iii, 38).

In her impassioned reverie ('Gallop apace, you fiery-footed steeds…'), when Juliet exhorts night and darkness to bring Romeo to her for very practical business between newlyweds, she is given a stupendous image (please note the details and the wording):

Jul. Lovers can see to do their amorous rites

By their own beauties.
(III, ii, 9–10)

While making love, presumably naked, lovers enjoy the sight of each other thanks to the beauty they emanate; they defy night and darkness by the light that irradiates from their bodies.

 https://doi.org/10.11647/OBP.0151.25

This is what would later be claimed of artworks: they emanate and irradiate their own light; they are themselves a source of light in darkness — this phosphorescence is the added charm of aesthetic beauty. Metaphorically, as Shakespeare (or his collaborator), puts it in *Pericles*:

> like a glow-worm in the night,
>
> The which hath fire in darkness, none in light. (II, iii, 44–45)

At Burlington House, for instance, Henry James would hint at the opportunity 'for the fog-smitten wanderer to pass out of the January darkness of Piccadilly into the radiant presence of Titian and Rubens'.[1] Paintings give light to rooms.

I'll briefly consider these poetic assumptions, and reversals, because, as so often in plays by Shakespeare, who was a master of contradictions and oxymora, everything turns to its opposite (as claimed in *Romeo and Juliet*, IV, v, 84–90: 'All things that we ordained festival / Turn from their office to black funeral; /... / And things change them to the contrary'). For Lucrece, in the poem written at around the same time as *Romeo and Juliet*, 'light and lust are deadly enemies' (*The Rape of Lucrece*, l. 674). Elsewhere, equally relentlessly and obsessively, the beauteous act of love that Juliet envisions illuminated by the lovers' bodies, is perceived and presented as the deed (*Lucrece*; *Pericles, Prince of Tyre*) or the act of darkness (*King Lear*; *Macbeth*; even *Antony and Cleopatra*, that sumptuous paean to tainted, mature love) — a dreadful, mischievous, despicable, and degrading act. One can also think of Sonnet 129, 'The expense of spirit in a waste of shames / is lust in action'.

This dialectic between fair and foul, light and dark, is persistent: it keeps one imprisoned in fetters, either way. Soon after, Milton would speak of 'No light, but darkness visible' (*Paradise Lost* I, 62–63): another perfect oxymoron that might be fancifully applied to artworks.

Neither Milton, nor Shakespeare, nor their contemporaries, of course, had museums to visit; the closest Shakespeare comes to such an idea

1 'The Old Masters at Burlington House' (1877), in John L. Sweeney (ed.), *The Painter's Eye. Notes and Essays on the Pictorial Arts* (London: Rupert Hart-Davis, 1956), p. 124. — The fog must have been very heavy. Emily Dickinson (presumably with no idea of a close encounter) seems to echo Shakespeare's concept in her poem N. 611: 'I see thee better — in the Dark — / I do not need a light — / The love of thee a prism be — Excelling violet /... / What need of day — To Those whose Dark — hath so — surpassing Sun' (ll. 1–4, 13–14).

is in the two-hundred-line-long description of the Shield of Achilles in *Lucrece* (ll. 1366–1562) — one of the best examples of modern (invented) ekphrasis and perhaps the first instance of a young woman confronting or measuring her destiny against or in connection with an artwork, as will be so frequently the case in nineteenth-century fiction.

Shakespeare's tension-ridden perception of the import of light and darkness in the drama of life was inherited and reflected across the centuries by novelists who strongly felt his influence, who visited the newly-founded museums with mixed feelings, and who had their characters enact there crucial confrontations with matters of love and death, light and darkness. The similarities are enticing: a dialectic of darkness and light(ing), similar to that envisioned by Shakespeare, is created by these novelists in museum spaces for the purposes of definition and discovery, and this is achieved in clearly Shakespearean terms. I shall briefly touch on examples by Hawthorne and James, by way of Melville and George Eliot.

In their time, a strong conception of the sacredness, sanctity (sacralità, in Italian, would be an even better word) of art arose and prevailed, brought in precisely by the establishment of museums as shrines, temples for spiritual contemplation and enhancement, where feelings of silence and awe were induced, even required, by a kind of semi-darkness or half-light. A crepuscular atmosphere would be predominant and propitious, and had to be maintained as such, allowing for no distraction — including that of too much light. Semi-darkness would be no obstacle, and might indeed be favourable to the appreciation of art works in museums.[2]

In his statements and stories, Hawthorne declared his predilection for twilight, and he was more interested in sculpture than in pictures

2 See Anna De Biasio, *Romanzi e musei. Nathaniel Hawthorne, Henry James e il rapporto con l'arte* (Venezia: Istituto Veneto di Scienze, Lettere ed Arti, 2006), who works extensively with classic texts on the subject, e.g. Pierre Bourdieu's *The Field of Cultural Production* (New York: Columbia University Press, 1986). — I have a Japanese print, the gift of a dear friend, that in full daylight is black and white, but in the twilight or near darkness shows a delicate pastel colouring. In 'The Lesson of the Master' (1888) James noted that museums (and studios) had rooms 'without windows, but with a wide skylight at the top, like a place of exhibition'. This was possible on top floors, or one-storey buildings.

(particularly the Venus di [*sic*] Medici, which he visited frequently at
the Uffizi). He noted that the pictures in the Florentine gallery, 'being
opposite to the light, are not seen to the best advantage'.[3] In his significant
novel *The Marble Faun* (1860), the use of cleaning and restoration to
bring light to darkness is explored in peculiar ways. Statues present no
problems: in the Capitol Hall of Sculptures they shine in the glimmer
of *giallo antico* (chs. 1 and 31), while copies of paintings by Old Masters,
such as those made by Hilda, may be better than the originals precisely
because they bring to light what was previously dark: 'From the dark,
chill corner of a gallery [...] she [Hilda] brought the picture into daylight,
and gave all its magic splendour for the enjoyment of the world' (ch. 6).

But in chapter 37 ('The Emptiness of Picture Galleries'), after her
vicarious experience of crime and guilt, Hilda, the shy copyist, the
'handmaid of old magicians', has lost her feeling for the Old Masters,
and she sees only gloom in them: even then, 'the icy daemon of
weariness, who haunts great picture galleries had set in'. In the following
chapters (chs. 38–40), this gloom is dissipated by her experience in St.
Peter's — which combines the features of a place of worship and those
of a museum — where 'light showered beneath the Dome', 'beams of
radiance' and 'long shafts of light' came through, and the place seems
imbued with sunshine. But she looks rather for the darkness of a
confessional, where this daughter of Protestant New England kneels to
sob a prayer and confess to a Catholic priest.

Finally, the question of darkness and light is openly faced in the last
chapter (50), in the Pantheon — where the 'peculiarity of its effect' is
due to 'the aperture in the dome — that great Eye, facing downward',
which will also allow rain to pour in, and where Kenyon, the sculptor,
now reconciled with Hilda, asks the question that interests us: 'There
is a dusky picture over that altar [...] let's go and see if this strong
illumination brings out any merit in it.' The answer is devastating: the
picture is little worth looking at, and a tabby-cat is sitting on the altar.

3 *Passages from the French and Italian Note-Books* (Boston: The Riverside Press, 1883),
 p. 286 (8 June, 1858), among others. At the Louvre, he confessed 'that the vast and
 beautiful edifice struck me far more than the pictures, sculptures, and curiosities
 which it contains', ibid., p. 20 (8 January, 1858).

First deviation: in his impassioned review, 'Hawthorne and his Mosses' (1850), Melville considered Hawthorne an American Shakespeare on the Hudson, walking down Broadway, fascinated by blackness like Melville himself. Melville had little relish for museums, which he considered akin to morgues; he was rather cold about paintings and statues, and his lecture 'Statues in Rome' (delivered in 1857–58, and reconstructed from newspaper reports), is perfunctory and even embarrassing in its opacity.[4] There are no museums in his fiction, but in his only novel set on land, *Pierre, or the Ambiguities* (1852), which is heavily influenced by Shakespeare (*Hamlet* and other plays), the protagonist shows a preference for dark, rather than bright, tell-tale pictures: in Bk. IV, 3–4, he cherishes the secret portrait drawn of (supposedly) his father, rather than the official, pompous, and highly visible portrait of him cherished by his mother.

Second deviation: in chapter 19 of *Middlemarch* (1872), in the Hall of Statues in the Vatican Museum a young woman — a breathing, blooming girl, clad in Quakerish gray drapery — seems not to react to, or indeed to see, a reclining statue of Ariadne-Cleopatra. Dorothea Brooke 'was not looking at the sculpture, probably not thinking at all: her large eyes were fixed dreamily on a streak of sunlight which fell across the floor'. Back in the Museum at the end of the chapter — after a 'meditative struggle' (as it will be called later) in her Via Sistina apartment, one that prefigures Isabel Archer's 'meditative vigil' in James's *The Portrait of a Lady* (1881, ch. 42) — Dorothea is seen 'in that brooding abstraction which made her pose remarkable. She did not really see the streak of sunlight on the floor more than she saw the statues; she was inwardly seeing the light of years to come in her own home and over the English fields.' This is the inward ray of perception of which James also wrote in 'The Art of Fiction', which takes precedence over the outward, and is often favoured by the confrontation with works of art.[5]

4 See *Journals* (Evanston and Chicago: The Northwestern-Newberry Edition, 1989); the lecture is rpt. in *The Piazza Tales* volume of the same edition. Melville had little to say of busts, even the Dying Gladiator (or Gaul), in the Hall of Emperors in the Capitol Museum (26 February 1857). Titian's *Assumption of the Virgin*, 'behind a coat of smoky grime' in the Frari church, had been hung in the bright light of the Academy Galleries when he saw it, and he noted that some observers complained that its colouring was too bright (ibid., p. 504).

5 For Dorothea, in Rome 'the past of a whole hemisphere seems moving in funeral', and she prefers the Campagna, 'where she could feel alone with earth and sky, away-from the oppressive masquerade of ages'. She is crushed by the Imperial and Papal city: 'Ruins and basilicas, palaces and colossi, set in the midst of the

Henry James reviewed Eliot's novel with interest, although he had reservations about her lack of aesthetic concern and the form of the work; but he seems to have remembered it well when writing of Isabel. Books of unequal merit have been written on James's innumerable personal and fictional visits to museums. I'll restrict myself to one crucial example, though a few preliminary points are in order.

Lewis Mumford maintained as early as 1926 that James treated Europe as a museum. The best example is in *The Wings of the Dove* (1902), where we have a crucial scene in the National Gallery, and a Shakespearean dark-light confrontation is enacted in Bk. IX, 2–4 — the sequence of a three-day change of weather: foul wind, coldness and livid air suddenly settling on the city during Milly Theale's crisis after a day of sunlight, and then the restoration of a deceptively fair, splendid weather.[6] 'Fair is foul, and foul is fair'. As for museums, properly speaking, James lived in a sort of museum all his life (as many have noted, Europe, British Society, and literary milieus became 'museum worlds' for him)[7] and was in and out of them as a matter of course day in and day out. But he went through at least four distinct and contradictory phases of appreciation.

sordid present, [...] the long vistas of white forms whose marble seemed to hold the monotonous light of an alien world: all this wreck of ambitious ideals, sensuous and spiritual [...] at first jarred her as with an electric shock', and then checked the flow of emotion. Later on, she would equate the overwhelming décor of St. Peter's to a sickness of the retina. Parallels with Isabel's experiences and realizations are stringent (e. g. 'the large vistas and wide fresh air [...] were replaced by anterooms and winding passages which seemed to lead nowither'), but Isabel finds a companionship of suffering, and a relief, in Rome's museums and in St. Peter's (ch. 49), as well as in the Campagna.

6 Lewis Mumford, *The Golden Day* (Boston: Beacon Press, 1957), p. 105. In *The Wings of the Dove*: 'The weather, from early morning, had turned to storm [...] It was a Venice all of evil that had broken out for them alike [...] a Venice of cold lashing rain from a low black sky, of wicked wind raging through the narrow passes, of general arrest and interruption ' (IX, 2). And yet, 'The weather changed, the stubborn storm yielded, and the autumn sunshine [...] came into his own again [...] Venice glowed and plashed and called and chimed again' (IX, 4). In *William Wetmore Story and his Friends* (1903) James admitted that the 'lingering *lurid*, in Venice, did more for the charm'.

7 Two of the best are Adeline R. Tintner, *The Museum World of Henry James* (Ann Arbor: Umi Research Press, 1986), and Viola Hopkins Winner, *Henry James and the Visual Arts* (Charlottesville: Virginia University Press, 1970). Recently, Jean Pavans, *Le musée intérieur de Henry James* (Paris: Seuil, 2016).

In his early days, he was against the hoarding of artworks in museums or galleries, which, as he saw it, wrenched them from their natural cultural contexts; even a badly-lit home was preferable to a gallery: 'the best fortune for good pictures is not to be crowded into public collections, — not even into the relative privacy of Salons Carrés and Tribunes, but to hang in largely spaced half-dozens in the walls of fine houses. Here the historical atmosphere, as one may call it, is almost a compensation for the often imperfect light.'[8]

When writing of museums for newspapers and travel books, in his essays for the *Atlantic Monthly* or his 'Letters' to *The Tribune*, he relished them as long as they were *European* museums — though often noting their dark and dim atmosphere (in the National Gallery itself, 'the pictures appear to as great an advantage as the London daylight allows').[9] Then, in *The American Scene* (1904), we have his famous (or infamous, as I consider it) blast against the new Metropolitan when it was moved to upper Fifth Avenue from 14th Street, which he saw and presented as the result and the embodiment of greed and monetary power. When finally he 'thematized' the question in his last novel *The Outcry* (1911, derived from an earlier play), the solution was exactly the opposite of his early view: pictures and artworks were saved, as long as they were given to and stored in the (London) National Gallery.

James was against the glare of exhibitions ('I like ambiguities and detest great glares' he wrote in *The Ambassadors*), and all for the rays of heavenly light that shone inside, in the inner consciousness of the individual. Yet he also manoeuvred his characters endlessly in and out of museums for discovery purposes. *The American* (1877) opens in the Salon Carré, and both the protagonist and the copyist, Noémie, are gently satirized for their preference for replicas; the museum itself is

8 Originally in *Transatlantic Sketches* (Boston: James R. Osgood & Co., 1875), p. 31, then in *English Hours*, now in *Collected Travel Writings. Great Britain and America* (New York: The Library of America, 1993), pp. 78–80, also quoted in V. Winner, *op.cit.*, p. 27, who rightly stresses the danger, in a museum world, of the estrangement of art from life: 'the portrait becomes a picture; the goddess or saint, a statue; the household object, an *objet d'art'*, *ibid.*, p. 128. This idea was also entertained by Paul Valéry in *Le problème des musées*, in *Pièces sur l'art* (Paris: Gallimard, 1934), pp. 115–23, quoted in Di Biasio, pp. 52–53, and by Lewis Mumford, for whom the museums were 'filled with the scraps of other cultures, the repository of an irrelevant and abstract conception of culture for our own day — quite divorced from history and common experience' (*The Golden Day*, cit., p. 108).

9 'The National Gallery' (1877), in *The Painter's Eye*, cit., p. 122

From Darkness to Light

slightly claustrophobic. Contrary to Dorothea Brooke, in *The Portrait of a Lady* Isabel finds that 'The blinds were partly closed in the windows of the Capitol, a clear, warm shadow rested on the figures [the Greek statues], and made them more mildly human'; their beauty is reflected in the floor — and the scene is altogether a pacifying experience (ch. 28). The glare and pomp of St. Peter's, where 'she paid her silent tribute to visible grandeur' (which was changed to 'the seated sublime' in the New York Edition), are set against, or mingle with, the darkness of her psychological insight.

In *The Ambassadors*, where a crucial scene is set in the Louvre, Strether 'might have been a student under the charm of a museum'; in *The Golden Bowl* (1904), Adam Verver's 'museum of museums [...] a receptacle of treasures sifted to positive sanctity' looms menacingly in a terrifying and largely improbable American City of the West — it is certainly worse than the Met. (But, just as the Capitol Museum and St. Peter's gave Isabel assurance in Rome, so in *The Golden Bowl*, in chapter thirty-three, the British Museum reassures Maggie about the worth of her husband the Prince: strange transnational quirks are at work here).

The most Shakespearean of James's scenes of light and darkness is set in a museum, in chapter twenty-five of the first volume of his unfinished autobiography, *A Small Boy and Others* (1913). From the vantage point of 1910, when he is presumably writing, he recalls an in-between experience, a terrible dream-visitation or nightmare he had experienced some decades before. He comes to this well-known episode from 'the rather bleak salles of the Ecole des Beaux-Arts'; now at the Louvre instead, he writes, 'I felt myself most happily cross that bridge over to Style constituted by the wondrous Galérie d'Apollon, drawn out for me as a long but assured initiation [...] a prodigious tube or tunnel through which I inhaled [...] a general sense of *glory* [...] not only beauty and art and supreme design, but history and fame and power'.

And he recalls how this 'splendid scene of things' had played 'a precious part' in his awakening from the 'most admirable nightmare of my life [...] the sudden pursuit, through an open door, along a huge high salon, of a just dimly-descried figure that retreated in terror before my rush and dash'.

After having been desperately frightened, he continues, 'I, in my appalled state, was probably still more appalling than the awful agent, creature or presence, whatever he was [...]. Routed, dismayed, the tables

turned upon him by my so surpassing him for straight aggression and dire intention, my visitant was already but a diminished spot in the long perspective, the tremendous, glorious hall' where he sped for *his* life, while a great storm of thunder and lightning played through the deep embrasures of high windows.[10]

Thus the scene of splendour and beauty the boy had so admired was to become 'the scene of that immense hallucination' — which transformed itself, however, into an experience of deliverance and affirmation, of life- and light-giving radiance. Darkness and fear are routed and dispersed in the wondrous Galérie d'Apollon, all light and glitter.

It seems to be the perfect reenactment of what the Master of Expression — as James called Shakespeare — had taught: the triumph of style and splendour over doom, and at the same time their coexistence, their verging on indissoluble correlation and unity. Glory is haunted by dark apparitions, it is reached through an experience of terror: 'there was alarm in it somehow as well as bliss'; 'the look of the rich light, the smell of the massively enclosed air' are renewed in James's mind without 'taking up the small scared consciousness'. With a final oxymoron, the Louvre remains, 'under a general description, the most peopled of all scenes not less than the most hushed of all temples.'[11]

We should rest here with him, in the hush among a crowd, in the bustle of a temple. But there is a final twist, an anti-climax or a let-down to subvert this loftiness of spirit. The main idea, the gist of the splendid and evocative scene just quoted, so personal, so expressive of James, so fit for my purpose, is in fact indebted to a less exalted source — Guy de Maupassant's *nouvelle Le Horla*, which James did not particularly like.[12] In the second version (1887) of this story in the form of a journal, the protagonist is haunted by a visitation, a ghost, a possible alter ego. On

10 The relevant pages in *A Small Boy and Others* (New York: Scribner, 1913), are pp. 346–51.

11 The relevant pages in *Autobiographies* (New York: The Library of America, 2016), pp. 208–11.

12 'Not a specimen in the author's best vein — the only occasion on which he has the weakness of imitation is when he strikes us as emulating Edgar Poe', James had written in his otherwise appreciative essay of 1888, 'Guy de Maupassant', now in *French Writers, Other European Writers, The Prefaces* (New York: The Library of America, 1984), p. 536.

waking up from a nap on 17 August he 'sees' the pages of a book left
open on a table turning by themselves, in front of his empty chair:

> D'un bond furieux, d'un bond de bête révoltée [...] je traversai ma
> chambre pour le saisir, pour l'étreindre, pour le tuer! [...] Mais mon
> siège, avant que je l'eusse atteint, se renversa comme si on êut fui
> devant moi [...] ma table oscilla, ma lampe tomba et s'éteignit, et ma
> fenêtre se ferma, comme si un malfaiteur surpris se fût élancé dans la
> nuit, en prenant à pleines mains les battant. // Donc, il s'était suavé; il
> avait eût peur, peur de moi, lui!

Exactly as in James (though he improves on it, stylistically and
otherwise). *Sic transit gloria mundi*? Is the glory of the Galérie d'Apollon
dissipated, and its brightness obfuscated by this source? It fits rather, I
believe, with the Shakespearean dichotomy with which we began: even
here, the inextricable tangle of light and darkness.

Coda

To restore some kind of balance, I find the (possible) violation of the
sacredness of art by its restoration to full light, and the fear and awe
inherent either in light or twilight, beautifully expressed by Fernando
Bandini, known for his poems in Italian, Veneto dialect and Latin, in
his *Caelum Sacelli Xystini* (1999, winner of the 'Certamen Vaticanum'
in 1996),[13] written after the epochal cleaning and restoration of the
Sistine Chapel in Rome. It opens with wonder and rejoicing at the new
brightness and light of the frescoes: 'inassueto stupeo splendere nitore /
tamquam sol infans irradiaret eas' (ll. 3–4), as on the first day of creation
(ll. 37–38). We see now the miracle that our fathers saw in the twilight
mode ('Quae tamen aspicimus nos nunc miracula, nostri / viderunt
crepera luce repressa patres', ll. 57–589). The secrets of the painter and of
humanity come to life and light (ll. 69ff.) now that they emerge from the
old colour ('vetere emergente colore', l. 83). One can hope that the wrath
of God be extinguished ('Ut demun extingui caeli desiderat iram!', l.
147). But a fear of impending doom, that light will be lost and darkness
prevail, resurfaces at the end: 'Huius sed nobis obscuro tempore saecli
/ nunc egressuri spes quoque lucis abest' (ll. 185–86). Only old prophets
can tell us of our future:"Tum corde ausculto nostrum si forte futurum
/ Ionas vel qaedam sacra Sibylla canat' (ll. 193–94).

13 Vicenza: Errepidueveneto, 1999; with facing Italian translations by the poet himself,
 which are equally beautiful.

26. The Museum on Stage: From Plato's Myth to Today's Perception

Alberto Pasetti Bombardella

The Platonic allegory of the myth of the cave is represented in an engraving by Jan Saenredam, made in 1604, two thousand years after the original concept was formulated and four hundred years before our time.[1] During this period the concept of light has evolved due to scientific and technical progress, but also as a result of the physiological evolution of the human brain in response to new environmental stimuli. According to the myth, prisoners are kept trapped in a single body position and they perceive their reality as limited by their condition.[2] They view the projection of shadows on a wall, which form the only reality they know and, therefore, the only possible truth. This myth represents symbolically the relationship between what is seen by the human eye and what could be seen if only one's perception was altered. If a prisoner could escape the wall behind him, he would discover the origin of the light and therefore a different truth.

In the field of lighting design, aspects such as positioning, visual angle, intensity and timing are physical factors developed to respond to technical and optical issues. These factors affect our perception of the visual scene, a process that requires a more complex conscious and unconscious elaboration. The historical evolution of evocative spaces, as

1 This engraving was shown during the exhibition 'Les Aventures de la verité' at the Maeght Foundation, November 2013, Saint Paul de Vence, France.

2 Plato, *The Republic* (Cambridge: Harvard University Press, 1935), pp. 119–234.

 https://doi.org/10.11647/OBP.0151.26

for a theatre stage, involves scenic designs — sometimes illusory — that invite an increased perceptive involvement from the viewer. The Greek theatre is our starting point and today's video mapping techniques, which can include lighting that ranges from traditional candle-light to digital light, is our destination. Today, neuroscientific research allows us to understand visual perception according to cognitive processes that could not even be imagined some time ago.[3]

From the Theatre to Neuroscience

Ever since classical Greek theatre, the stage has been a major contemplative focus, forming an archetype for visual perception that has been developed in the following centuries. More precisely, during the Renaissance, the Baroque years, neoclassicism and the beginning of the nineteenth century, the perception of theatrical space evolved with the invention of innovative stage machinery and lighting technology. The physical spatial relationship between spectators and actors on stage depended on the development of an optimal architectural design, which enhanced the immersive nature of the theatrical experience.[4]

Light as an artefact evolved from the incandescent light source. Some attempts were made in the post-Renaissance era to direct the radiation of light toward the stage and the scenery. Nicola Sabatini invented a mechanism that could reflect light onto the stage, using a specular surface modulating directionality and flux.[5] However the major steps towards the full control of lighting effects depended on the development of gas lighting first, and subsequently on electrical supply in the mid-nineteenth century. As a result, theatres became a field of never-ending experimentation and a place to develop innovative solutions and visual effects that were then adopted by architects and, later, by film directors.

3 Today, diagnostic techniques are made possible using 'brain imaging' which splits into structural imaging (cranial diseases) and functional imaging (metabolic diseases), using computerized tomography and nuclear magnetic resonance in order to enhance brain activity according to external stimuli.

4 Both sceneries and perspective on the stage represent a first virtual step toward spatial reproduction. Stagecraft represents a major technical evolution in which the spectator gets involved emotionally.

5 Luca Ruzza, *Nicola Sabbatini. Pratica di fabricar scene e macchinari ne' teatri* (Roma: Ed. Nuova Cultura, 2011).

In Renaissance painting, the two-dimensional representational technique common to medieval and Byzantine art fell out of use as perspective was introduced, involving the observer more deeply. From the second half of the sixteenth century, artists such as Caravaggio and his followers developed a new optical effect later known as the 'dark room' technique. Today, these visual solutions are scarcely explored by the scientific community on a neurological basis. Nevertheless, Semir Zeki[6] has studied the visual phenomenon from the inside, studying the ways in which the brain interprets the light signals coming from art works. He has stated that the relationship between subcortical visual functions and the brain is essential to create an image. What the human eye perceives depends on a complex interaction between the visual primary cortex and different sub-cortical areas that deal with specific aspects of vision (colour, morphology, movement). Brain processes function as a sophisticated computer that reacts to external stimuli by activating individual stored visual interpretations. Therefore, the brain takes part in the creation of an image, with the viewer as a co-author of the scene.

Towards a Museum on Stage

The design of an exhibition today depends mostly on the quality of its visual communication, which leads to new ways of viewing its cultural contents. In this respect exhibitions employ techniques that are closer to theatre lighting strategies, almost putting cultural heritage on a conceptual stage, enhancing the evocative potential of objects and artworks using accent lighting and luminance control. A new digital lighting system, guided by curators and historians, has a pervasive effect that allows the viewer to explore new interpretative paths and to reach new levels of perception, which were not even conceivable in the past. Light, in this respect, becomes a narrative tool improving the quality of visual perception. Thus, it is possible to conceive a general view of a sixteenth-century painting, such as Tintoretto's *Crucifixion*,[7] and

6 Semir Zeki, *Inner Vision: An Exploration of Art and the Brain* (Oxford: Oxford University Press, 1999).

7 *The Crucifixion* was painted by Jacopo Robusti, Tintoretto, in 1565 and represents the largest painting in the Scuola Grande di San Rocco (1224 x 536 cm), https://www.wikiart.org/en/tintoretto/crucifixion-1565

subsequently to emphasize details, enhancing the perception of colours and choosing the most appropriate colour temperature.[8] New lighting techniques may represent a new approach to the perception of art, but it is equally true that a guided interpretation is always a partial truth, just as the prisoners in the Platonic myth see only a version of reality. Therefore, the idea of the 'museum on stage' represents, nowadays, a big opportunity to enhance the fruition of cultural heritage, allowing new innovative paths for a deeper emotional experience. The dynamic lighting design solution at the Scuola Grande di San Rocco, developed for the extraordinary *Crucifixion*, represents a first attempt in this direction.

8 These interpretative choices should be made keeping in mind that the original lighting conditions are not replicable, because of the pigment fading due to the historical exposure.

27. Time and Light[1]

Antonio Foscari

We travelled at least two hours — crossing a stretch of the endless Russian plain enveloped in an opalescent luminosity — in order to arrive in Zagorsk, an important centre of spiritual life. On the way I wondered how much of the Byzantine architectural tradition the Orthodox Church had kept.

As we crossed over the threshold of the church, Barbara and I found ourselves surrounded by utter darkness; it erased from our minds whatever reference we might have had to the outside world. Each of us was immersed in an infinite solitude.

After a couple of steps I halted, unsure if I was about to trip over a step or bang against something. In such darkness one even becomes unsure about how to stand. I crossed my arms behind my back. After a few seconds the sturdy hands of a man I had neither heard nor seen obliged me to hold them straight down my sides. This assertion of order summoned a glimmer of consciousness to the surface. I then heard a song I had been unaware of until that moment (just as, at first, one does not hear the noise of a small stream when entering the woods). It was a virginal voice that flowed fluently behind me, both sweet and resigned. This voice and its hieratic cadence fascinated me. Almost with a sense of vertigo, I later learnt that what I was hearing was a fragment, an infinitesimal part of a song that had lasted without any interrruption for over five hundred years, that is, since the death

1 Transcribed by Micaela Dal Corso.

 https://doi.org/10.11647/OBP.0151.27

of the Venerable Sergei of Radonez, the founder of this monastery. Nothing has ever interrupted this song of an incommensurable length: not the alternating of days and nights, not pestilence or war, not the revolution that upended the political order of Russia in the last century, not Communism. Nothing. Therefore Barbara and I had not walked *out* of time, but *into* time, on entering this darkness. We had entered that time, that conception of time that had ruled the Byzantine civilization for more than a millennium. Byzantine time is nothing but a chain of instants that follow one another for ever, always identical one with the other. Perhaps it is the perception of a temporal dimension totally other than the one we live in nowadays, hurried and syncopated, that allowed me to perceive some tiny glowing points in the great darkness that enveloped me, almost materially.

At this time, I had never seen any of the works by the artist James Turell, so I had a surprised and suspended sense of what was happening to me. Slowly, with time — in this case, physiological time — my pupils started dilating in the primordial effort to penetrate the darkness. I started perceiving the physical nature — as it were — of those fragments of light. I saw that they swung slightly and vibrated as if they had a fleeting life of their own.

Those glowing lights, becoming tiny flames, formed something like a small constellation: a mysterious constellation, at a human height, which inspired a vague feeling of hope. After a while — after how long? — I perceived in front of me, above my head, something like a halo of light: a luminosity that was at first hardly perceptible, but slowly started to reveal its precious essence. It was a golden surface that reflected, very parsimoniously, the scant light of some tall, thin, brown candles, on which small flames swayed.

My eyes were captured by this luminosity. It was something I had never experienced before. I stood waiting with a feeling of hope. I could not possibly say how long this lasted. The mystery that had conquered all my senses had become, at this point, an unfathomable depth, that enigmatic penumbra at the center of the halo of golden light.

As if we had invoked it, as if our waiting had the quality of prayer, at the center of that halo, which became more and more luminous as the minutes went by, the face of Christ appeared. Something like a miracle had happened. This Man was not 'real' like those painted by artists,

with realistic physiognomic traits portraying a real individual man. The face of this Man was iconic: it was the same face that appeared — always identical — to all the worshippers in the Orthodox church who invoked his appearance in the darkness of their existence.

This was the reason for the darkness that had annulled my own identity when I had crossed over the threshold of this church, and made us feel infinitely alone, in spite of our being — Barbara and myself — close to each other. It had made the material substance of this sacred place disappear into the darkness, as well as its spatial form. It had reduced our notion of time to the sense, merely physiological, of pupils dilating. That darkness had allowed us, unsuspecting wayfarers, to live a mystical experience: to witness the miracle of an apparition.

On entering a church, the Orthodox worshipper separates himself from the contingent reality of the world, in order to approach — as much as he can — the dimension of the sacred (which remains for him unreachable, beyond the iconostasis, where the eucharist celebrations take place). Concentrating on prayer, on invoking the divine, he might see the figure he implores for mercy appear from darkness.

This experience should not have surprised Barbara and myself, two Venetians who are familiar with the glory of the chapel next to the Ducal Palace. Inside there is not only the limited surface of a rectangle covered with gold — with tesserae of gold mosaic — just like the background of a painting. The whole 'sky' is covered with gold: its arcades and vaults reflect gleams of light within which figures and stories, angels and saints on a golden background appear.

Why then were we caught unaware in the church of Zagorsk?

Because when we enter our beautiful palatine chapel, we are betrayed by what we already know. This knowledge reduces any feeling of expectation, when it does not forbid it entirely. But we are also betrayed by light: for centuries now, light has desecrated the ancient darkness of Byzantine origin. We are the victims, as it were, of those who, a few centuries ago — adopting the European Gothic style — opened onto the southern apse of the church transepts those immense rose windows that allow the sun to flood the chapel with light, especially during the midday hours.

In spite of this gross act of desecration, darkness has persisted in many other Venetian churches from the proto-Renaissance period. Not so much, I believe, out of respect for the teaching of Leon Battista Alberti,[2] who thought that too much light was incompatible with the sacredness of a holy place, but for a more intriguing historical reason. After the fall of Constantinople into the hands of Islamic forces in 1453, Venice wanted to show she was, in the west, the legitimate heir of the political authority and of the cultural riches of that 'second Rome' that Emperor Constantine had founded on the shores of the Bosphorus. Therefore a form of neo-Byzantinism inspired the architecture of the most significant Venetian churches for some time.

Let us think of the church dedicated to Saint John Chrysostom — not by accident a Greek saint — which has, again not by accident, a Greek-cross plan. Three supreme artists, among those active in Venice at the beginning of the sixteenth century, were called to confront this explicit proposition of neo-Byzantinism — a conceptual neo-Byzantinism. These artists did not avoid the problem of light, but they dealt with it, with great critical lucidity, or rather — as we are entering modernity — they dealt with the influence of light on the perception of an image.

On the main axis of the church, on the high altar, the figure of Saint John Chrysostom is represented with other figures in a small canvas. He is not in the centre of the composition. He is not in a frontal position. In fact, the shade of a canopy obscures him. Concentration is required — and therefore time is needed — to see this saint clearly: the great Sebastiano del Piombo has cleverly defined the duration required in order to have a clear perception.

After only a few decades, the ancient Venetians judged that this took too long. Therefore the shape of the chapel was altered. The vault that covered the space was eliminated in order to open six windows that were to throw as much light as possible from above onto Sebastiano's painting. As a result, the length of time needed for perception was shortened. Yet, today, to us, the children of electricity, it still seems too long.

But let us remain in this church. In order to realize how deeply felt and understood this concept was at the beginning of the sixteenth century, in addition to the knowledge of the 'time of perception', we should shift

2 Leon Battista Alberti (1404–72) was an Italian architect, poet, author, artist, priest, philosopher, linguist and cryptographer.

Fig. 27.1 Sebastiano del Piombo, *Saints John Chrysostom, John the Baptist, John the Evangelist, Theodore, Mary Magdalen, Lucy and Catherine,* San Giovanni Grisostomo, Venice, 1510-11. Wikimedia. Public domain, https://commons.wikimedia.org/wiki/File:Sebastiano_del_piombo,_pala_di_san_giovanni_crisostomo_01.jpg

focus from the main altar to the two altars set along the transversal axis of the church. They are installed in two chapels, topped by vaults, which take their light from two small, narrow, and high windows — almost two slits — opening in the small space. The works placed on the altars of these two chapels were conceived with the premise that they would only receive scant lighting, which would strike the pieces obliquely from these slits.

On these two altars, with these specific and limited sources of light, Tullio Lombardo and Gentile Bellini placed two masterpieces. They did so with equally refined but different conceptions which it is worth now considering.

Fig. 27.2 Tullio Lombardo, *Traditio Legis* (detail), San Giovanni Grisostomo, Venice, 1500-2. Photograph (cropped) by Didier Descouens, 13 September 2015. CC BY-SA 4.0, https://commons.wikimedia.org/wiki/File:San_Giovanni_Grisostomo_(interno)_-_pala_marmorea_di_Tullio_Lombardo.jpg

Tullio Lombardo (ca.1455–1532) — the greatest sculptor in Venice during this fascinating period — carved a scene in half-relief on a thick, white marble slab, portraying the *Traditio Legis*, where Christ appears with the twelve Apostles and the Virgin (in this case an allegory of Venice) kneeling in front of Him. The relief of these figures is limited. The perception of the consistency of the single figures, in their whiteness, is allowed only by the faint shadow they project onto the marble, thanks to the scant light that grazes them, entering from the side slits. For those who wish to capture the details, the refinement, and the accurate drawing of these figures — fourteen in number — crowding together, superimposed onto one another, almost amalgamating one with the other, Tullio asks for time — a modern person would say patience — time of a duration that Tullio cleverly regulates.

Bellini — the master of colour and shadow — does not follow Tullio, whose approach is based on the material quality of the white marble and on the perfection of form. Instead, he violates darkness; or more correctly, the concept of darkness. In the penumbra of the chapel where his beautiful *pala* is placed, he creates a fascinating landscape, made vivid by brilliant sunlight.

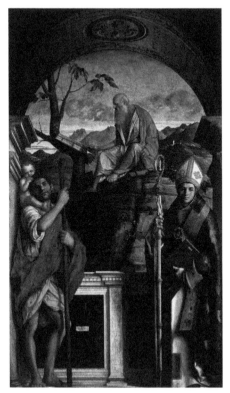

Fig. 27.3 Giovanni Bellini, *Saints Christopher, Jerome and Louise of Toulouse, San Giovanni Grisostomo*, Venice, 1513. Wikimedia. Public domain, https://commons.wikimedia.org/wiki/File:Bellini,_Sts_Christopher,_Jerome_and_Louis_of_Toulouse.jpg

The visitor of nowadays — our contemporary — does not have the patience to wait, so that his eyes and then his mind can apprehend the naturalistic luminosity of this virtual sky. He switches on a spotlight using a coin, to satisfy his impatience to see everything right away, without 'wasting time'.

To return to the Scuola Grande di San Rocco. In this magnificent upper hall of the Scuola, I cannot conclude my observations on the 'time of perception' without discussing the canvasses by Tintoretto. First, we will consider Andrea Palladio's architecture, primarily the Redentore church.

Palladio, in the church of the Redentore, has the light burst into the church — first the light of dawn and then the light of sunset — through

the great windows he has placed on the long walls of the nave. During the remainder of the day, light converges at floor level, beneath the dome, entering from the many windows he positioned on the walls of the exedrae on both sides of this central space. What enhances the luminosity of the church is the whiteness — according to Palladio the 'bianchezza' — of the walls and of all the architectural *ornaments*.

With a brightness of such intensity, with the distinct perception that such light allows, with the sharpness that every material, every form, every detail assumes, this church — built by Venice almost as a response to the outcome of the sixteenth-century Council of Trent — does not allow the worshipper, or anyone who frequents it, any form or experience of mysticism. It calls for a distinct perception of every single thing, and this stimulates that form of rational consciousness, that form of modernity, of which Palladio — in his own way — reverting to the lesson of the ancients, meant to be the prophet.

As a consequence of this 'lesson', from the beginning of the sixteenth century, darkness — that darkness that Leon Battista Alberti still defended, almost devotedly — lost all its conceptual significance and became an anachronistic mental category. It failed to resist the acceleration of history. There was no longer the time for perception that needed time. This irruption of sunlight bursting into space — of the same nature as the illumination Giovanni Bellini had introduced to the church of St John Chrysostom — was such a strong, one could say even revolutionary message, that after Palladio's Redentore had arrived in the cultural universe of Venice, changes were made in almost all the churches of the city to enhance the luminosity of the interiors (such as the alteration made in the main chapel of St John Chrysostom). However, although this development has never been adequately researched, I am not going to focus on it now.

Instead, I must mention Tintoretto at San Rocco as I close. It is obvious that Tintoretto was determined to avoid that form of modernity based on the unhampered victory of light. That is, Tintoretto does not believe it is natural light — from an imaginary sky, spreading out into space through large windows — that creates a true illumination in man. By making everything visible, light reduces the possibility of distinguishing the value of one thing or the other. Tintoretto's figures do not frequent the Palladian spaces; one could say they retreat from them.

They emerge from a darkness that has an almost material consistency. They are liberated from this darkness by Tintoretto himself. It is he who gives light with his own brush, it is he who makes the Light. It is Tintoretto who decides, in a peremptory way, the time necessary for the message he wants to communicate.

Bibliography

Abram, Sara (ed.), *La Crocifissione di Tintoretto* (Turin: Editoria, 2000, 2013).

Acidini Luchinat, C. (ed.), *I restauri nel Palazzo Medici Riccardi. Rinascimento e Barocco* (Cinisello Balsamo, Milan: Silvana, 1992).

Adam, William, *Description of Buxton, Chatsworth, and Castleton, in Gem of the Peak* (Derby: Henry Mozley & Sons, and W. & W. Pike, 1847), https://babel.hathitrust.org/cgi/pt?id=hvd.32044102827607

Adelson, Warren, William H. Gerdts, Elaine Kilmurray, Rosella Mamoli Zorzi, Richard Ormond and Elizabeth Oustinoff (eds.), *Sargent's Venice* (New Haven, CT and London: Yale University Press, 2006).

Adelswaerd-Fersen de, J., *Ébauches et Débauches* (Paris: Librairie Léon Vanier, 1901), https://gallica.bnf.fr/ark:/12148/bpt6k62133x

Afinoguénova, Eugenia, 'Art Education, Class, and Gender in a Foreign Art Gallery: Nineteenth-Century Cultural Travelers and the Prado Museum in Madrid', *Nineteenth-Century Contexts* 32 (2010), 47–63.

Allen, Harriet Trowbridge, *Travels in Europe and the East: During the Years 1858–59 and 1863–64* (New Haven, CT: Tuttle, Morehouse & Taylor, 1879), https://catalog.hathitrust.org/Record/005789635

Anderson, Isabel (ed.), *Larz Anderson: Letters and Journals of a Diplomat* (Whitefish, MT: Literary Licensing, LLC, 2011).

Andrikopoulos, Panos, 'Democratising Museums: A Brief History of Museum Lighting', Heritage Science Research Network, 6 June 2016, https://heritagescienceresearch.com/2016/06/06/democratising-museums/

Arata, Stephen D., 'Object Lessons: Reading the Museum in *The Golden Bowl*', in Alison Booth (ed.), *Famous Last Words: Changes in Gender and Narrative Closure* (Charlottesville, VA: University Press of Virginia, 1993), pp. 199–229.

Arregui, Juan P., 'Luminotecnia teatral en la primera mitad del siglo XIX: de la herencia barroca a la introducción del gas', *Stichomythia* 3 (2005), 1–49.

Aso, Noriko, *Public Properties*: *Museums in Imperial Japan* (Durham: Duke University Press, 2014).

Auchard, John (ed.), *Italian Hours* (University Park, PA.: The Pennsylvania State University Press, 1992).

Austen, Jane, *Pride and Prejudice* (London: Egerton, 1813), http://www.gutenberg.org/files/42671/42671-h/42671-h.htm

Avery, Kevin, *Church's Great Picture*: *The Heart of the Andes* (New York: Metropolitan Museum of Art, 1993).

Bachelor, A., *Traces of the Roman and the Moor* (New York: Lamport, Blakeman, & Law, 1897).

Baedeker, Karl, *Great Britain. Handbook for Travellers* (Leipzig: Karl Baedeker Publisher, 1890), https://archive.org/details/greatbritainhan07firgoog

Baker, Paul R., *The Fortunate Pilgrims: Americans in Italy. 1800–1860* (Cambridge, MA: Harvard University Press and Oxford University Press, 1964).

Bailey, Brigitte, 'Gender, Nation, and the Tourist Gaze', *American Literary History* 14.1 (2002), 60–82.

Baldin, Mario, *La illuminazione pubblica a Venezia. Il nuovo impianto* (Venice: Tipografia di S. Lazzaro, 1928).

Baldwin, Peter, *In the Watches of the Night*: *Life in the Nocturnal City, 1820–1930* (Chicago, IL: The University of Chicago University Press, 2015).

Barbantini, Nino, 'La mostra di Tintoretto: un grande successo', *La Gazzetta di Venezia*, 22 April 1937, R.S.7, n. 414, http://digitale.bnc.roma.sbn.it/tecadigitale/giornale/CFI0391298/1937/aprile?paginateDetail_pageNum=10

Barber, Julia Langdon, *Mediterranean Mosaics; or, The cruise of the Yacht Sapphire, 1893–1894* (New York: privately printed, [1895]), https://catalog.hathitrust.org/Record/005777331

Barberis, M. *et al.* (eds.), *Mariano Fortuny* (Venice: Marsilio, 1999).

Barker, Shirley, 'The Female Artist in the Public Eye: Women Copyists in the Uffizi, 1770–1859', in T. Balducci and H. Belnap Jensen (eds.), *Femininity and Public Space in European Visual Culture, 1789–1914* (London: Routledge, 2014), pp. 65–77.

Baxley, Henry Willis, *Spain. Art-remains and Art-realities, painters, priests, and princes. Being notes of things seen, and of opinions formed, during nearly three years' residence and travels in that country*, 2 vols. (New York: Appleton, 1875), https://catalog.hathitrust.org/Record/100484144

Beaufort, C. de (Comtesse de la Grandville), *Souvenirs de voyage, ou, Lettres d'une voyageuse malade*, 2 vols. (Paris: Ad. Le Clère, 1836), https://gallica.bnf.fr/ark:/12148/bpt6k1027332

Belin, Jules Leonard, *Le Simplon et L'Italie septentrionale*: *promenades et pélerinages*, 2nd ed. (Paris: Belin-Leprieur, 1843), https://gallica.bnf.fr/ark:/12148/bpt6k106444z

Bell, Ian F. A., *Henry James*: *Fiction as History* (Lanham, MD: Rowman & Littlefield, 1985).

Beltran, Alain and Patrice A. Carré, *La fée et la servante*: *La societé française face a l'électricité* (Paris: Éditions Belin, 1991).

Bercovitch, Sacvan, *The Rites of Assent* (London and New York: Routledge Press, 1993).

Black's Tourist Guide to Derbyshire: *its towns, watering places, dales and mansions, with map of the county, plan of Chatsworth and Haddon Hall* (Edinburgh: Black, 1868), https://catalog.hathitrust.org/Record/009789947

Blaugrund, Annette, 'The Tenth Street Studio Building: A Roster', *The American Art Journal* 14 (Spring 1982), 64–71.

Bolzan, Loredana, 'Una lunga (in)fedeltà. Vite veneziane e non di Henri e Marie de Régnier', in *Personaggi stravaganti a Venezia* (Crocetta del Montello: Antiga, 2010).

Boni, G., *Venezia imbellettata* (Rome: Stabilimento Tipografico Italiano, 1887).

Boone, Elizabeth, *Vistas de España. American Views of Life and Art in Spain, 1860–1914* (New Haven, CT: Yale University Press, 2007).

Bortolan, Gino (ed.), *Il Patriarcato di Venezia 1974* (Venice: Tipo-Litografia Armena, 1974).

Boschini, Marco, *La carta del navegar pittoresco* (Venice: Baba, 1660), https://digi.ub.uni-heidelberg.de/diglit/boschini1660/0295

Boschini, Marco, *La carta del navegar pittoresco*, critical edition by Anna Pallucchini (Venice and Rome: Istituto per la collaborazione culturale, 1966).

Bourdieu, Pierre, *The Field of Cultural Production* (New York: Columbia University Press, 1986).

Bradley, Carol, 'Copisti Americani nelle Gallerie Fiorentine', in M. Bossi and L. Tonini (eds.), *L'Idea di Firenze*: *Temi e interpretazioni dell'arte straniera dell'Ottocento* (Florence: Centro Di, 1989), pp. 61–67.

Brewer, Cecil, 'American Museum Buildings', *Journal of the Royal Institute of British Architects*, 3rd series, 20 April 1913, 306–403.

Brewster, Anne, 'A Landmark in Rome,' undated journal clipping, Anne Hampton Brewster Manuscript Collection, Historical Society of Pennsylvania.

Brewster, Anne, *St. Martin's Summer* (Boston, MA: Ticknor & Fields, 1866), https://catalog.hathitrust.org/Record/008658127

Brewster, Anne, 'Letter from Rome,' *Philadelphia Evening Bulletin*, 28 June 1869.

Brewster, Anne, 'Correspondence. Letter from Rome. The Last Days of the Carnival,' *Philadelphia Evening Bulletin*, 24 February 1871.

Brewster, Anne, 'New Treasures Brought to Light at Pompeii,' *Boston Daily Advertiser*, recorded on 7 August 1875; published on 21 August 1875.

Brewster, Anne, 'The Old Monuments — A Remarkable Etruscan Statue — Memorials of an Ancient Lady — Interesting Speculations,' *Boston Daily Advertiser*, 1 January 1878.

Brewster, Anne, 'Italian Notes,' *Philadelphia Daily Evening Telegraph*, 17 January 1881, p. 8.

Brewster, Anne, *Journal of Anne Hampton Brewster*, 4 November 1868–1892, Box 4, folder 2, Anne Hampton Brewster Manuscript Collection, The Library Company of Philadelphia.

Bridgeland, Judith I, 'Salvator Rosa's "Landscape with Jacob's Dream"', 18 July 2012, http://jibridgland.blogspot.co.uk/2012/07/salvator-rosas-landscape-with-jacobs.html

Brieu-Galaup, Florence, *Venise, un refuge romantique (1830–48)* (Paris: L'Harmattan, 2007).

Brigham, Gertrude Richardson, 'Freer Collection Viewed in Private', *Washington Post*, 2 May 1923.

Brooks, Van Wyck, *The Dream of Arcadia: American Writers and Artists in Italy, 1760–1915* (London: Dent, 1959).

Brooks, Van Wyck, *Fenollosa and His Circle* (New York: Dutton, 1962).

Brusegan, Marcello, *Catalogo dei manoscritti del Fondo Mariutti Fortuny* (Venice: Biblioteca Nazionale Marciana, 1997).

Bryant, William Cullen, *Letters of a Traveller* (New York: Appleton, 1859).

Burbitt, Elihu, *A Walk from London to John O'Groats with Notes by the Way*, 2nd ed. (London: Sampson Low, Son, & Marston, 1864), https://archive.org/stream/walkfromlondonto00burr#page/n11/mode/thumb

Burbitt, Elihu, *The Works of the Reverend Orville Dewey D. D.* (London: Simms and McIntyre, 1844), https://archive.org/details/worksoforvillede00dewe

Butor, Michel, 'Voyage et récriture', *Romantisme* 4 (1972), 4–19.

Carbon, Claus C. and Pia Deininger, 'Golden Perception', *i-PERCEPTION* 4.6 (2013), 468–76.

Chagnon-Burke, Véronique, 'Rue Laffitte: Looking at and Buying Contemporary Art in Mid-Nineteenth Century Paris', *Nineteenth Century Art Worldwide* 11.2 (2012), 31–54 http://www.19thc-artworldwide.org/summer12/veronique-chagnon-burke-looking-at-and-buying-contemporary-art-in-mid-nineteenth-century-paris

Chamberlain, Joshua Lawrence, John De Witt and John Howard Van Amringe, *Universities and Their Sons: History, Influence, and Characteristics of American Universities* (Boston, MA: R. Herndon Co., 1898).

Chatsworth House Trust, *Your Guide to Chatsworth* (Leicester: Streamline Press Ltd., 2011).

Chiari Moretto Wiel, Maria Agnese, 'L'Annunciazione di Tiziano nella Scuola Grande di San Rocco. Appunti', in *Scuola Grande Arciconfraternita di San Rocco, Notiziario* 37 (May 2017), 50–57.

Church, John A., 'Scientific Miscellany: A New Electric Light', *The Galaxy. A Magazine of Entertaining Reading* 30.3 (1875), 415–16, https://babel.hathitrust. org/cgi/pt?id=pst.000066654551;view=1up;seq=425

Ciotti, A., 'Curiosando sulla Scuola Grande Arciconfraternita di San Rocco', *Quaderni della Scuola Grande di San Rocco* 7 (2001).

Clegg, Jeanne, *Ruskin and Venice* (London: Junction Books, 1981).

Clegg, Jeanne and Paul Tucker (eds.), *The Dominion of Daedalus* (St. Albans, UK: Brenthan Press, 1994).

Cole, Alphaeus P. and Margaret W. Cole, *Timothy Cole Wood Engraver* (Dublin, New Hampshire, NH: William L. Bauhan Publisher, 1935).

Cole, Thomas, *Salvator Rosa Painting Banditti* (Boston, MA: Museum of Fine Arts, 1832–40).

Cole, Timothy and W. J. Stillman, *Old Italian Masters Engraved by Timothy Cole with Historical Notes by W. J. Stillman and Brief Comments by the Engraver* (New York: The Century Co., 1892), https://babel.hathitrust.org/cgi/ pt?id=nyp.33433071001907

Coleman Sellers, Charles, *Charles Willson Peale* (New York: W. W. Norton & Co., 1969).

Coleman Sellers, Charles, *Mr. Peale's Museum, Charles Willson Peale and the First Popular Museum of Natural Science and Art* (New York: W.W. Norton & Co., 1980).

Comment, Bernard, *The Panorama* (London: Reaktion Books, 1999).

Conlin, Jonathan, *The Nation's Mantelpiece: A History of the National Gallery* (London: Pallas Athene, 2006).

Conn, Steven, 'Where Is the East: Asian Objects in American Museums, from Nathan Dunn to Charles Freer', *Winterthur Portfolio* 35 (2000), 168–73.

Cook, Joel, *England Picturesque and Descriptive. A Reminiscence of Foreign Travel* (Philadelphia: Porter and Coates 1882), https://archive.org/details/ englandpicturesq00cook

Cooper, James Fenimore, *Excursions in Italy* (London: Bentley, 1838), https:// archive.org/details/excursionsinita00coopgoog/page/n11

Cooper, James Fenimore, *Gleanings in Europe*, 2 vols. (Philadelphia: Carey, 1838), https://archive.org/details/gleaningsineuro01coopgoog/page/n10

Coronato, Rocco, *Shakespeare, Caravaggio, and the Indistinct Regard* (Milton: Taylor & Francis, 2017).

Cortissoz, Royal, 'The Freer Gallery', *New York Tribune*, 6 May 1923.

Cortissoz, Royal, 'The New Freer Gallery as a Test of Taste', *Literary Digest*, 2 June 1923.

Cunha Resende, Aimara de, *Journey Through Light and Darkness: A Study of Duplication in Shakespeare*, Master's thesis, Universidade federal de Minas Gerais, 1983.

Cushing, Caroline, *Letters Descriptive of Public Monuments, Scenery and Manners in France and Spain*, 2 vols. (Newburyport, MA: Allen, 1832).

Dall'Acqua Giusti, Antonio, *L'Accademia e la Galleria di Venezia. Due relazioni storiche per l'esposizione di Vienna del 1873* (Venice: Visentini, 1873), https://archive.org/stream/bub_gb_JjSJQXH4J6kC/bub_gb_JjSJQXH4J6kC_djvu.txt

Davanzo Poli, Doretta, *Seta e oro. La collezione tessile di Mariano Fortuny* (Venice: Cassa di Risparmio-Biblioteca Nazionale Marciana, 1997–98).

De Benedictis, Cristina, et al., *La Palazzina dei Servi a Firenze* (Firenze: Edifir, 2014).

De Biasio, Anna, *Romanzi e musei* (Venezia: Istituto Veneto di Scienze, Lettere ed Arti, 2006).

De Luxán García de Diego, Margarita, 'Restauración de la iluminación natural', *Informes de la construcción* 40 (1989), 37–41.

De Mille, J. B., *The Dodge Club or Italy in 1859* (Philadelphia, PA: published for private circulation, 1869), https://catalog.hathitrust.org/Record/000285095

'Death of Albert Bierstadt, Landscape-Painter', *The American Architect and Building News* 75 (1902), [n.p.].

Dickens, Charles, *The Uncommercial Traveller* (New York: Charles Scribner's Sons, 1905), https://www.gutenberg.org/files/914/914-h/914-h.htm

Dorey, Helen, 'Exquisite Hues and Magical Effects', in Sandra Coley (ed.), '*The Stained Glass Collection of Sir John Soane's Museum.*' *The Journal of Stained Glass*, special number 27 (2004).

Downes, William Howe, *Spanish Ways and By-Ways, with a glimpse of the Pyrenees* (Boston, MA: Cupples, 1883), https://catalog.hathitrust.org/Record/006571923

Druzik, James and Bent Eshoj, 'Museum Lighting: Its Past and Future Development', in T. Padfield and K. Borchersen (eds.), *Museum Microclimates, Contributions to the Conference in Copenhagen, 19–23 November 2007* (Copenhagen: National Museum of Denmark, 2007), pp. 51–56, http://www.conservationphysics.org/mm/musmic/musmic150.pdf

Dyson, Stephen, *The Last Amateur: The Life of William J. Stillman* (Albany, NY: State University of New York Press, 2014).

'Electric Lighting at Chatsworth', *Sheffield and Rotherham Independent*, 9 December 1893, 174–75.

'Electric Lighting in Boston', *Electrical World and Engineer*, 19 September 1903. Reprinted in *General Electric Company Review*, 1 November 1903.

Ellison, Ralph, 'The Novel as a Function of American Democracy', in his *Going to the Territory* (New York: Random House, 1986), pp. 308–20.

Emerson, Ralph Waldo, *Essays. First Series* (Boston, MA: Houghton, Mifflin, 1876), https://catalog.hathitrust.org/Record/009775811

Emerson, Ralph Waldo, *The Letters of R. W. Emerson*, R. L. Rusk (ed.), 6 vols. (New York: Columbia University Press, 1939).

Ernest, Philippe, Marquis de Beauffort, *Souvenirs d'Italie, par un catholique* (Paris: Société des beaux-arts, 1839), https://archive.org/details/bub_gb_JrR_tOTeLnYC

Evans, Augusta Jane, *St. Elmo: A Novel* (New York: Carleton, 1867), https://catalog.hathitrust.org/Record/012192452

Fenollosa, Ernest, *Epochs of Chinese and Japanese Art*, 2 vols. (New York: Dover, 1963).

Field, Kate, *Ten Days in Spain* (Boston, MA: Osgood, 1875), https://archive.org/details/tendaysinspain00fielgoog/page/n14

Filippin, Sara, 'Fotografie e fotografia nella storia dell'Accademia di Belle Arti di Venezia, 1850–1950', in Nico Stringa (ed.), *L'Accademia di Belle Arti di Venezia, l'Ottocento*, 2 vols. (Crocetta del Montello, TV: Antiga edizioni, 2016), I, pp. 233–69.

Fresa, Franca Marina, 'Monumenti di carta, monumenti di pietra', in G. Romanelli (ed.), *Palazzo Ducale. Storia e restauri* (Verona: San Giovanni Lupatoto, 2004), pp. 205–22.

Fuller, Margaret Ossoli, *At Home and Abroad or Things and Thoughts in America and Europe*, Arthur B. Fuller (ed.) (Boston, MA: Brown, Taggard and Chase, 1860; 2nd ed. New York: The Tribune Association, 1869, https://babel.hathitrust.org/cgi/pt?id=miun.abx8370.0001.001

Fulton, Charles C., *Europe Through American Spectacles* (Philadelphia: J. B. Lippincott, 1874).

Fuso, Silvio and Alessandro Mescola (eds.), *Immagini e materiali del laboratorio Fortuny* (Venice: Marsilio, 1978).

'Gas at Chatsworth', *Sheffield and Rotherham Independent*, 29 November 1861.

Gautier, Théophile, *Italia*, 2nd ed. (Paris: Hachette, 1855).

Gilman, Benjamin Ives, *Museum Ideals of Purpose and Method* (Cambridge, MA: Harvard University Press, 1923; 1st ed. Cambridge: Printed by order of the trustees of the Museum at the Riverside Press, 1918, https://archive.org/details/museumidealspur00bostgoog).

Goldstein, Malcolm, *Landscape with Figures: A History of Art Dealing in the United States* (New York: Oxford University Press, 2000).

Goncourt, E. et J. de, 'Venise la nuit. Rêve', in *L'Italie d'hier, Notes de voyages, 1855–1856* (Paris: G. Charpentier et E. Fasquelle, 1894), https://archive.org/details/litaliedhiernote00gonc

Gotti, Aurelio, *Le Gallerie di Firenze. Relazione al Ministero della Pubblica Istruzione in Italia* (Florence: Celini alla Galileiana, 1872).

Haacke, Hans, 'Museums: Managers of Consciousness', in Matthias Flügge and Robert Fleck (eds.), *Hans Haacke: For Real: Works 1959–2006* (Düsseldorf: Richter, 2006), pp. 271–81.

Hale, Edward Everett, *Seven Spanish Cities* (Boston, MA: Little, Brown, 1883).

Hamilton, James, *London Lights: The Minds that Moved the City that Shook the World, 1805–51* (London: John Murray, 2007).

Hammer, William, 'Notes on Building, Starting and Early Operating of the First Central Station in the World, Holborn Viaduct, London, England.' Private Memorandum book, Hammer Papers, Box 20, folder 1, Smithsonian Institution Archives.

Hannah, Daniel, 'James, Impressionism, and Publicity', *Rocky Mountain Review of Language and Literature* 61.2 (2007), 28–43.

Harrison, James Albert, *Spain in Profile: a summer among the olives and aloes* (Boston, MA: Houghton, Osgood, 1879), https://catalog.hathitrust.org/Record/009790082

Hartridge, Gustavus, 'The Electric Light and its Effects Upon the Eyes', *The British Medical Journal* 1.1625 (20 February 1892), 382–83, https://www.jstor.org/stable/20245251?seq=1#metadata_info_tab_contents

Havard, H., *Amsterdam et Venise* (Paris : E. Plon et Cie, 1877), https://books.google.co.zm/books?id=OOLy19mudyEC&printsec=frontcover&source

Hawthorne, Nathaniel, *Passages from the French and Italian Notebooks*, ed. by Sophia Peabody Hawthorne (Boston, MA: Houghton, Mifflin, 1871; London, Strahan & Co., 1871 ed. available at, https://catalog.hathitrust.org/Record/009834365)

Hawthorne, Nathaniel, *The Marble Faun, or the Romance of Monte Beni* (Boston, MA: Ticknor and Fields, 1860), https://catalog.hathitrust.org/Record/001027404

Hawthorne, Sophia Peabody, *Notes on England and Italy* (New York: Putnam, 1869), https://archive.org/details/notesinenglandit00hawt/page/n8

Hay, John, *Castilian Days* (Boston, MA: Osgood, 1871), https://catalog.hathitrust.org/Record/011564563

Hazlitt, William, 'On Going a Journey', in *Table-Talk, or, Original Essays* (New York: Chelsea House, 1983), pp. 249–61.

Henderson, Helen W., 'The Freer Collection', in *The Art Treasures of Washington* (Boston, MA: L. C. Page and Co., 1913), pp. 229–51, https://archive.org/stream/cu31924020704619#page/n359/mode/2up

Hewison, Robert, *Ruskin on Venice* (New Haven: Yale University Press, 2009).

Higgonet, Anne, 'Museum Sight', in Andrew McClellan (ed.), *Art and its Publics: Museum Studies at the Millennium* (Oxford: Blackwell Publishing, 2003), pp. 133–48.

Hillard, George Stillman, *Six Months in Italy*, 2 vols. (Boston, MA: James R. Osgood, 1853).

Hochman, Michel, Rosella Lauber, and Stefania Mason (eds.), *Collezionismo d'arte a Venezia. Dalle origini al Cinquecento* (Venezia: Marsilio, 2008).

Homer, Winslow, 'Art Students and Copyists in the Gallery of the Louvre', *Harper's Weekly*, 11 January 1868.

Howard, Hugh, *The Painter's Chair. George Washington and the Making of American Art* (New York: Bloomsbury Press, 2009).

Howat, John K., *Frederic Church* (New Haven, CT and London: Yale University Press, 2005).

'Inauguration Ball. The Largest and Most Brilliant Ever Had', *Washington Evening Star* 57.8, 5 March 1881, https://chroniclingamerica.loc.gov/lccn/sn83045462/1881-03-05/ed-1/seq-1/

Inwood, Stephen, *City of Cities: The Birth of Modern London* (London: Macmillan, 2005).

Isabella Stewart Gardner Museum, Inc., Boston, *Annual Report* (Portland: Southworth-Anthoensen Press, 1925).

James, Henry, *A Little Tour in France* (Oxford: Oxford University Press, 1984).

James, Henry, *A Small Boy and Others* (New York: Scribner's, 1913), https://catalog.hathitrust.org/Record/000481811

James, Henry, *A Passionate Pilgrim and Other Tales* (Boston, MA: James E. Osgood & Co, 1875), https://archive.org/details/passionatepilgri00jameiala

James, Henry, *Autobiography* (New York: Library of America, 1984).

James, Henry, *Collected Travel Writings* (New York: Library of America, 1993).

James, Henry, *Complete Letters of Henry James 1855–1872*, 2 vols. Pierre A. Walker and Greg W. Zacharias (eds.) (Lincoln: University of Nebraska Press, 2006).

James, Henry, *Complete Stories 1864–1874* (New York: The Library of America, 1999).

James, Henry, *Complete Stories 1892–1898* (New York: The Library of America, 1996).

James, Henry, *Complete Stories 1898–1910* (New York: The Library of America, 1996).

James, Henry, *Italian Hours* (London: Heinemann, 1909), https://catalog. hathitrust.org/Record/001027550

James, Henry, *Literary Criticism French Writers; Other European Writers; The Prefaces to the New York Edition* (New York: The Library of America, 1984).

James, Henry, *The Ambassadors* (New York: Penguin, 1986).

James, Henry, *The American* (New York: Signet, 1963).

James, Henry, *The Art of Travel*, ed. by Morton Dauwen Zabel (Garden City: Doubleday Anchor, 1958).

James, Henry, *The Wings of the Dove* (Baltimore: Penguin, 1976).

James, Henry, 'Traveling Companions', *The Atlantic Monthly* 26 (1870), 600–14, https://en.wikisource.org/wiki/Travelling_Companions_(New_York:_Boni_ and_Liveright,_1919)

James, P. D., *Death Comes to Pemberley* (New York: Alfred A. Knopf, 2011).

Jameson, Anna Brownell, *Diary of an Ennuyée* (Boston, MA: Lilly, Wait, Colman and Holden, 1833; 1826 ed. available at https://archive.org/details/ diaryanennuyeby00jamegoog)

Jarves, Deming, *Reminiscences of Glass-Making* (Boston, MA: Eastburn's Press, 1854), http://www.gutenberg.org/ebooks/44284

Jarves, James Jackson, *Art Studies: The 'Old Masters' of Italy* (New York: Derby and Jackson, 1861), https://archive.org/details/artstudiesoldma03jarvgoog

Jarves, James Jackson, *Italian Sights and Papal Principles Seen Through American Spectacles* (New York: Harper and Brothers, 1856), https://archive.org/ details/italiansightsan03jarvgoog

Jarves, James Jackson, *Letters Relating to a Collection of Pictures Made by Mr. J. J. Jarves* (Cambridge, MA: H. O. Houghton & Co., 1859), https://archive.org/details/lettersrelating00jarvgoog; https://babel.hathitrust.org/cgi/pt?id=hvd.32044108139858

Jarves, James Jackson, *The Art-Idea: Sculpture, Painting, and Architecture in America* (New York: Hurd and Houghton, 1865), https://catalog.hathitrust. org/Record/011535205

Jewitt, Llewellynn (ed.), *Black's Tourist's Guide to Derbyshire: Its Towns, Watering Places, Dales and Mansions, With Map of the County, Plan of Chatsworth and*

Haddon Hall (Edinburgh: A. and C. Black, 1868), http://babel.hathitrust.org/cgi/pt?id=uva.x000698551

Johnson, Kendall, *Henry James and the Visual* (Cambridge: Cambridge University Press, 2007).

Jones, Franklin D., *Engineering Encyclopedia: A Condensed Encyclopedia and Mechanical Dictionary for Engineers, Mechanics, Technical Schools, Industrial Plants, and Public Libraries, Giving the Most Essential Facts about 4500 Important Engineering Subjects*, 3rd ed. (New York: The Industrial Press, 1941).

Kagan, Richard L., 'Yankees in the Prado. A Historiographical Overview', *Boletín del Museo del Prado* 25 (2007), 32–45.

Kaplan, Fred, *Henry James: The Imagination of Genius, a Biography* (Baltimore, MD: Johns Hopkins University Press, 1999).

King, Edward Smith, *Europe in Storm and Calm* (Springfield, MA: Nichols, 1885).

Kirkland, Caroline M., *Holidays Abroad, or Europe from the West*, 2 vols. (New York: Baker and Scribner's, 1849), https://catalog.hathitrust.org/Record/008617292

Knox, Page S., 'Scribner's Monthly 1870–1881: Illustrating a New American Art World', unpublished doctoral dissertation, Columbia University, 2012, http://academiccommons.columbia.edu/item/ac:146372

Kummerow, Burton K. and Mary K. Blair, *BGE at 200 Years, Moving Smart Energy Forward, A History* (Baltimore, ME: Maryland Historical Society Press, 2016).

Lanzi, Luigi Antonio, *La Real Galleria di Firenze accresciuta e riordinata* (Florence: Comune di Firenze, 1782), http://www.memofonte.it/home/files/pdf/lanzi_realgalleria.pdf

Lapucci, Roberta, *Caravaggio e l'ottica* (Florence: Il Prato, 2010).

Larrabee, Denise M., *Anne Hampton Brewster: 19th-Century Author and 'Social Outlaw'* (Philadelphia, PA: The Library Company of Philadelphia, 1992).

Le Vert, Octavia Walton, *Souvenirs of Travel*, 2 vols. (Mobile: Goetzel & Co., 1857), https://catalog.hathitrust.org/Record/006523310

Lecomte, Jules, *Venise ou coup-d'oeil littéraire, artistique, historique, poétique et pittoresque* (Paris: Hippolyte Souverain, 1844), https://gallica.bnf.fr/ark:/12148/bpt6k106360t

Lees-Milne, James, *The Bachelor Duke. A Life of William Spencer Cavendish 6th Duke of Devonshire 1790–1858* (London: John Murray, 1991).

Lepschy, Anna Laura, *Davanti a Tintoretto, una storia del gusto attraverso i secoli* (Venice: Marsilio, 1998).

Levi, Donata, 'Ruskin's Gates: dentro e fuori il museo', in Roberto Balzani (ed.), *Collezioni, museo, identità fra XVIII e XIX secolo* (Bologna: il Mulino, 2006), pp. 68–105.

Lomazzo, Giovanni Paolo, *Rime* (Milan: Paolo Gottardo Pontio stampatore, 1587), https://archive.org/details/rimedigiopaololo00loma

Mackenzie, Alexander Slidell, *Spain Revisited*, 2 vols. (New York: Harper Brothers, 1836).

Maino, Marzia, *L'esperienza teatrale di Mariano Fortuny* (Padua: Bolzoni Editore, 2017).

Malan, Alfred Henry, 'Chatsworth', *The Pall Mall Magazine* 11.46 (1897), 169–83.

Mamoli Zorzi, Rosella, 'Dal buio alla luce: La Scuola Grande di San Rocco da Ruskin e James a Fortuny', *Notiziario della Scuola Grande Arciconfraternita di San Rocco* 32 (2014), 49–73.

Mamoli Zorzi, Rosella, *In Venice and in the Veneto with Henry James* (Venice: Supernova, 2005).

Mamoli Zorzi, Rosella, 'Tintoretto e gli americani nell'Ottocento', *Annali di Ca'Foscari* 35 (1996), 189–224.

Manthorne, Katherine, *Tropical Renaissance. North American Artists Exploring Latin America, 1839–1879* (Washington, D.C.: Smithsonian Institution Press, 1989).

Mariutti de Sanchez Rivero, Angela, *Quattro spagnoli in Venezia* (Venice: Ongania, 1957).

Mariuz, Adriano, *L'adorazione dei pastori di Tintoretto. Una stravagante invenzione* (Verona: Scripta edizioni, 2010).

Mark Twain's Letters (Berkeley, CA: University of California Press, 1988).

Marks, Arthur S., 'Angelica Kauffmann and Some Americans on the Grand Tour,' *The American Art Journal* 12.2 (1980), 4–24.

Marshall, Louise, 'A Plague Saint for Venice: Tintoretto at the Chiesa di San Rocco', in *Artibus et Historiae* 66 (2012), 153–87.

Mason, Stefania and Linda Borean (eds.), *Collezionismo d'arte a Venezia. Il Seicento* (Venice: Marsilio, 2007).

Mason, Stefania and Linda Borean (eds.), *Collezionismo d'arte a Venezia. Il Settecento* (Venice: Marsilio, 2009).

Mason Rinaldi, Stefania, 'La peste e le sue immagini nella cultura figurativa veneziana', in *Venezia e la Peste. 1348–1797* [exhibition catalogue] (Venice: Marsilio Editori, 1979), pp. 209–24.

Matheson, Susan B. and Victoria J. Solan, 'Street Hall: The Yale School of the Fine Arts', *Yale University Art Gallery Bulletin* (2000), 46–67.

Mattosi, Claudia, 'The Torchlight Visit', *RES 49* (Spring-Autumn 2006).

Maupassant, Guy de, *La vie errante* (Paris: P. Ollendorff, 1890), https://gallica.bnf.fr/ark:/12148/bpt6k104914x

Mazza M., *Galleria degli Uffizi 1758–1775: la politica museale di Raimondo Cocchi* (Modena: Panini, 1999).

Mazza M., Fileti and Tomasello B., *Antonio Cocchi, primo antiquario della Galleria fiorentina: 1738–1758* (Modena: Panini, 1996).

Mazzucco, Melania G., *Jacomo Tintoretto & i suoi figli* (Milan: Rizzoli, 2009).

Melville, Herman, *Journals* (Evanston and Chicago, IL: Northwestern Newberry Edition, 1989).

Melville, Herman, *Moby Dick: or the Whale* (Evanston: Northwestern University Press, 2001).

Merimée, Prosper, 'Les grands maîtres du Musée de Madrid', *L'Artiste* 1 (March 1831), 73–75.

Merrill, Linda, 'The Washington Building', in *Freer: A Legacy of Art* (Washington, D.C.: Freer Gallery of Art, 1993), pp. 235–53.

Meyer, Annie Nathan, 'Charles L. Freer, Art Collector', *New York Evening Post*, 29 September 1919.

Michi, Nomura, *Sekai isshū nikki* (Tokyo: privately published, 1908).

Miller, Angela, *The Empire of the Eye: Landscape Representations and American Cultural Politics, 1825–1875* (Ithaca and London: Cornell University Press, 1993).

Miller, Lillian B. and Sidney Hart (eds.), *The Selected Papers of Charles Willson Peale and His Family. Volume 5: The Autobiography of Charles Willson Peale* (New Haven, CT and London: Yale University Press, published for the National Portrait Gallery, Smithsonian Institution, 2000).

Miller, William Haig, 'A Day at Chatsworth', *The Leisure Hour: A Family Journal of Instruction and Recreation* 83 (1853), 490–93.

Mizuta, Miya Elise, 'Tokyo', in Sandy Isenstadt, Margaret Maile Petty, and Dietrich Neumann (eds.), *Cities of Light: Two Centuries of Urban Illumination* (London: Routledge, 2014).

Moleón Gavilanes, *Pedro, El Museo del Prado. Biografía del edificio* (Madrid: Museo del Prado, 2011).

Molinier, E., *Venise ses arts décoratifs ses Musées et ses collections* (Paris: Imprimerie de l'Art, 1889), https://archive.org/stream/venisesesartsdec00moli/veniseses artsdec00moli_djvu.txt

Moncel, Comte Th. du and William Preece, *Incandescent Lights, with Particular Reference to the Edison Lamps at the Paris Exhibition* (New York: Van Nostrand, 1882), https://catalog.hathitrust.org/Record/000847293

Montaran, Marie Constance Albertine, Fragmens, *Naples et Venise, avec cinq dessins par E. Gudin et E. Isabey* (Paris: J. Laisné, 1836), https://gallica.bnf.fr/ark:/12148/bpt6k2059131

'Monthly Record of American Art', *The Magazine of Art* 10 (1887), pp. xx–xx.

Morgan, Keith N., 'The Patronage Matrix: Charles A. Platt, Architect, Charles L. Freer, Client', *Winterthur Portfolio* 17.2/3 (1982), 121–34.

Moulton, Louise Chandler, *Lazy Tours in Spain and Elsewhere* (Boston, MA: Roberts, 1896; repr. 1897, https://babel.hathitrust.org/cgi/pt?id=yale.39002007650568)

Mumford, Lewis, *The Golden Day* (Boston, MA: Beacon Press, 1958).

Murray, John, *Handbook for Travellers in Northern Italy: Comprising Piedmont, Liguria, Lombardy, Venetia, Parma, Modena, and Romagna*, 11th ed. (London: John Murray, 1869), https://catalog.hathitrust.org/Record/100150512

Musacchio, Jacqueline M., 'Infesting the Art Galleries of Europe: the Copyist Emma Conant Church in Paris and Rome', *Nineteenth-Century Art Worldwide* 10.2 (2011).

Museo italiano della ghisa, *Storia dell'illuminazione, Origini e storia dell'illuminazione pubblica a Venezia*, http://www.museoitalianoghisa.org/assets/images/pdf/Storia-illuminazione-VE-IT.pdf

Nute, Kevin, *Frank Lloyd Wright in Japan* (London: Chapman & Hall, 1993).

Nye, David E., *American Illuminations* (Cambridge, MA: MIT Press, 2018).

Nye, David E., *Consuming Power: A Social History of American Energies* (Cambridge, MA: MIT Press, 1998).

Nye, David E., *Electrifying America* (Cambridge, MA: MIT Press, 1990).

Osborne, Carol M., 'Yankee Painters at the Prado', in Suzanne L. Stratton (ed.), *Spain, Espagne, Spanien: Foreign Artists Discover Spain, 1800–1900* (New York: Equitable Gallery, 1993), 59–77.

Osma, Guillermo de, *Mariano Fortuny. His Life and Work* (London: Aurum, 1980).

Otter, Chris, *The Victorian Eye: A Political History of Light and Vision in Britain, 1800–1910* (Chicago, IL: Chicago University Press, 2008).

Paglia, Gabriele, 'La paura e il piacere da Palazzo Ducale a Ca' Rezzonico. Visitare Venezia tra leggenda nera e leggenda rosa in Scritti in ricordo di Filippo Pedrocco', in *Bollettino dei Musei Civici di Venezia 2014–2015 dedicato a Filippo Pedrocco* (Venice: Skira/Fondazione Musei Civici di Venezia, 2014), pp. 202–09.

Pallucchini, Rodolfo and Paola Rossi, *Tintoretto. Le opere sacre e profane*, 2 vols. (Milan: Alfieri — Gruppo editoriale Electa, 1982).

Passer, Harold, *The Electrical Manufacturers, 1875–1900: A Study in Competition, Entrepreneurship, Technical Change, and Economic Growth* (Cambridge, MA: Harvard University Press, 1953), pp. 195–204.

Pavans, Jean, *Heures jamesiennes* (Paris: Éditions de la Différence, 2008).

Pavans, Jean, *Le monde intérieur de Henry James* (Paris: Seuil, 2016).

Pavon, G., *La nascita dell'energia elettrica a Venezia. 1866–1904* (Venice: Enel Distribuzione and Cartotecnica Veneziana, 2001).

Peale, Rembrandt, *Notes on Italy* (Philadelphia, PA: Carey, 1831).

Perkins, Robert F. and William J. Gavin, *The Boston Athenaeum Art Exhibition Index, 1827–1874* (Cambridge, MA: MIT Press, 1980).

Perosa, Sergio (ed.), *Ruskin e Venezia. La bellezza in declino* (Florence: Olschki, 2001).

Plato, *The Republic* (Cambridge, MA: Harvard University Press, 1935, also available at http://classics.mit.edu/Plato/republic.html).

Poldi, Gianluca, 'Gli azzurri perduti nei dipinti di Tintoretto. Ri-vedere le cromie grazie alle analisi scientifiche', in Sara Abram (ed.), *La Crocifissione di Tintoretto. L'intervento sul dipinto dei Musei Civici di Padova* (Turin: Editoria 2000, 2013), pp. 101–13.

Portús, Javier, *Museo del Prado, memoria escrita, 1819–1994* (Madrid: Museo del Prado, 1994).

Posocco, Franco, 'Il restauro di Tintoretto a San Rocco', in *Scuola Grande Arciconfraternita di San Rocco, Notiziario* 37 (2017), 104–07.

Posocco, Franco, *La vicenda urbanistica e lo spazio scenico: Scuola Grande di San Rocco* (Padua: Biblos, 1997).

Prime, Samuel Irenaeus, *The Alhambra and the Kremlin: The South and North of Europe* (New York: Randolph, 1873), https://catalog.hathitrust.org/Record/000814032

Querini Stampalia, Andrea, *Nuova guida annuale di Venezia* (Venice: Premiata Tipografia Lacchin, 1856).

Redgrave, Richard, 'The Construction of Picture Galleries', *The Builder*, 28 November 1857, 689–90.

Régnier, Henri de, *Esquisses vénitiennes* (Paris: Collection de l'Art Décoratif, 1906), https://archive.org/details/esquissesvnitie00dethgoog

Régnier, Henri de, *L'Altana ou La Vie vénitienne* (Paris: Mercure de France, 1928).

Régnier, Henri de, *L'Illusion héroique de Tito Bassi* (Paris: Mercure de France, 1916), https://archive.org/details/lillusionhro00rguoft

Régnier, Henri de, *Portraits et souvenirs* (Paris: Mercure de France, 1913), https://archive.org/details/portraitsetsouve00rguoft

Revere, Joseph Warren, *Keel and Saddle: a retrospect of forty years of military and naval service* (Boston, MA: Osgood, 1872), https://catalog.hathitrust.org/Record/007669778

Richardson, Edgar P., Brooke Hindle and Lillian B. Miller (eds.), *Charles Willson Peale and His World* (New York: Harry N. Abrams Publishers, 1982).

Ridolfi, Carlo, *Vita di Iacopo Robusti*, in *Le meraviglie dell'arte, overo le vite de gl'illustri pittori veneti*, 2 vols. (Venice: Giovan Battista Sgava, 1648, https://digi.ub.uni-heidelberg.de/diglit/ridolfi1837bd2. Repr. Venice: Filippi editore, 1994).

Ridolfi, Enrico, *Il mio direttorato delle regie Gallerie fiorentine*: *Appunti* (Florence: Tipografia Domenicana, 1905).

Rockwell, Charles, *Sketches of Foreign Travel, and Life at Sea*, 2 vols. (Boston, MA: Tappan & Dennet, 1842), https://archive.org/details/sketchesoffor02rock/page/n6

Romanelli, Giandomenico, *La luce e le tenebre. Tintoretto alla Scuola Grande di San Rocco* (Venice: Marsilio, 2011).

Romanelli, Giandomenico *et al.* (eds.), *Museo Fortuny a Palazzo degli Orfei* (Milan: Skira, 2008).

Roulet, Mary Nixon, *With a Pessimist in Spain* (St. Louis, MO: Herder, 1899), https://catalog.hathitrust.org/Record/008644492

Ruskin, John, *Guida ai principali dipinti nell'Accademia di Belle Arti di Venezia 1877*, ed. by Paul Tucker, trans. By Emma Sdegno (Milan: Electa, 2014).

Ruskin, John, *Modern Painters*, 2 vols. (New York and Chicago, IL: The Library Edition, 2009).

Ruskin, John, *'Résumé' of Italian Art and Architecture* (1845), Paul Tucker (ed.) (Pisa: Scuola Normale Superiore, 2003).

Ruskin, John, *The Complete Works of John Ruskin in 39 vols.*, E. T. Cook and Alexander Wedderburn (eds.) (London: Allen, 1903–1912), https://catalog.hathitrust.org/Record/002569741

Ruskin, John, *The Stones of Venice*, 3 vols. (London: George Allen & Unwin Ltd., 1925), http://www.gutenberg.org/files/30756/30756-h/30756-h.htm

Ruzza, Luca, *Pratica di fabricar scene e macchine ne' teatri di Nicola Sabbatini* (Roma: Nuova Cultura, 2011).

Salomone, William, 'The Discovery of Nineteenth–century Italy: An Essay in American Cultural History', *The American Historical Review* 73 (1968), 1359–91.

Saunders, David, 'Pollution and the National Gallery', *National Gallery Technical Bulletin* 21 (2000), 77–94.

Schivelbusch, Wolfgang, *Luce. Storia dell'illuminazione artificiale nel secolo XIX* (Parma: Pratiche, 1994).

Schloss, Dietmar, *Culture and Criticism in Henry James* (Tübingen: Gunter Narr Verlag, 1992).

Schulz, Andrew, 'Museo Nacional del Prado, Madrid: Absolutism and Nationalism in Early-Ninetenth-Century Madrid', in Carole Paul (ed.), *The*

First Modern Museums of Art (Los Angeles, CA: The J. Paul Getty Museum, 2012), pp. 237–60.

Sdegno, Emma (ed.), *Looking at Tintoretto with John Ruskin* (Venice: Marsilio, 2018).

Sdegno, Emma, 'Reading the Painting's Suggestiveness', in Jeanne Clegg and Paul Tucker (eds.), *The Dominion of Daedalus* (St. Albans, UK: Brentham Press, 1994), pp. 100–15.

Sdegno, Emma, 'On Translating Ruskin's Academy Guide', *The Companion* 15 (2015), 48–49.

Searing, Helen, *New American Art Museums* (New York: Whitney Museum of Art, 1982).

Settis, Salvatore and Franco Posocco (eds.), *La Scuola Grande di San Rocco* (Modena: Franco Cosimo Panini, 2008).

Shapiro Harold I. (ed.), *Ruskin in Italy: Letters to his Parents 1845* (Oxford: Clarendon Press, 1972).

Sharpe, C. Melvin, 'Brief Outline of the History of Electric Illumination in the District of Columbia', Records of the Columbia Historical Society, Washington, D.C., 48/49 (1946–1947), 191–207, https://www.jstor.org/stable/40064095?seq=1#metadata_info_tab_contents

Sherman, Daniel, *Worthy Monuments: Art Museums and the Politics of Culture in Nineteenth-Century France* (Cambridge, MA: Harvard University Press, 1989).

Sigourney, Lydia H., *Pleasant Memories of Pleasant Lands* (Boston, MA: Munroe, 1842), https://en.wikisource.org/wiki/Pleasant_Memories_of_Pleasant_Lands

Sinisi, Silvana and Innamorati, Isabella, *Storia del teatro. Lo spazio scenico dai greci alle avanguardie* (Milan: Mondadori, 2003).

Sirén, Osvald, *A Descriptive Catalogue of the Pictures in the Jarves Collection Belonging to Yale University* (New Haven, CT: Yale University Press, 1916), https://archive.org/details/descriptivecatal00sir

Sizer, Theodore, 'James Jackson Jarves, a Forgotten New Englander', *The New England Quarterly* 6 (1933), 328–52.

Sloan, James, *Ramblings in Italy* (Baltimore: Maxwell, 1818).

Smee, Sebastian, 'Taniguchi, Ando, and the Allure of Japanese Architecture', *Boston Globe*, 29 November 2014, https://www.bostonglobe.com/arts/2014/11/29/taniguchi-ando-and-penumbral-allure-japanese-architecture/NmkjEZNnfJXrXPsUyhmhRP/story.html

Smith, Nicholas, 'Let There Be Light! Illuminating the V&A in the Nineteenth Century', https://www.vam.ac.uk/blog/caring-for-our-collections/let-there-be-light-illuminating-va-nineteenth-century

Soane, Sir John, *Description of the house and museum on the north side of Lincoln's Inn Fields, the residence of Sir John Soane... With graphic illustrations and incidental details* (London: Printed by Levey, Robson, and Franklyn, St. Martin's Lane, 1835), https://archive.org/details/gri_descriptiono00soan/page/n12

Sonaglioni, Demetrio, 'La nuova luce dinamica della Sala dell'Albergo', in *Scuola Grande Arciconfraternita di San Rocco, Notiziario* 32 (2014), 74–87

Stael, Madame de, *Corinne; or, Italy*, trans. by Isabel Hill (London: Richard Bentley, 1838), https://books.google.co.uk/books?id=6kxgAAAAcAAJ&prin tsec=frontcover&dq=corinne,+or+italy+1838&hl=en&sa=X&ved=0ahUKEwj V8eaw4tjdAhXMKMAKHbCfBVkQ6AEILzAB

Stebbins, Theodore (ed.), *The Lure of Italy: American Artists and the Italian Experience, 1760–1914* (Boston, MA: Museum of Fine Arts, 1992).

Steegmuller, Francis, *The Two Lives of James Jackson Jarves* (New Haven: Yale University Press, 1951).

Steen, Jürgen, 'Eine neue Zeit..!' in *Die Internationale Elektrotechnische Ausstellung 1891* (Frankfurt am Main: Historisches Museum, 1991).

Stevenson, Robert Louis, 'A Plea for Gas Lamps', in his *'Virginibus Puerisque' and Other Papers* (Boston, MA: Small, Maynard & Co, 1907), pp. 249–56, https://archive.org/stream/virginibuspueris05stev#page/254/search/a+plea+for

Stieringer, Luther, 'The Evolution of Exposition Lighting', *Western Electrician* 29.12 (21 September 1901), 187–92, https://archive.org/stream/westernelectrici29chic#page/186/mode/2up/search/Stieringer

Stillman, W. J., 'Cole and his Work', *The Century* 37 (November 1889).

Stoddard, Charles Augustus, *Spanish Cities; with glimpses of Gibraltar and Tangier* (New York: Scribner's, 1892), https://catalog.hathitrust.org/Record/006592552

Stone, Donald D., 'The Museum World of Henry James. Adeline R. Tintner', *Nineteenth-Century Literature* 42 (1987), 251–53.

Stowe, William, *Going Abroad* (Princeton, NJ: Princeton University Press, 1994).

Stringa, Nico (ed.), *L'Accademia di Belle Arti a Venezia*, 2 vols. (Crocetta del Montello, Treviso: Antiga, 2016).

Strout, C, 'Henry James's Dream of the Louvre, "The Jolly Corner", and Psychological Interpretation', *The Psychohistory Review* 8 (1979), 47–52.

Sturgis, Russell, Jr., *Manual of the Jarves Collection of Early Italian Pictures, deposited in the gallery of the Yale School of the Fine Arts. Being a catalogue, with descriptions of the pictures contained in that collection, with biographical notices of artists and an introductory essay, the whole forming a brief guide to the study of early Christian art* (New Haven, CT: Yale College Press, 1868), https://archive.org/details/gri_33125006446203

Sweeney, John L., *The Painter's Eye. Notes and Essays on the Pictorial Arts* (London: Rupert Hart-Davis, 1956).

Swinney, Geoffrey N., 'Attitudes to Artificial Lighting in the Nineteenth Century', University Museums in Scotland (2002), http://www.umis.ac.uk/conferences/conference2002_%20swinney.html

Swinney, Geoffrey N., 'Gas Lighting in British Museums and Galleries', *Museum Management and Curatorship* 18:2 (1999), 113–43.

Swinney, Geoffrey N., 'The Evil of Vitiating and Heating the Air. Artificial Lighting and Public Access to the National Gallery, London, with Particular Reference to the Turner and Vernon Collections', *Journal of the History of Collections* 15.1 (2003), 83–112.

Tafuri, Manfredo, *Venezia e il Rinascimento. Religione, scienza e architettura* (Turin: Einaudi, 1985).

Tanaka, Stefan, *New Times in Modern Japan* (Princeton, NJ: Princeton University Press, 2004).

Tanizaki, Junichiro, *In Praise of Shadows*, trans. by Thomas J. Harper and Edward G. Seidensticker (Sedgwick: Leete's Island Books, 1977).

Taylor, Brandon, *Art for the Nation: Exhibitions and the London Public 1747–2001* (Manchester: Manchester University Press, 1999).

The Duchess of Devonshire, *Treasures of Chatsworth. A Private View* (London: Constable, 1991).

'The Electric Light at Chatsworth', *Nottinghamshire Guardian*, 16 December 1893.

The Selected Papers of Charles Willson Peale and his Family (New Haven, CT: Yale University Press, 1982).

The Works of the Reverend Orville Dewey: with a biographical scketch (London: Simms and McIntyre, 1844), https://catalog.hathitrust.org/Record/011156590

Tintner, Adeline R., *The Museum World of Henry James* (Ann Arbor, MI: UMI Research Press, 1986).

Tippens, Darryl et al., *Shadow and Light: Literature and the Life of Faith* (Abilene, TX: Abilene Christian University Press, 2013).

Tomoroy, Leslie, *Progressive Enlightenment: The Origins of the Gaslight Industry, 1780–1820* (Cambridge, MA: MIT Press, 2012).

Tonini, Camillo and Michelle Gottardi, 'Sissi e Venezia. Tre incontri particolari', in M. Bressan (ed.), *Elisabetta d'Austria, Trieste e l'Italia* (Monfalcone: Monfalcone, 2000), pp. 52–73.

Tousey, Sinclair, *Papers From Over the Water* (New York: American News Company, 1869).

Tseng, Alice Y., *The Imperial Museums of Meiji Japan: Architecture and the Art of the Nation* (Seattle: University of Washington Press, 2008).

Tuckerman, Henry P., *The Italian Sketch-Book* (Boston, MA: Light, Stearns & Cornhill, 1837), https://catalog.hathitrust.org/Record/007675127

Valcanover, Francesco, *Jacopo Tintoretto e la Scuola Grande di San Rocco* (Venice: Storti editore, 1983 and 2010).

Valery, Antoine Claude Pasquin, *Voyages historiques, littéraires et artistiques en Italie pendant les années 1826, 1827 et 1828; ou, L'indicateur Italien*, 3 vols. (Paris: Le Normant, 1831), https://catalog.hathitrust.org/Record/000351140

Valéry, Paul, *Pièces sur l'art* (Paris: Gallimard, 1934).

Vedrasco, A, 'La luce elettrica nel Palazzo Ducale', *L'Adriatico*, 13 July 1896.

Villa, Massimo Maria, 'Venezia. Vedere oltre lo sguardo', *Luce e design* 12 (2014), http://www.lucenews.it/venezia-vedere-oltre-lo-sguardo/

Volpin, Stefano, Antonella Casoli, Michela Berzioli and Chiara Equiseto, 'I colori scomparsi: la materia pittorica e le problematiche di degrado', in Grazia Fumo e Dino Chinellato (eds.), *Tintoretto svelato. Il soffitto della Sala dell'Albergo nella Scuola Grande di San Rocco. Storia, ricerche, restauri* (Milan: Skira editore, 2010), pp. 138–45.

Urry, John, *The Tourist Gaze* (New York: Sage, 2002).

Wallace, Alfred, *The Progress of the Country* (New York: Harper Brothers, 1901).

Ward, Humphrey, *History of the Athenaeum, 1824–1925* (London: Printed for the club, 1926).

Warner, Charles Dudley, *A Roundabout Journey* (Boston, MA: Houghton, Mifflin, 1883), https://babel.hathitrust.org/cgi/pt?id=nyp.33433082478334;view=1up;seq=9

Warner, Langdon, 'The Freer Gift of Eastern Art to America', *Asia* 23 (1923), 593–94.

Warren Adelson, William H. Gerts, Elaine Kilmurray, Rosella Mamoli Zorzi, Richard Ormond and Elizabeth Oustinoff (eds.), *Sargent's Venice* (New Haven, CT, and London: Yale University Press, 2006).

Warren, Kenneth W., 'Still Reading James?', *The Henry James Review* 16.3 (1995), 282–85.

Watt, Ian, '"Worthy of the Palace of Aladdin?" The introduction of Gas and Electricity to the Country House', in Marilyn Palmer and Ian West (eds.), *Technology in the Country House* (Stamford: Paul Watkins Publishing, 2013), pp. 108–23.

Watts, Harvey M., 'Opening of the Freer Gallery of Art', *Art and Archaeology* 15.6 (1923), 271–77.

Wharton, Edith and Codman Ogden, Jr., *The Decoration of Houses* (New York: Charles Scribner's Sons, 1897), https://babel.hathitrust.org/cgi/pt?id=cool.ark:/13960/t3320hg54

Whistler, James McNeill, *Mr. Whistler's Ten o' Clock* (London: Chatto & Windus, 1888), https://archive.org/details/mrwhistlerstenoc00whis/page/n2

Willmes, Ulrich, *Studien zur Scuola di San Rocco in Venedig* (München: Scaneg, Verlag R. A. Klein, 1985).

Winner, Hopkins Viola, *Henry James and the Visual Arts* (Charlottesville, VA: Virginia University Press, 1978).

Workman, Fanny Bullock, *Sketches Awheel in Modern Iberia* (New York: Putnam's, 1897).

Wright, Natalia, *American Novelists in Italy* (Philadelphia, PA: University of Pennsylvania Press, 1965).

Wright of Derby, J., *The Academy by Lamplight* (New Haven, CT: Yale Center for British Art, original date 1769).

Yarrington, Alison, 'Under Italian Skies, the 6th Duke of Devonshire, Canova and the Formation of the Sculpture Gallery at Chatsworth House', *Journal of Anglo-Italian Studies* 10 (2009), 41–62.

Zangemeister, Karl, *Inscriptiones Parietariae Pompeianae, Herculanenses, Stabianae* (Berolini Reimer, 1871), https://archive.org/details/inscriptionespar41zang/page/n8

Zanotto, Francesco, *Pinacoteca della Imp. Reg. Accademia Veneta delle Belle Arti*, 2 vols. (Venice: Giuseppe Antonelli, 1830).

Zeki, Semir, *Con gli occhi del cervello* (Roma: Di Renzo, 2008).

Zeki, Semir, *The Inner Vision* (Oxford: Oxford University Press, 1999).

List of Illustrations

Chapter 1

Chapter 2

Chapter 3

Chapter 4

Chapter 5

Chapter 7

Chapter 10

Chapter 12

Chapter 13

Chapter 16

Chapter 17

Chapter 20

Chapter 22

Chapter 23

Chapter 27

Index

This book need not end here...

Share

All our books—including the one you have just read—are free to access online so that students, researchers and members of the public who can't afford a printed edition will have access to the same ideas. This title will be accessed online by hundreds of readers each month across the globe: why not share the link so that someone you know is one of them?

This book and additional content is available at:
https://doi.org/10.11647.OBP.0151

Customise

Personalise your copy of this book or design new books using OBP and third-party material. Take chapters or whole books from our published list and make a special edition, a new anthology or an illuminating coursepack. Each customised edition will be produced as a paperback and a downloadable PDF.

Find out more at:
https://www.openbookpublishers.com/section/59/1

You may also be interested in:

Cultural Heritage Ethics
Between Theory and Practice
Edited by Constantine Sandis

https://doi.org/10.11647/OBP.0047

Modernism and the Spiritual in Russian Art
New Perspectives
Edited by Louise Hardiman and Nicola Kozicharow

https://doi.org/10.11647/OBP.0115

Vertical Readings in Dante's Comedy
Volume 1
George Corbett and Heather Webb

https://doi.org/10.11647/OBP.0066

Lightning Source UK Ltd.
Milton Keynes UK
UKHW021426201120
373676UK00002B/17

9 781783 745494